HEIDE CHRISTIANSEN

Charming FRANCE

teNeues

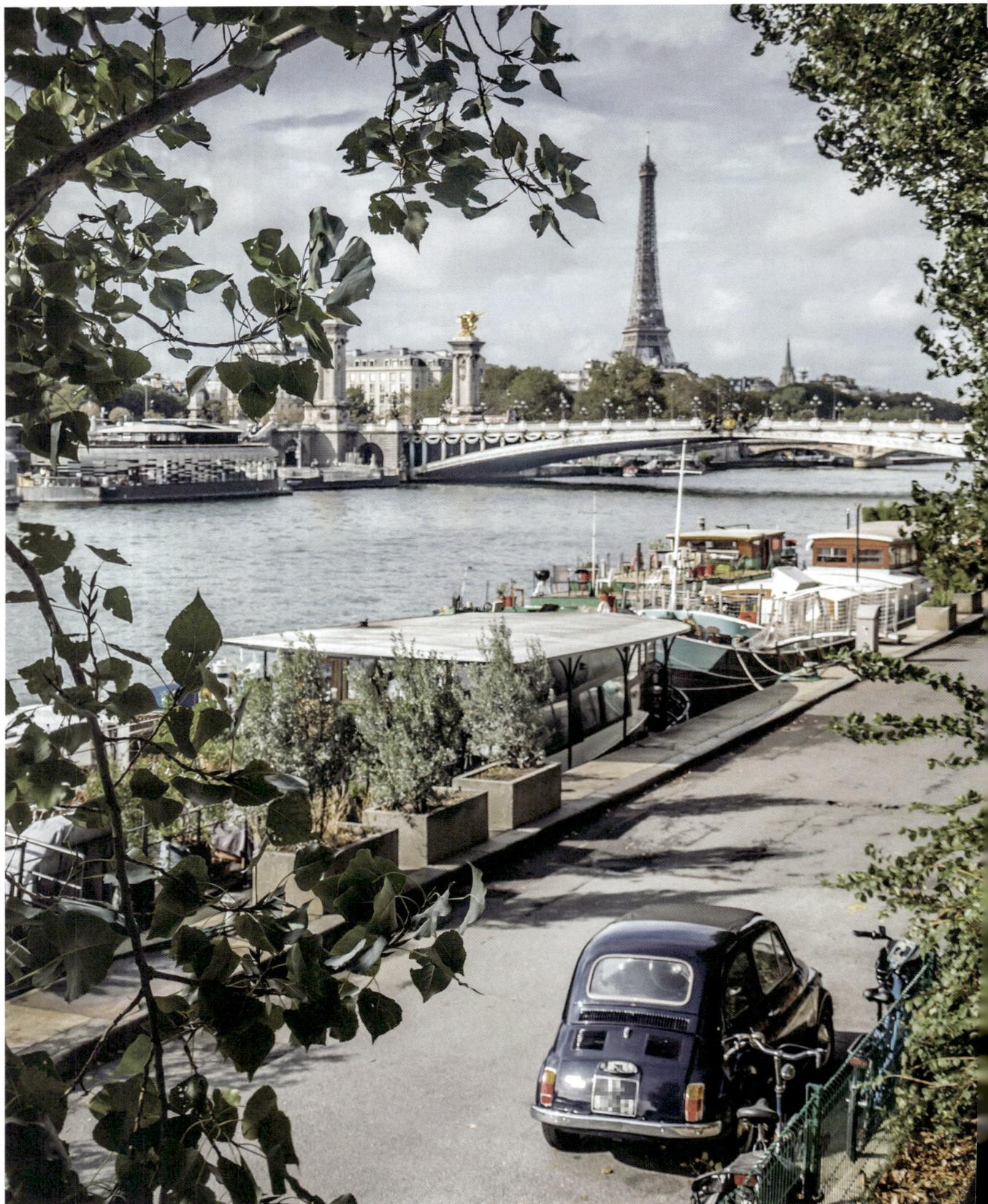

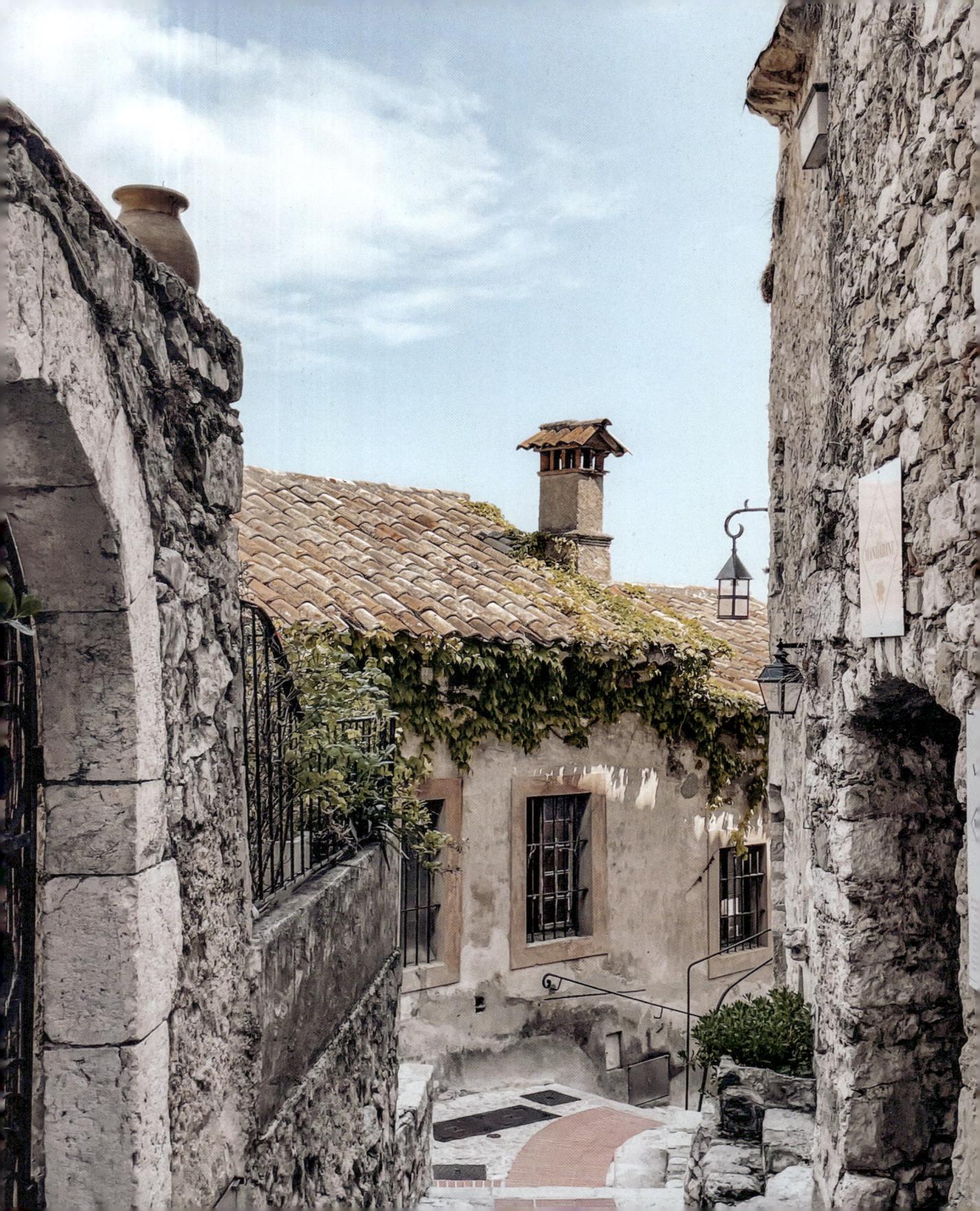

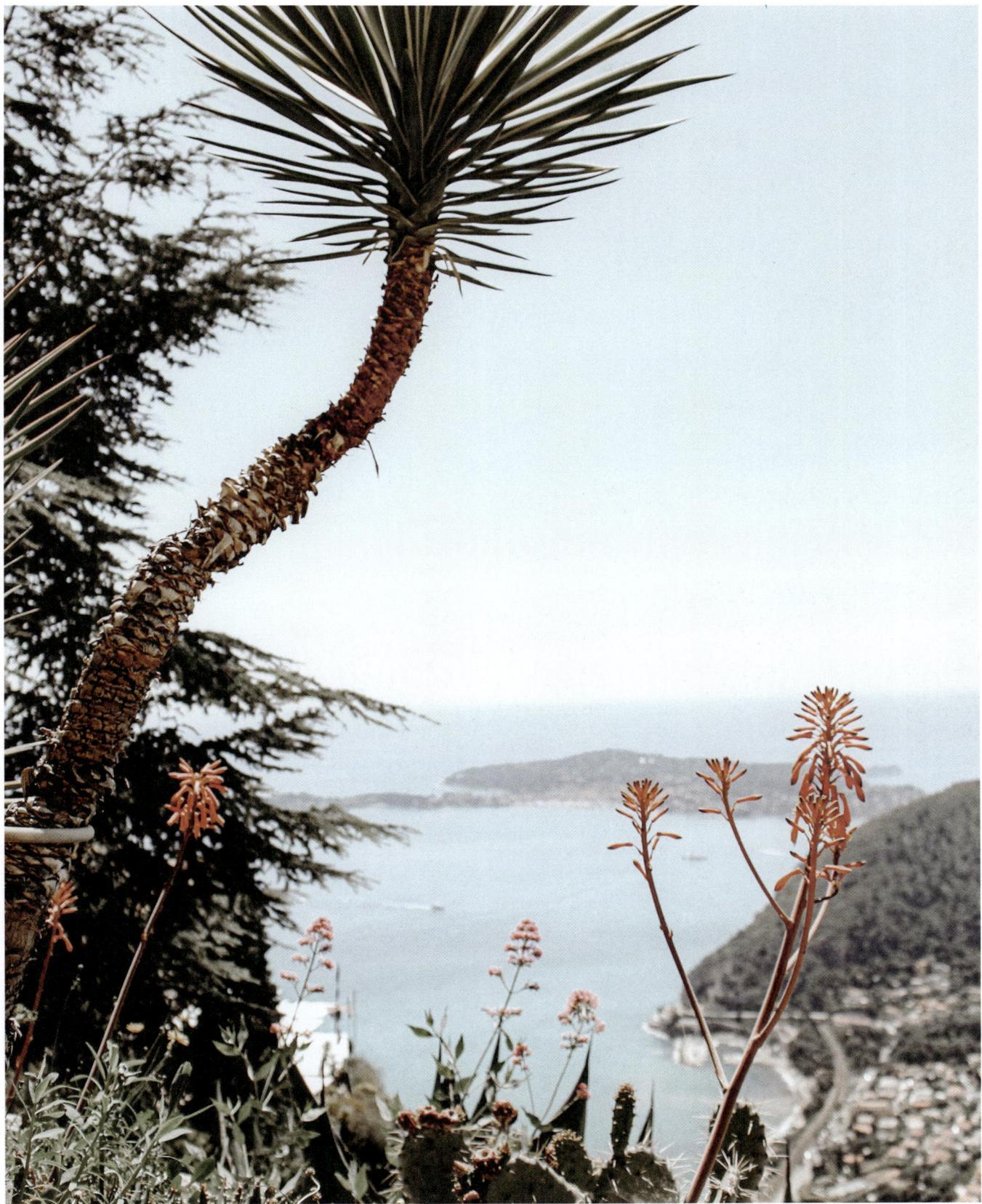

CONTENTS

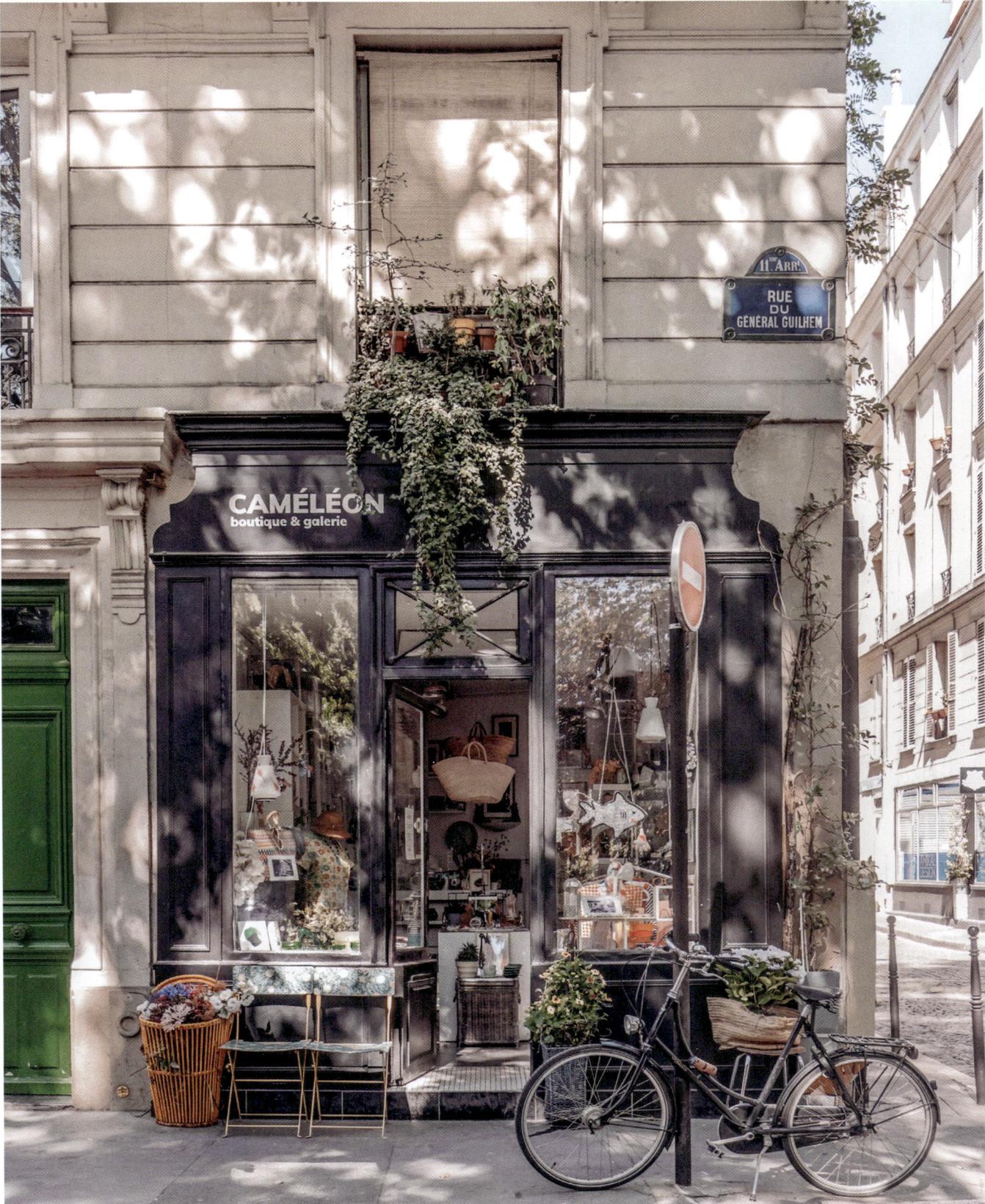

(FOREWORD

I'M IN LOVE WITH FRANCE

When they come to France, many Canadians experience love at first sight. For me, however, it was a much later second look that got me interested in *la Grande Nation*. Of course, as a Canadian one automatically feels connected, if only because of the linguistic ties. I was even in France a lot as a youngster, travelling with my family, and so I became acquainted with the country from the perspective of a tourist. This usually meant plunging into a throng of people busy with the colorful amusements of a vacation, until I'd had enough, which sometimes didn't take very long. It didn't leave very many lasting impressions. When I go to France today, I do it differently. Many times, it was the mood of the photographs posted by influencers on social media that raised my appetite to travel to out-of-the-way corners of France, to discover the charm of small village squares and wonderful old stone houses and buildings. If you have been there and felt the incomparable warm light of the façades along a narrow street in the old town of Arles, or somewhere in Roussillon, you know how charming France can warm your heart. My reaction to Paris resembled the scenario in which the slightly chaotic, always refreshing and spontaneous Emily (from *Emily in Paris*) strolls through the City of Love. Her character inspired me to go back and explore the streets on either side of the Seine and visit some of my old favorite spots, discover new, charming shops and cafes, and have a fresh look at a city that everyone acts like they know like the back of their hand. The invitation of *Charming France* is for you to follow me on a photographic journey through Charming France and fall completely in love again, as I did, with the picturesque corners of *la Grande Nation*.

Heide Christiansen loves exploring the most beautiful places on Earth and using expressive, tone-setting images to construct amazing narratives. Writer Anja Klaffenbach is likewise enthusiastic about travel and the experience of discovery. She writes about their shared passion for the world's most charming spots.

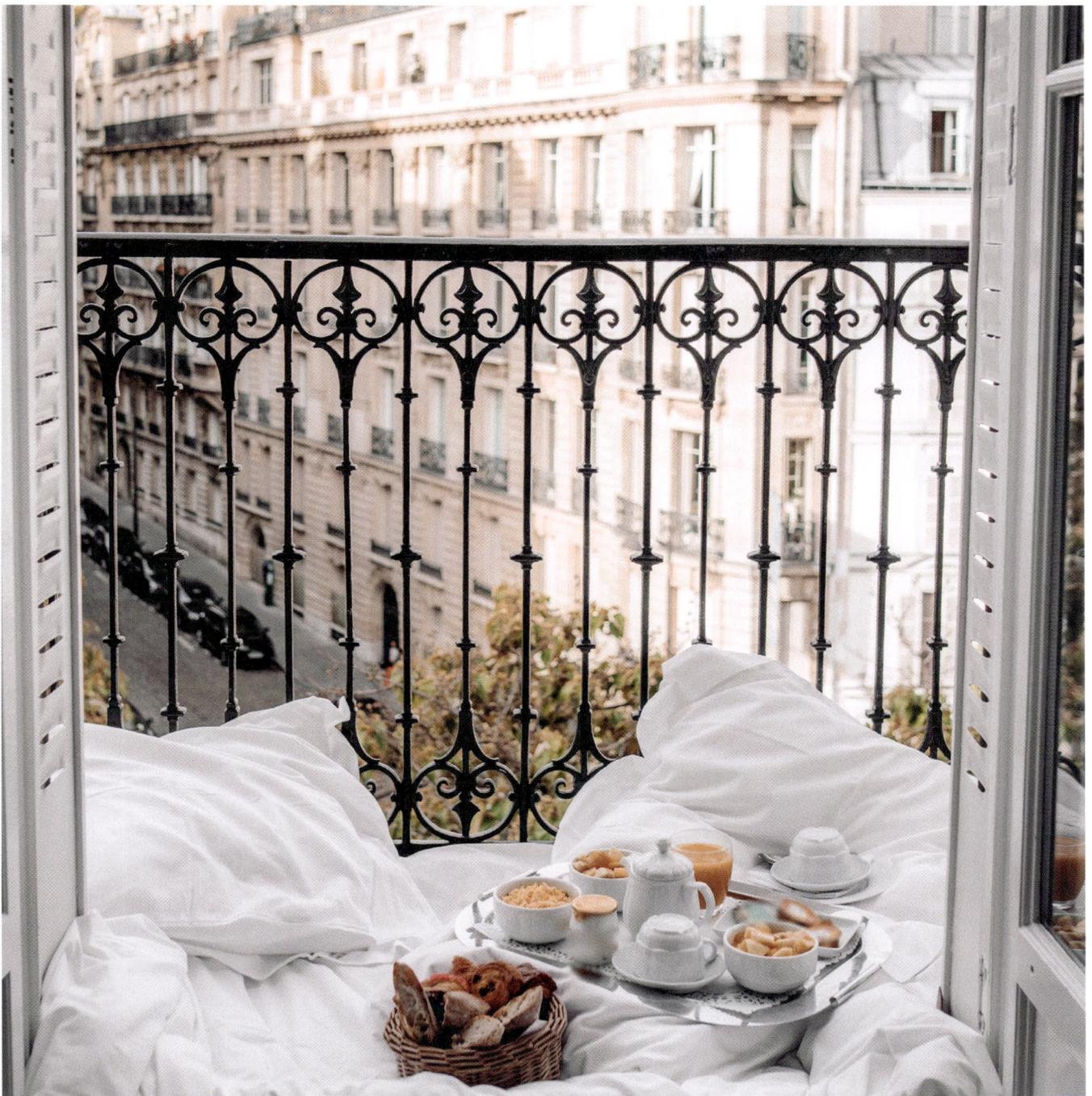

Above:
*In love with France: Start the day with a café au lait and discover the city and countryside
from new perspectives—magnifique!*
Previous Pages:
*Experience Paris at its finest—whether strolling along the Seine or relaxing in charming street cafés
(Pages 2 and 3). A trip to Provence: Perched on the cliffs with a wistful view of the sea, the picturesque village
of Èze beckons (Pages 4 and 5). At every street corner, you'll find a cozy restaurant or a charming boutique:
the 11th arrondissement of Paris (Page 7).*

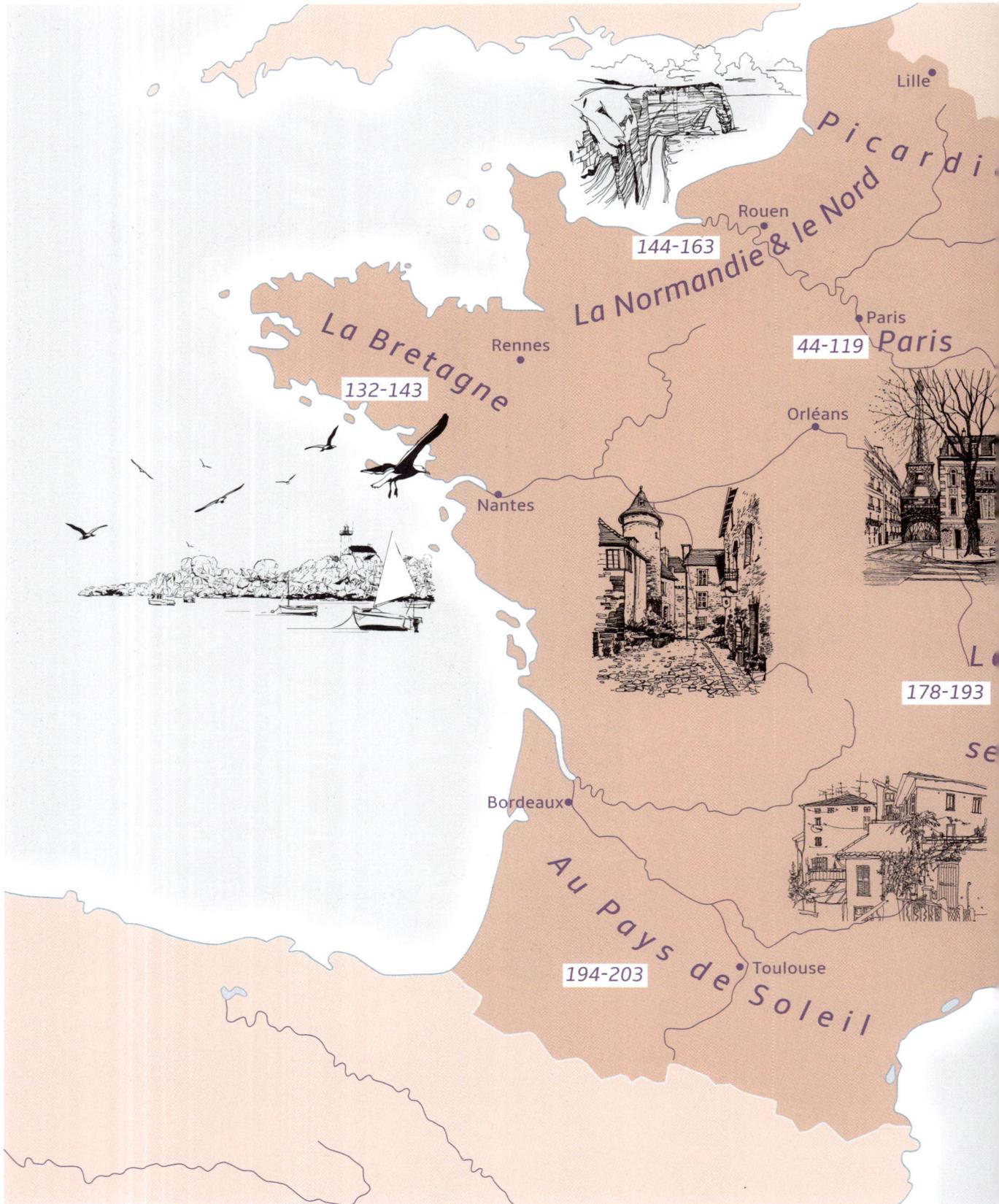

Lille

P i c a r d i e

Rouen

144-163

La Normandie & le Nord

Paris

44-119 Paris

La Bretagne

Rennes

132-143

Orléans

Nantes

178-193

se

Bordeaux

Au Pays de Soleil

194-203 Toulouse

Charming FRANCE

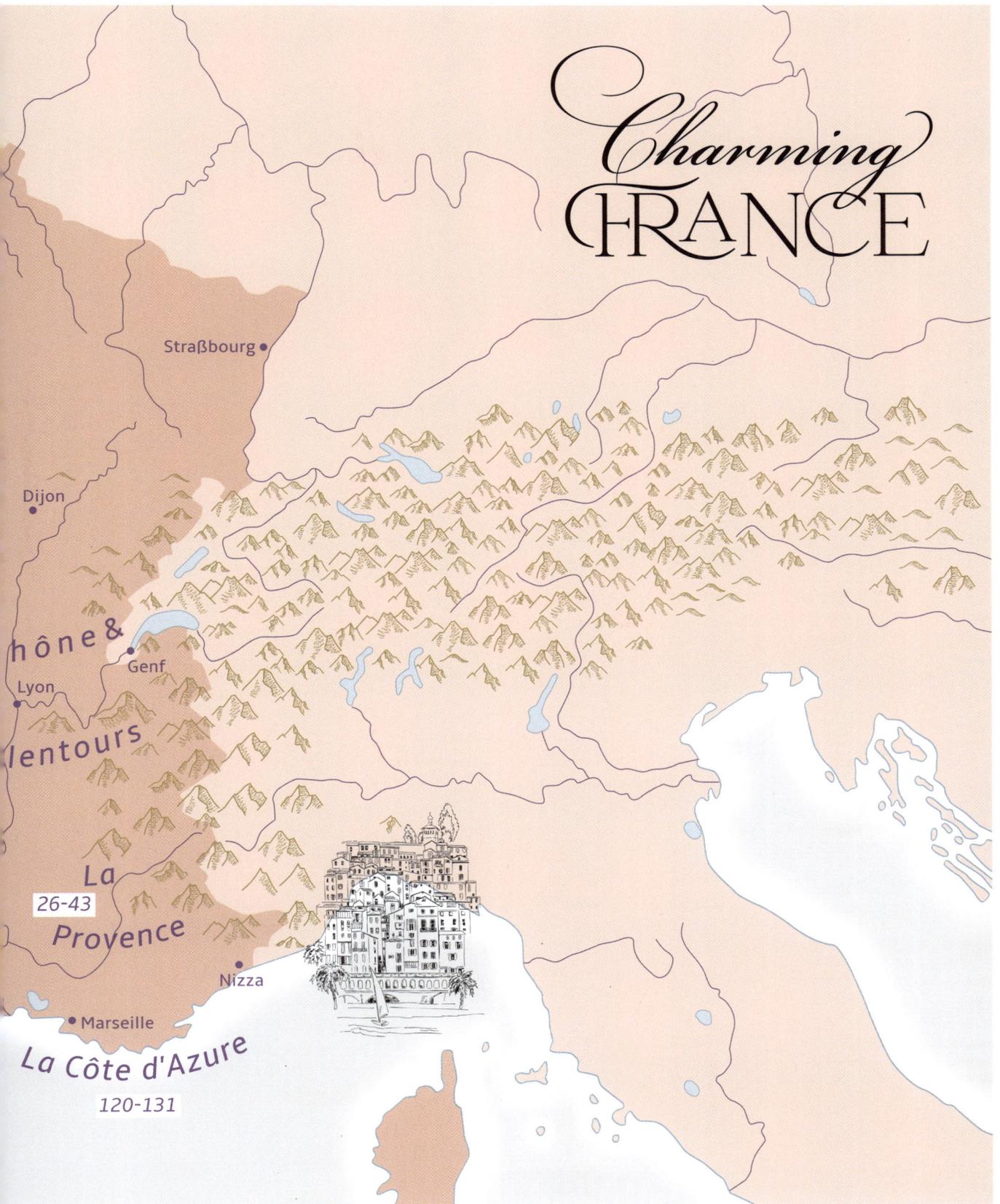

Straßbourg •

Dijon
•

hône&

Genf
•

Lyon
•

lentours

La

26-43

Provence

Nizza
•

• Marseille

La Côte d'Azure

120-131

LA FRANCE ET L'ART

WALKING IN THE FOOTSTEPS OF ARTISTS

If you set out to walk where the great painters once roamed, you will almost automatically discover some of France's most visually striking locations. Let's begin in Paris, where in the nineteenth century a lively artists' quarter sprang up on the hill of Montmartre. Strolling over the cobblestones of Rue de L'Abreuvoir, one can still sense the village-like charm that once drew the *crème de la crème* of the Impressionists—Henri de Toulouse-Lautrec, Pierre-Auguste Renoir, Édouard Manet—along with Vincent van Gogh. Claude Monet, however, left the city behind and followed the Seine to the countryside, settling in Giverny. Even today, his garden transports visitors to the luminous world of his water lily paintings. But it was the South of France, with its golden light and ever-shifting shadows, that held an almost supernatural pull for generations of artists. Pablo Picasso spent his final years in a spacious villa nestled in the hills near Mougins. Today, the narrow lanes of the old village center, dotted with art studios and galleries, still draw art lovers. For a closer look at Picasso's work, make your way to nearby Antibes, where some of his most significant pieces are housed in a museum within his former studio at the medieval Château Grimaldi—perched between the picturesque old town and the sparkling blue sea. Vincent van Gogh too was captivated by the South, particularly the ancient Roman city of Arles, with its sweeping landscapes and winding old-city streets. The incomparable golden light and deep blue sky he had longed for in Paris inspired him to paint more than 300 works during his time in Provence. Even today, as you wander through the old town past colorful shutters and café tables beneath broad awnings, you may feel as if you stepped into one of his paintings.

Right:
Strolling through the charming streets of the many Provence villages sometimes feels like wandering through an impressionist masterpiece.

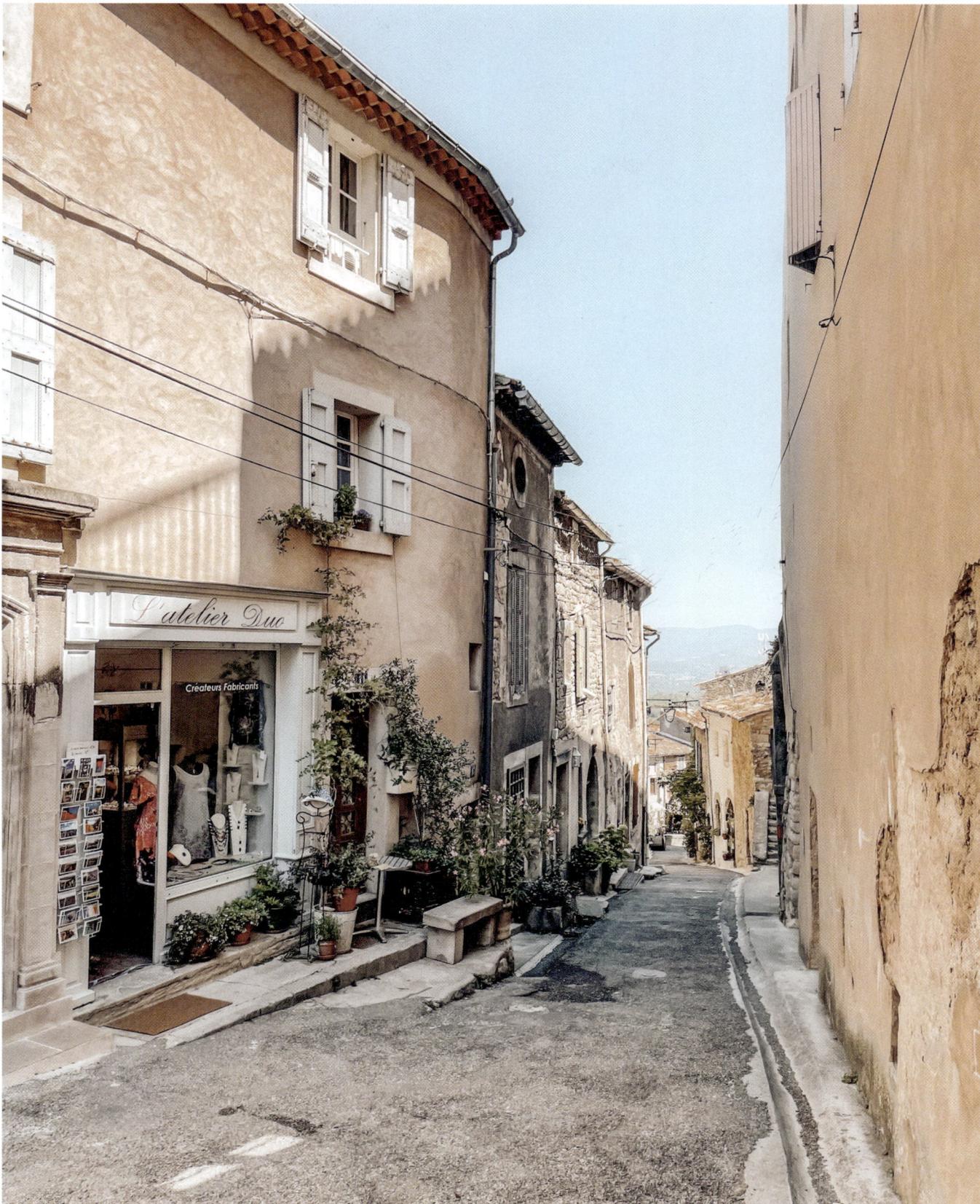

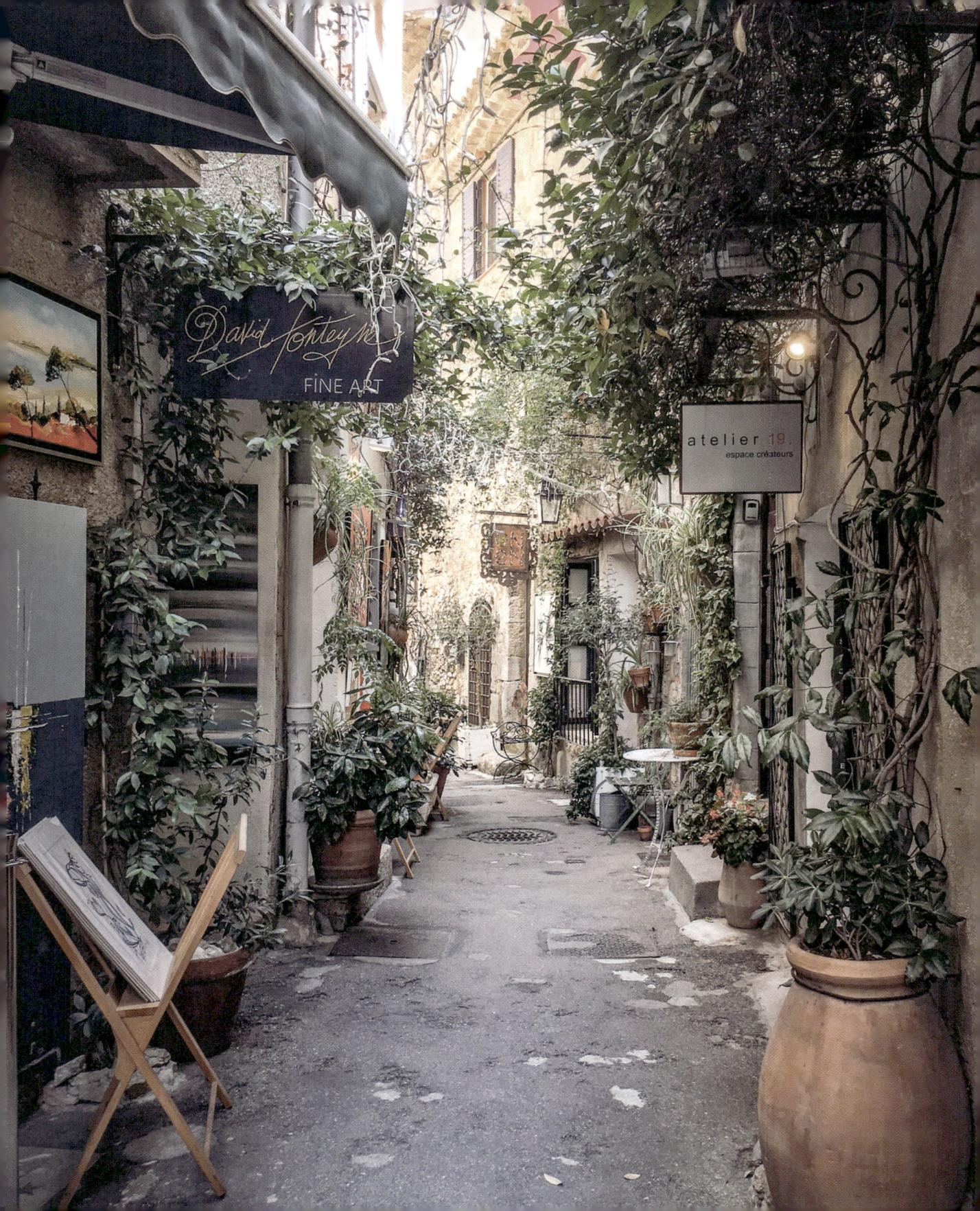

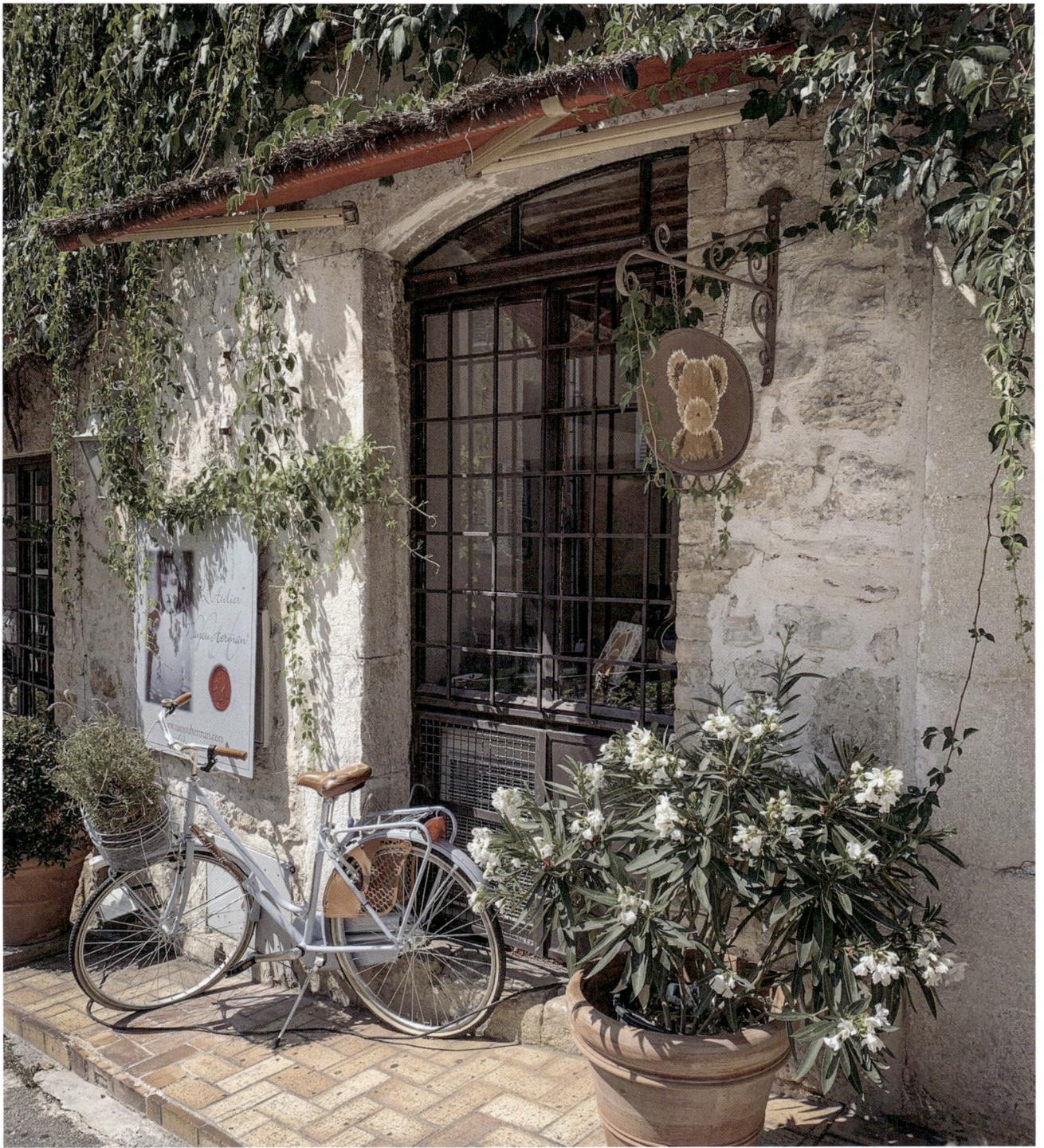

Above and at left:
Pablo Picasso once made his home amid the narrow streets of Mougins. Any one of them could spark artistic inspiration. These rows of verdant facades, like paintings themselves, stay with you long after you've seen them.

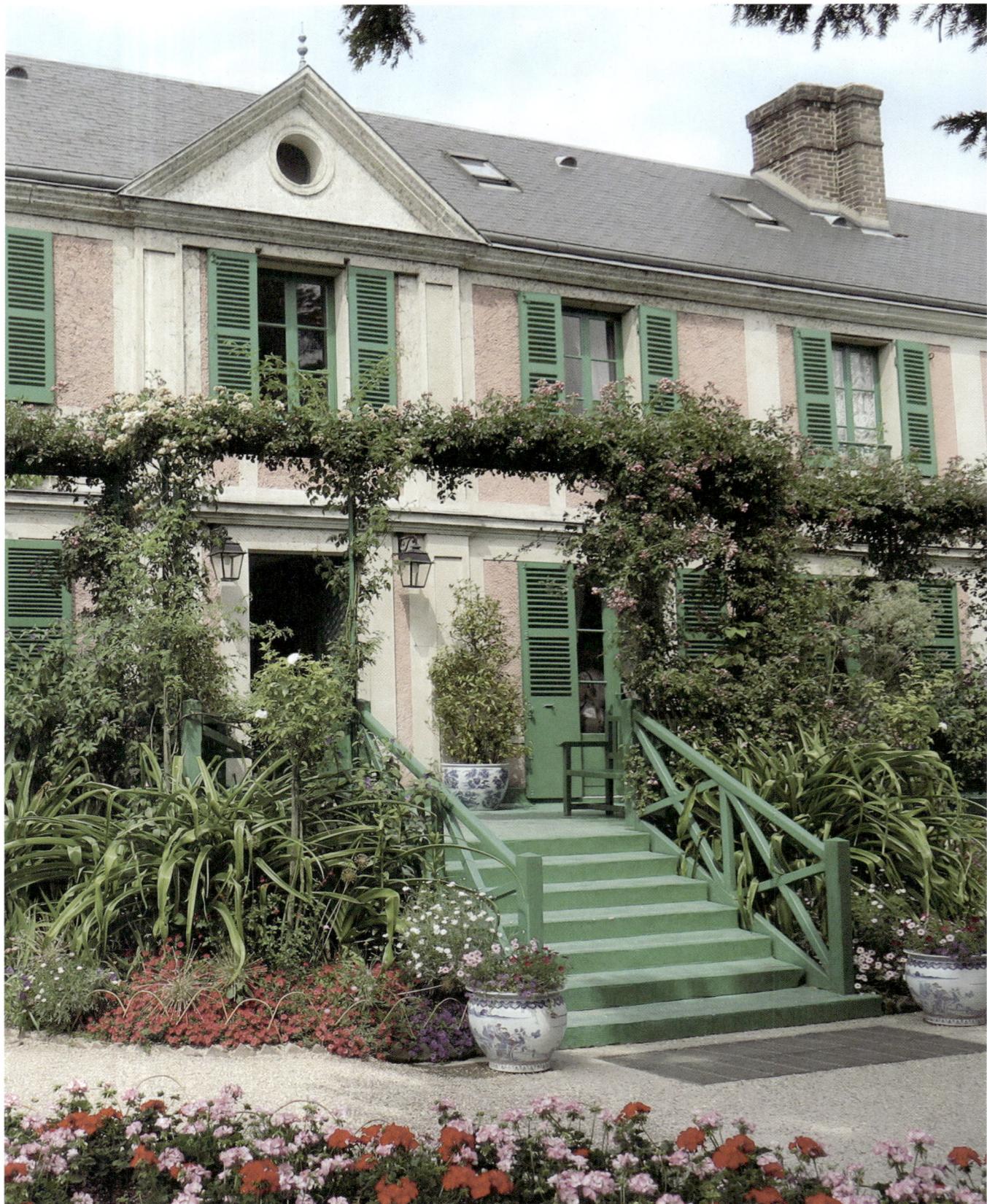

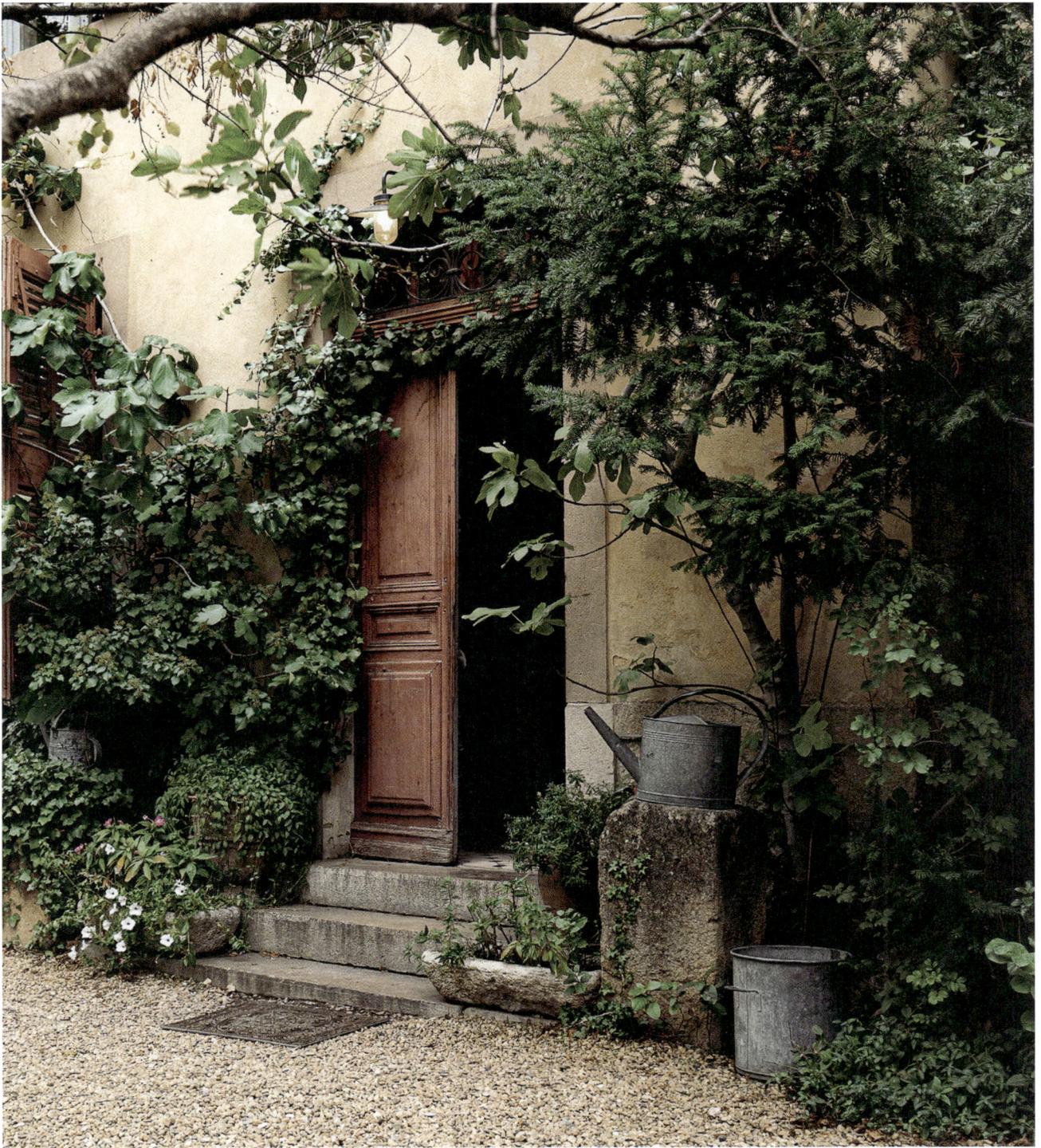

Above:
The door to Paul Cézanne's studio in Aix-en-Provence opens into a bygone art world.
Left:
Monet painted his mesmerizing water lilies in the gardens surrounding his home in Giverny.

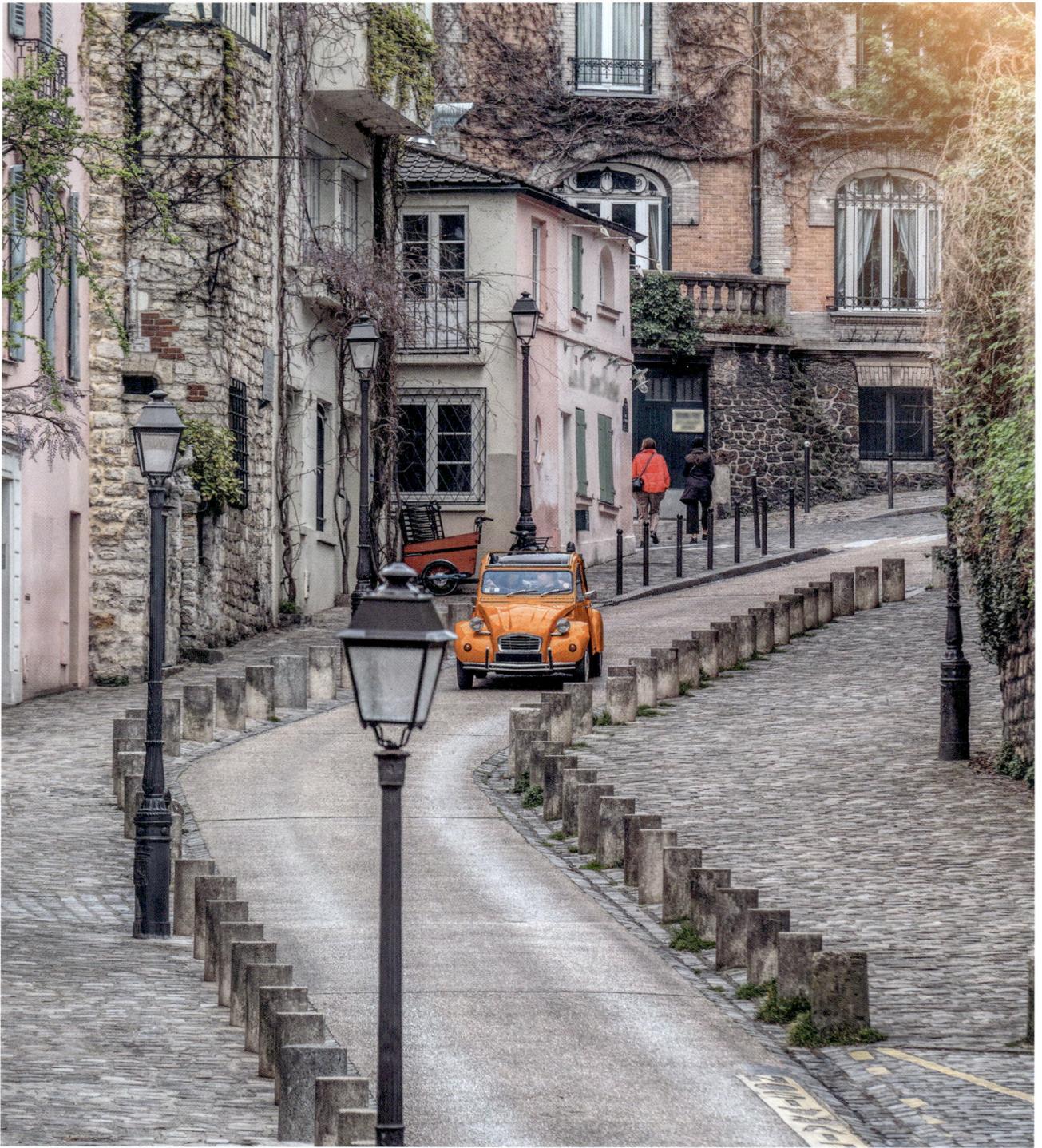

Above and at right:
La Maison Rose, at the end of Rue de L'Abreuvoir in Montmartre, was once a favorite haunt of artists. Naturally, Emily, the protagonist of the Netflix series Emily in Paris, *could not pass up this highly Instagrammable spot.*

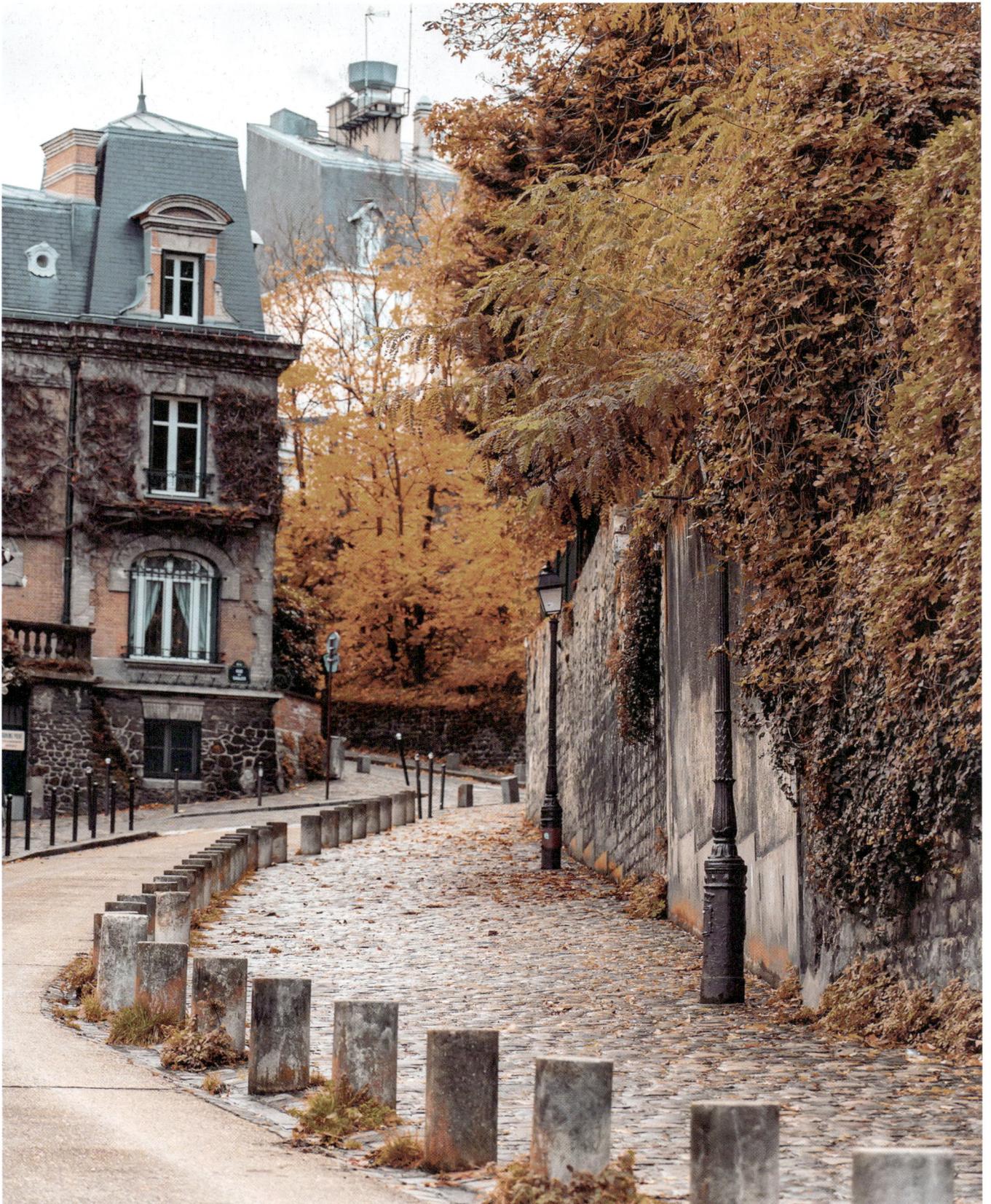

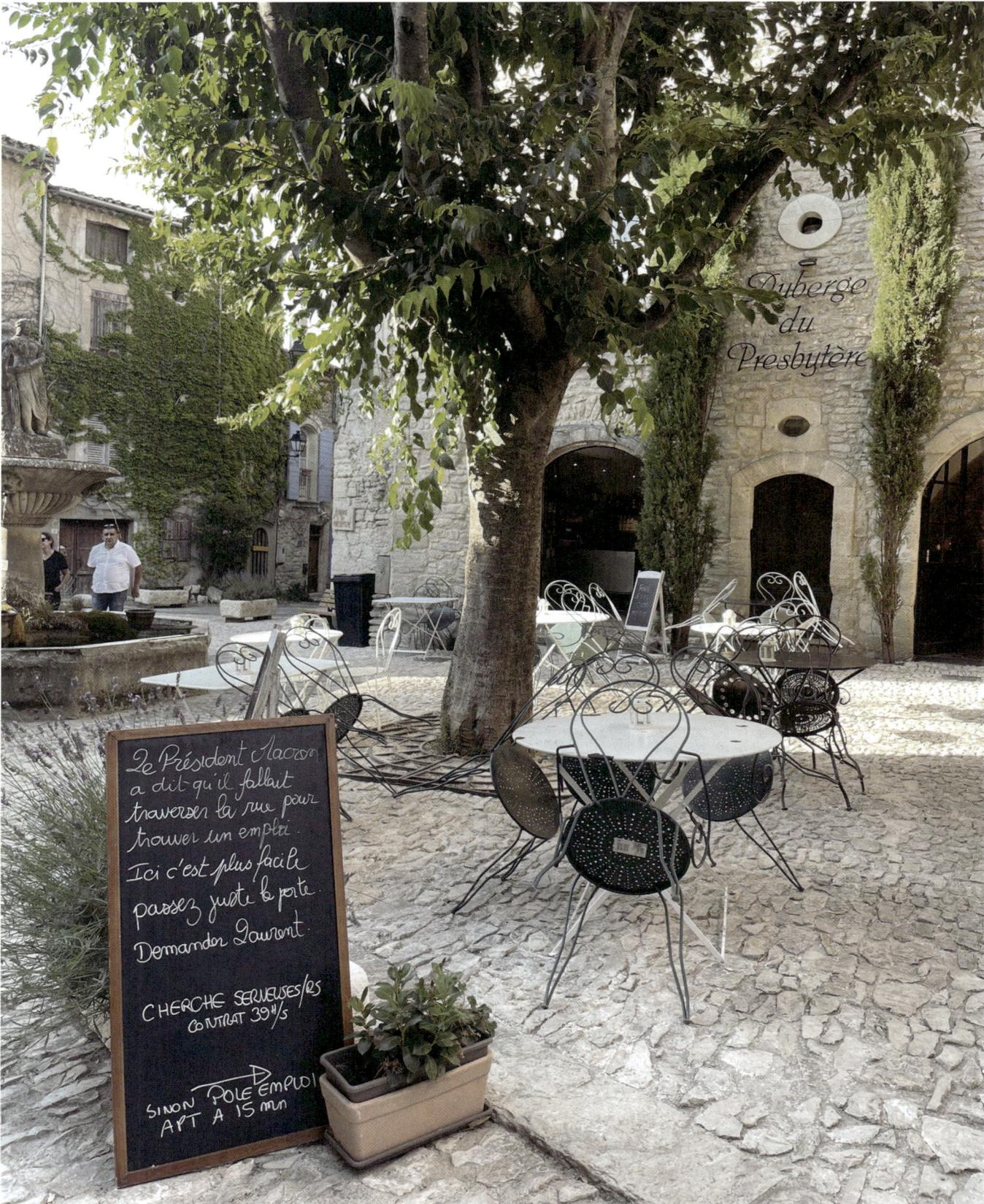

Auberge du Presbytère

Le Président Macron a dit qu'il fallait traverser la rue pour trouver un emploi. Ici c'est plus facile passez juste la porte. Demander Laurent.

CHERCHE SERVEUSES/RS
CONTRAT 39H/S

SINON POLE EMPLOI
APT A 15 mn

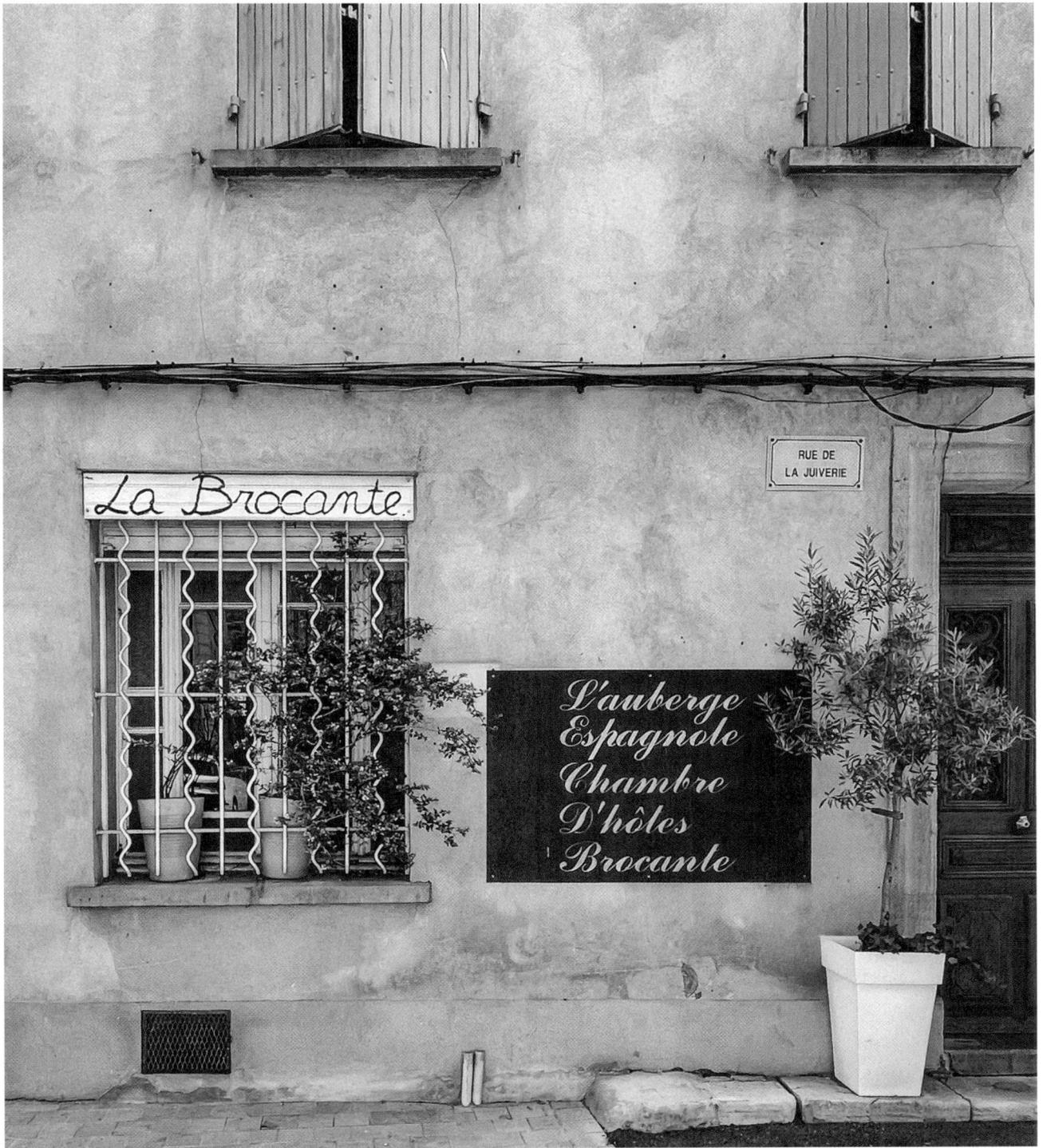

Above:
While Apt may be the capital of the Luberon, its historic center, with its narrow streets like Rue de la Juiverie,
is still marked by a charming village tranquility.
Left:
Time seems to stand still at Place de la Fontaine in the charming village of Saignon.

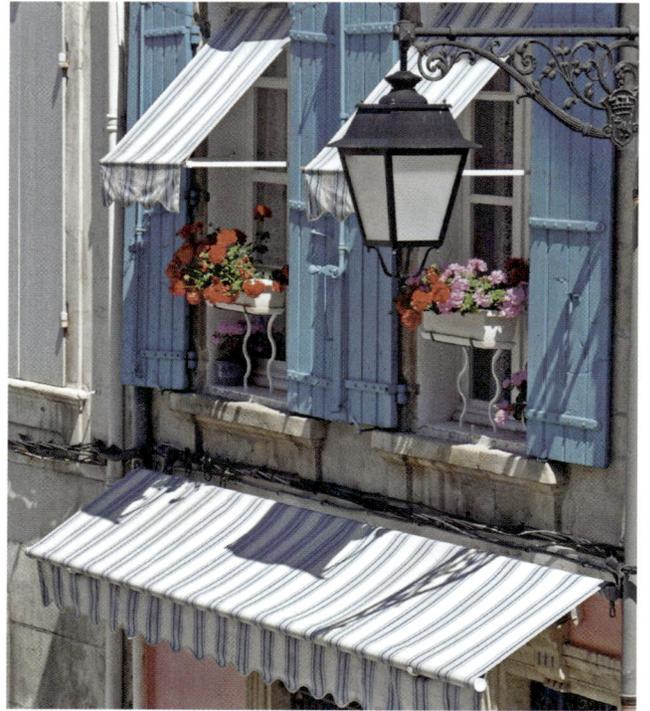

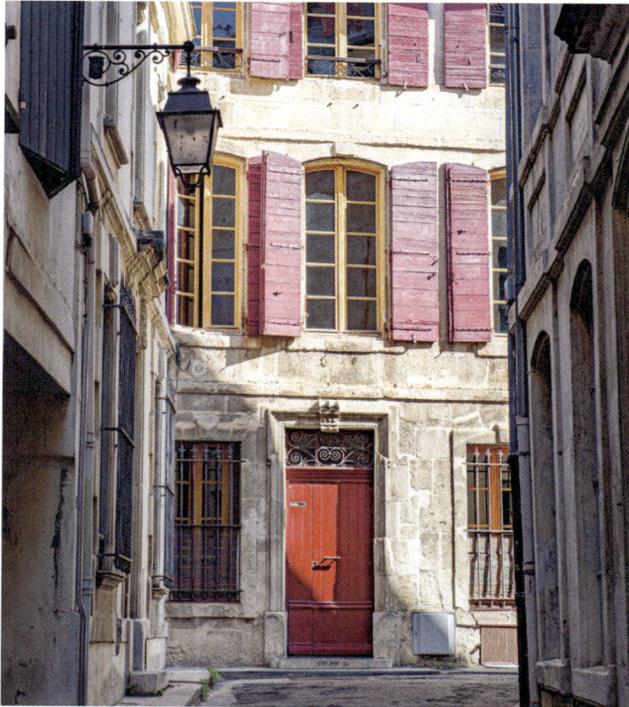

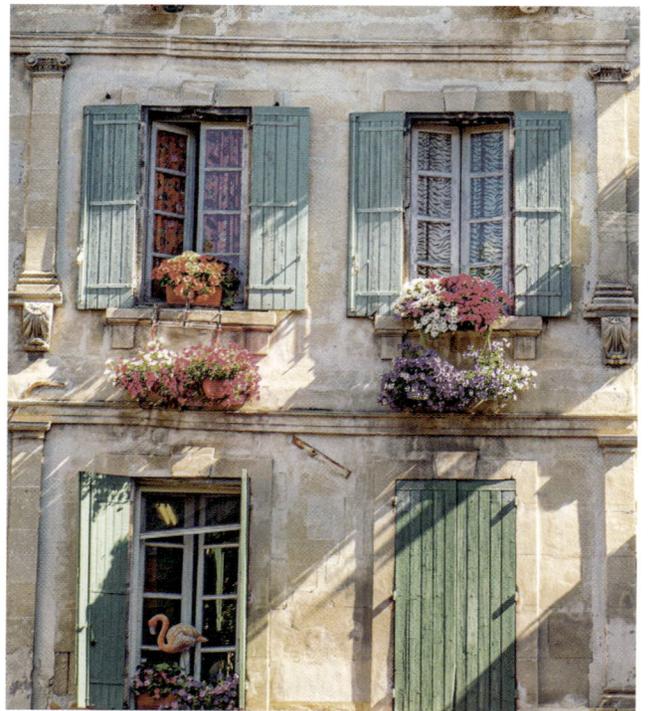

These pages:
All the bright doors and shutters make the old town of Arles look like a life-sized van Gogh painting.

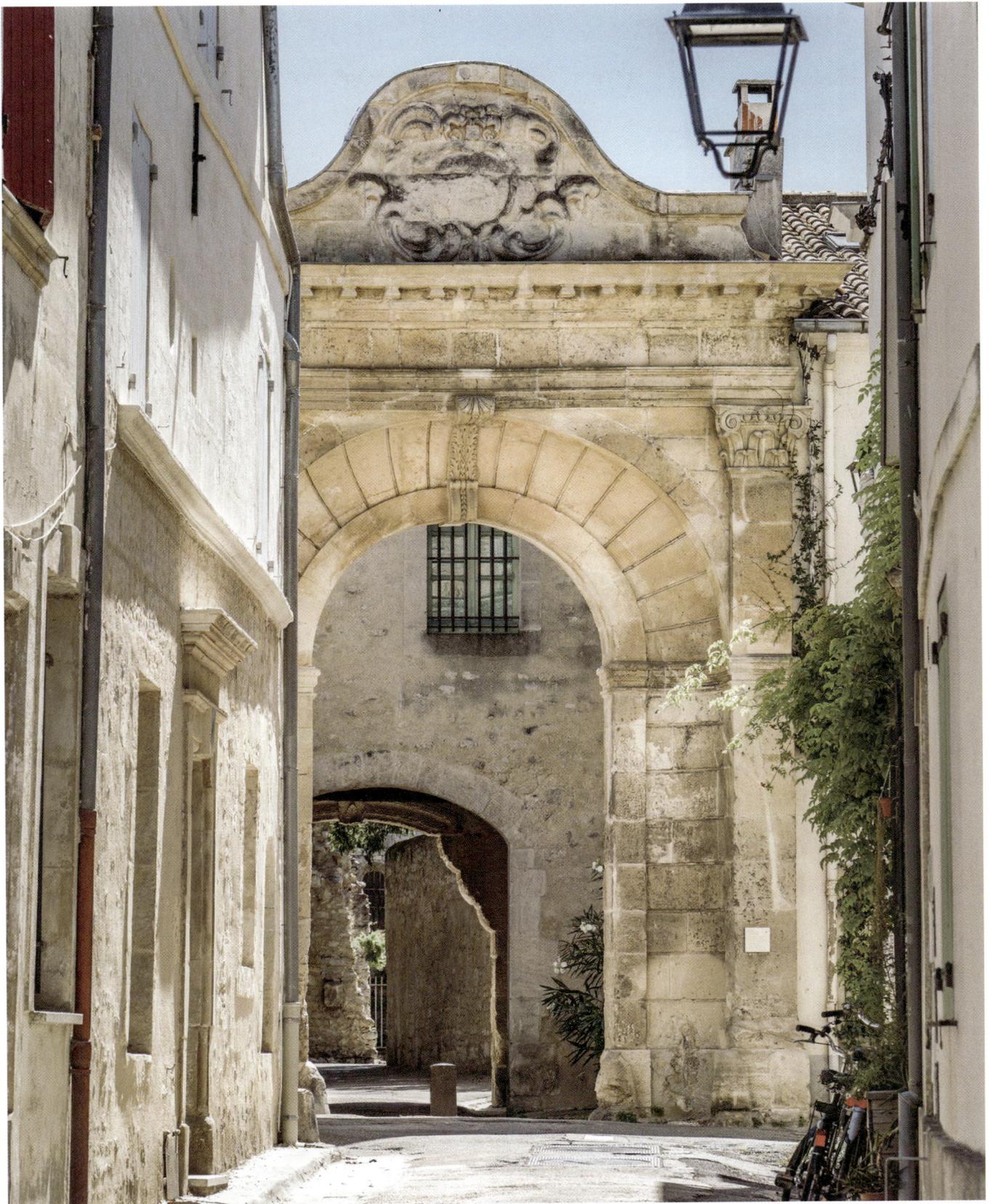

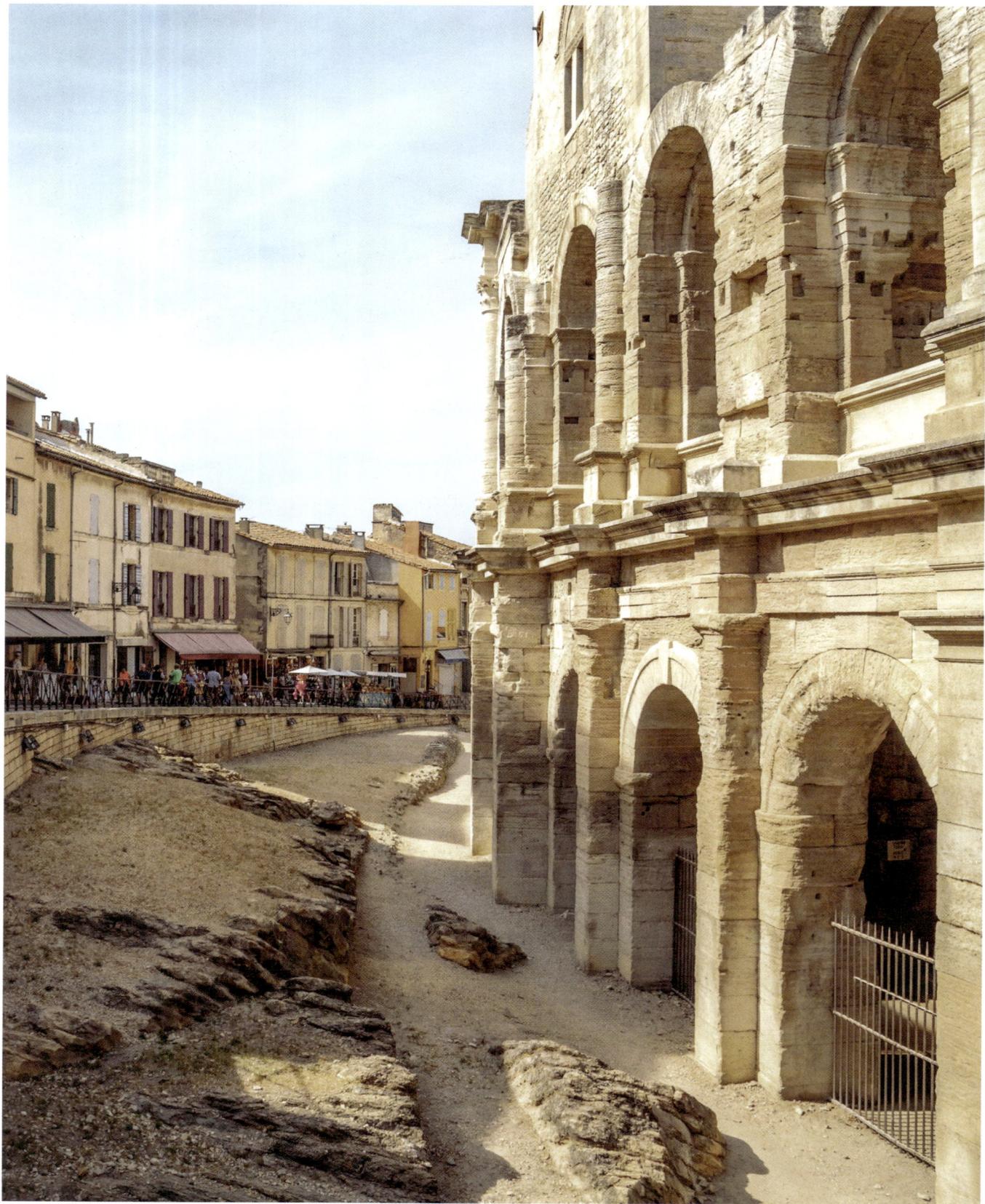

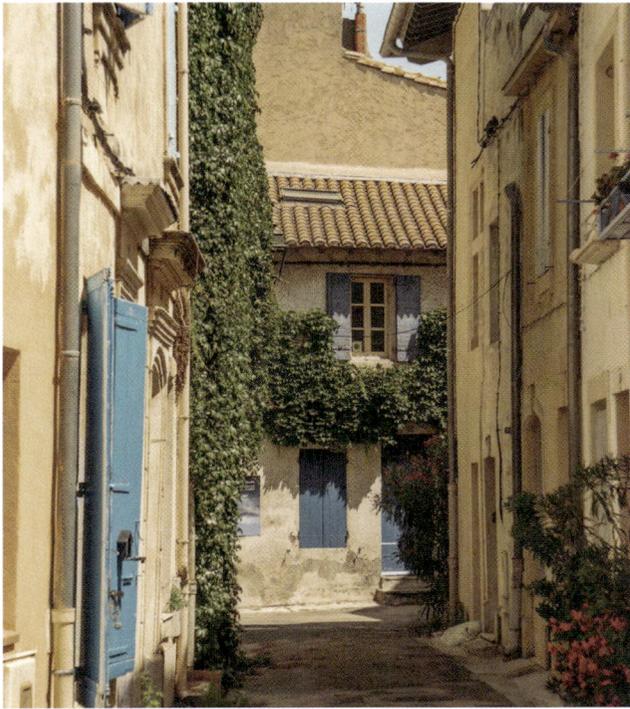
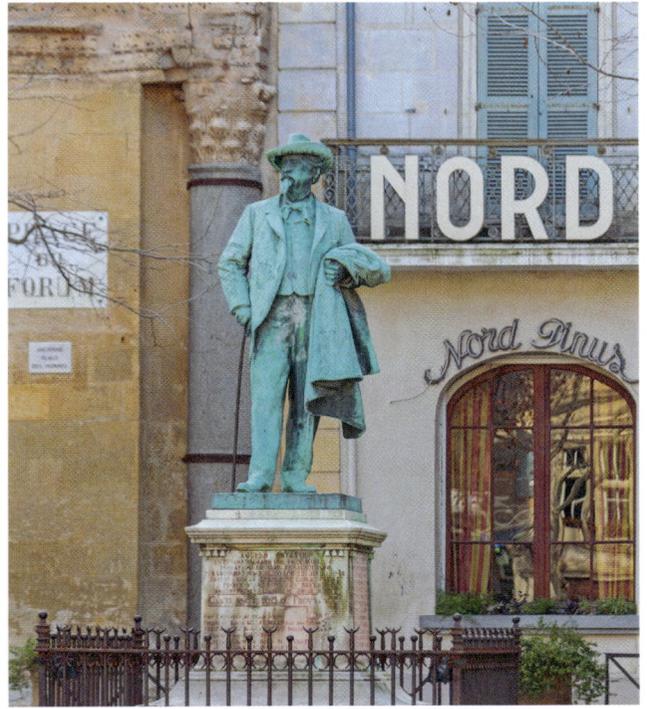
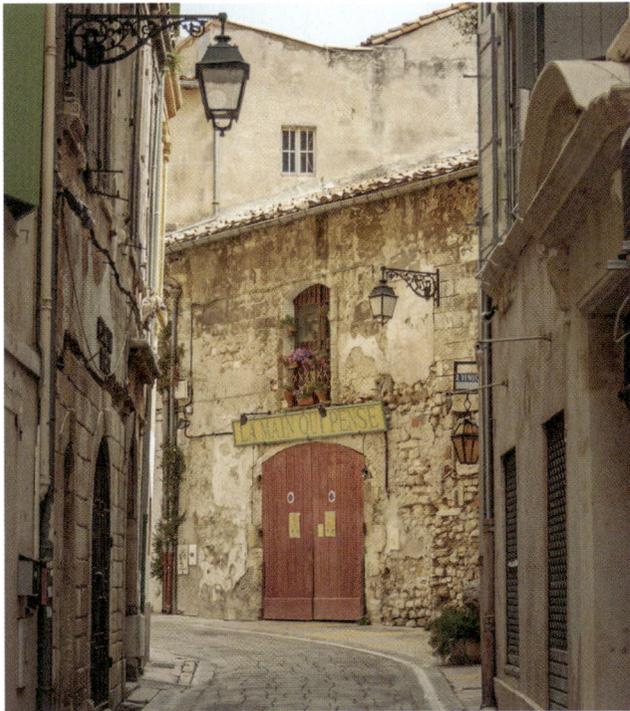
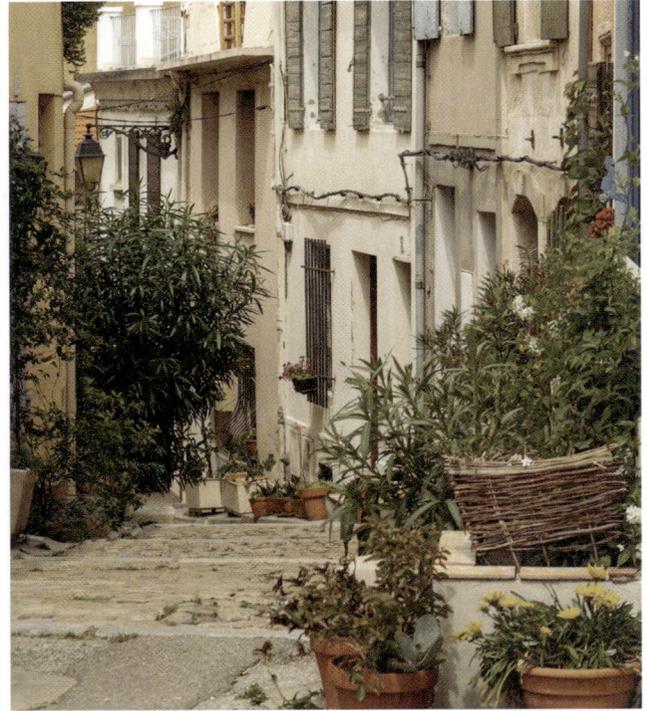

These pages:
*In the golden light of afternoon, the streets of Arles between the Rhône and the Roman amphitheater
can seem suspended in time.*

LA PROVENCE

VILLAGE IDYLL IN MEDIEVAL STRONGHOLDS

Just as Paris is—perhaps quintessentially—urban, Provence has maintained its character as a realm of small, idyllic villages. Especially in the rocky landscape of the Luberon, *villages perchés*—tiny settlements of stone houses that crown the hilltops—make for a seemingly fairy-tale setting, with tightly winding, narrow passageways amid small, clustered buildings, standing at odd angles, their picturesque charm shaped by centuries. The look of the typical facade shifts subtly from region to region. In Mirmande, Gordes or Les Baux-de-Provence, for example, rough-dressed stone predominates, sometimes conforming sturdily to the walls of the old fortifications. Elsewhere, most notably in Roussillon, the "Red City", stucco facades glow in warm ochre tones derived from the locally available stone. For centuries, painters have been enchanted by the earthy pigments of this region, which have long captured Provence's warm, golden light on canvas. The winding, narrow streets of the iconic *villages perchés*—hilltop villages—often resemble miniature fortresses. What was once a challenge for medieval inhabitants is now a priceless charm: the tightly clustered, centuries-old buildings allow no room for modern architectural blunders. Many of these hilltop communities take immense pride in preserving their rustic beauty, drawing admiration both in person and on social media. Exploring the *plus beaux villages de France*—the most beautiful villages in France—is always a visual delight. Villages like Lauris and Lourmarin offer picture-perfect settings that transport you to another era. At midday, you might find these tranquil lanes bathed in serene stillness. Vibrant shutters are closed against the sun, and a gentle Mediterranean breeze stirs the scrambling greenery on the walls. Somewhere on a little stone wall, a cat dozes in the sunshine, nestled among terracotta pots encrusted with chalky mineral deposits.

Right:
Picturesque streets, ivy-covered facades, town walls draped in flaming pink bougainvillea in Saint-Paul-de-Vence.

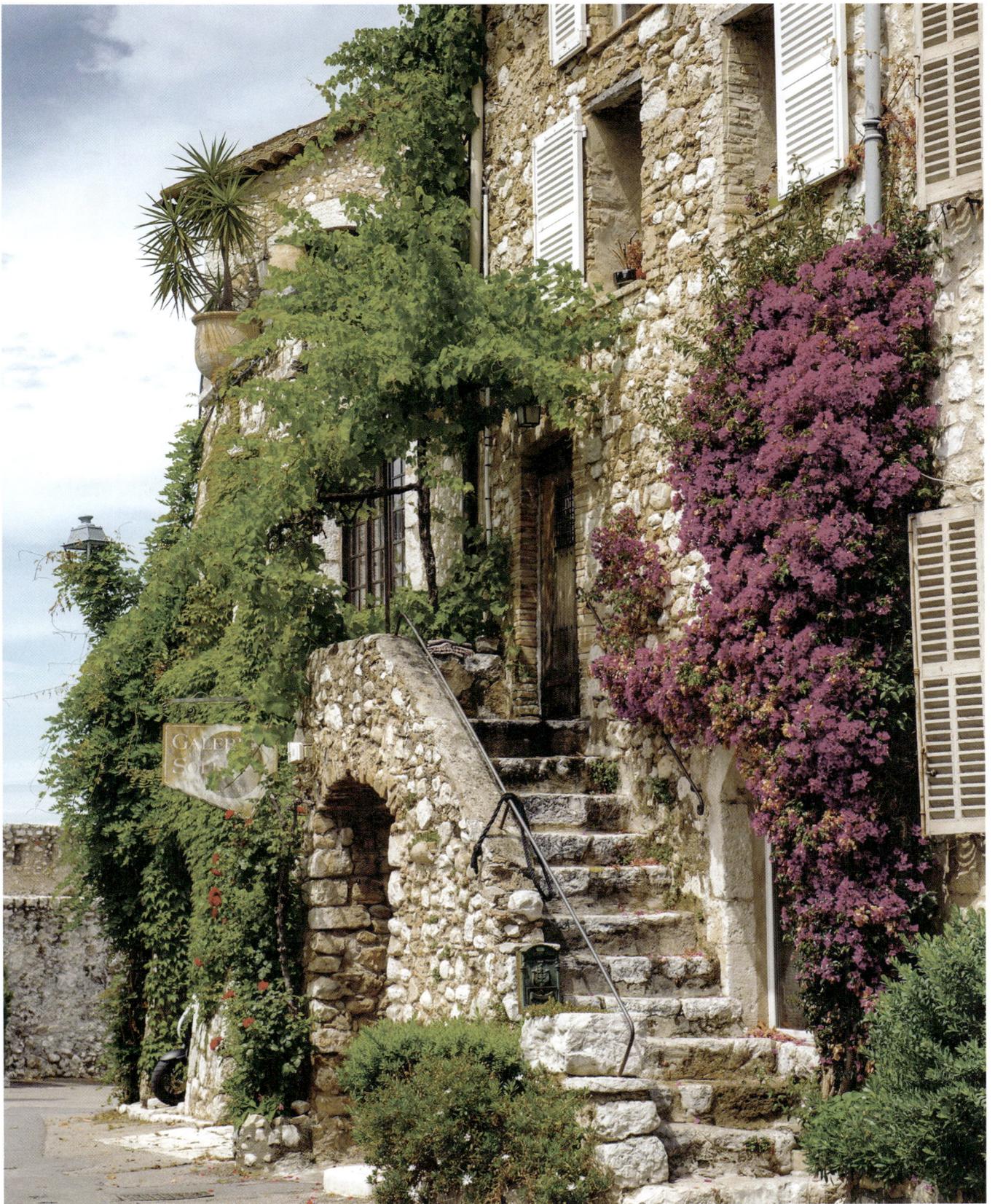

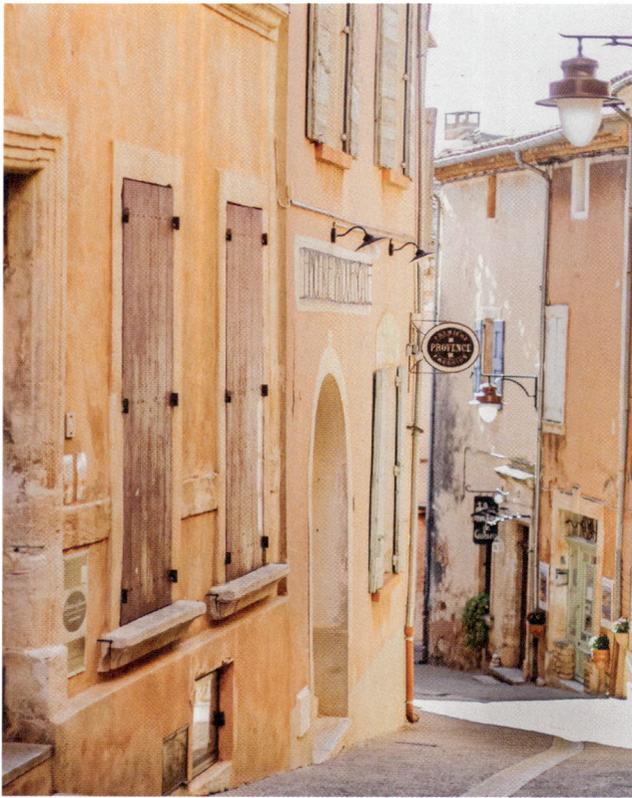
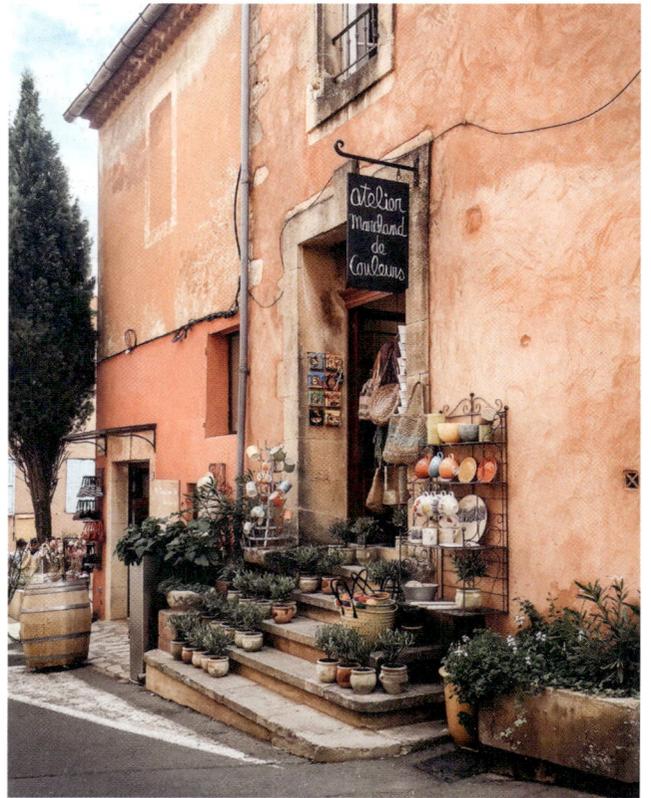
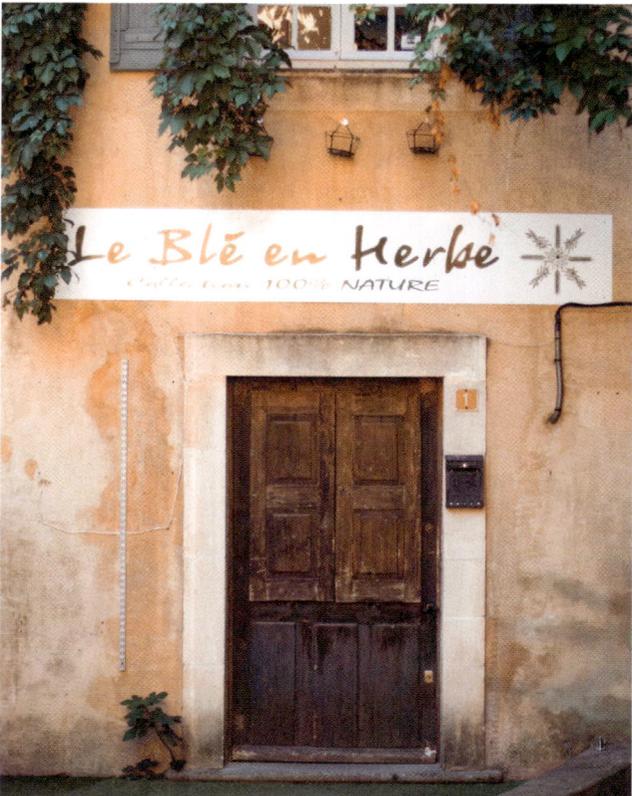
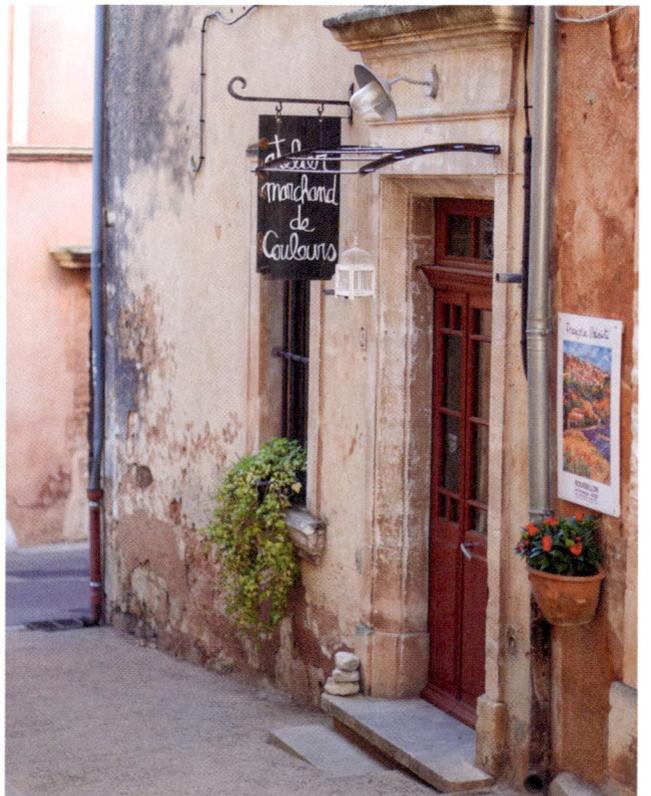

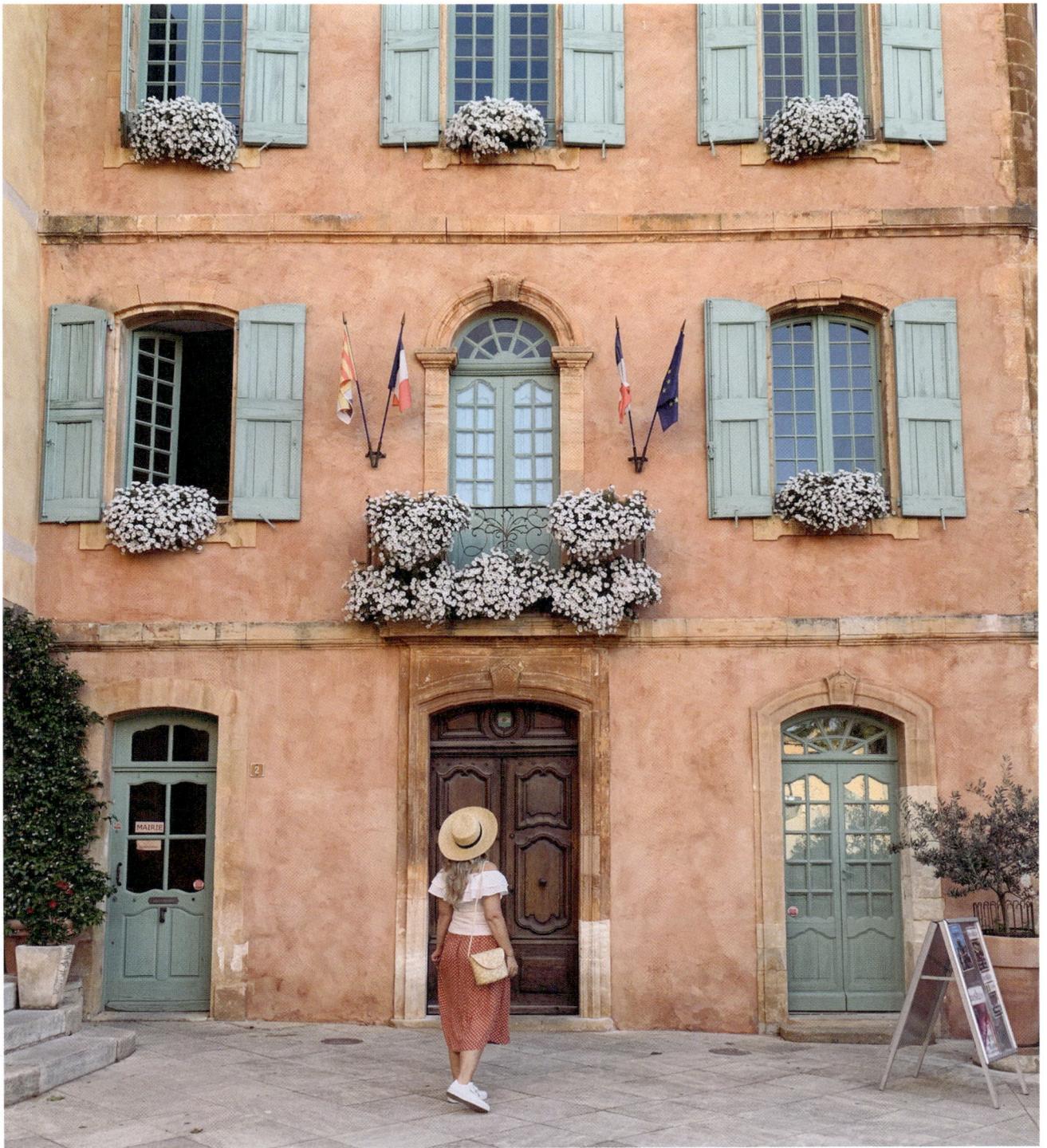

Above and at left:

Roussillon is a harmonious blend of orange and ochre. The Romans were already extracting valuable ochre pigments from the reddish-yellow cliffs near this vividly colored village, and painters still covet the pigments.

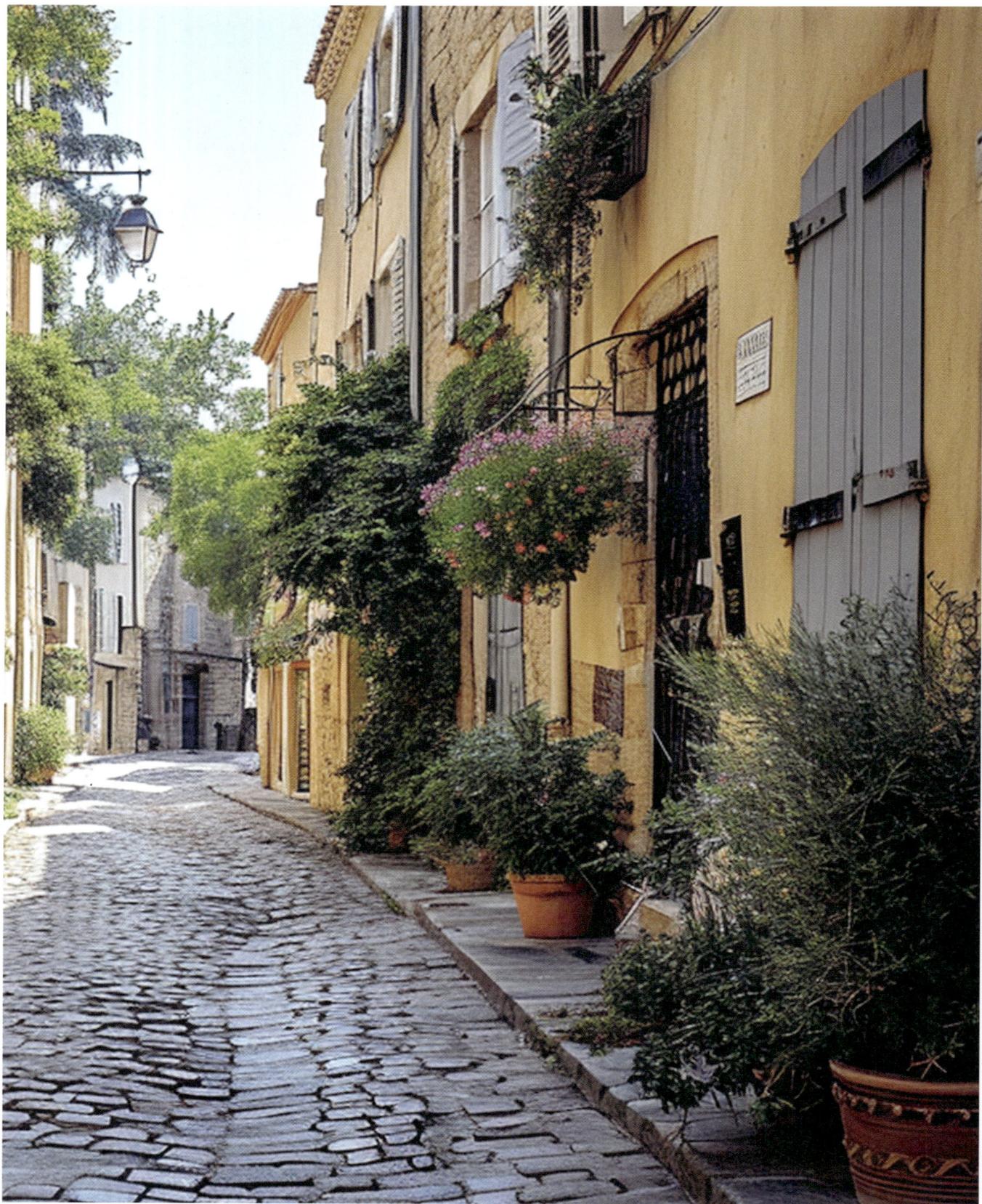

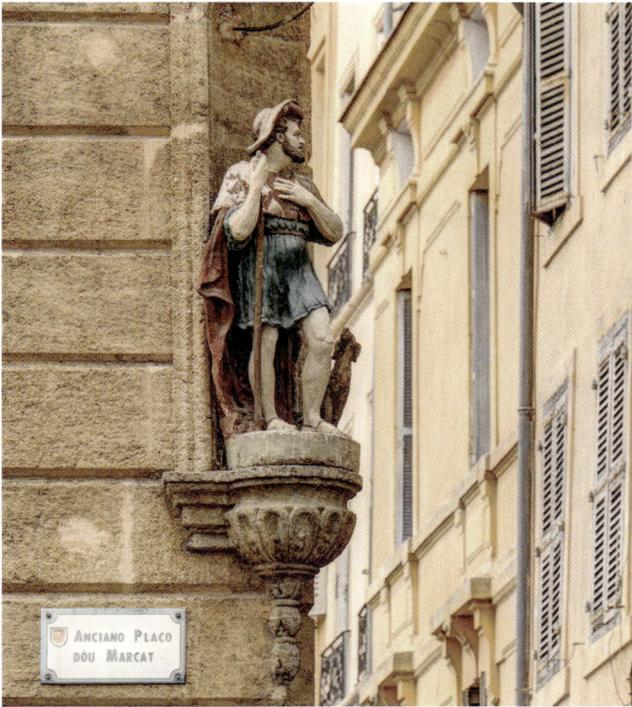

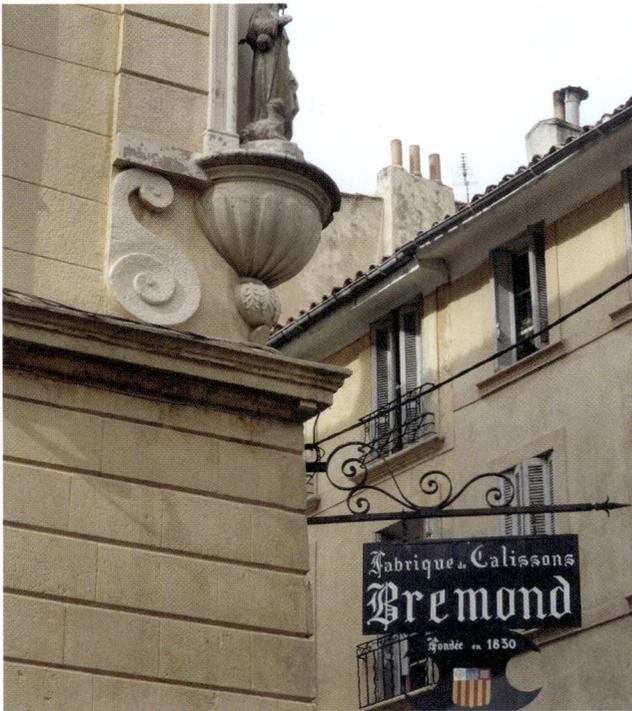
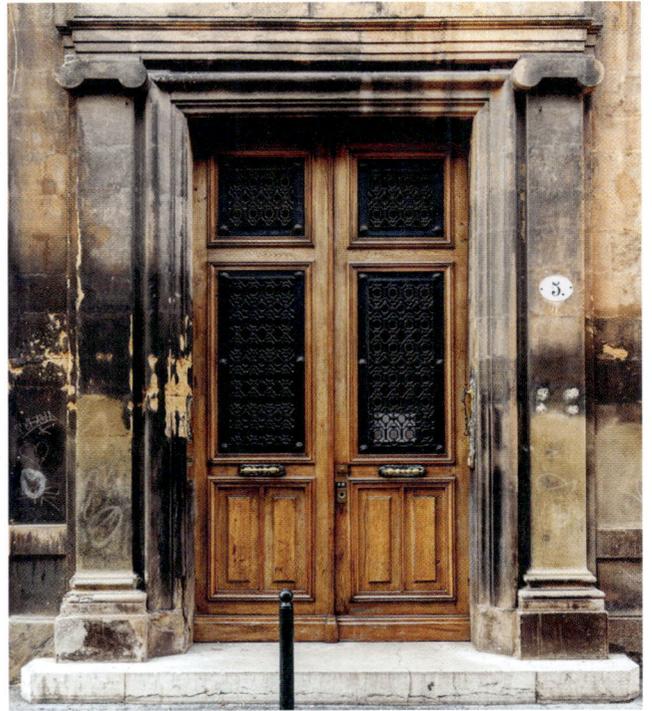

Above and at left:
The narrow cobblestone streets that wind through Aix-en-Provence offer cool respite. Look up from time to time to discover hidden architectural gems on the old facades.

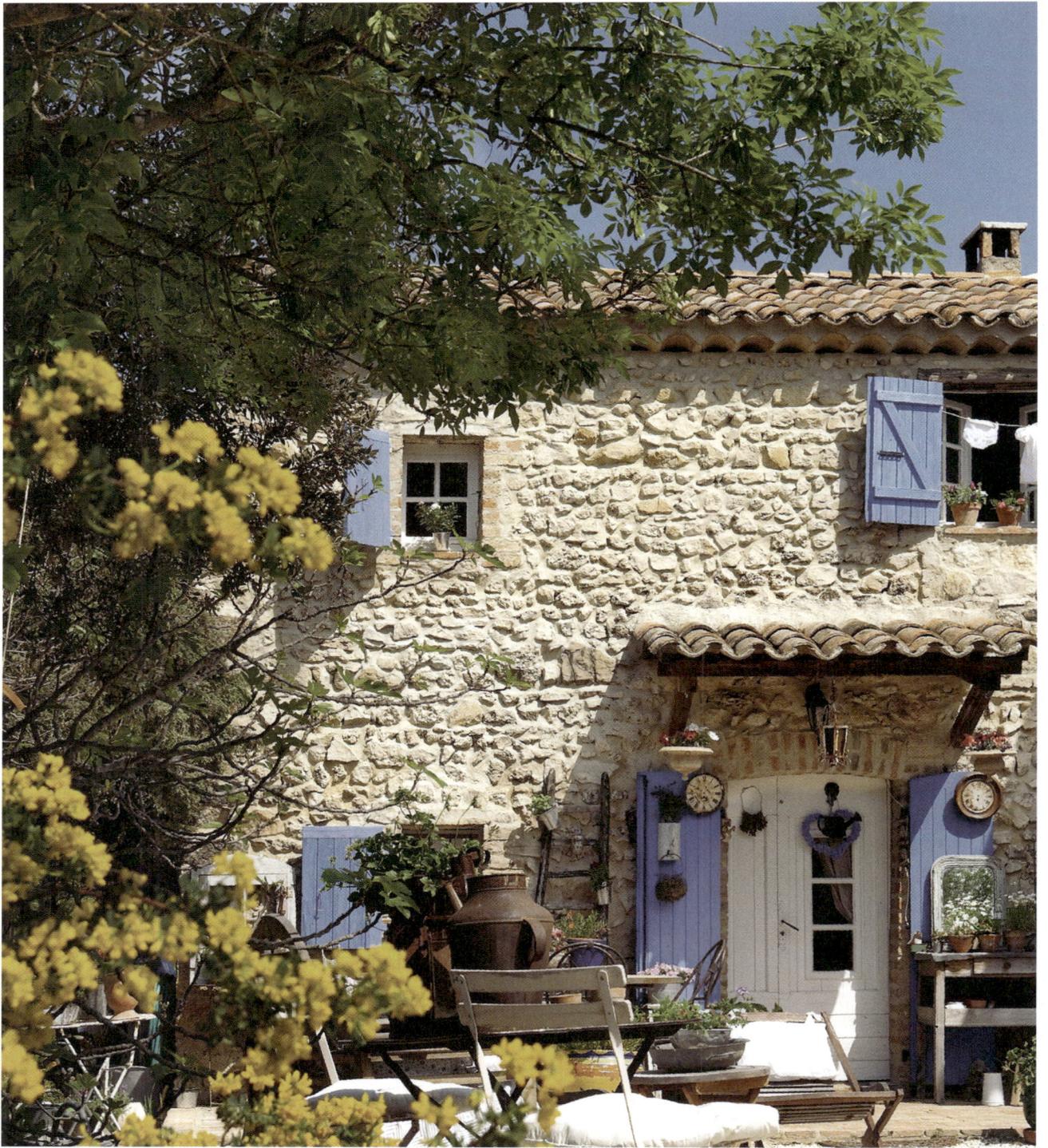

Above and at right:
Seven of the villages officially recognized among the "most beautiful in France" are in the department of Vaucluse.
You'll know why when you set eyes on the charming old houses with their bright shutters …

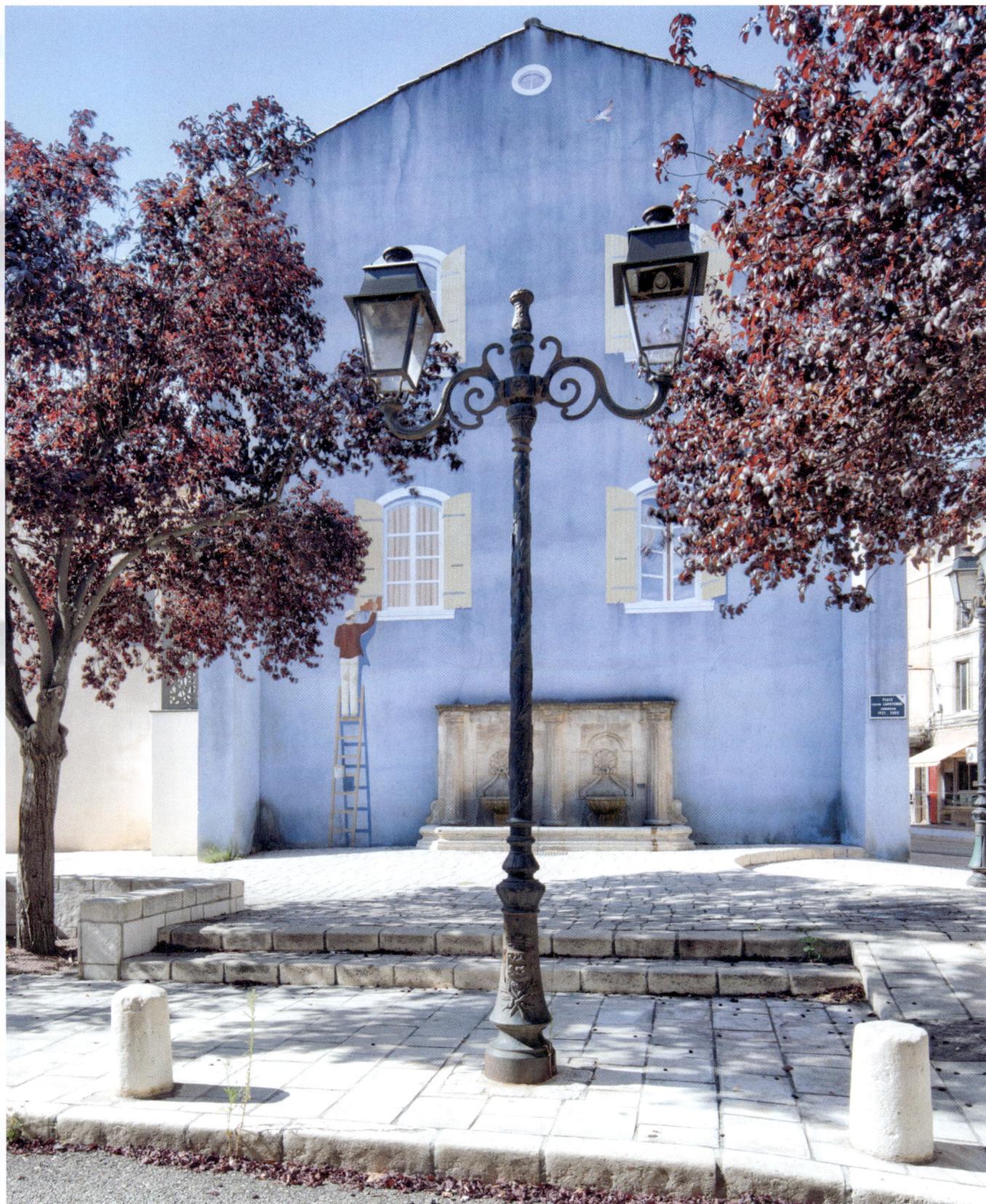

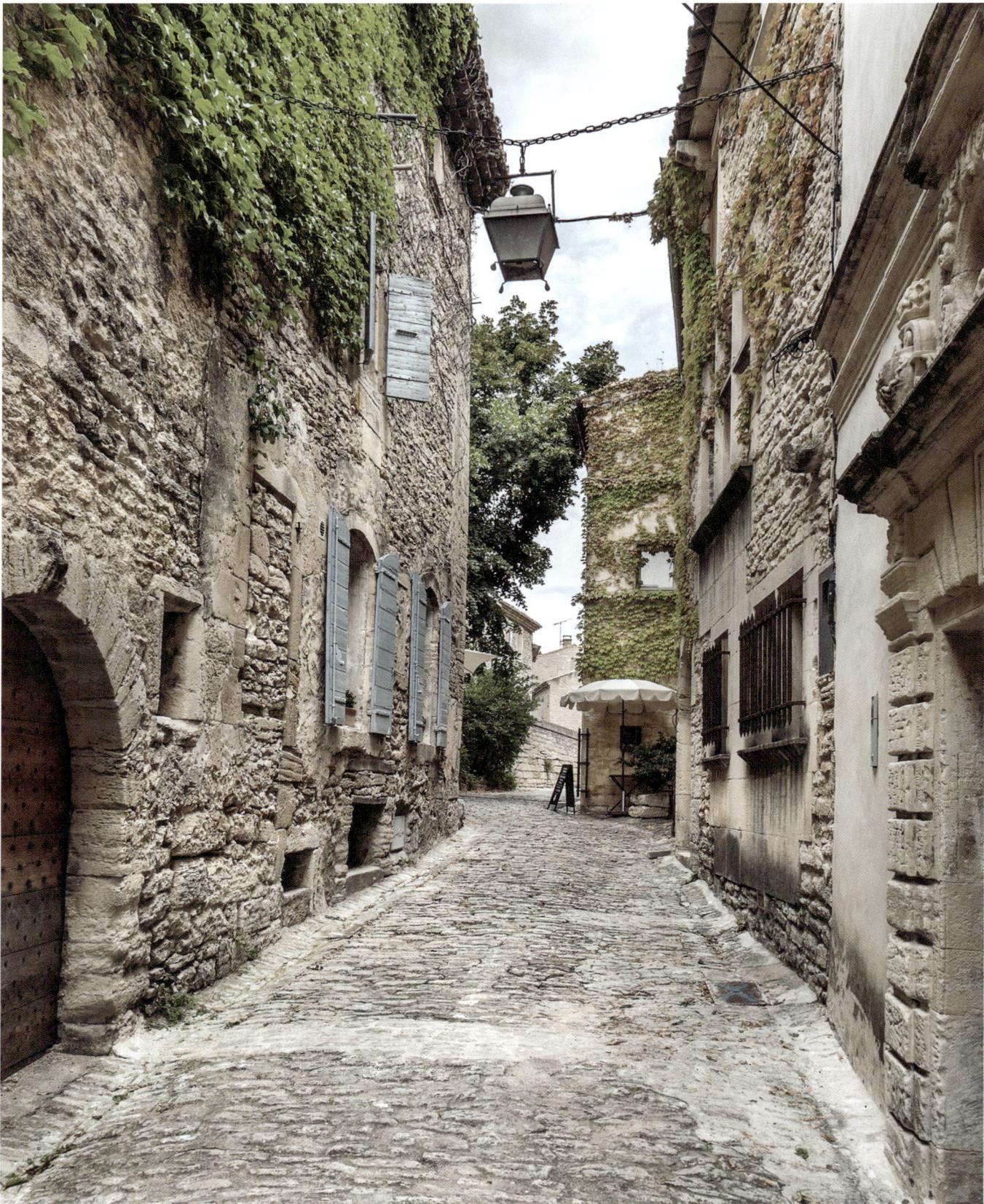

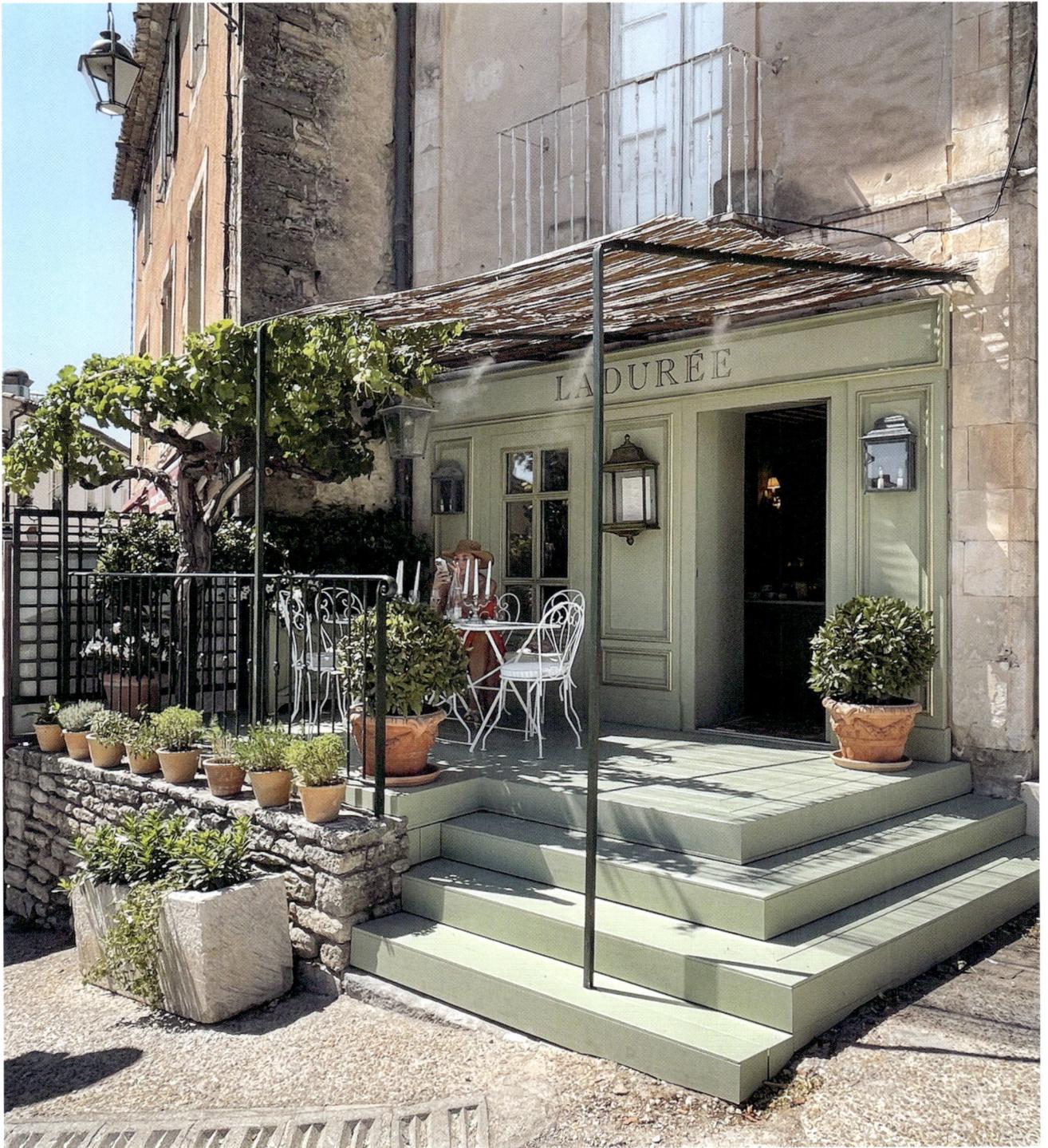

Above and at left:
Gordes is a small mountain village with steep streets that tops the list for many visitors to Vaucluse. Some will sweeten their stay at the famous pastel world of the patisserie Ladurée.

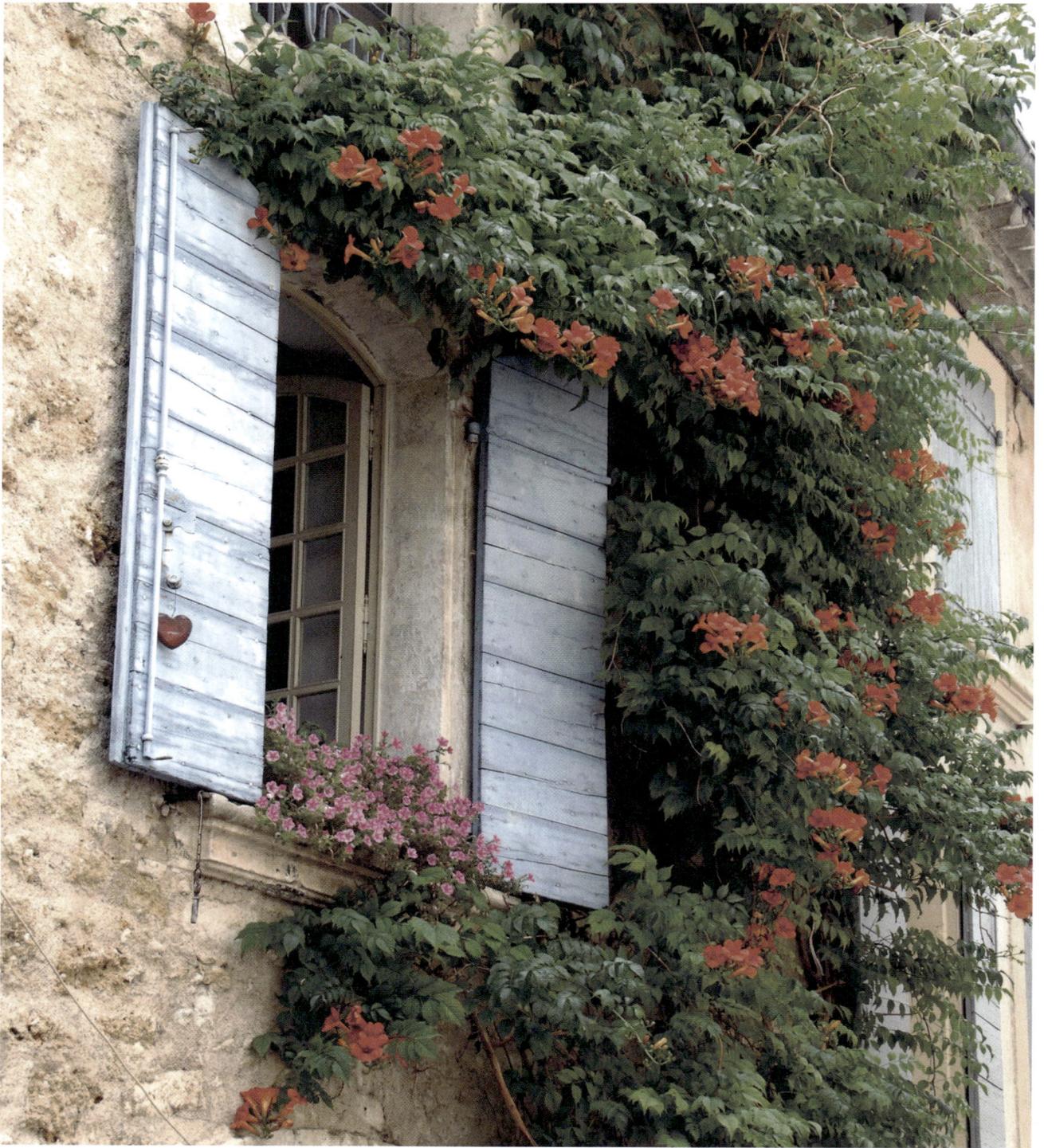

Above and at right:
In the southern reaches of the Luberon massif, the magical old houses of Lauris and Lourmarin,
two of the most charming villages in France, captivate the eye.

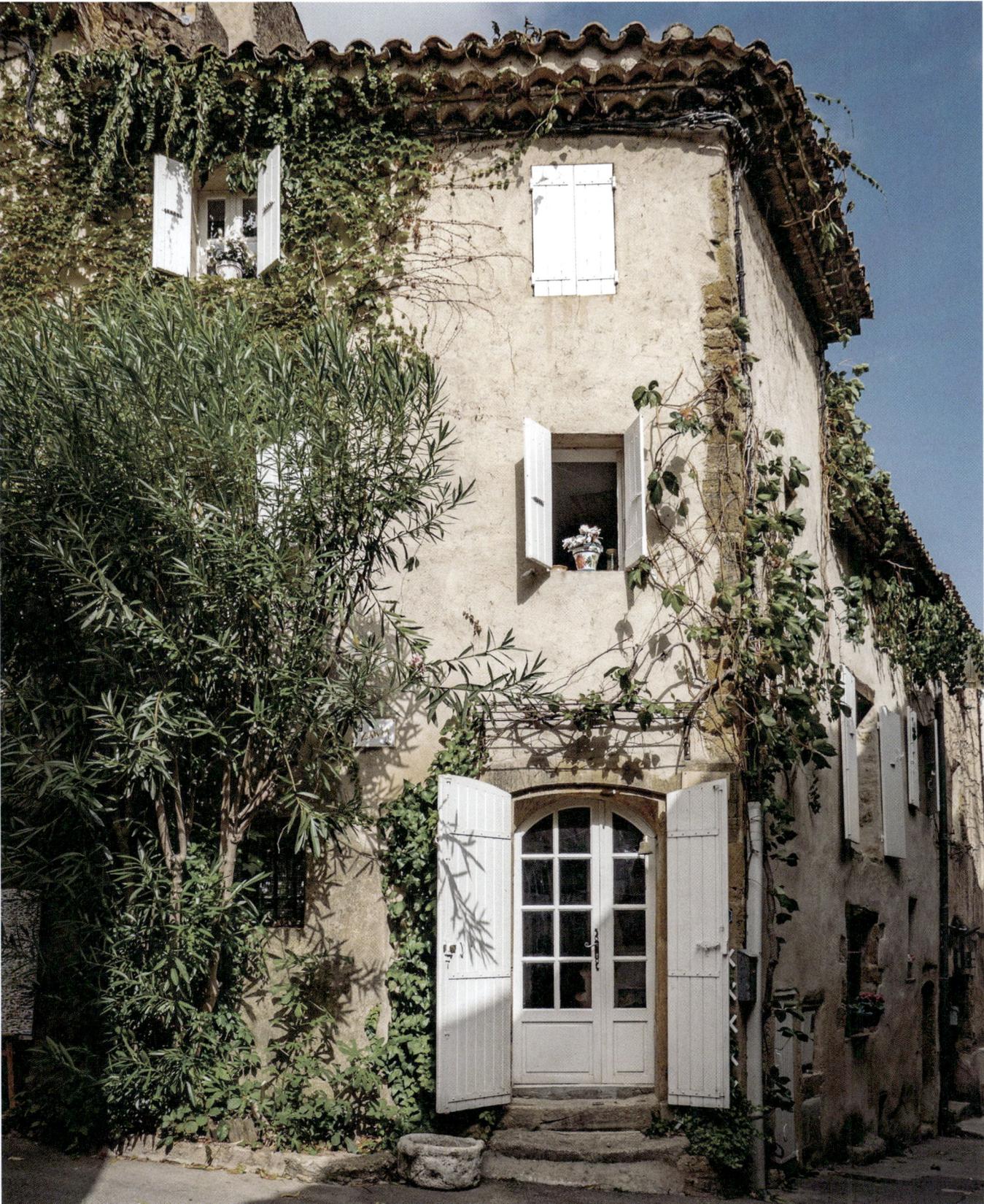

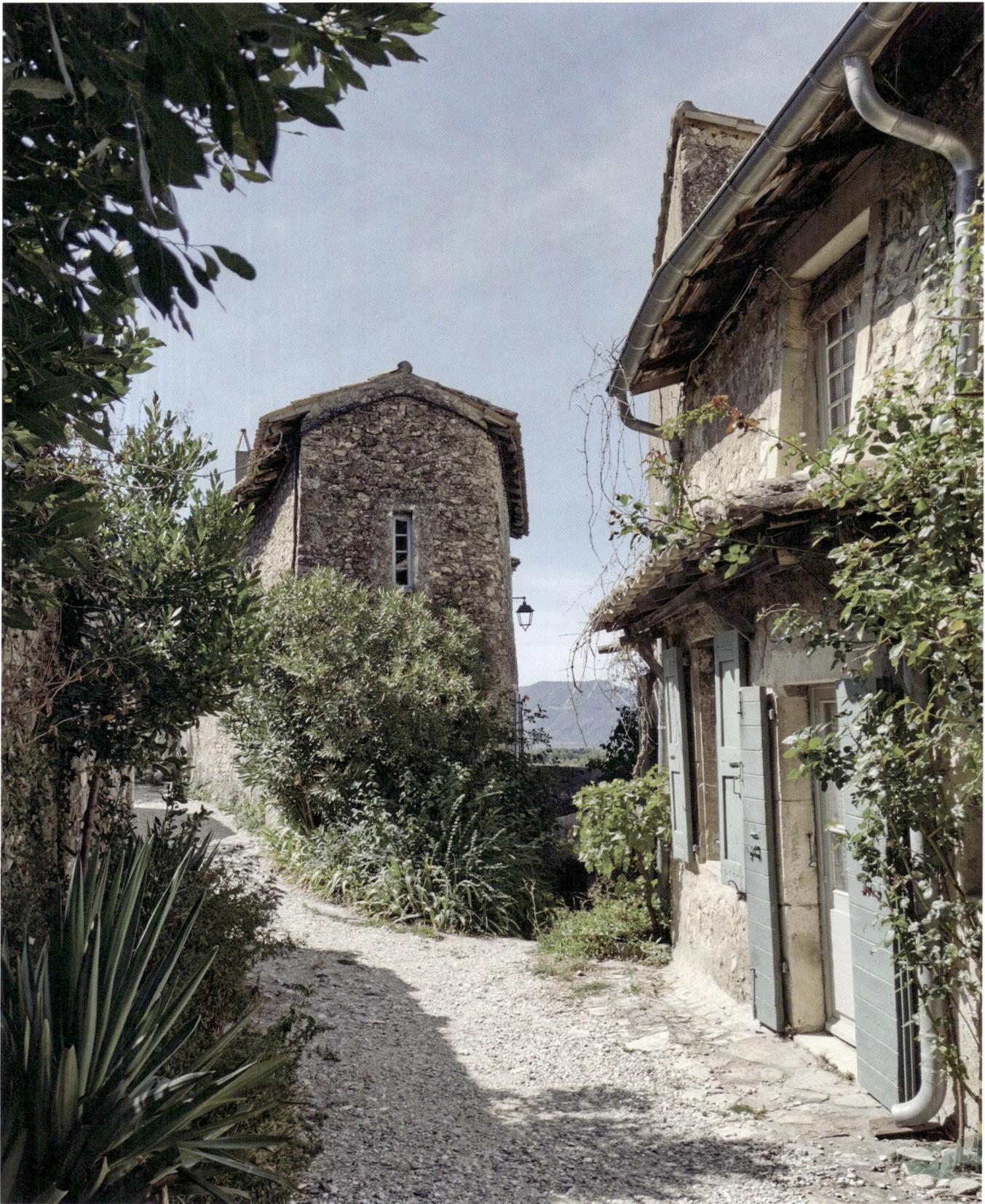

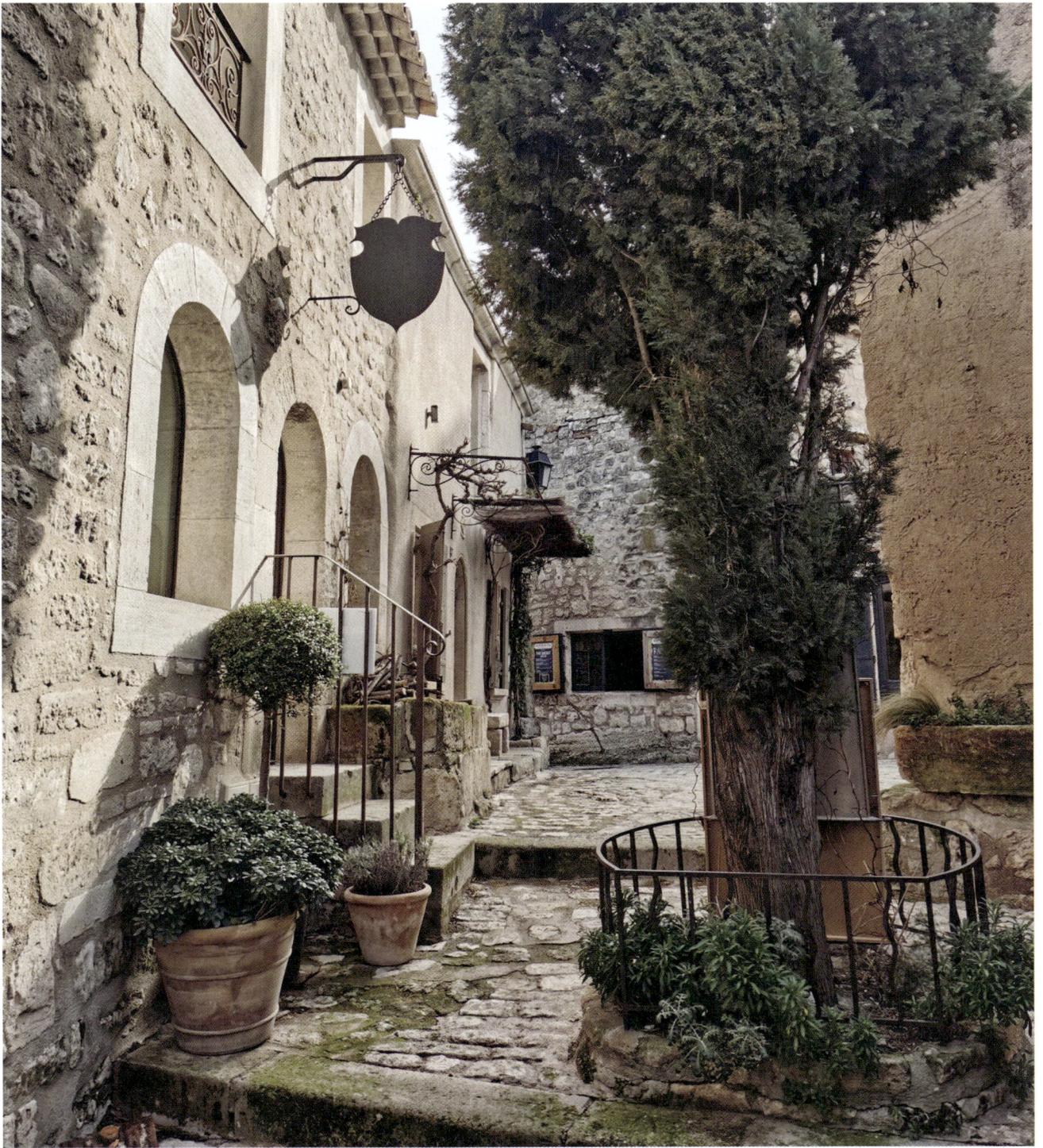

Above and at left:
Mirmande embodies medieval charm. Farther south, Les Baux-de-Provence nestles charmingly beneath the ruins of an ancient castle.

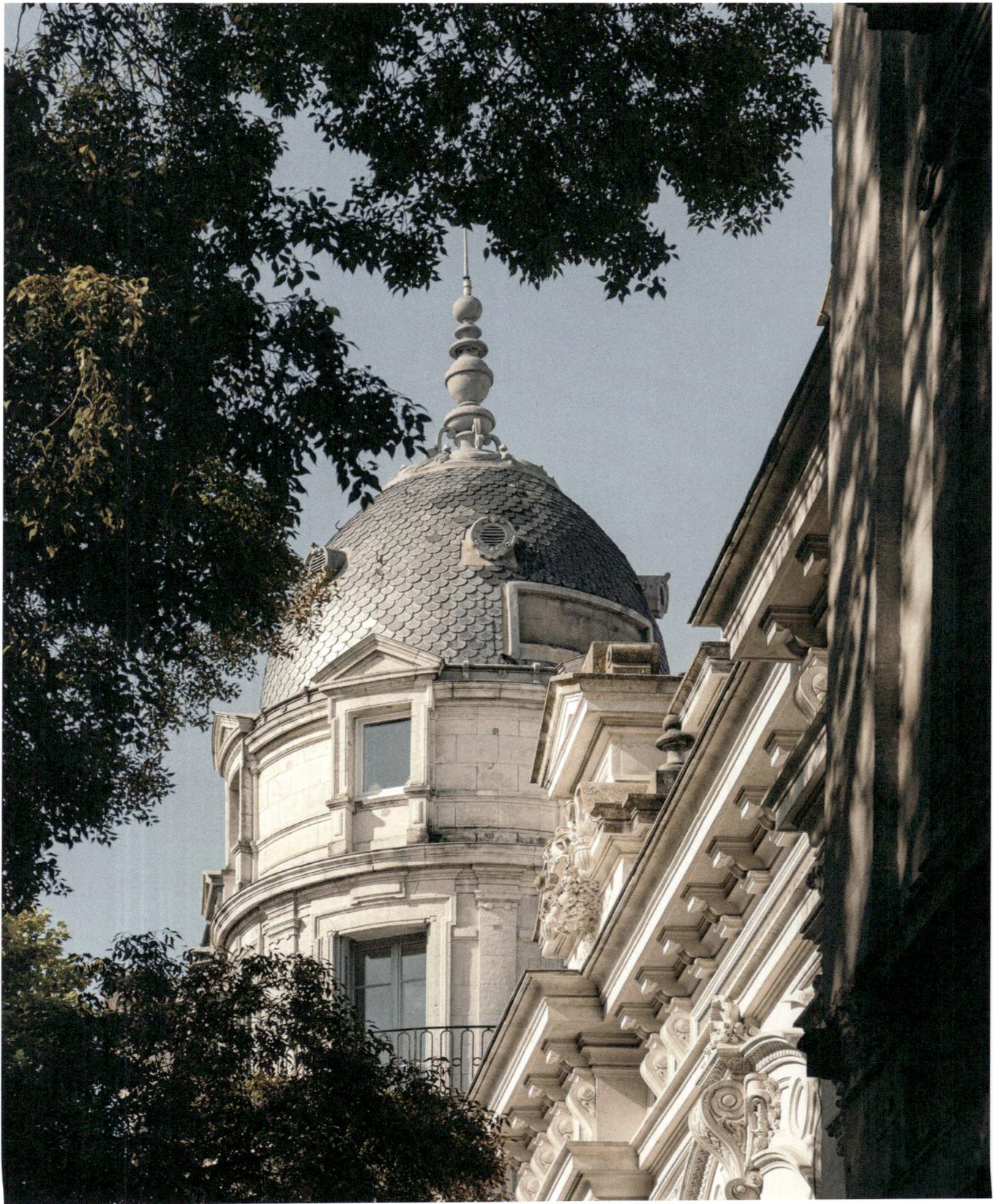

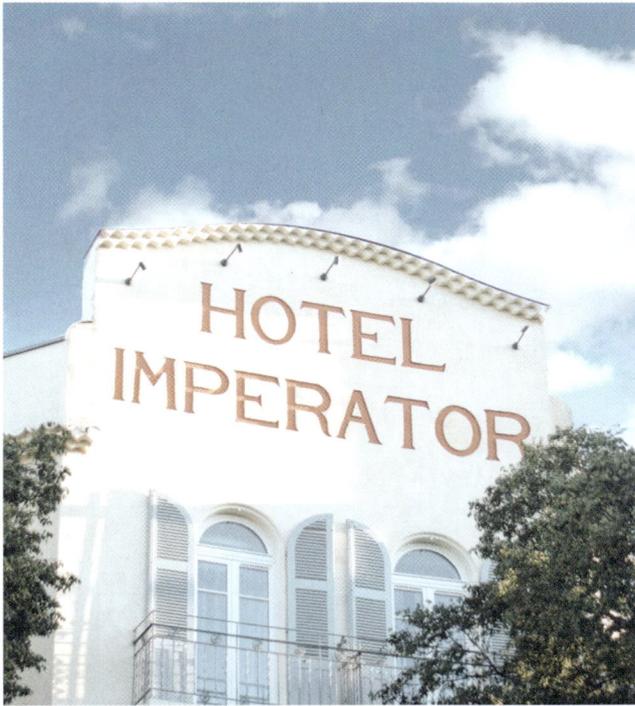
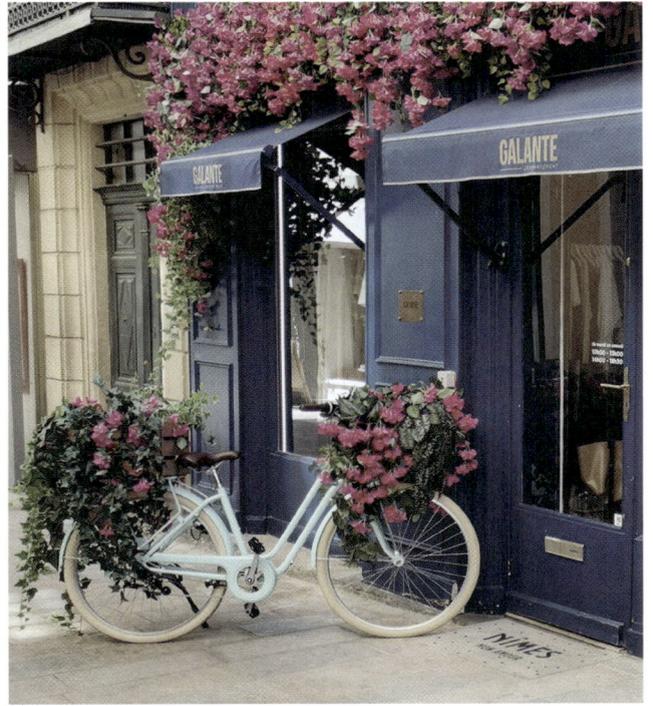
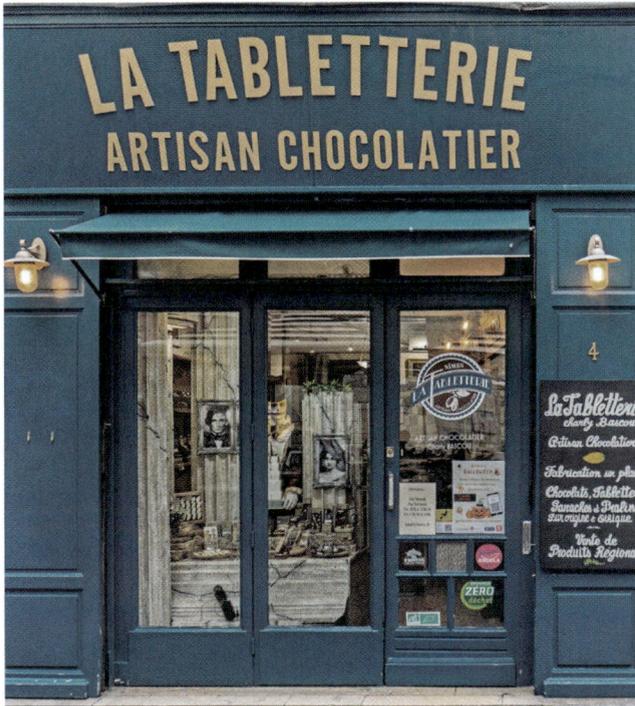
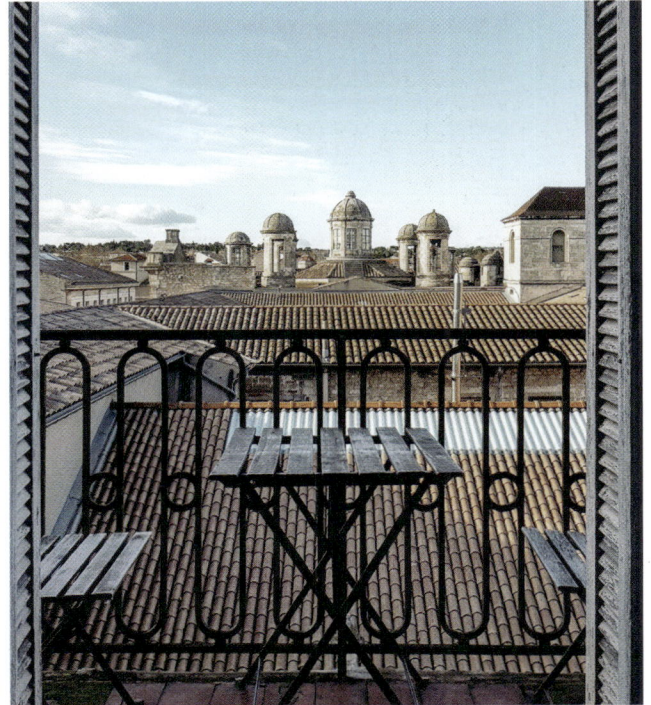

Above and at left:
Nîmes, a Roman-era gem, invites lingering in small cafés and chocolateries.

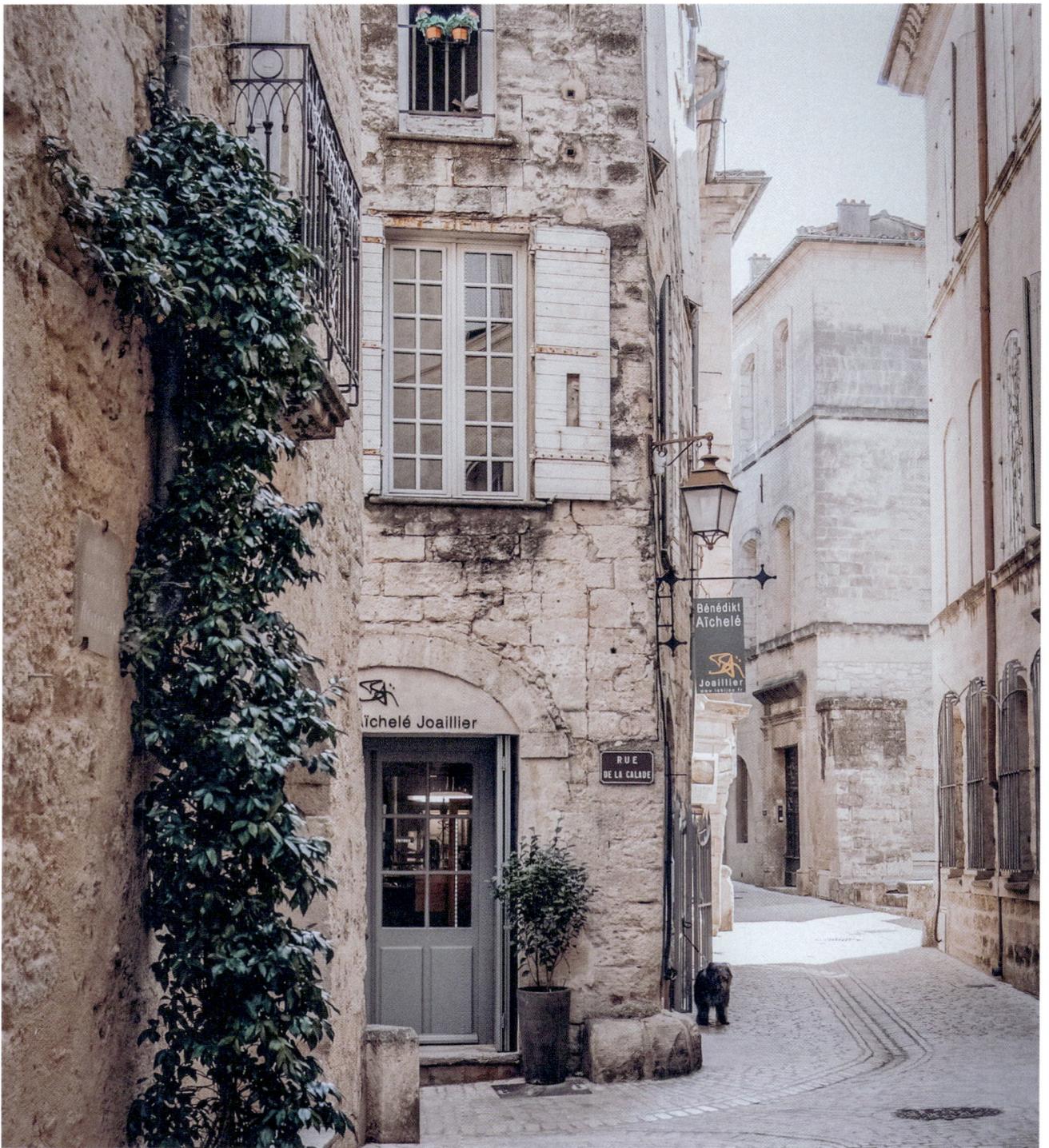

Above and at right:
A location scout for a cinematic adaptation of a fairy-tale would likely feel the pull of Uzès,
with its ancient streets beneath a stately fortified castle. And that's before even glimpsing the Tour Fenestrelle,
the leaning bell tower of Uzès Cathedral.

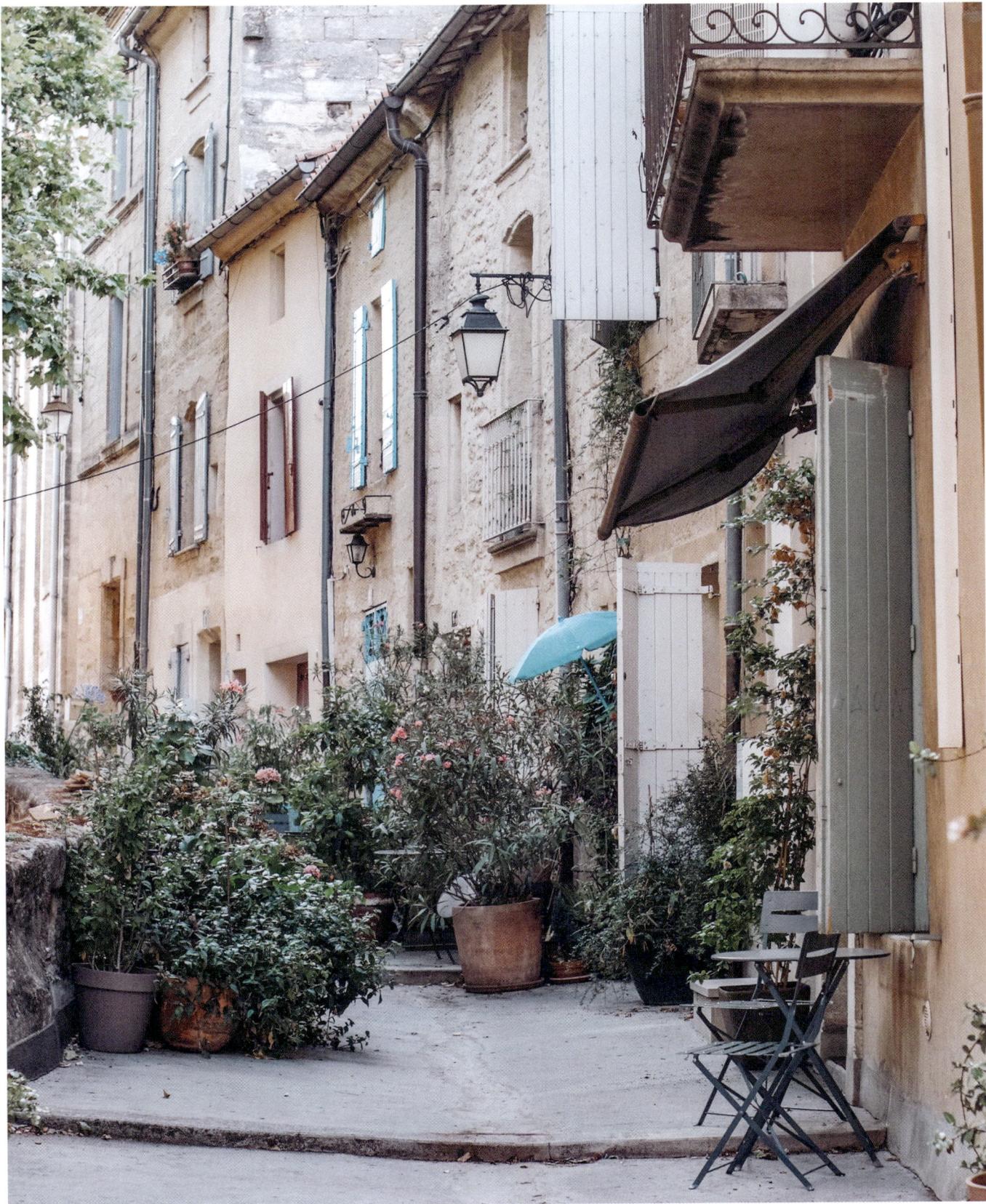

LES FLEURS DE PARIS

A CITY IN BLOOM

"Il est entré dans mon cœur une part de bonheur dont je connais la cause ..."—Strolling through the streets of Paris in spring, you might find yourself unconsciously humming the melody of *La Vie en Rose*. And it's no surprise—walking beneath the pink cherry blossom clouds in the Jardin des Tuileries seems to summon Edith Piaf's timeless chanson. The city, awash in blossoms to lift the heart, takes on an even more romantic allure in springtime. On the Champ de Mars, delicate pink Japanese cherry blossoms seem to dwarf even the Eiffel Tower. The smallest green pockets between streets turn into pastel-draped oases. Square Gabriel Pierné, tucked behind the Institut de France on the Seine, with just a handful of trees, feels almost enchanted during the cherry blossom amid the stone façades. It is a favorite spot for lovers, and home to a unique stone bench, shaped like an open book, perfect for a shared moment of peace. With cafés and *pâtisseries* lining nearly every street, you don't have to worry about missing the blooms. Look closely, and much of the floral splendor reveals itself as the work of human hands. Yet, for those sipping a *café au lait* or *apéritif* on rattan chairs at outdoor terraces, the vibrant, romantic ambiance lingers year-round. For flower enthusiasts, the Marché aux Fleurs Reine-Elizabeth-II on Île de la Cité is well worth a visit. The market has been a Parisian institution since the nineteenth century, and Queen Elizabeth II herself was captivated by it on her first state visit in 1948. It's a haven for small, independent florists who sell their carefully tended blooms, preserving a tradition that feels timeless. Once home to a bustling bird market, the area has changed with the times; now, the only chirping comes from the city's proliferating parks and green spaces.

Right:
During cherry blossom season, many things in Paris are viewed through rose-colored glasses, even the Eiffel Tower.

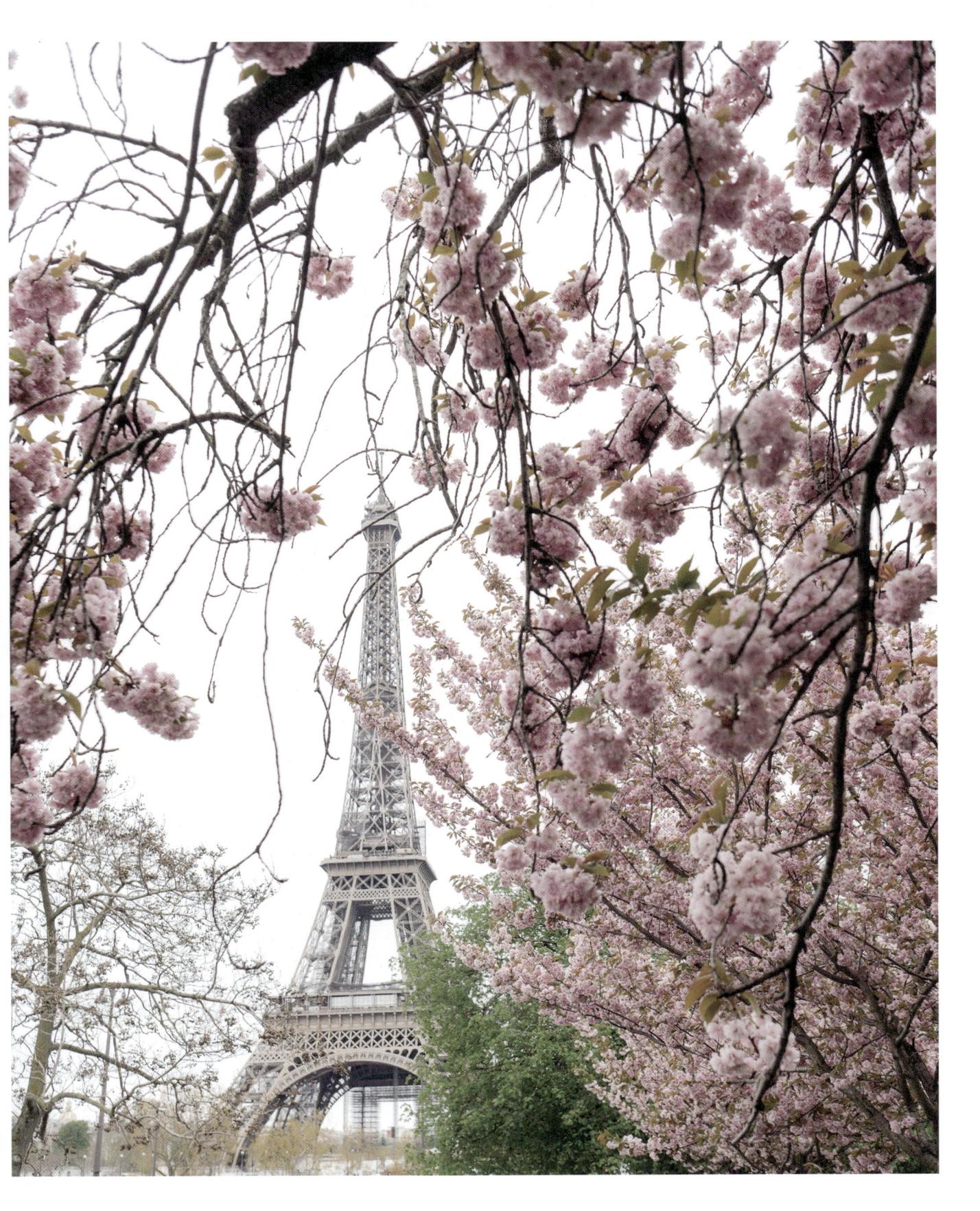

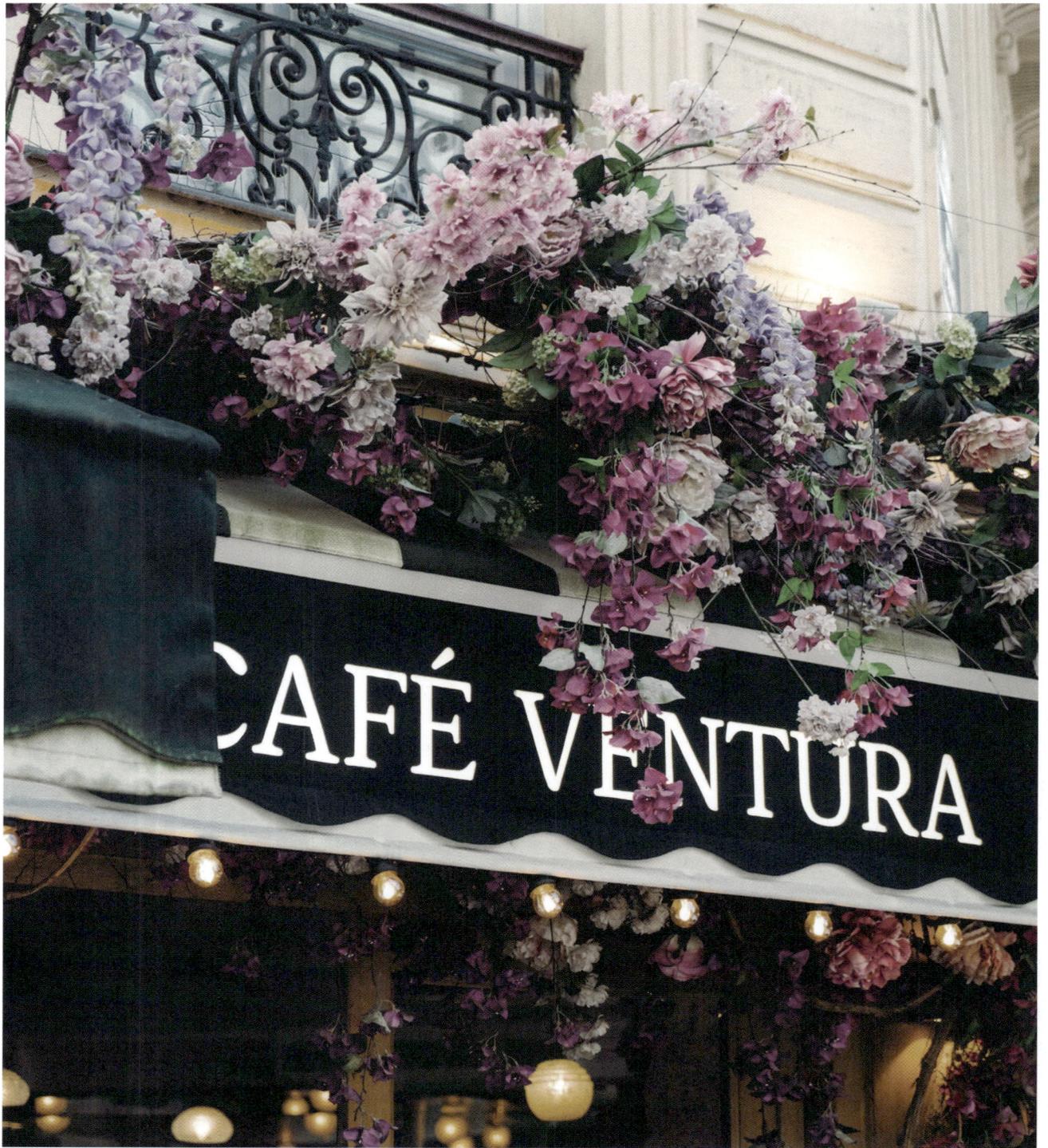

Above and at right:
Though artificial, the lush blooms on the façades of many Parisian cafés draw admirers
and are a staple of the cityscape.

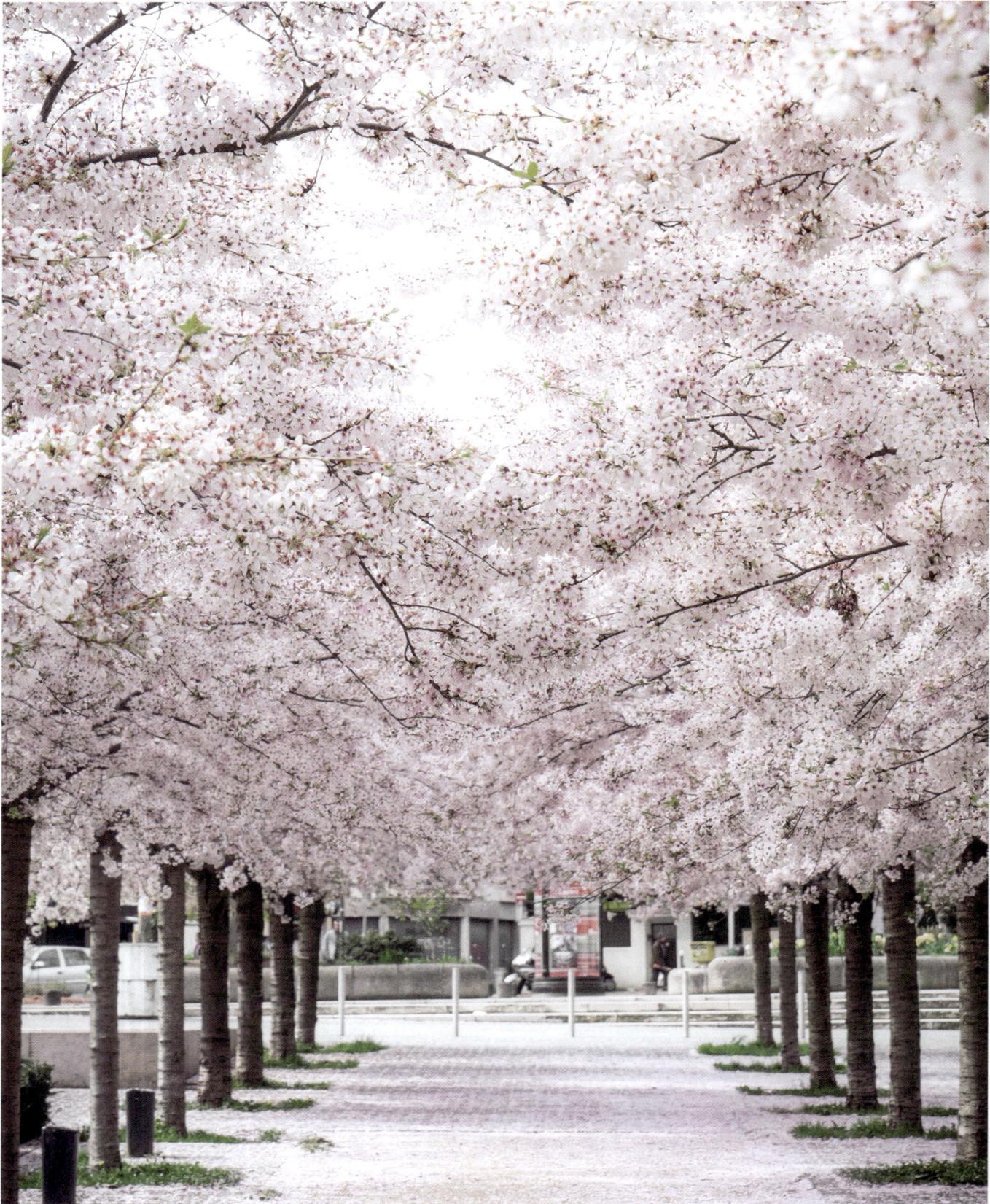

Above and at left:

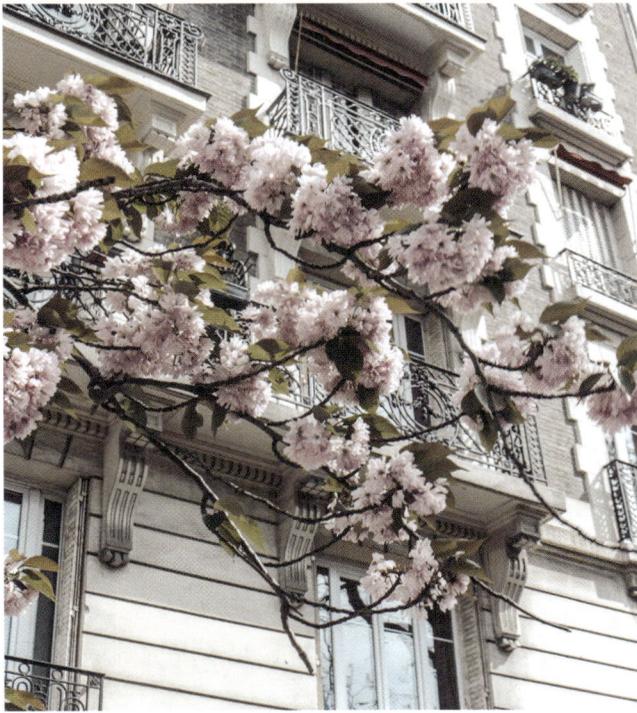

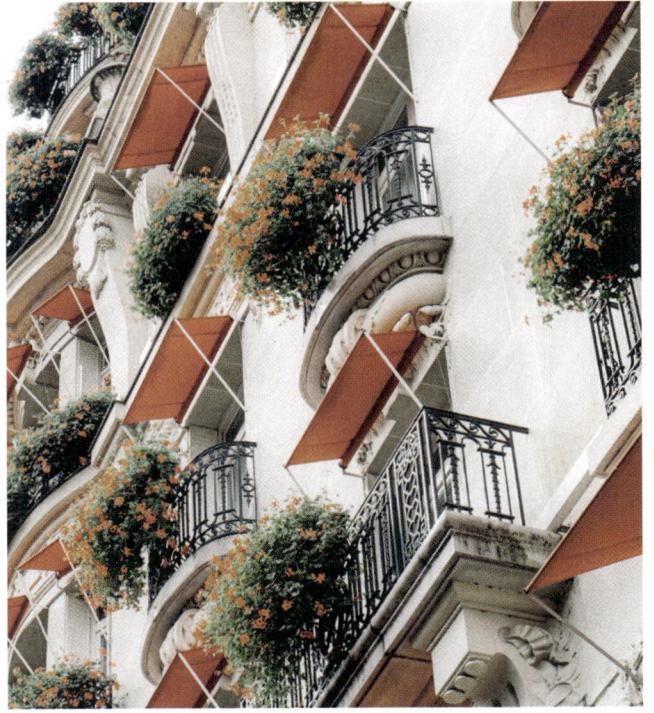

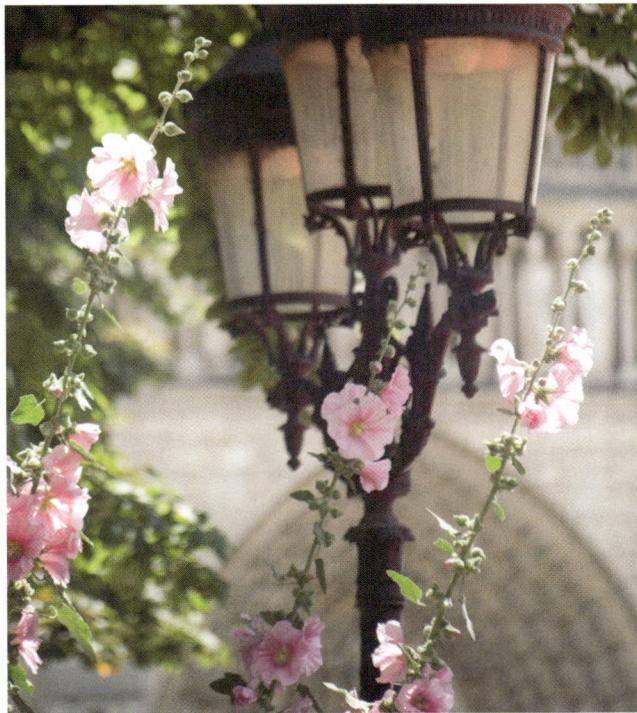

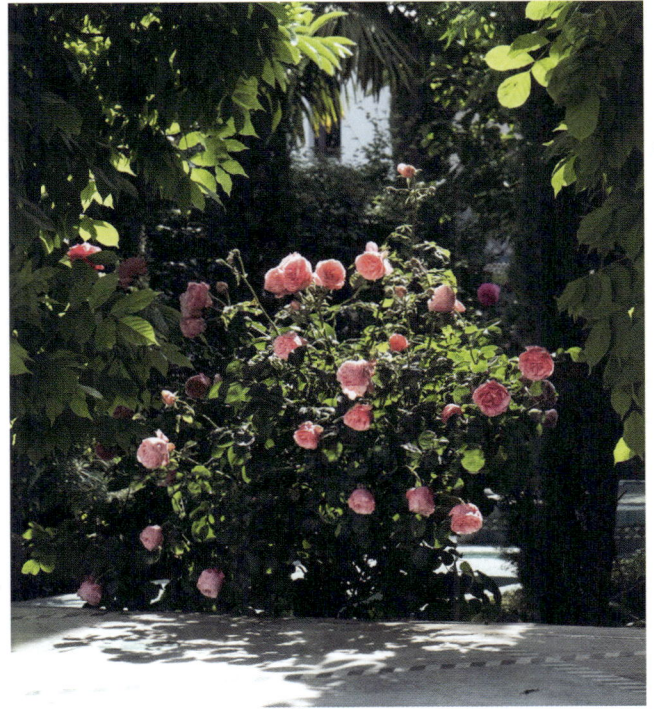

Paris comes alive in spring. People brighten grey exteriors by tucking plants into the smallest nooks.
Beneath rows such as these, a soft carpet of pink petals lines the way.

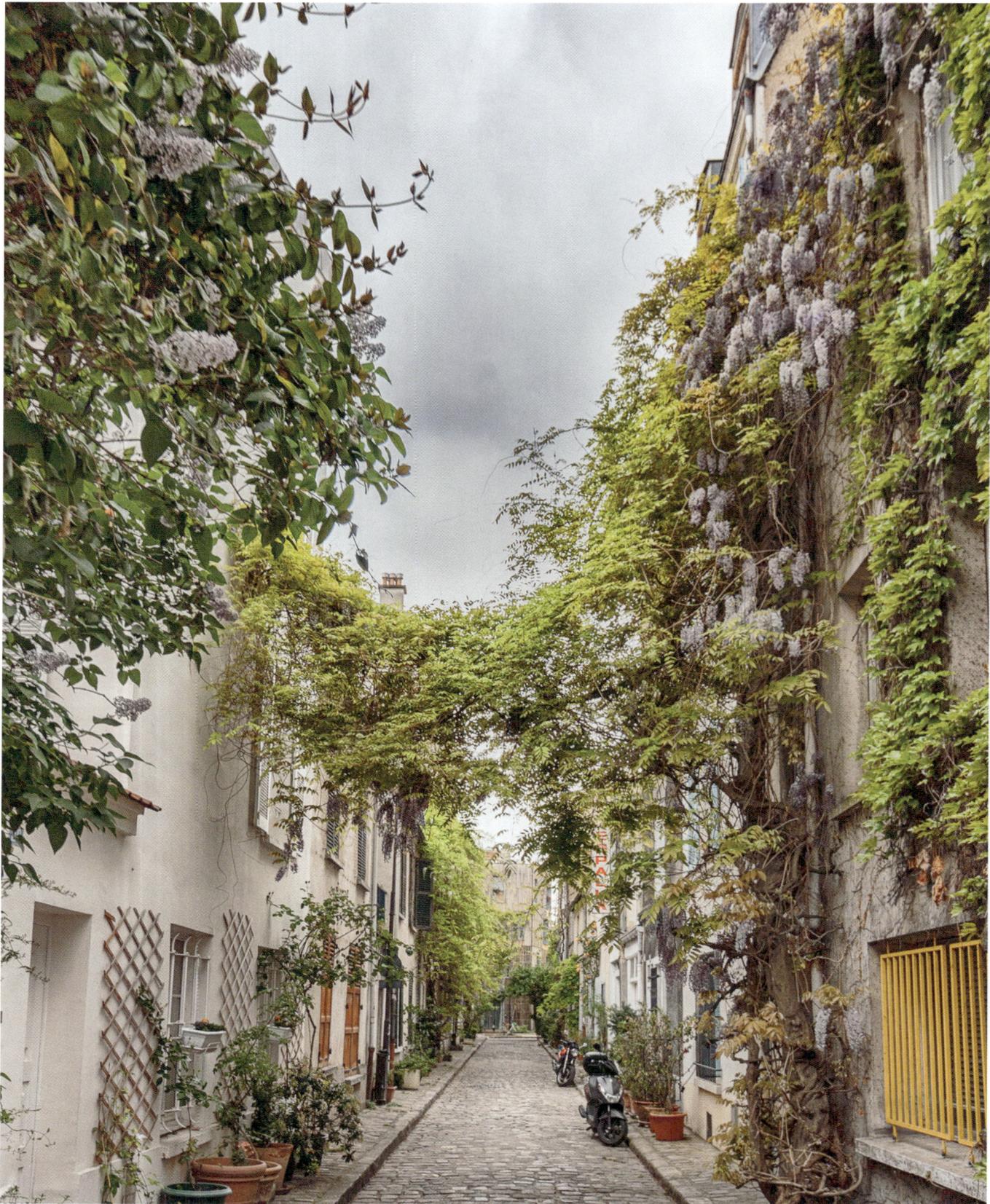

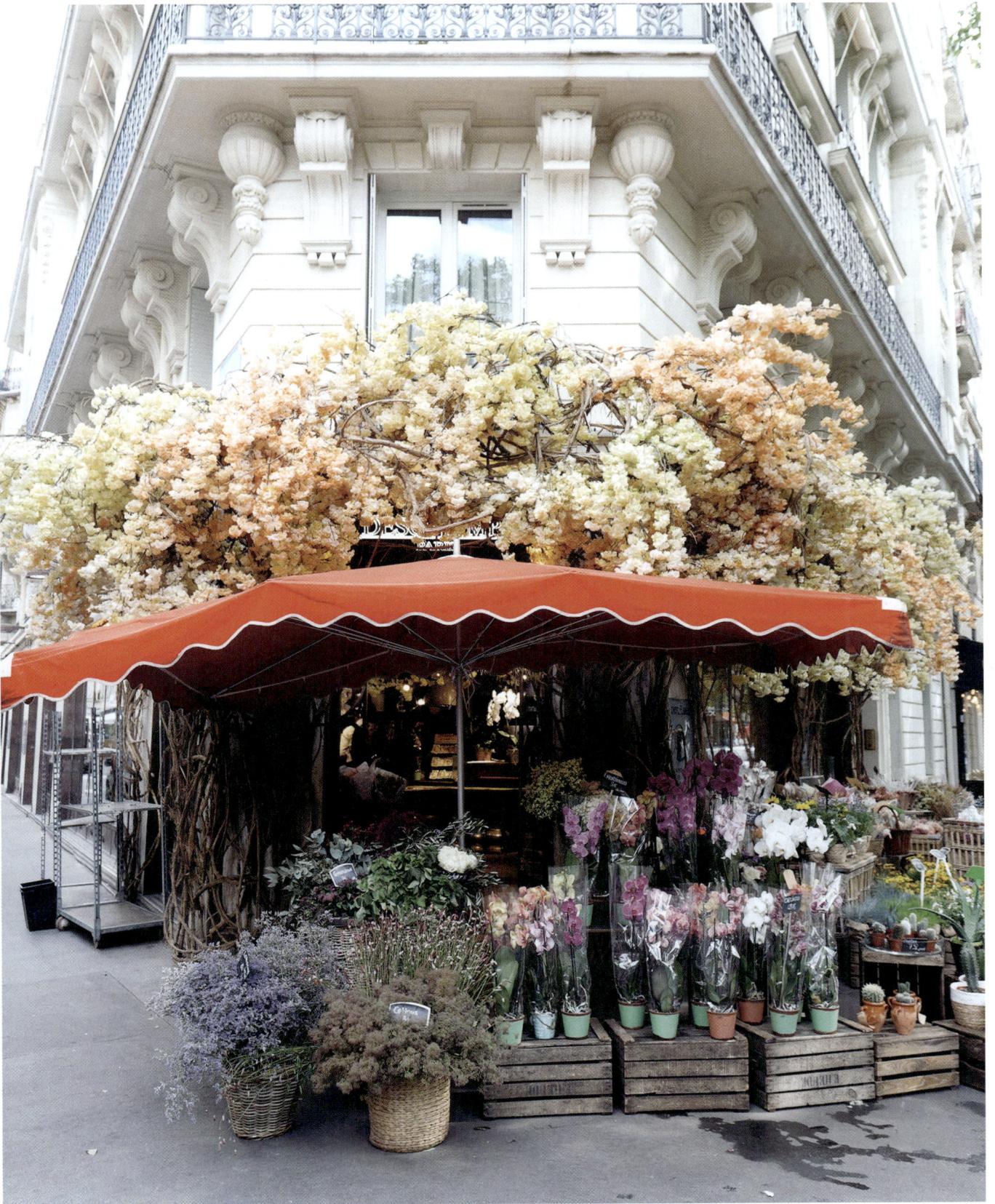

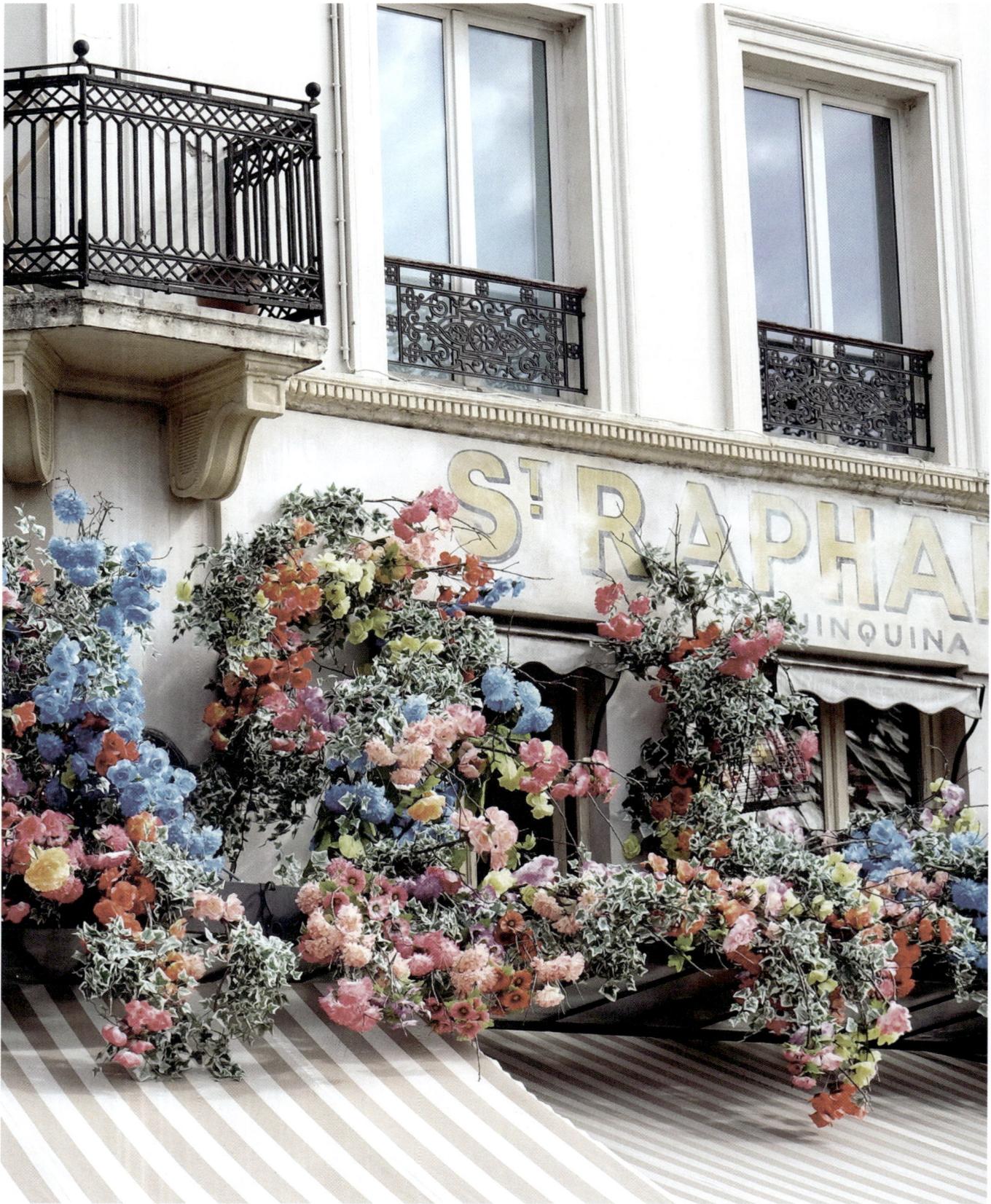

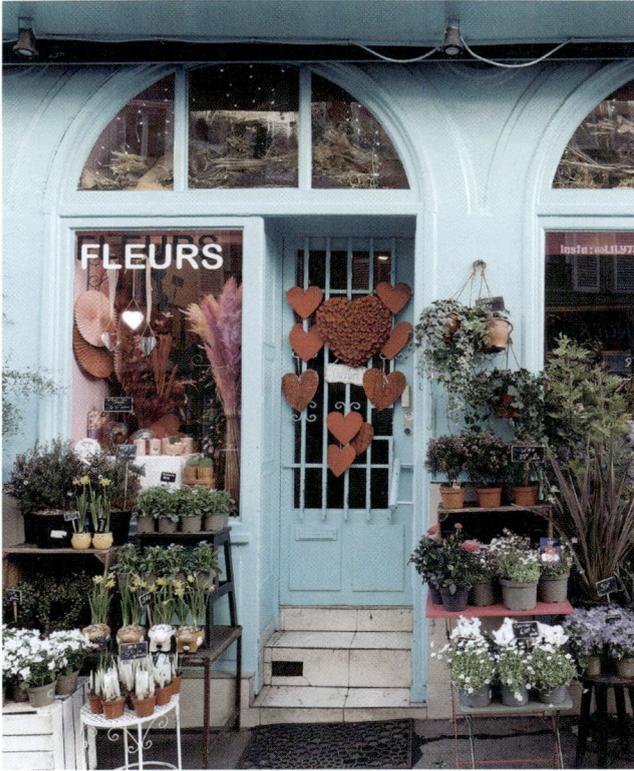

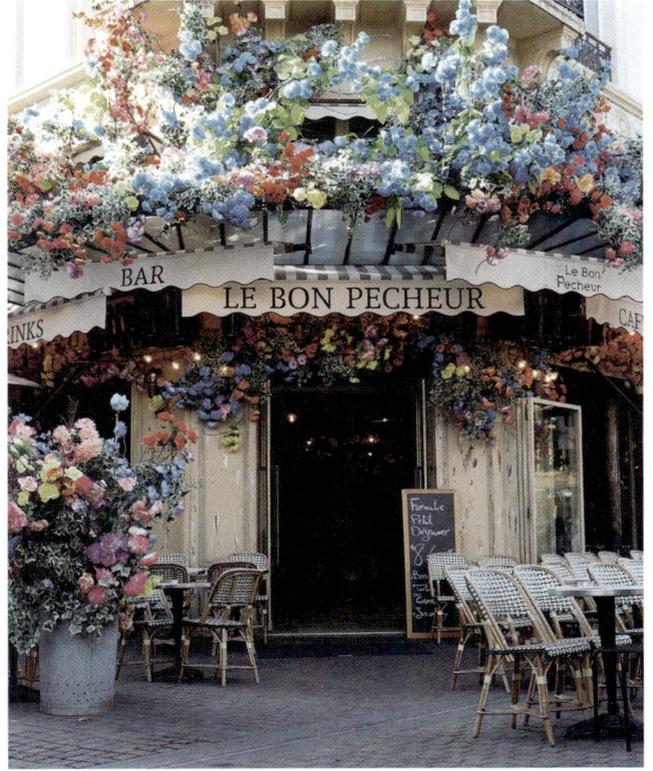

These and previous pages:

Whether flower shop or restaurant, exteriors overflow with floral displays that delight both eye and spirit.
Who cares if the colorful magnificence isn't literally rooted in nature?

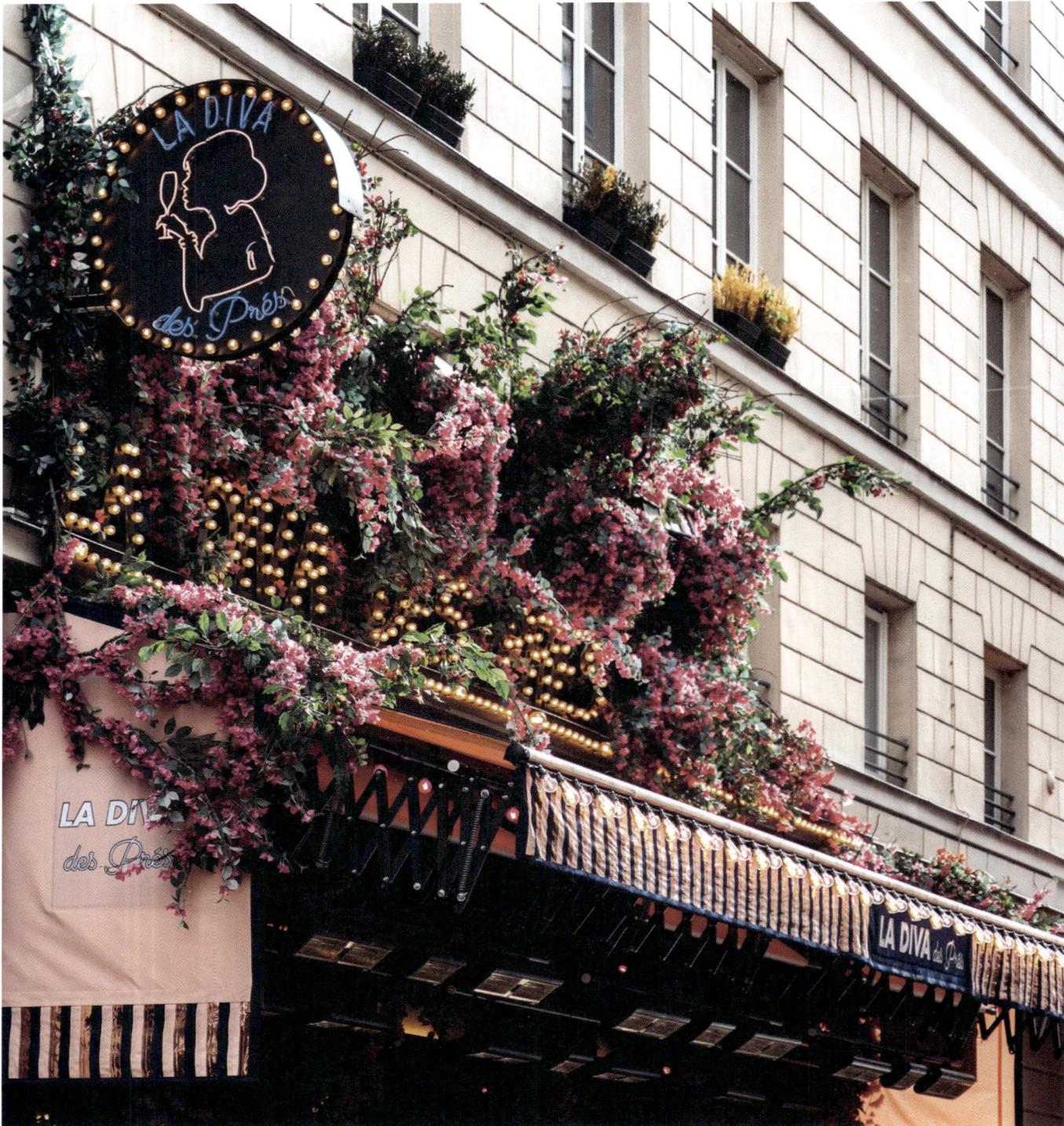

Left:
For those who can't get enough of the pink blossom shower on Valentine's Day, the traditional restaurant La Diva des Prés in Saint-Germain-des-Prés is the perfect choice.

Right:
The Marché aux fleurs Reine-Elizabeth-II is a perfect spot to immerse yourself in a sea of flowers. A stroll through this cascade of vibrant colors is a surreal experience.

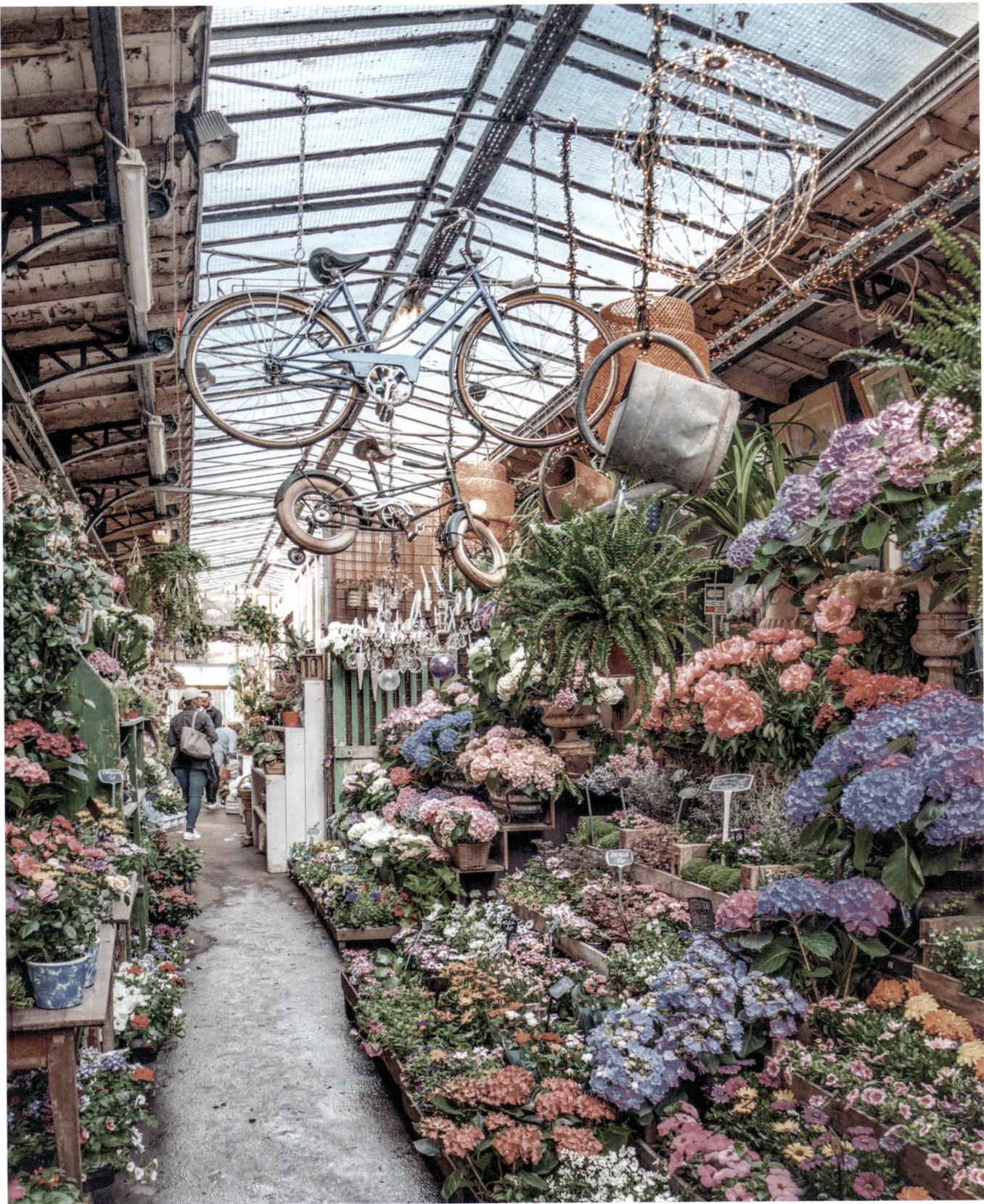

PARIS – LA RIVE DROITE

GLAMOUR, HYPE, AND NOSTALGIA

Bienvenue à la Rive Droite, the stretch of Paris west of the Seine between the Arc de Triomphe and the Bastille. This area is defined by the grand boulevards, nineteenth-century orchestrations of Napoleon's city planner Baron Haussmann, carved across a medieval maze of alleys. What was once regarded as a conservative and staid commercial district is now seen as the epitome of Paris at its youthful, vibrant best—an image the Netflix series *Emily in Paris* actively cultivates. So, why not explore the most charming neighborhoods of the Right Bank by following in Emily's steps? The world of chic agencies and luxury boutiques between the Elysée Palace, the Louvre, and the Jardin du Palais Royal may look buffed out at first glance. Yet their façades exude nostalgic elegance and indeed are safeguarded as an architectural legacy. Their charm inhabits every corner. Wooden storefronts with golden lettering and splendidly adorned *bel étages* with wrought-iron balconies beckon you to look up and take it all in. Between Le Marais and the Canal Saint-Martin lies trendy Paris: a playground of fashion, street art, galleries, elegant bars, and cozy restaurants. It's always worth looking behind the façades—perhaps you'll stumble upon a *pâtisserie* like Au Petit Versailles du Marais, where the ceiling paintings rival those of a royal palace. Farther north, between Opéra and La Butte Montmartre, the spirit of artistic romanticism is alive and well. A stroll through these neighborhoods, past bustling cafés and quaint shops, is brimming with delightful surprises. Here, a bizarre bit of graffiti hidden in a quiet courtyard; there, a charming lane seemingly untouched by time. Cobblestone streets, pastel-hued houses, and whimsical details at every turn conjure a storybook Paris. And before you know it, you've stumbled upon yet another perfectly Instagrammable scene fit for Emily herself.

Right:
In the upscale 1st arrondissement, one of the oldest districts in Paris, it's easy to spot artistic facade details everywhere.

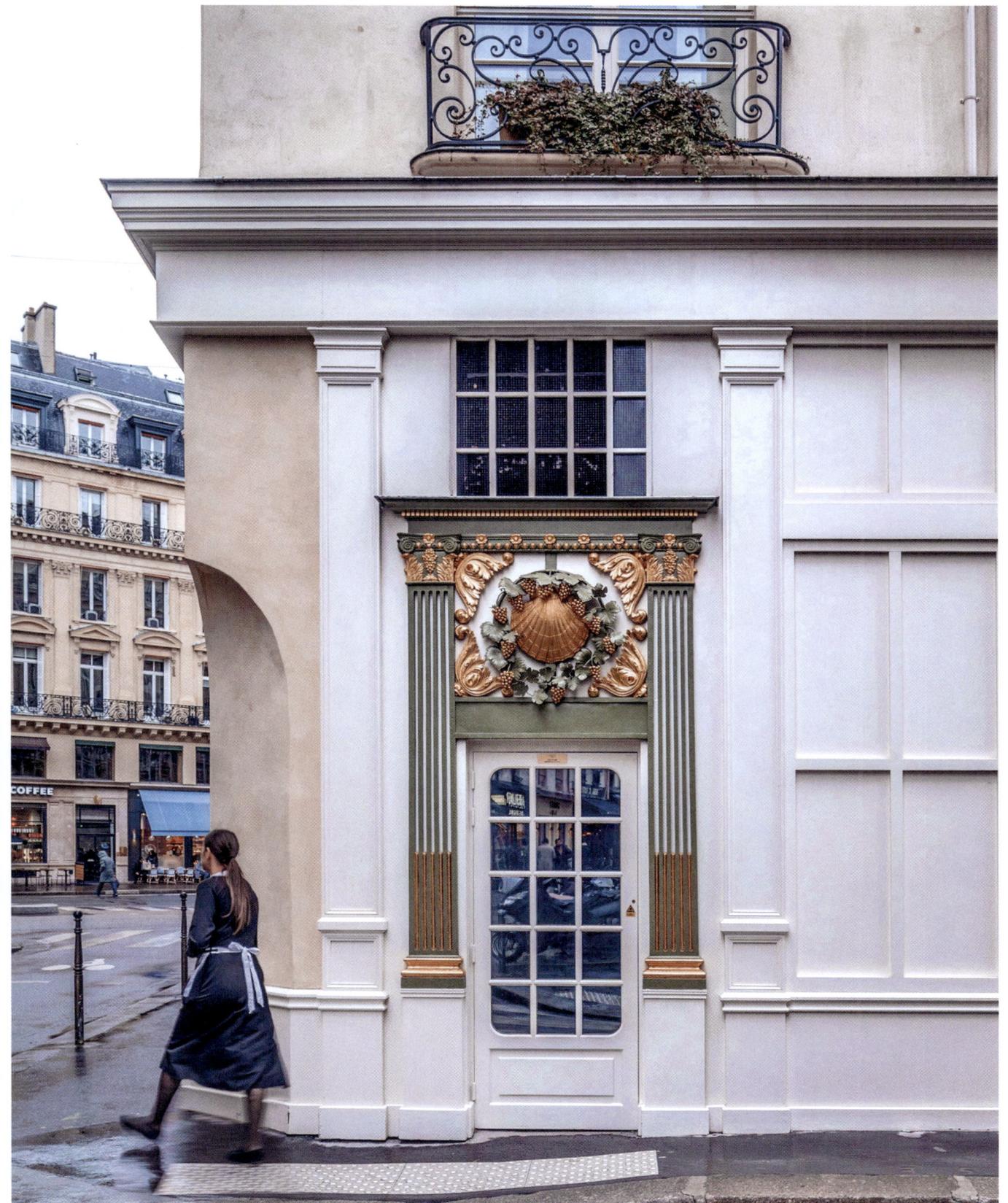

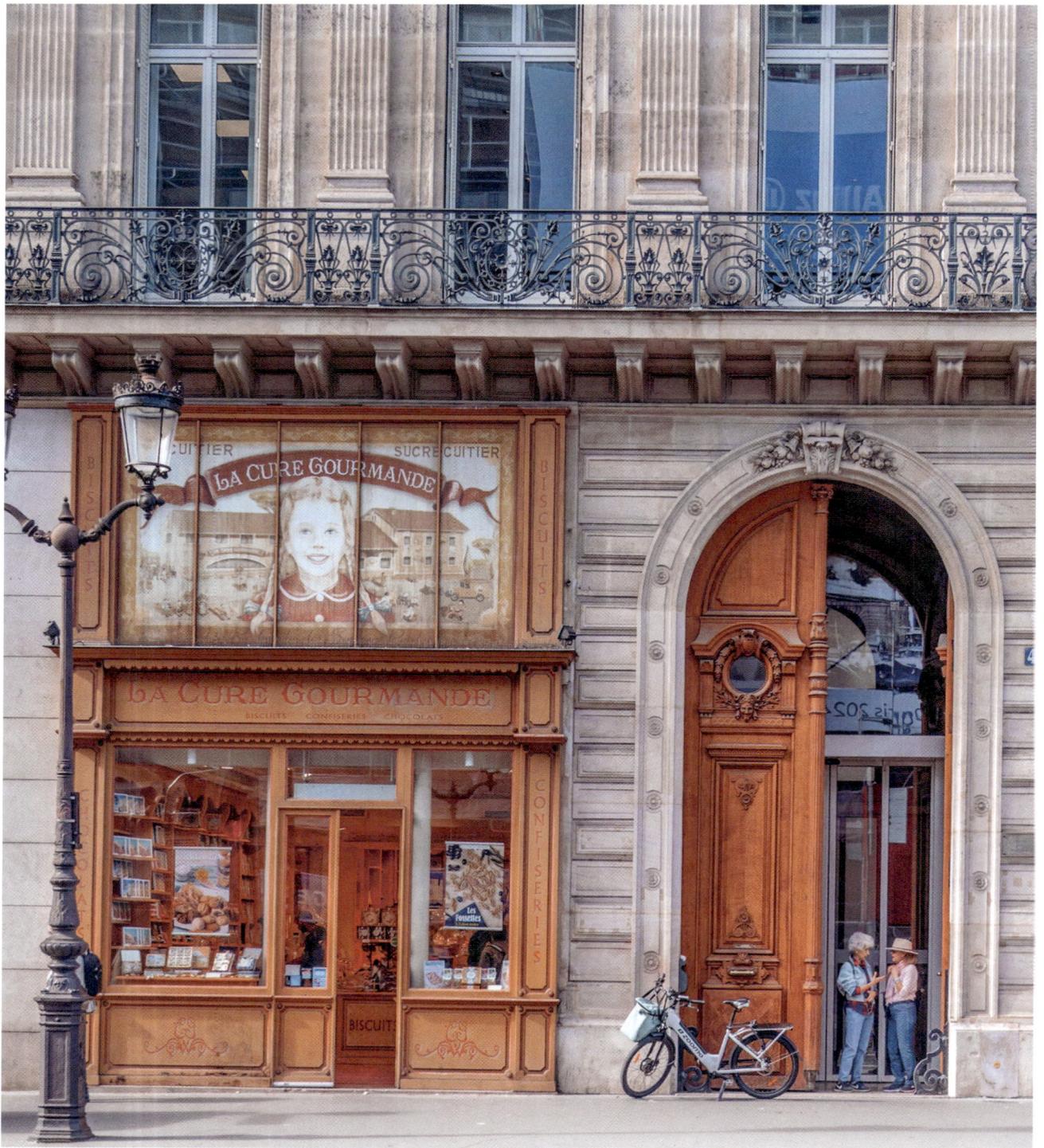

Above and at right:
Sweet treats have a long tradition in Paris—take in the elegant façades of venerable pâtisseries like La Cure Gourmande or the incomparable Stohrer, delighting Parisian palates since 1730.

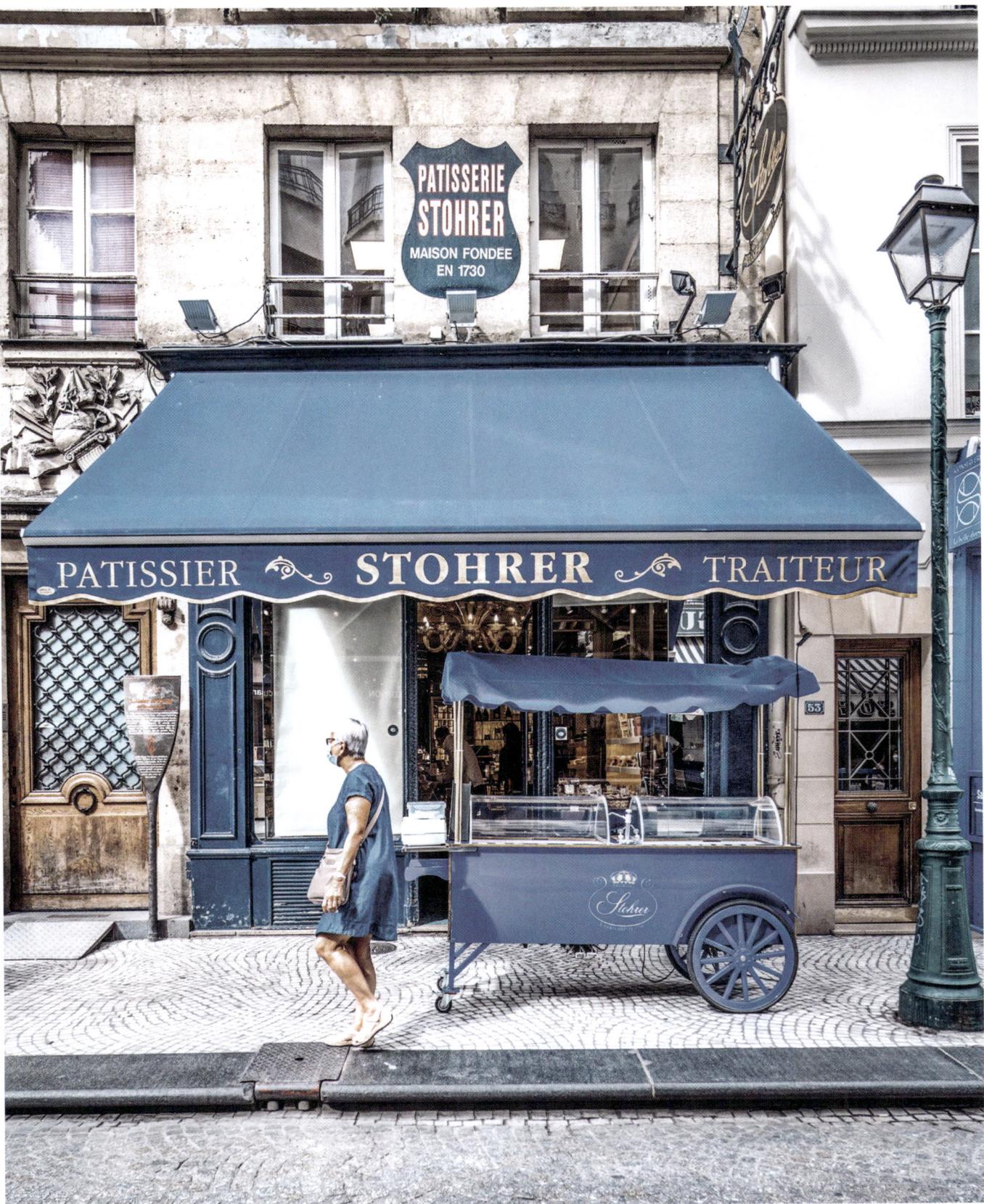

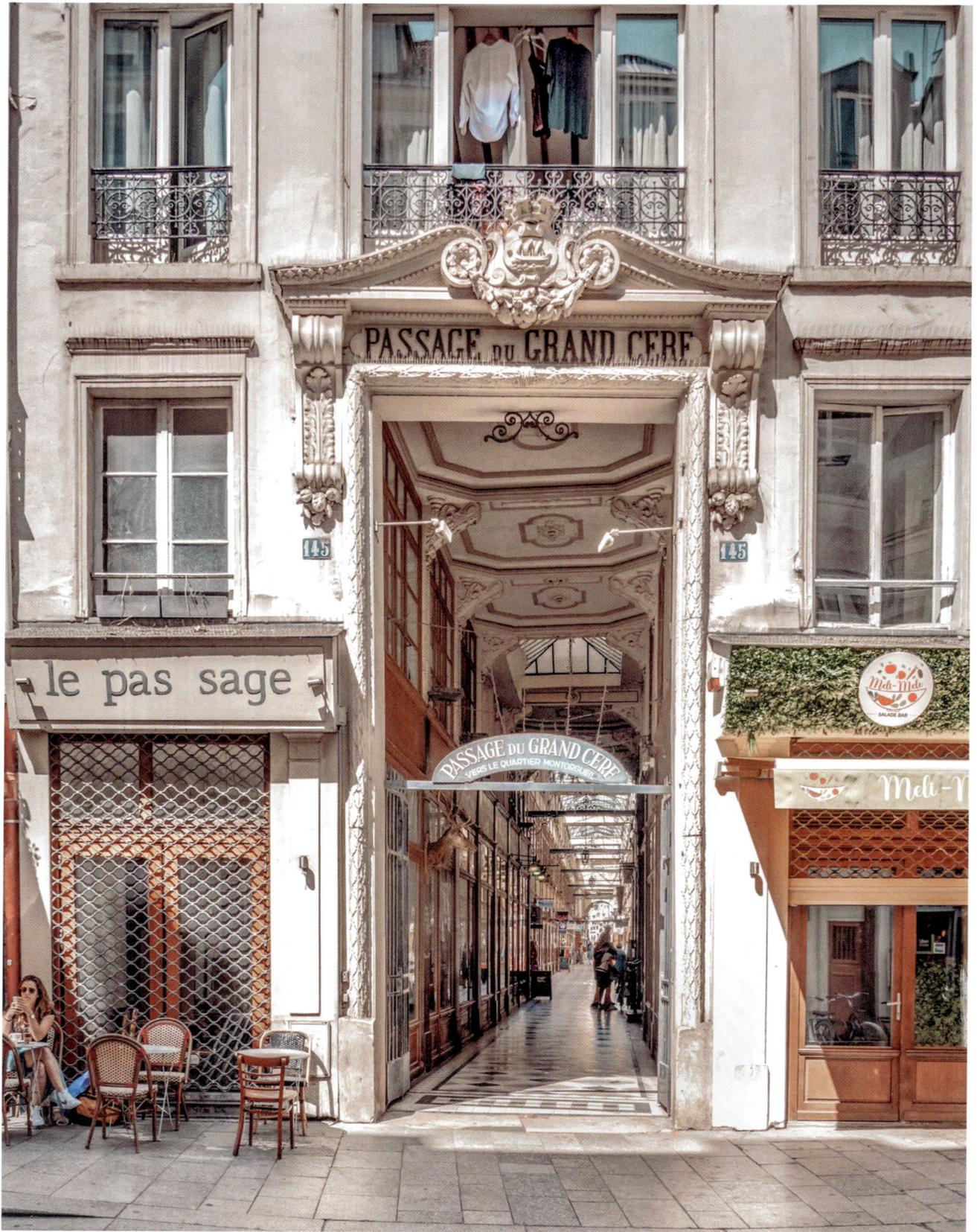

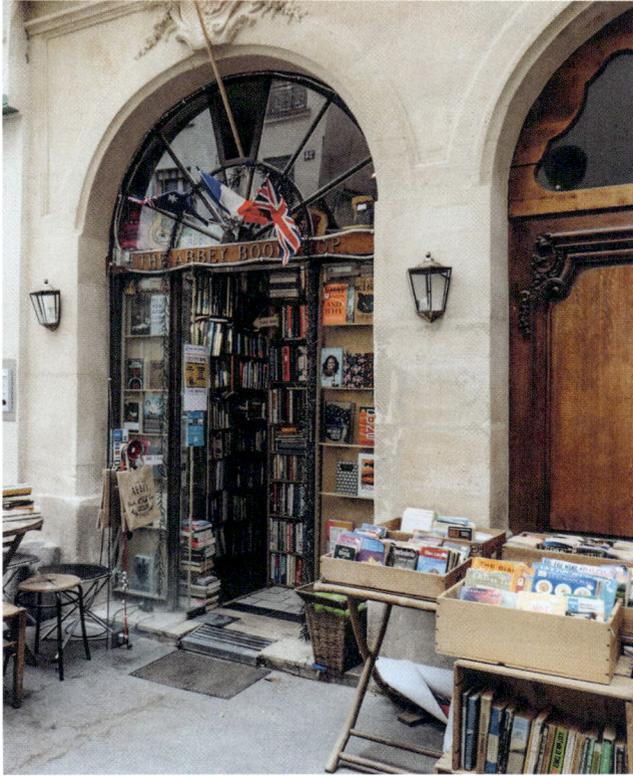

Above and at left:
What could be better than wandering the streets of Paris? Along the way, you'll come across
charming antiquarian bookshops and the timeless grandeur of historic arcades full of shops like
Passage du Grand-Cerf in the 2nd arrondissement.

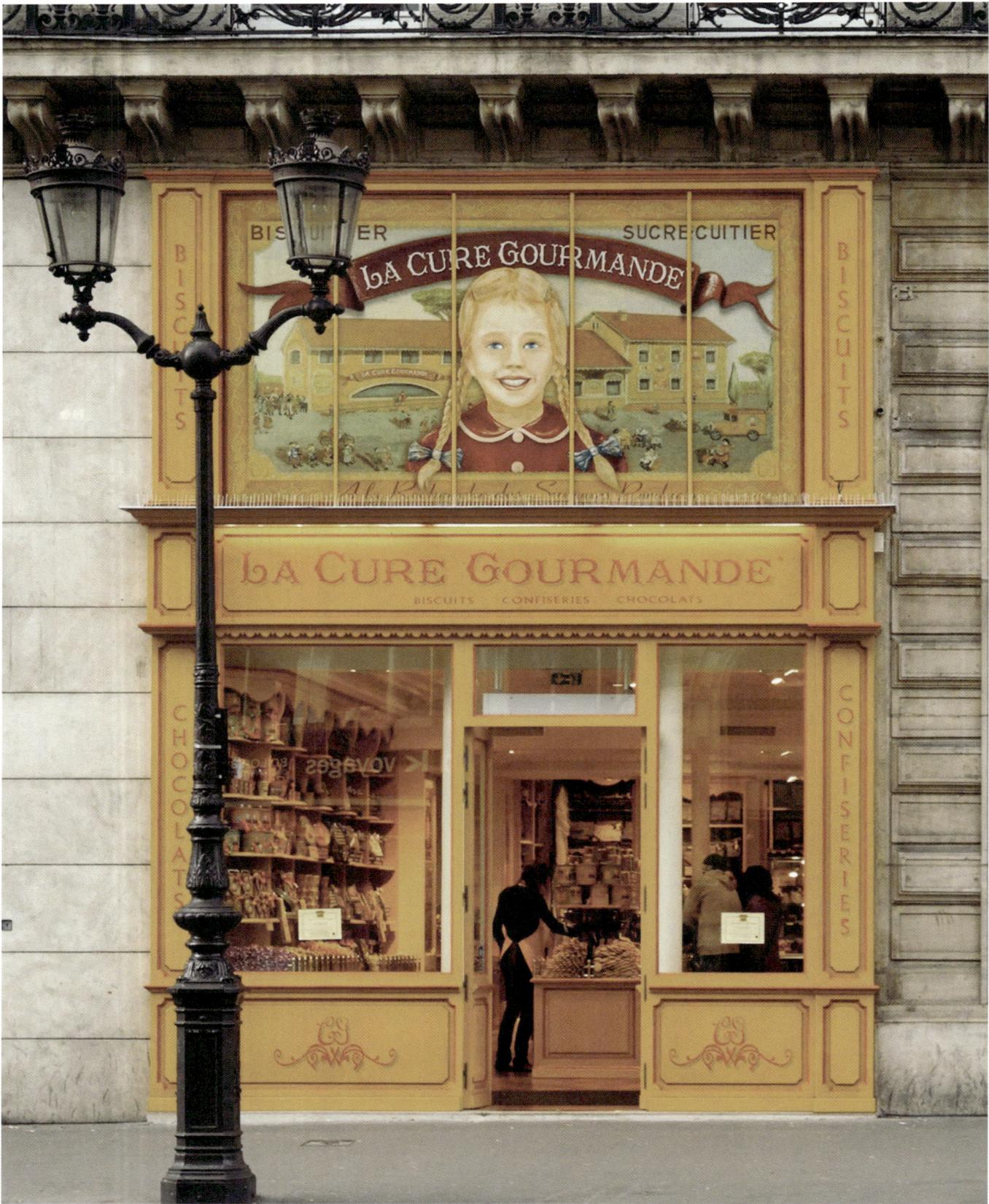

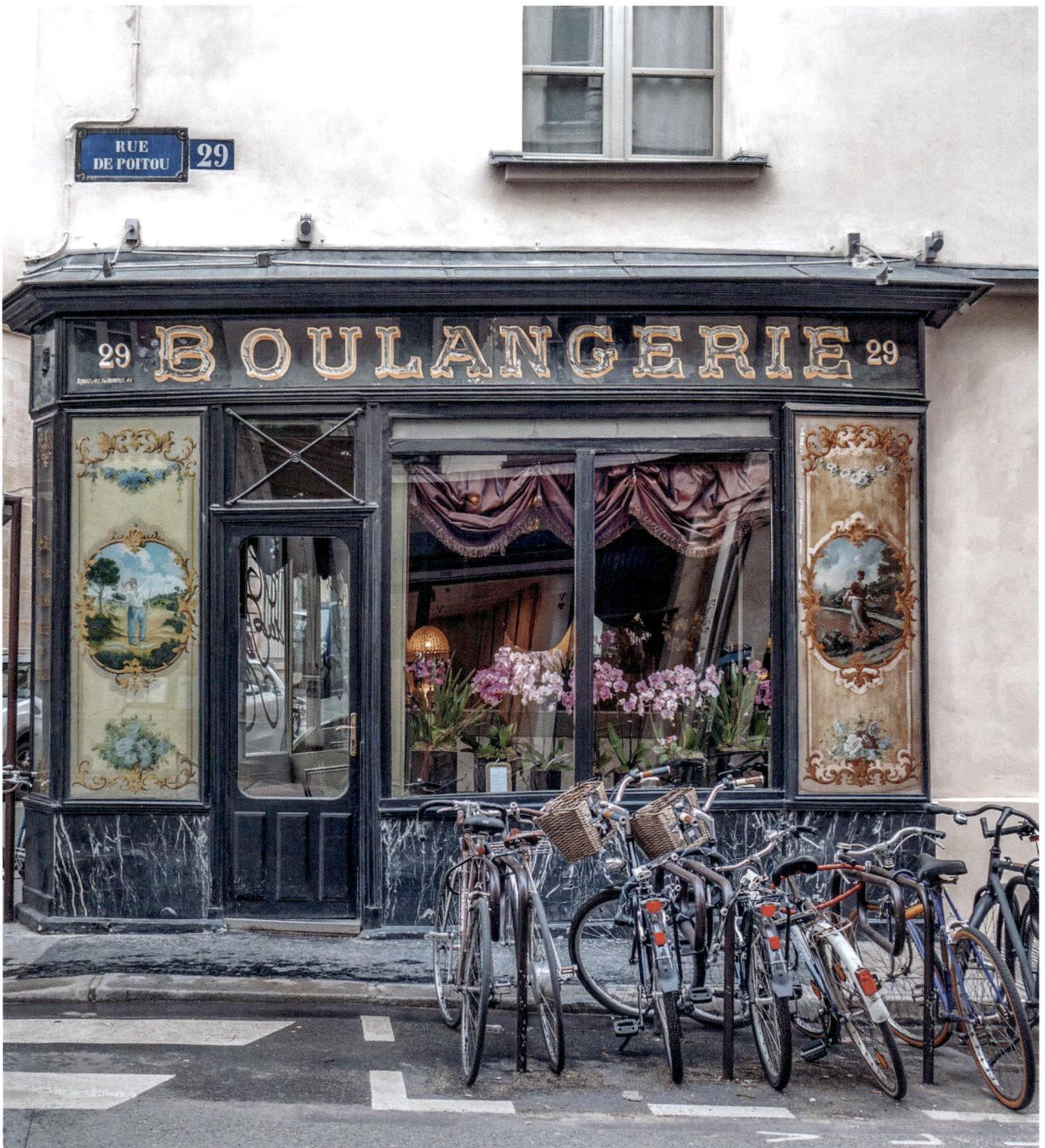

Above:
Baguette or sack? The façade of what is likely Paris's oldest bakery, dating back to the seventeenth century, stands as a historical landmark. Inside is now a luxurious hotel.

Left:
Not only the elegant facade but also the shop, reminiscent of a treasure chest with its attention to detail, make a visit to this traditional patisserie more than worthwhile.

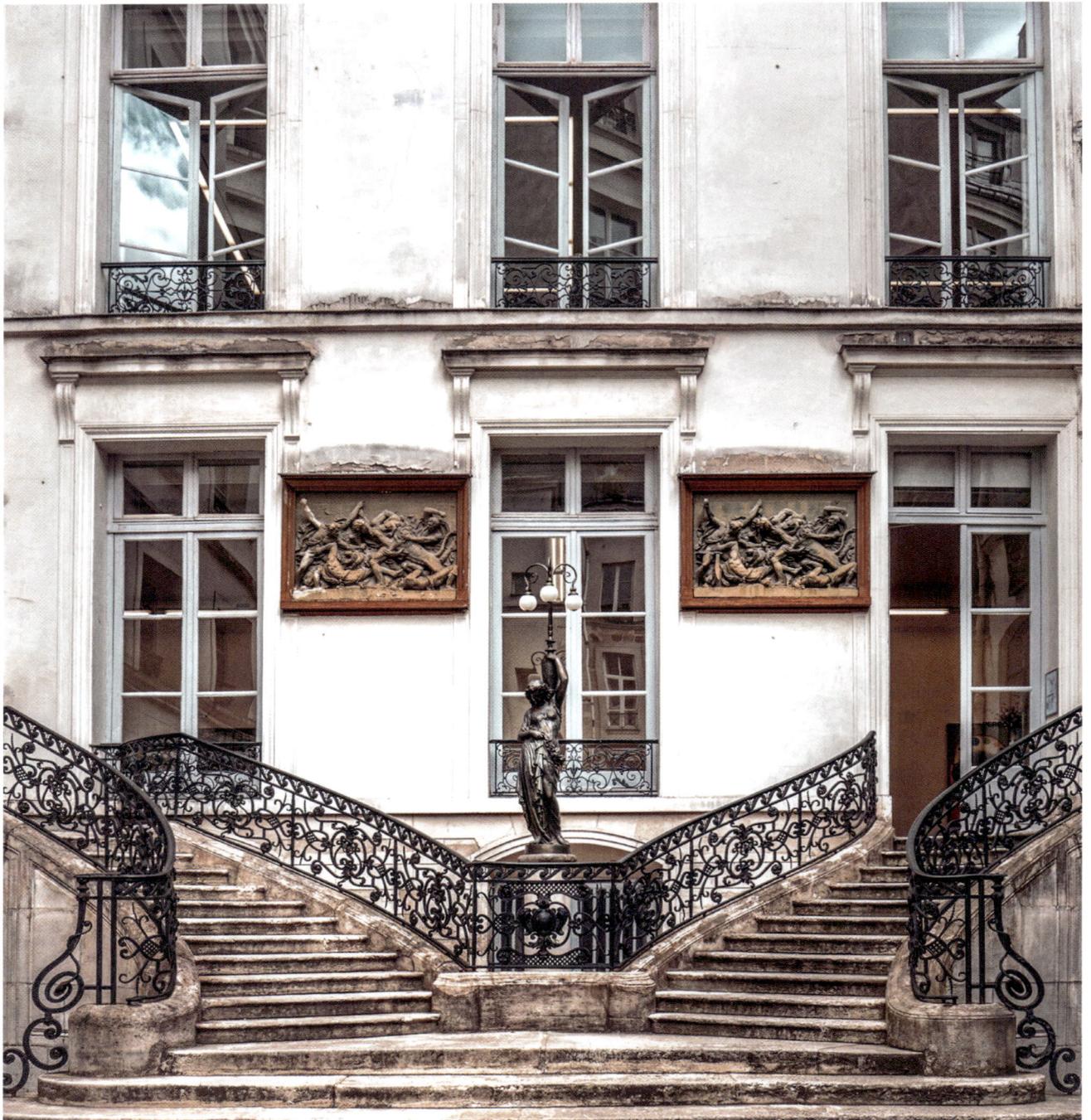

Above:
On the trail of Emily in Paris*: The magnificent double staircase in a courtyard on Rue de Turenne leads to a real-life Parisian art gallery.*
Right:
Fans of Emily *will instantly recognize the park at Place des Vosges—the iconic setting for a romantic picnic—both on screen and off.*
Following Pages:
The charming café on Île Saint-Louis, right by the bridge connecting the Seine islands, seems to want to freeze time.
A visit to Au Petit Versailles du Marais is like a journey back to the 19th century: magnificent ceiling paintings turn the patisserie into a cathedral of sweet delights.

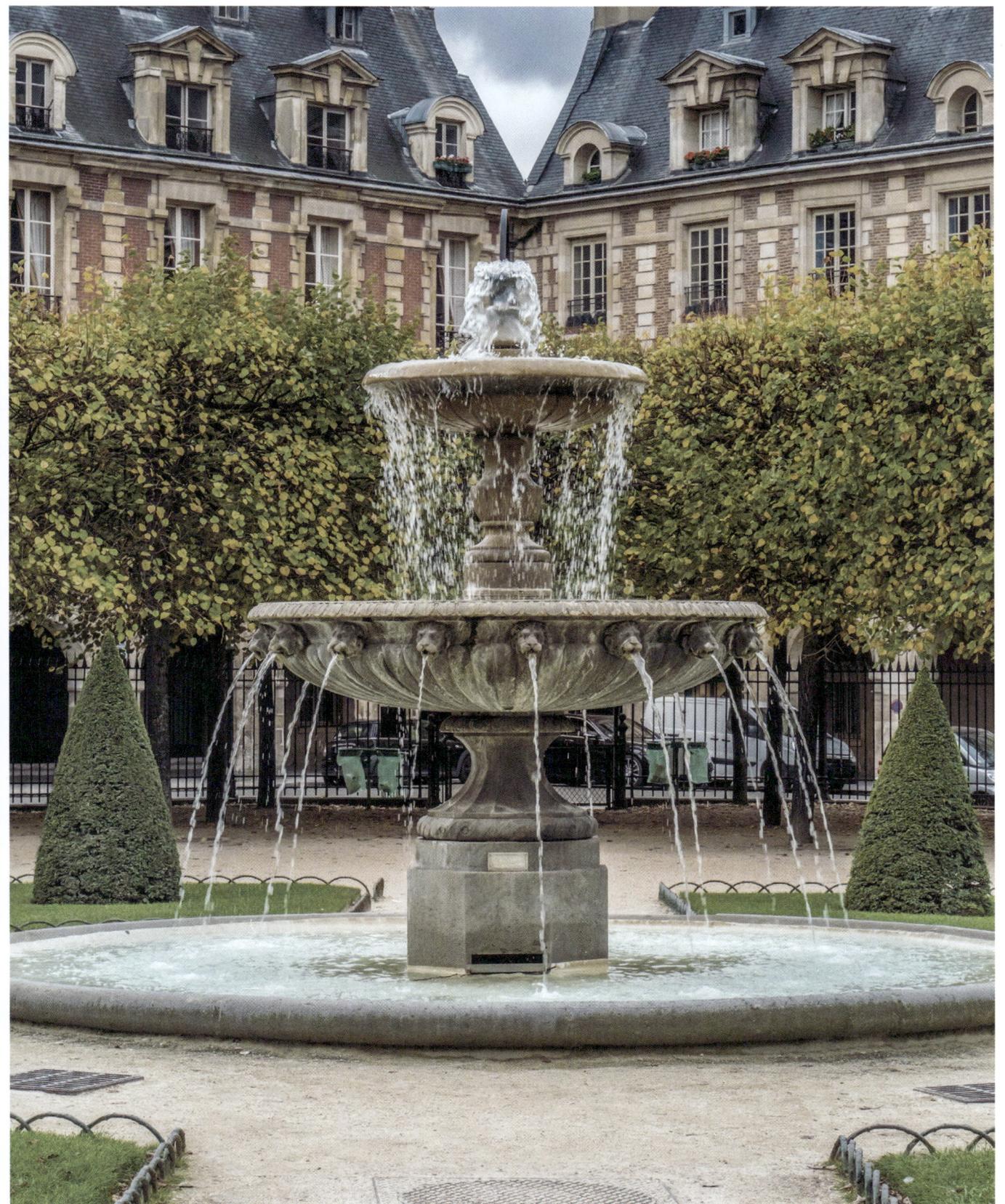

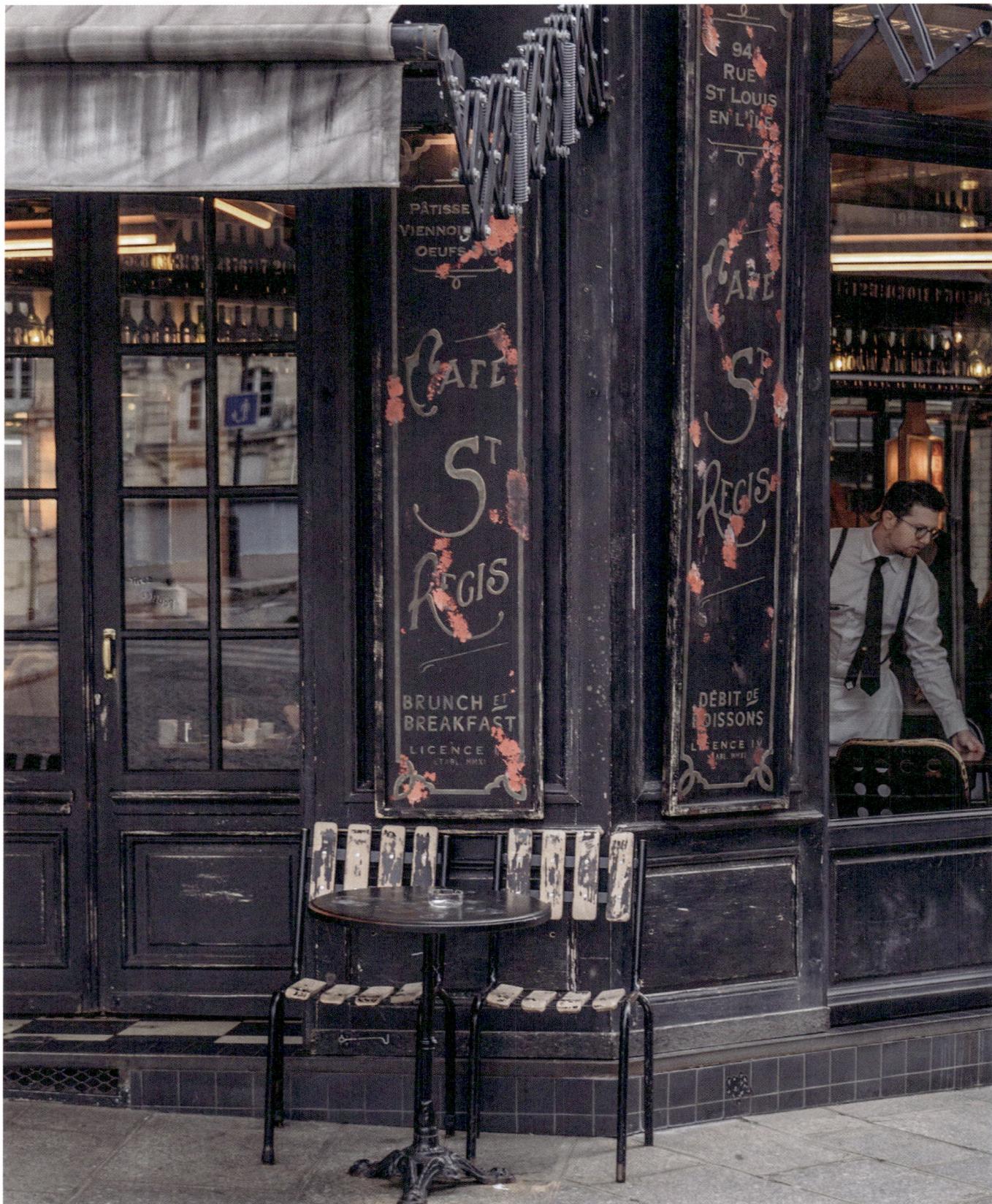

PÂTISSE
VIENNOI
OEUFS

94
RUE
ST LOUIS
EN L'ÎLE

CAFE
St
REGIS

CAFE
St
REGIS

BRUNCH ET
BREAKFAST

DÉBIT DE
BOISSONS

LICENCE
ÉTABL MMXI

LICENCE IV
ÉTABL MMXI

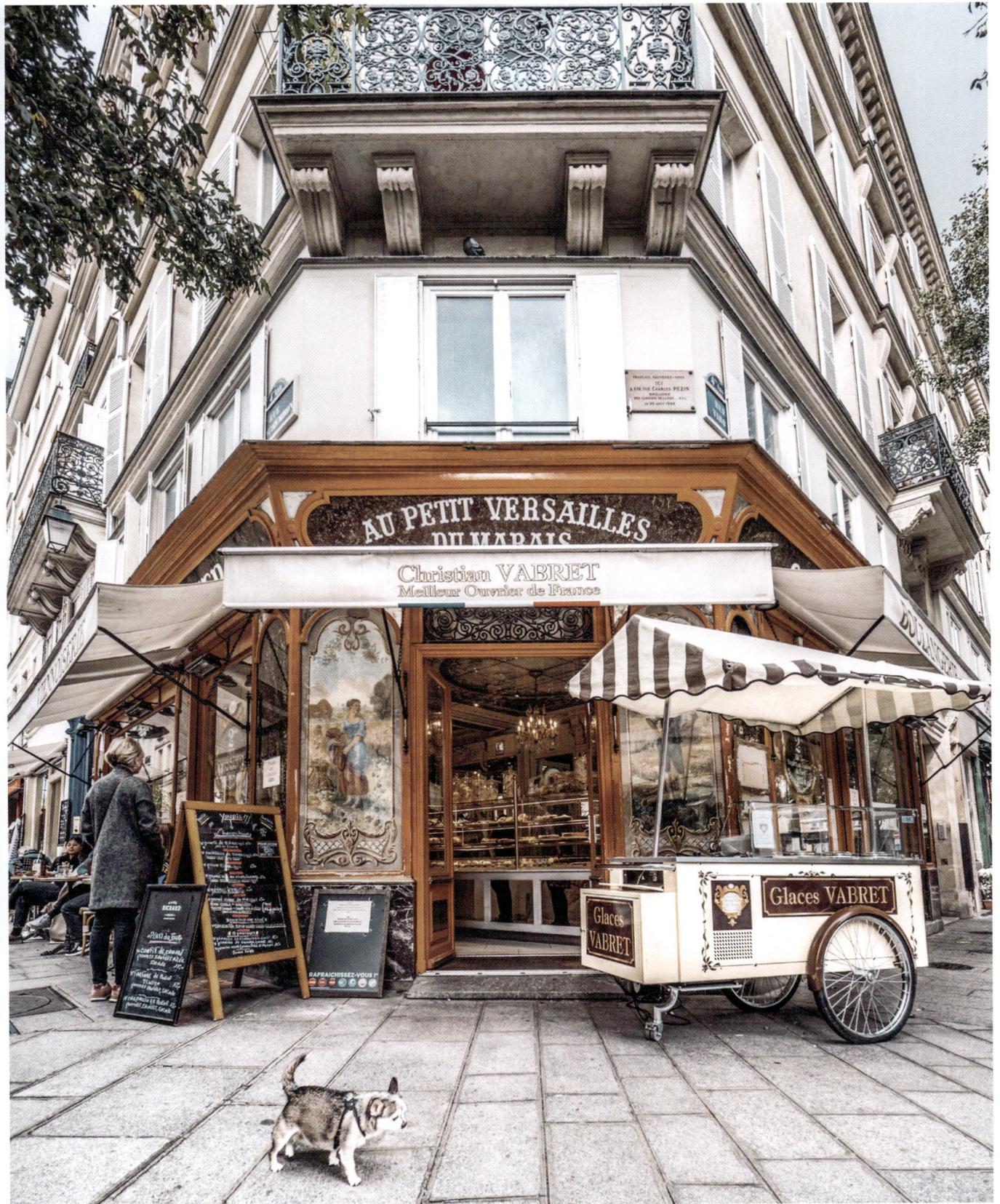

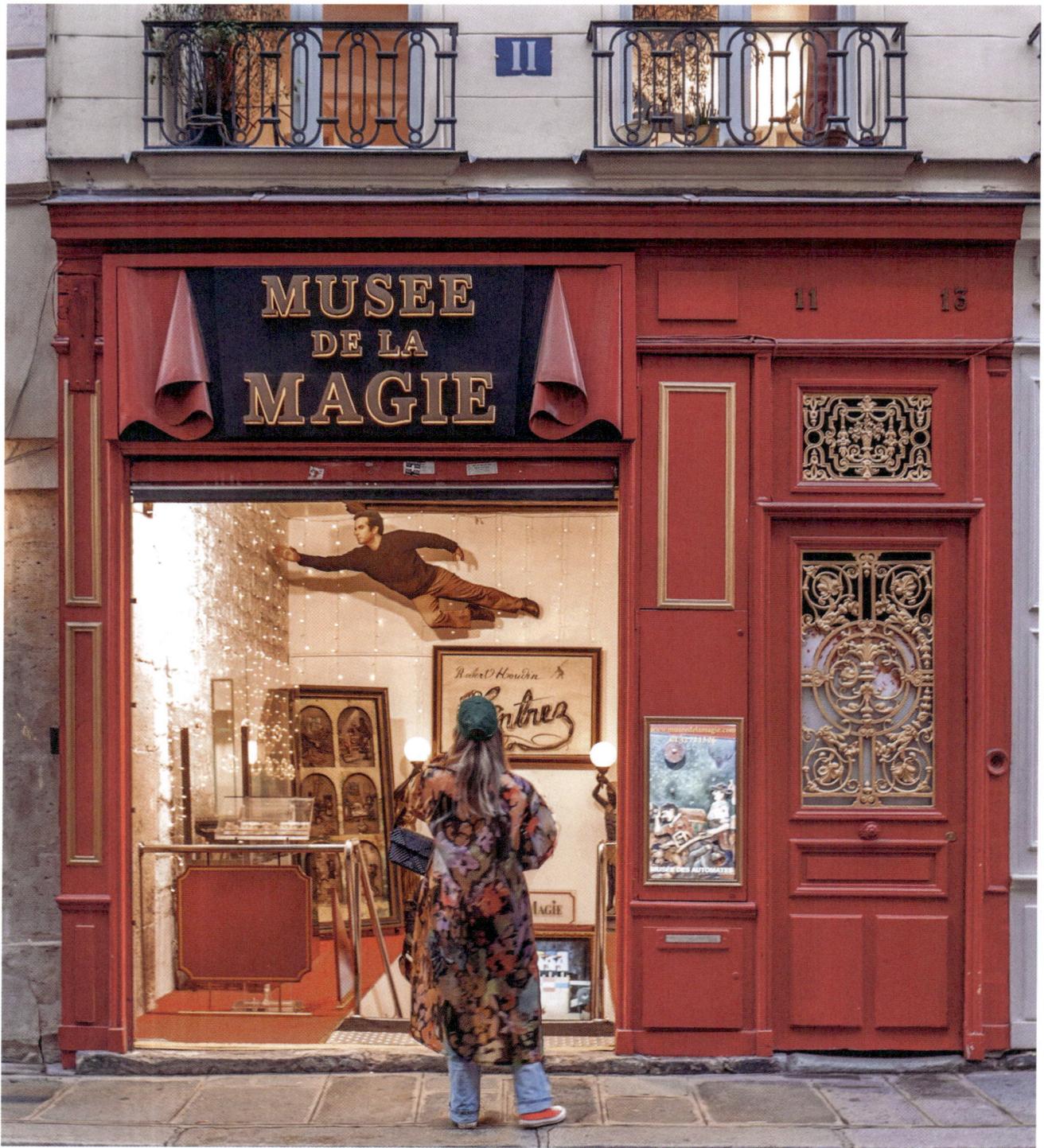

Above:
The façade of the Musée de la Magie on Rue Saint-Paul in the 4th arrondissement is a spectacle in itself.

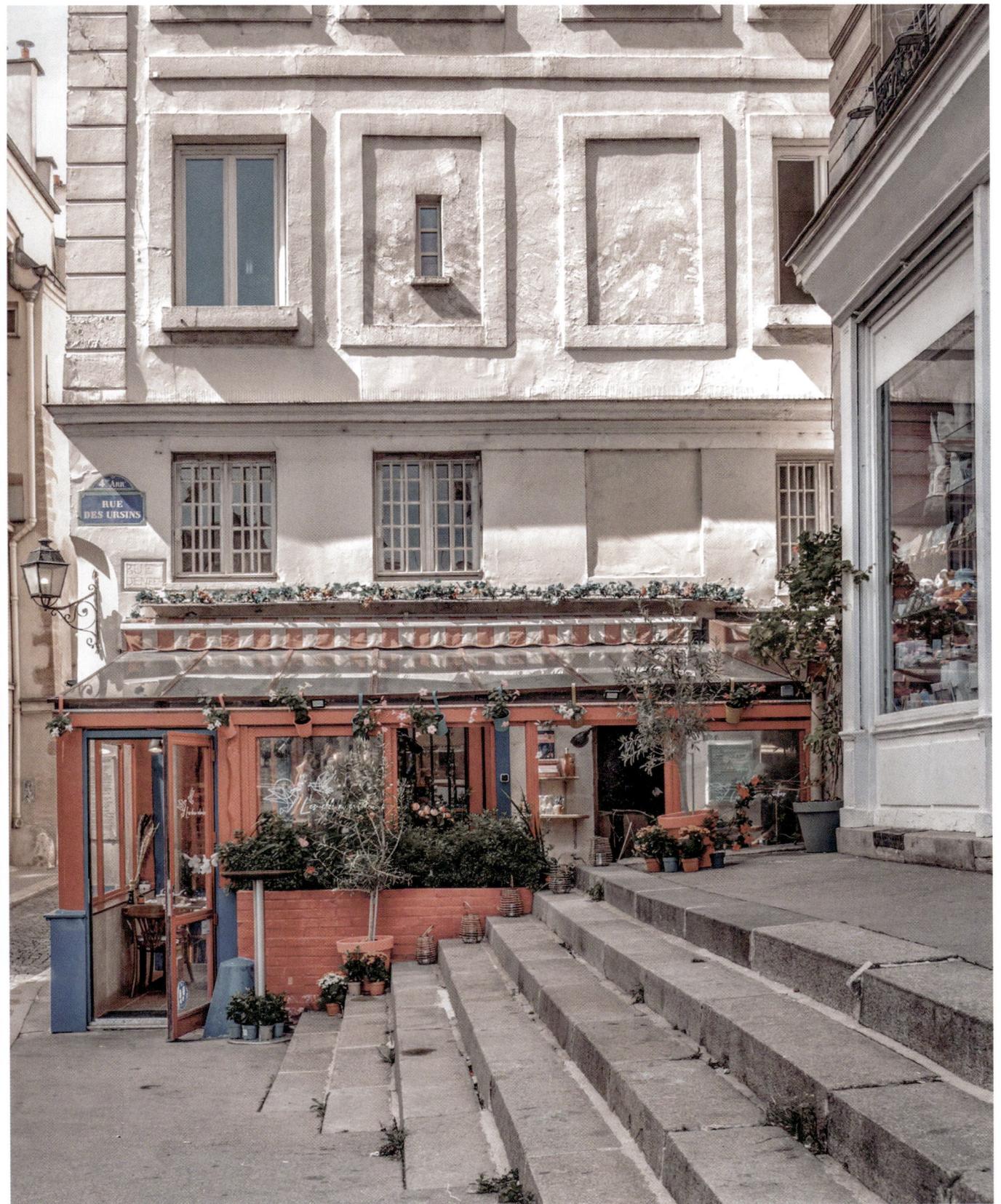

RUE
DES URSINS

RUE
DENFE

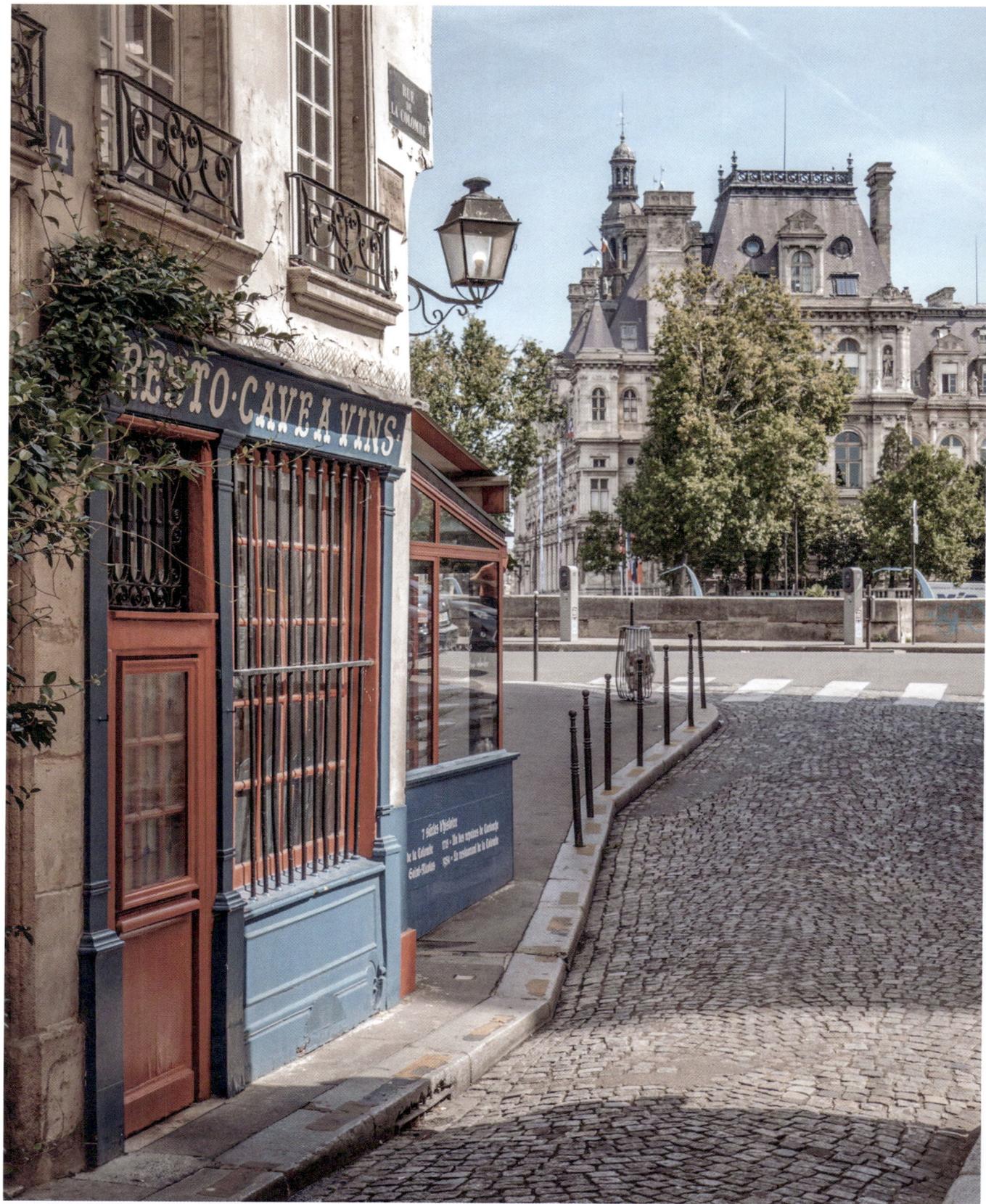

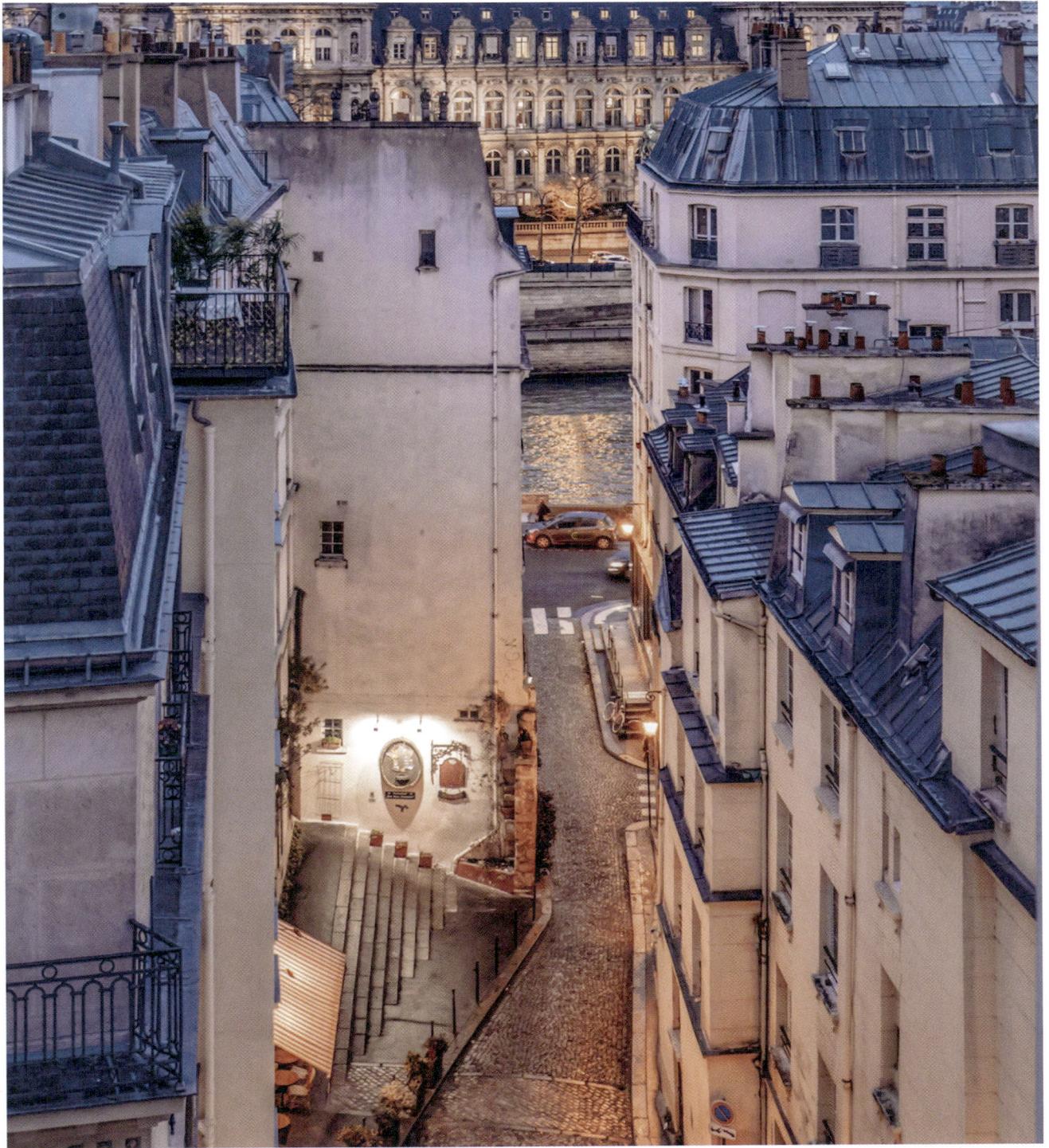

Above, at left, and the previous page:
A sentimental legend has formed around Rue de la Colombe on Île de la Cité: The tale of a faithful dove who, after a house collapsed on its mate, kept bringing her seeds and water until kindhearted neighbors intervened to reunite the lovebirds.

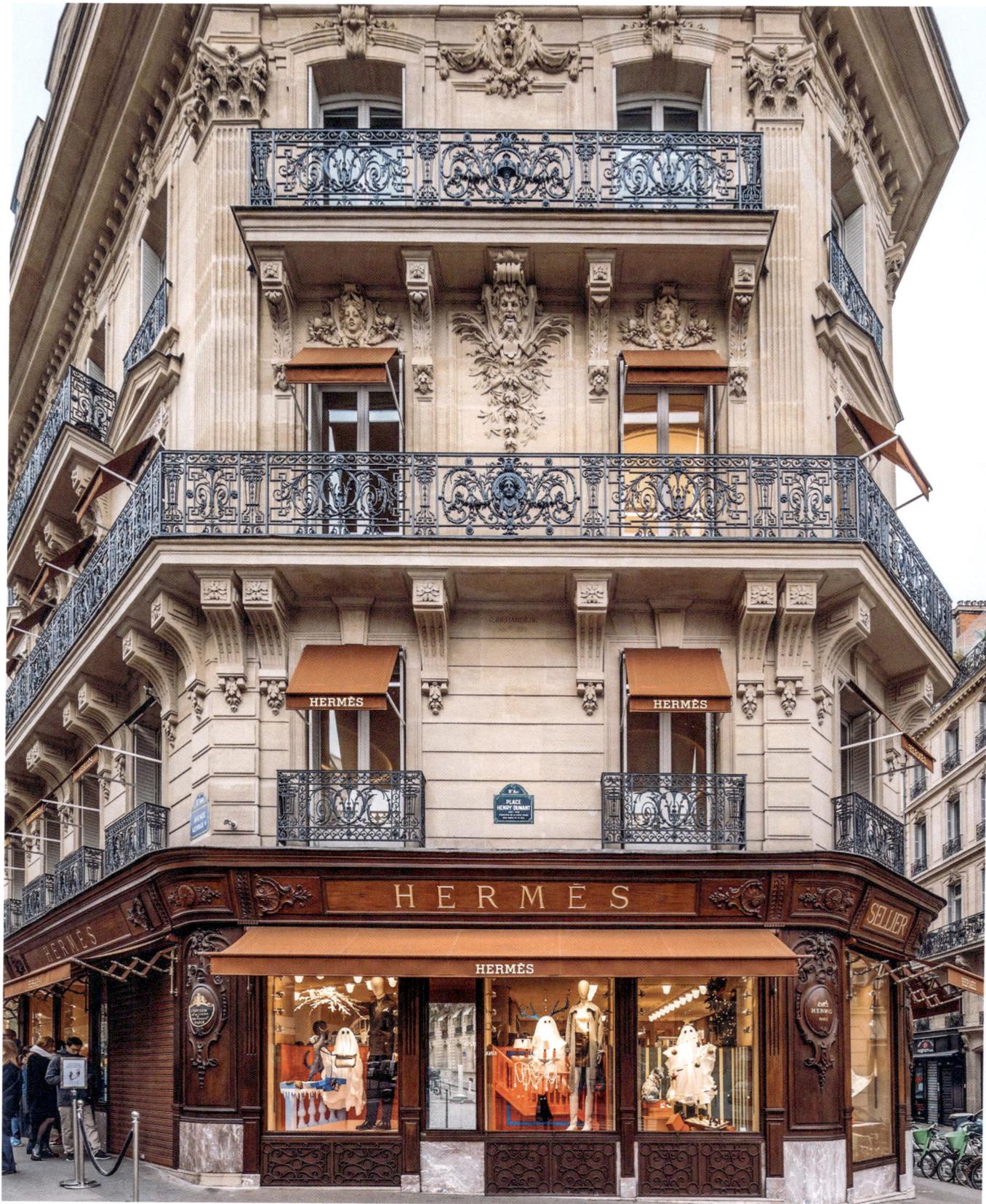

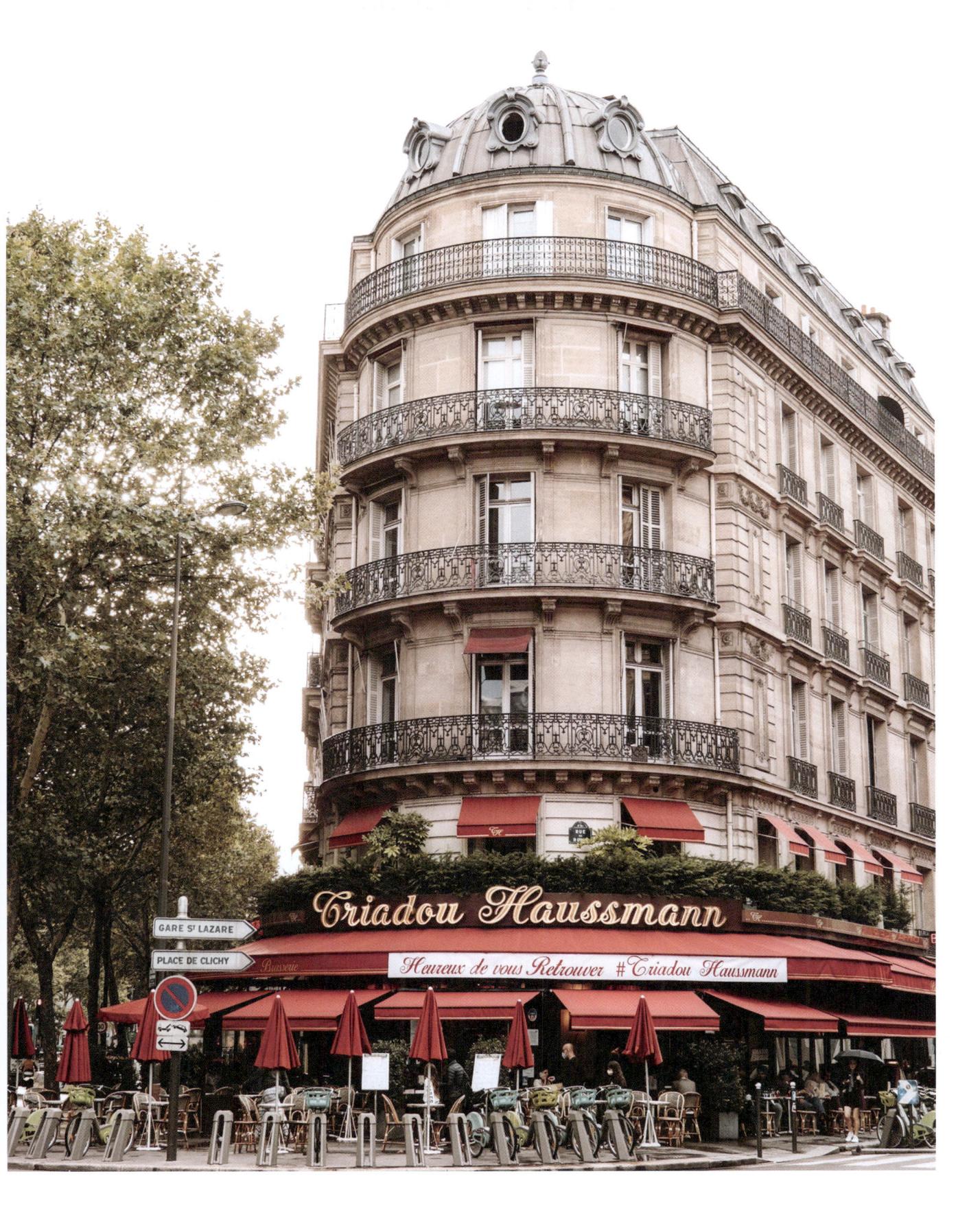

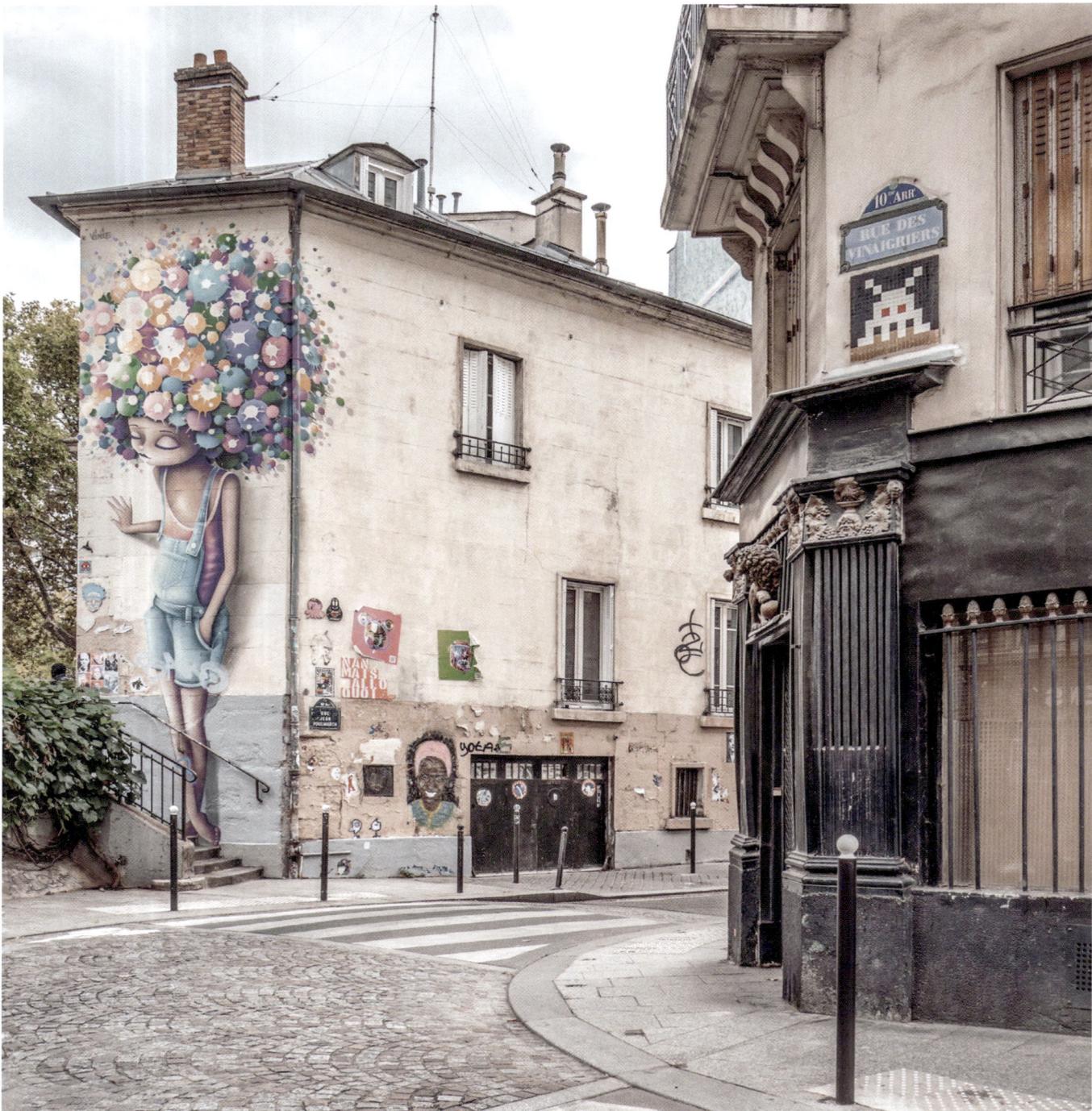

These pages:
Dull façades yield to imagination: In the Canal Saint-Martin area, vibrant street art crops up unexpectedly as you stroll down Quai de Valmy on a romantic date—just like in Emily in Paris.

Previous pages:
The opulently adorned stone facade and golden letters still pay homage to the hat maker Ernest Motsch, who outfitted his shop with this magnificent wooden front in 1870. What would Paris be without its grand facades adorned with delicate wrought-iron balconies?

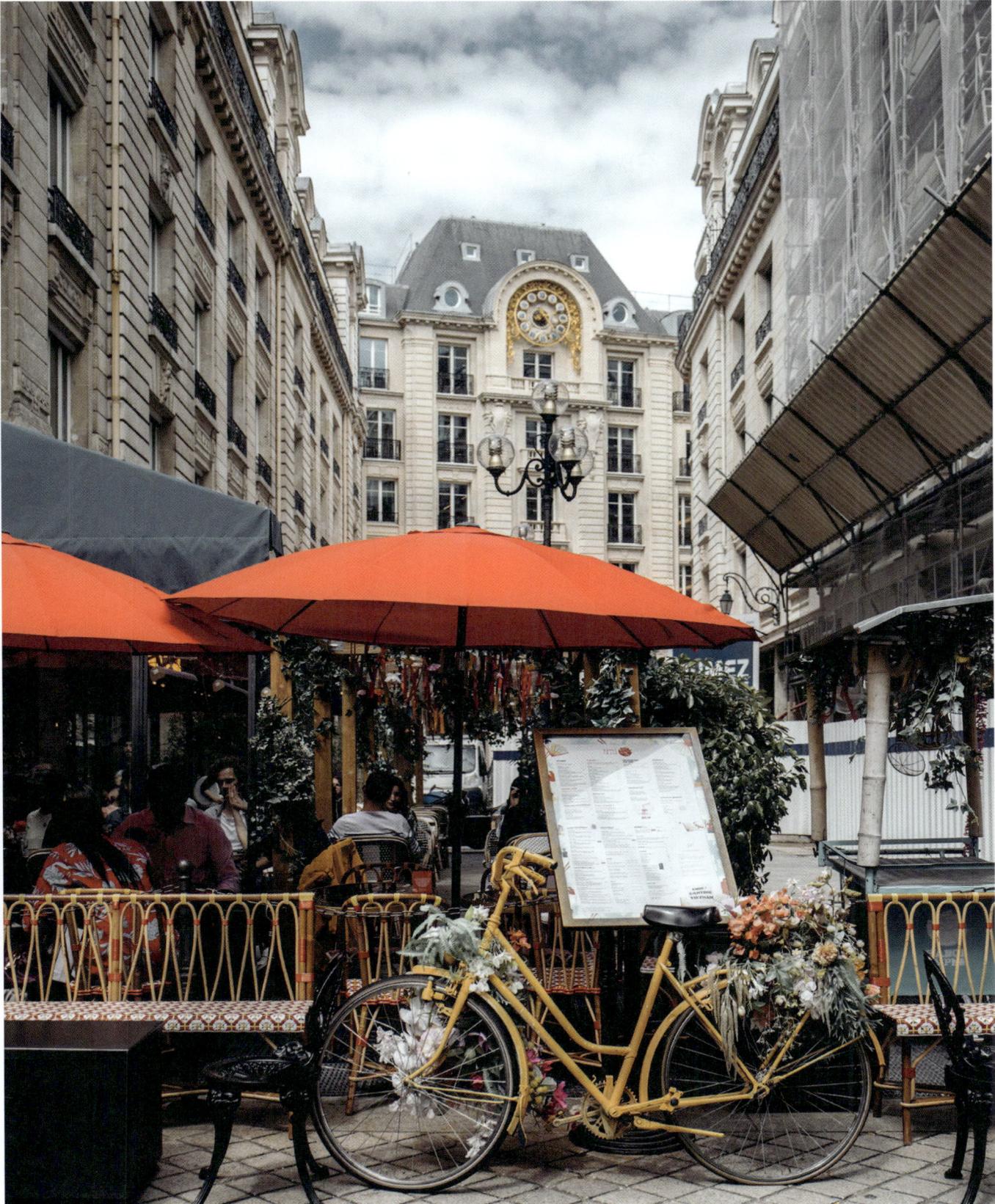

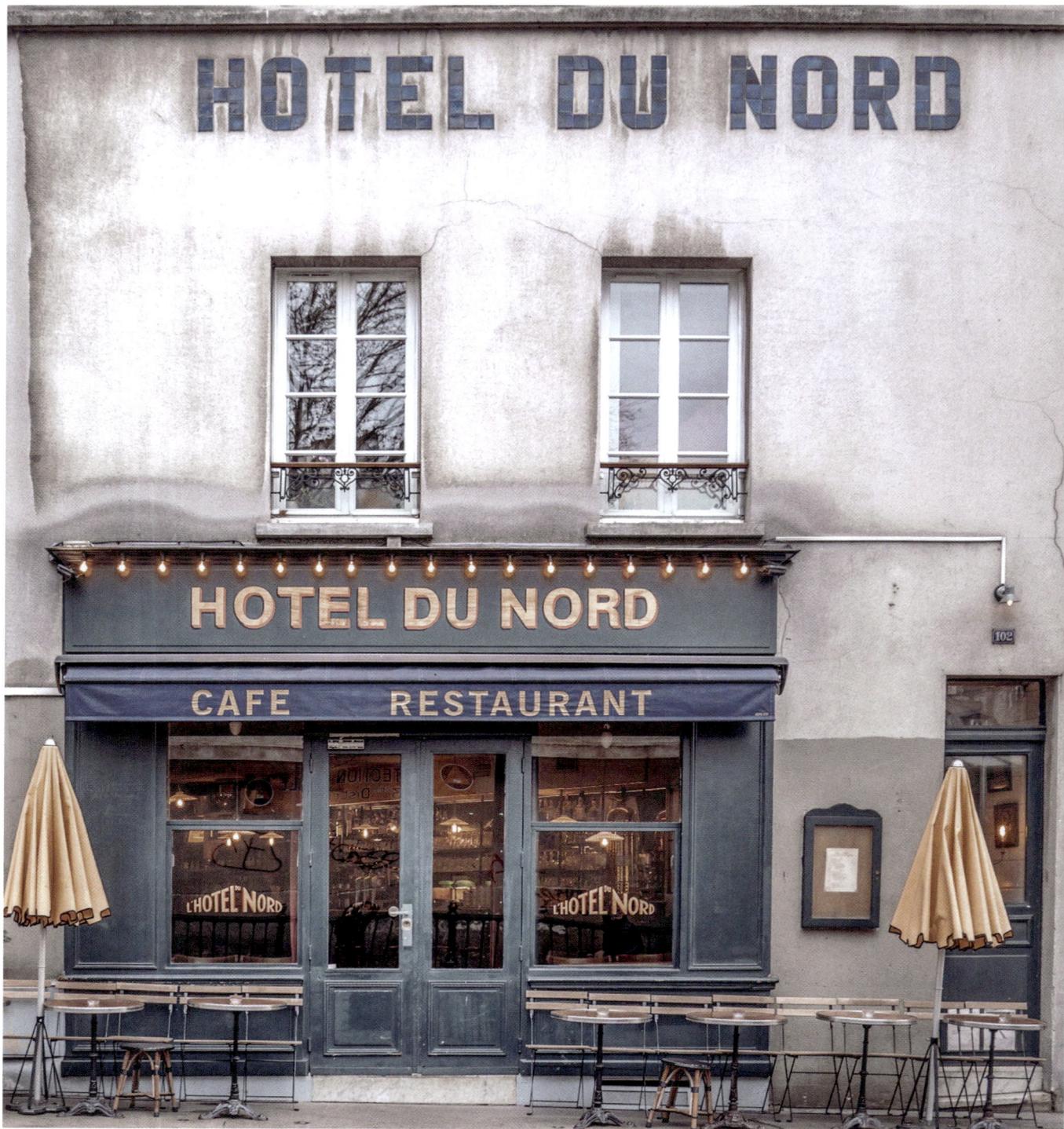

Above:
The Hotel du Nord once served as the backdrop for the classic film noir of the same name. Today, the brasserie preserves the atmosphere of the 1940s, saved by devoted film buffs who preserved this historical landmark.

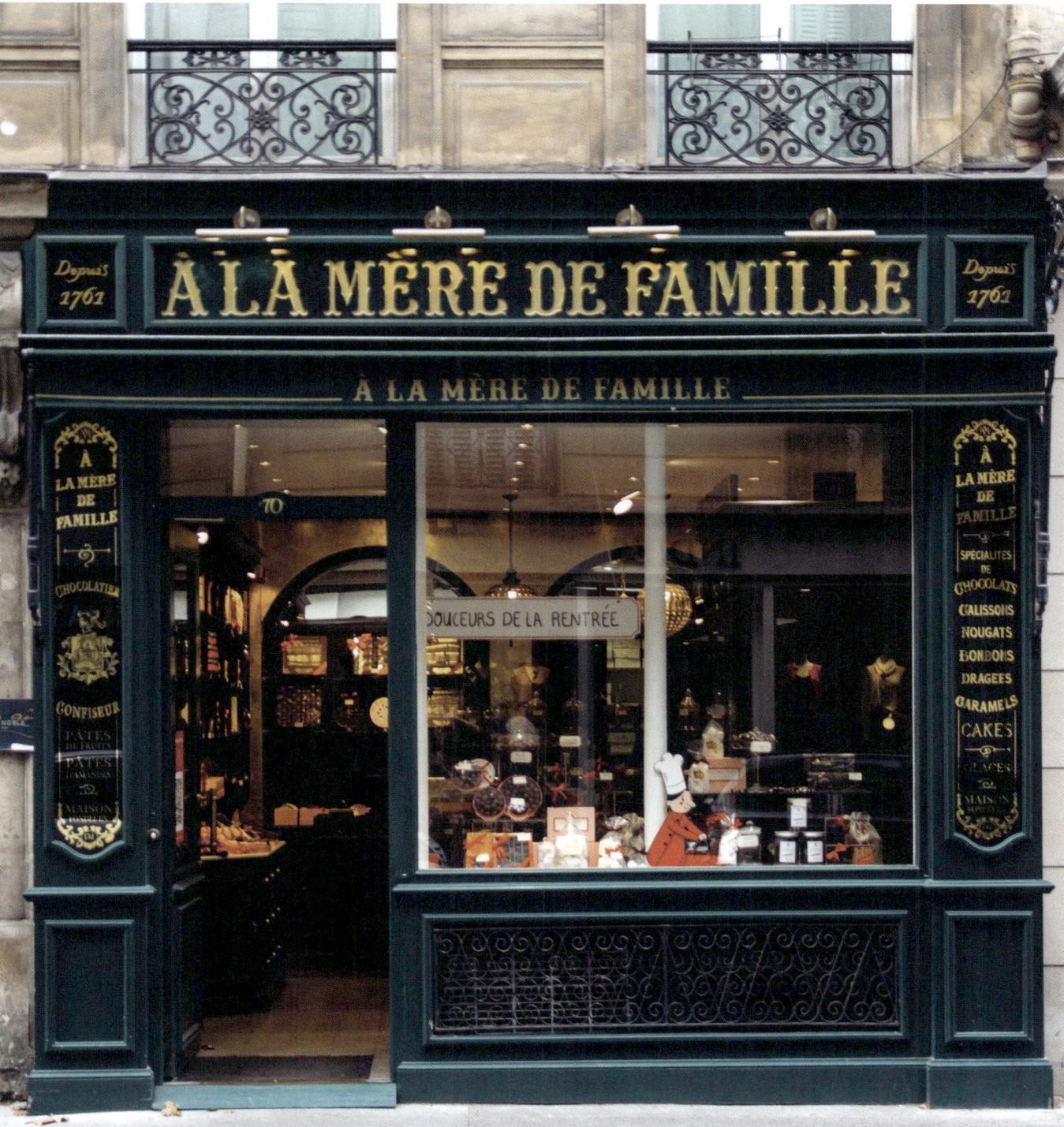

Above:
À la Mère de Famille is believed to be the oldest chocolaterie in Paris. Their display is as enchanting as a scene from Chocolat.

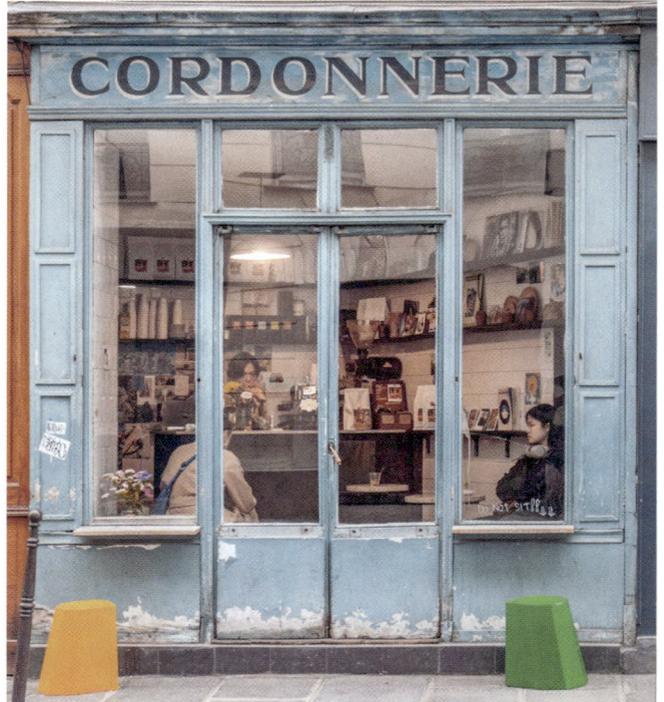

Above and at right:
Wander past nostalgic shopfronts, and suddenly—just as on Cour Damoye—you find yourself drawn into winding, time-worn Parisian alleys, where cobbled streets, cast-iron lanterns and wisteria-draped façades await.

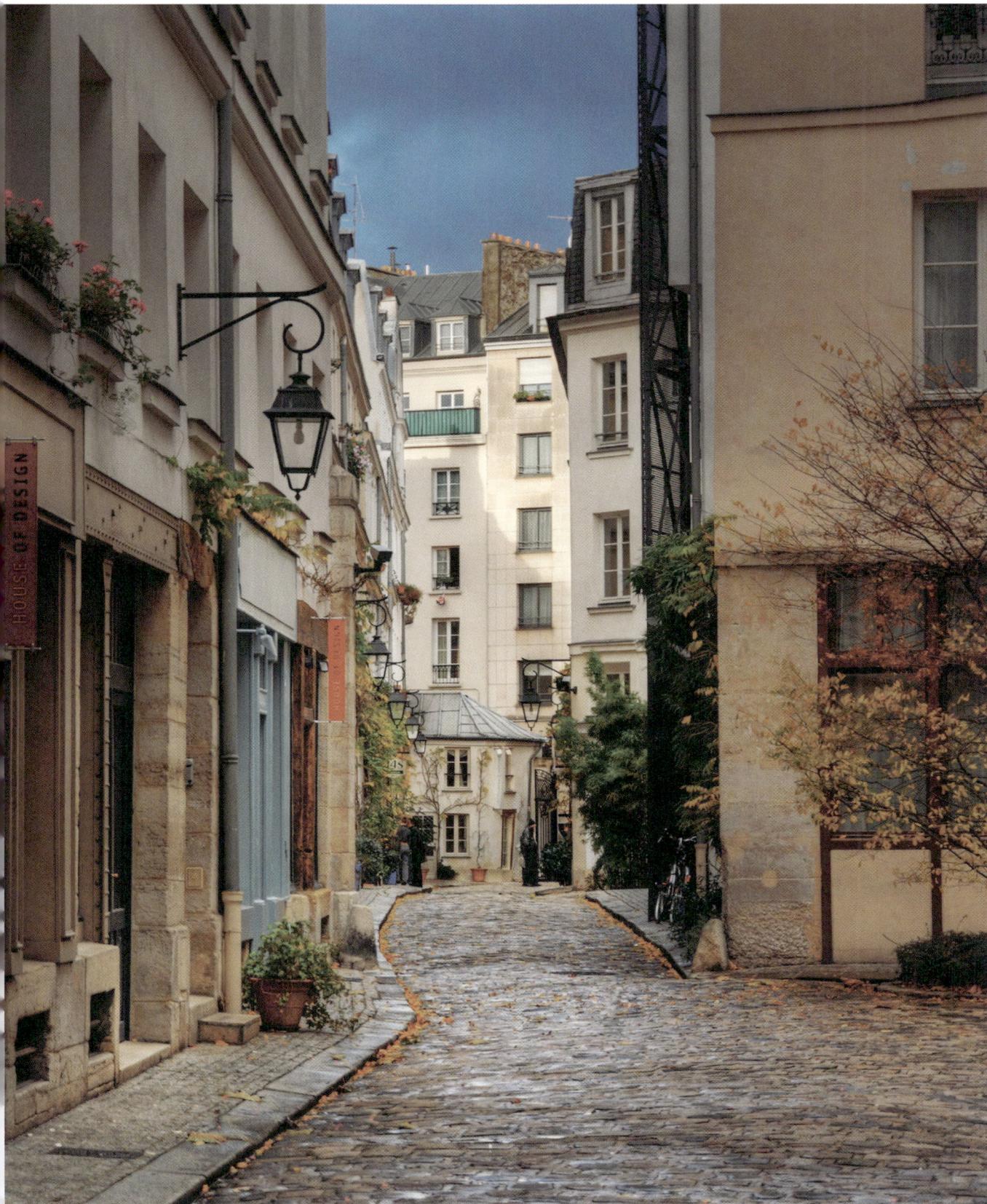

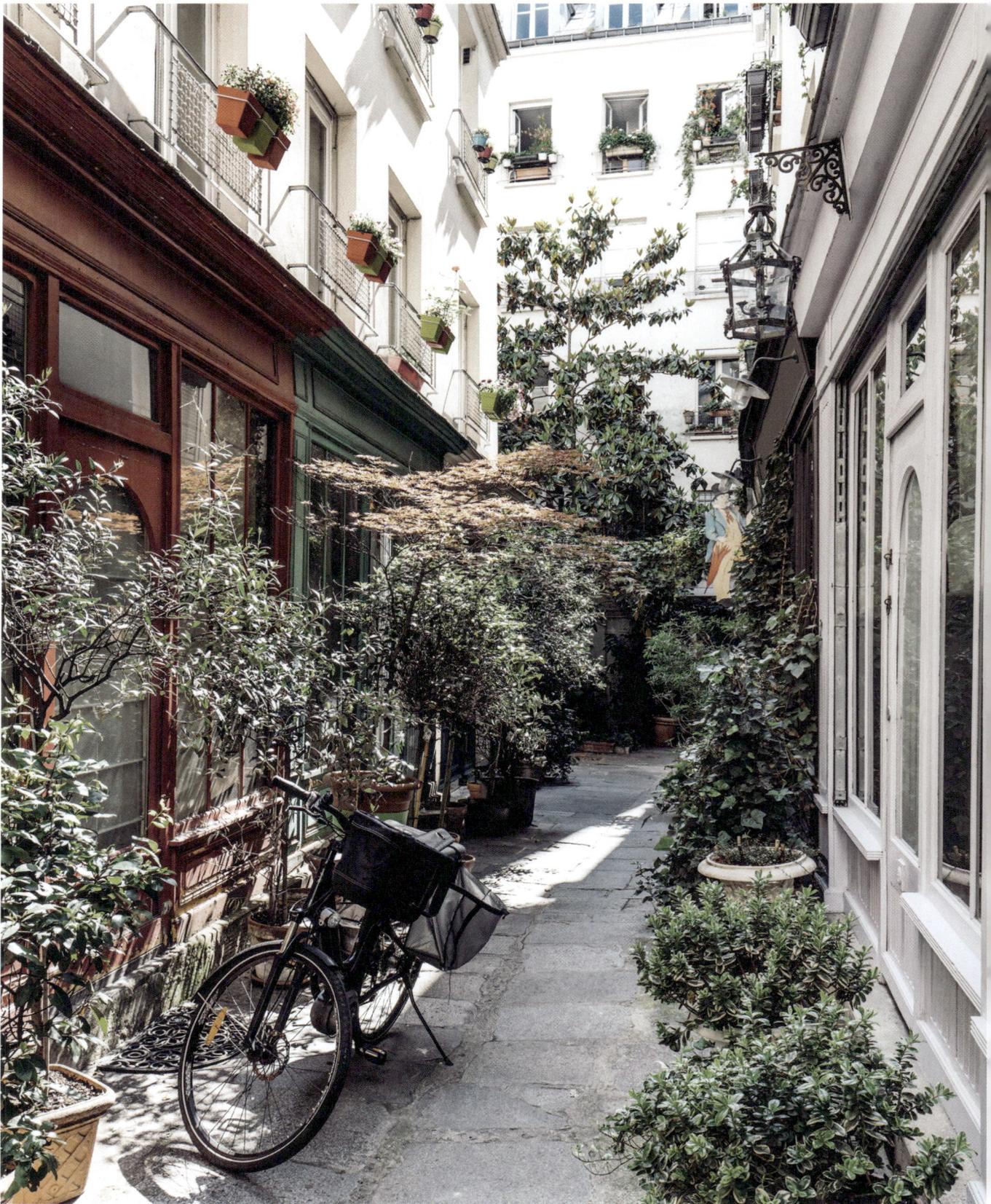

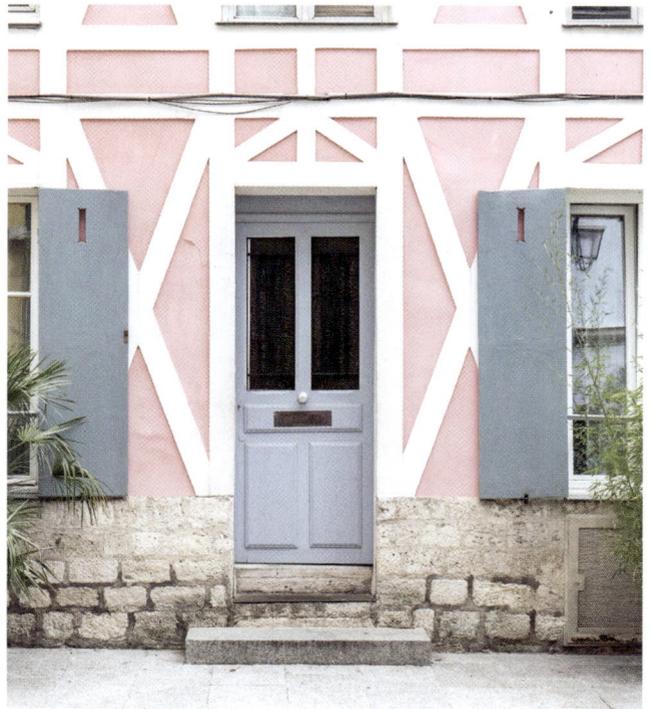

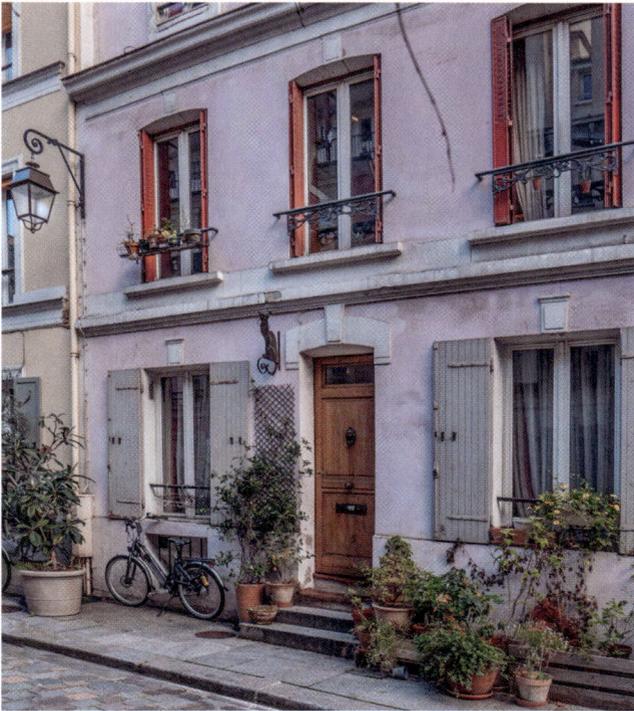

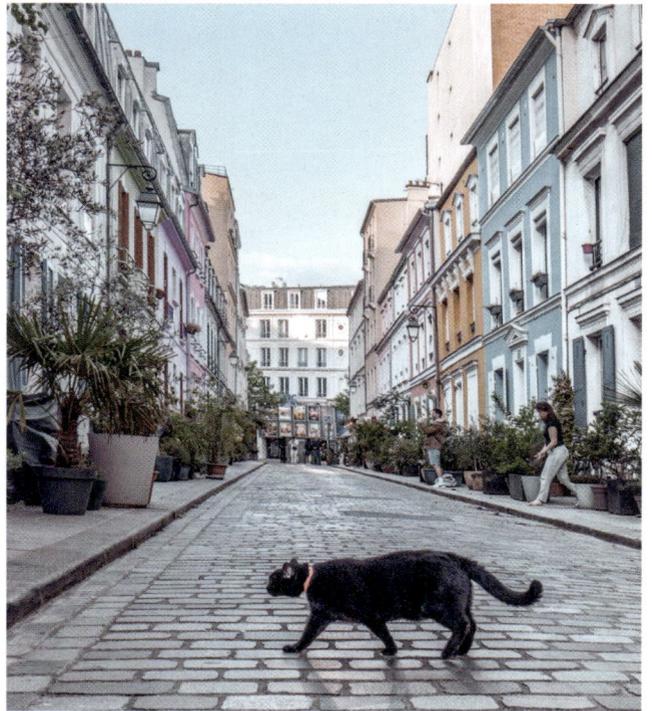

Above and at left:
Perhaps the most colorful street in Paris—and one of its most photogenic—is Rue Crémieux in the 12th arrondissement—which is usually a lot busier than this.

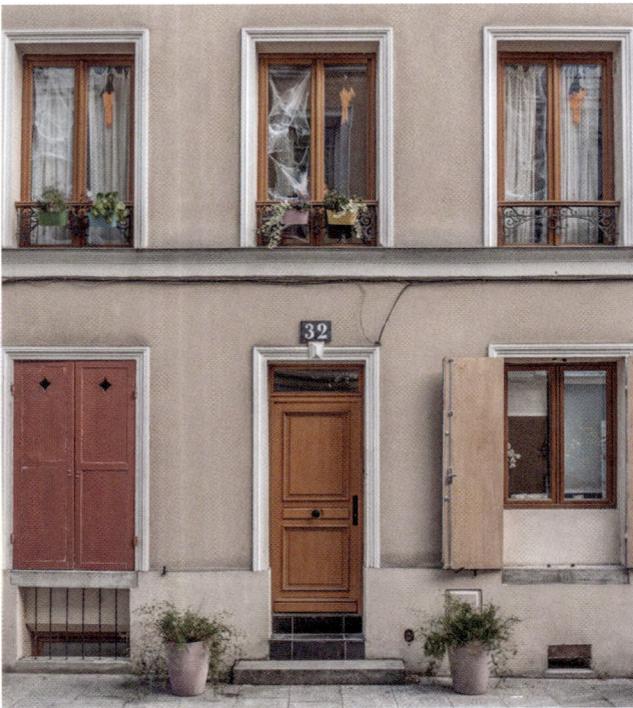

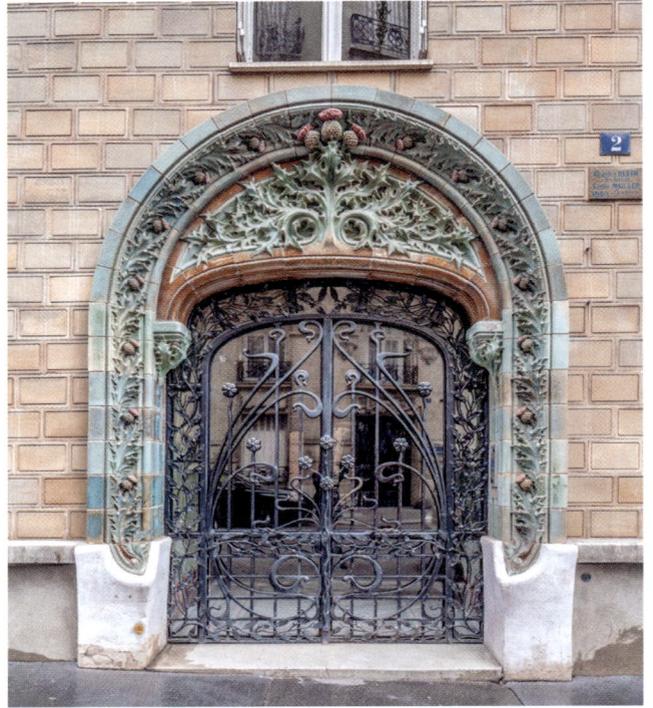

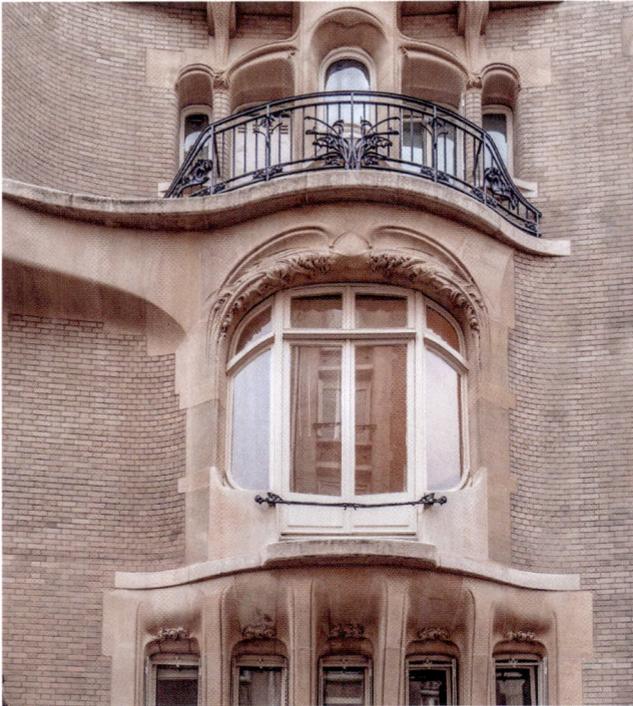

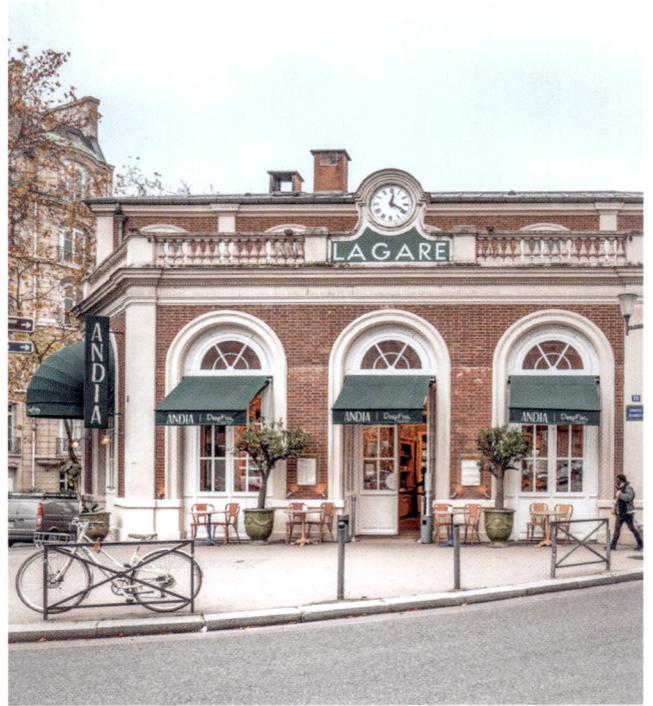

Above:

Playful and a little mysterious, the 16th arrondissement is also home to many a picturesque courtyard gate. The former Passy train station (bottom right) now houses a small but exquisite restaurant.

Right:

The charm of days gone by is palpable at first glance of this old photography shop on Rue des Batignolles.

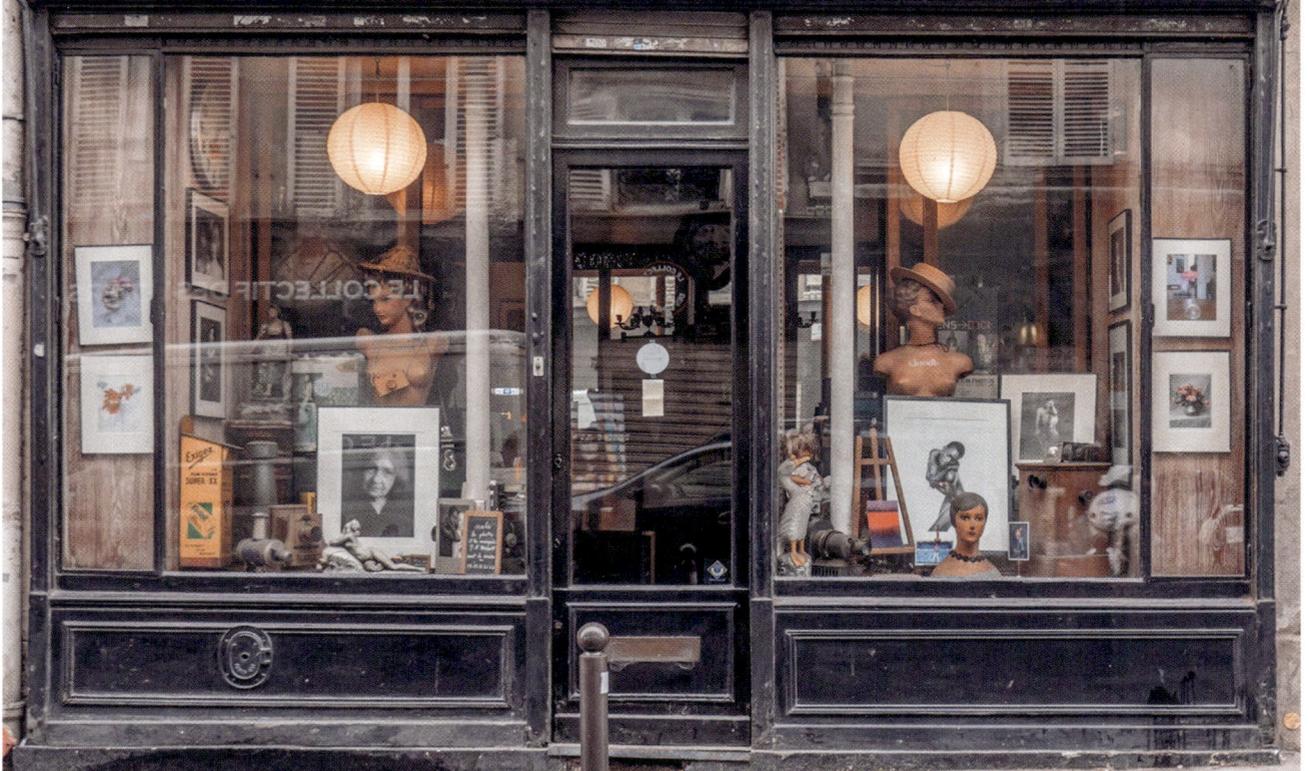

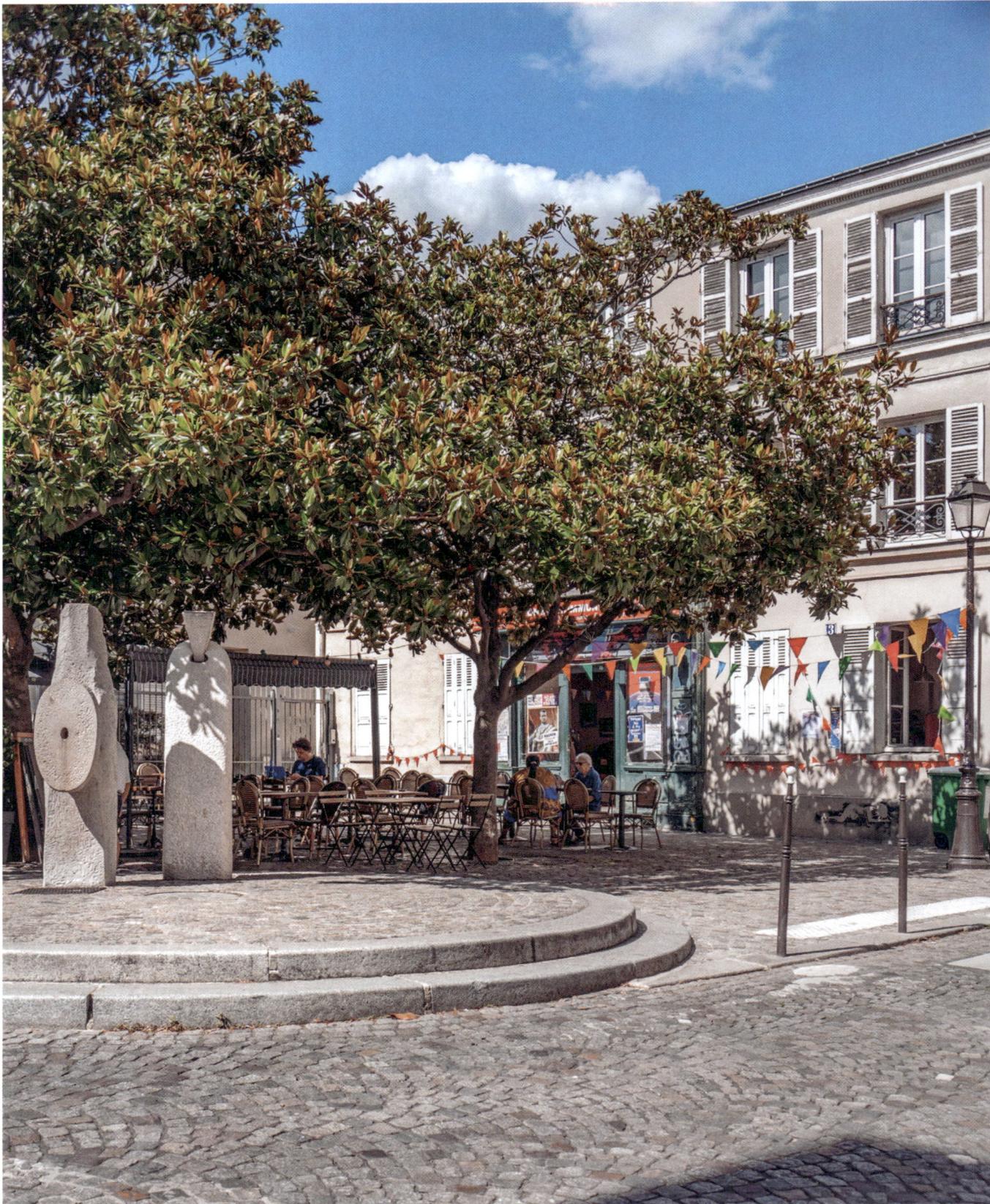

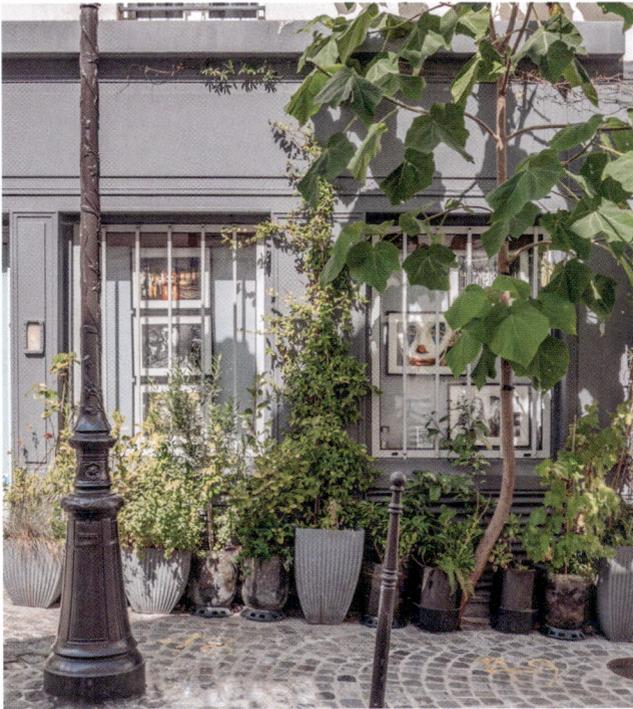
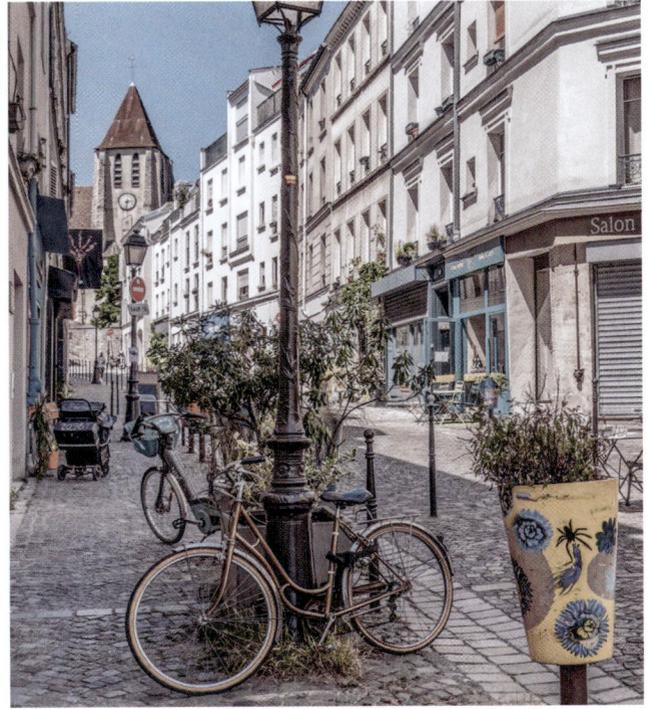
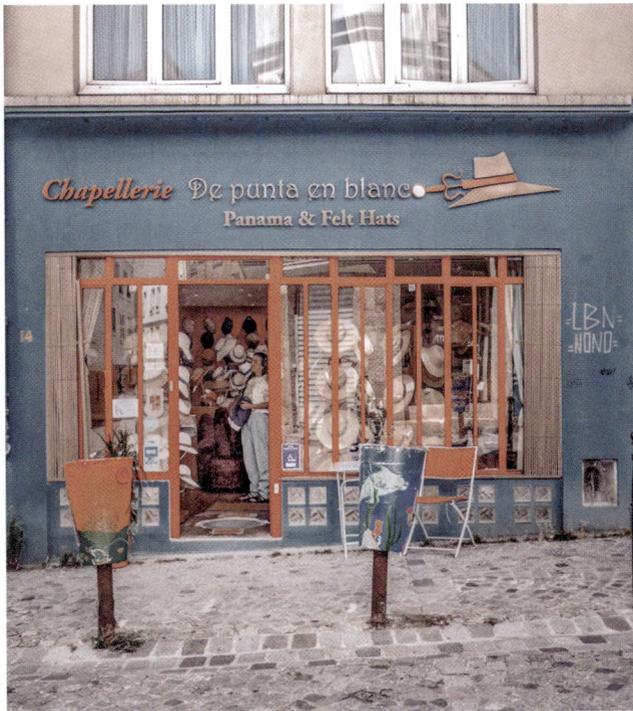
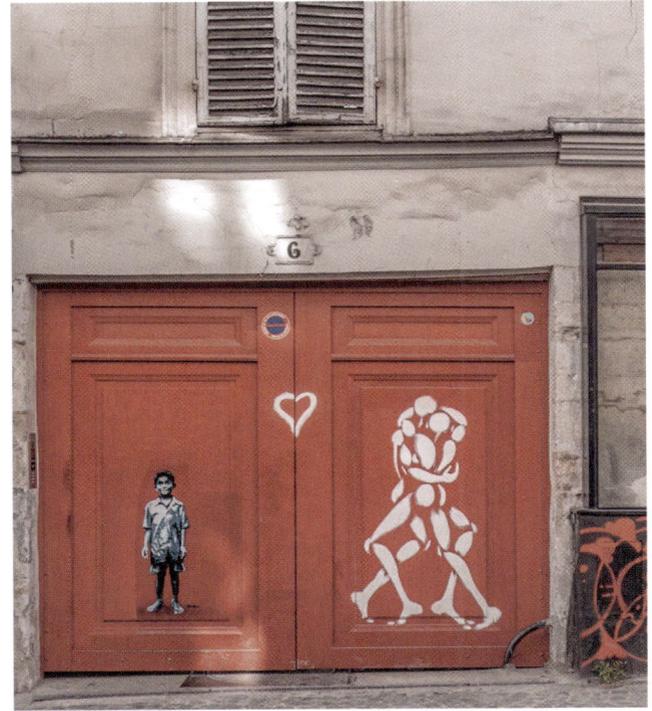

Above and at left:
With its quiet squares and cobblestone streets, parts of the 20th arrondissement maintain an almost village-like charm. Yet today, most visitors are drawn to the Cimetière du Père-Lachaise—which is better known for the artists resting there.

PARIS –
LA RIVE GAUCHE

LIBERTÉ, ÉGALITÉ AND A BOL DE CAFÉ

Sometimes, in one of the neighborhoods on the Left Bank, it feels like you could catch a trace of the old intellectual Paris, of Jean-Paul Sartre and Simone de Beauvoir. In reality, it's worlds colliding, with artists and students scooching over for bougie conservatives. The Rive Gauche is an enticing place for a lively stroll: in the 5th arrondissement, the Quartier Latin, centered around the Sorbonne; in the 6th, the artist's quarter of Saint-Germain-des-Prés, where old bookstores and cafés line the winding alleys. Their colorful façades bear the patina of time with wistful elegance: rattan bistro chairs, a *bol de café au lait* on a small table, and the unhurried pleasure of simply watching passersby. Baron Haussmann's grand boulevards, cut through Paris in the nineteenth century, play a lesser role on the Left Bank. The Latin Quarter's medieval streets have preserved their picturesque charm. Rue Mouffetard, a tight squeeze paved with cobblestones, inspired writers from Victor Hugo to Hemingway, and even today, Parisian students gather in its countless little bookstores, cafés, and bars. The neighborhood was seemingly designed for *Emily in Paris*, scenes from which were filmed just around the corner at Place de l'Estrapade. Synonymous as the Left Bank may have been with free-spirited, unconventional, and bohemian Paris up until the 1970s, it has also seen its share of gentrification. Still, there is plenty for architecture enthusiasts in the elegant 7th arrondissement. The magnificent Art Nouveau façades alone are worth the visit. Each stroll past the Lavirotte building on Avenue Rapp reveals further details among its lavish ornamentation.

Right:
*Behind this striking façade and mosaic lies a charming brasserie with a slightly risqué past;
it was once home to a well-known bordello.*

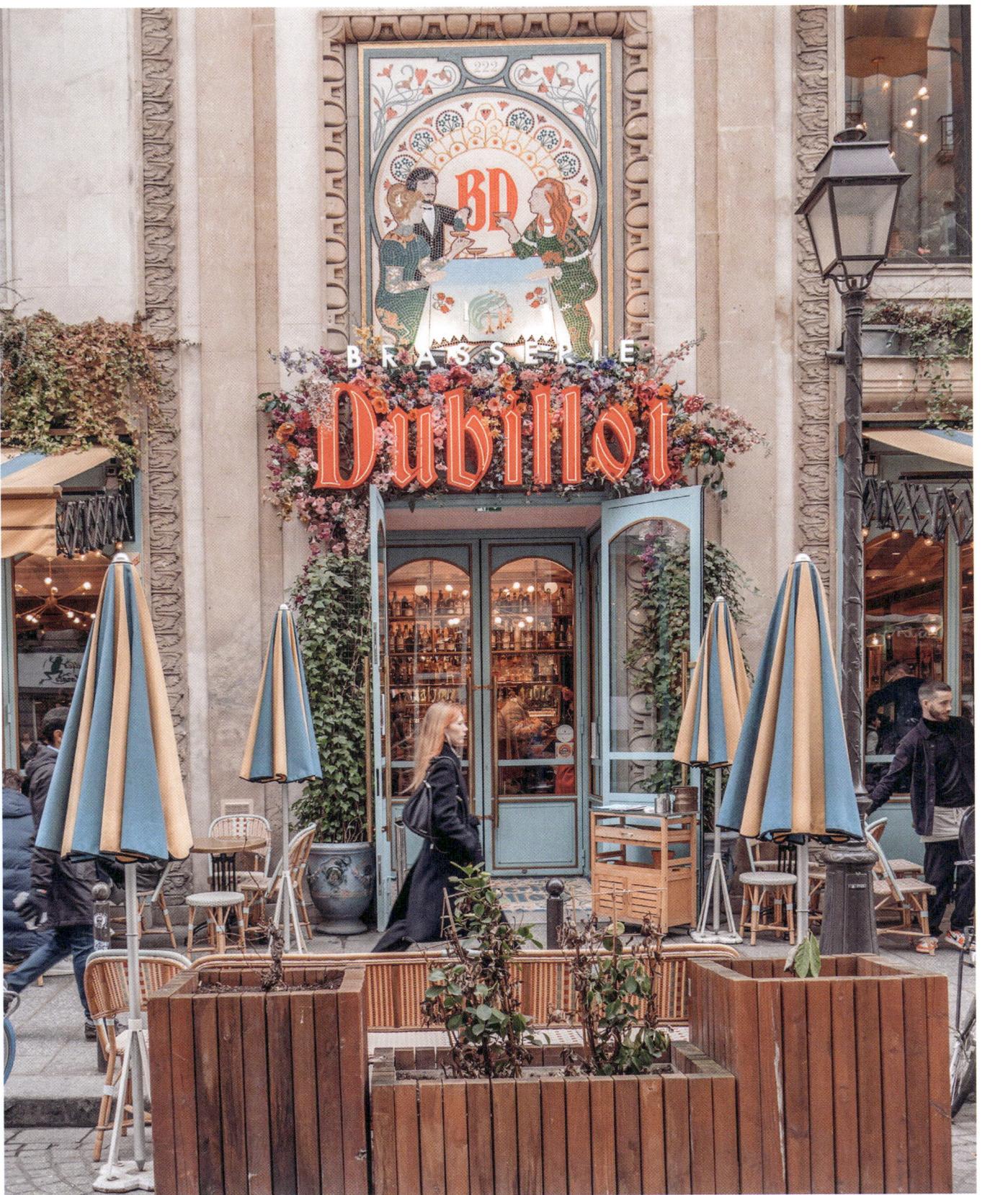

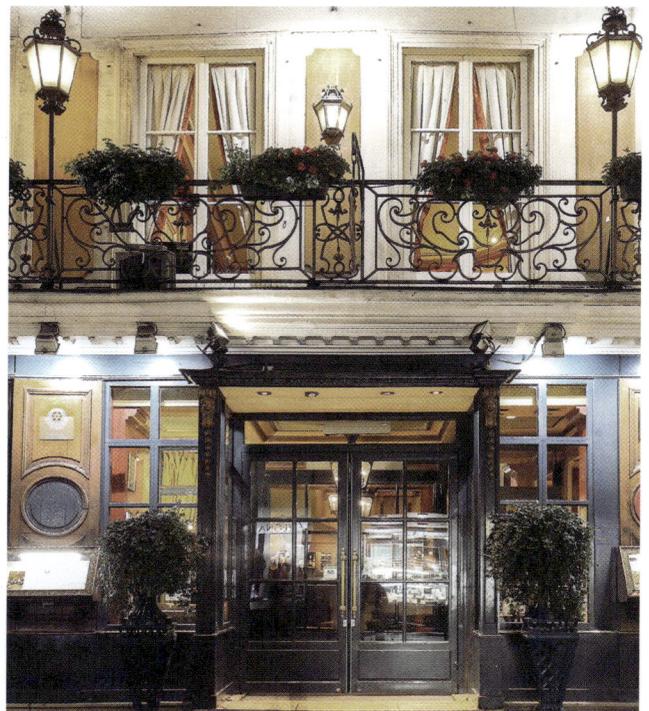

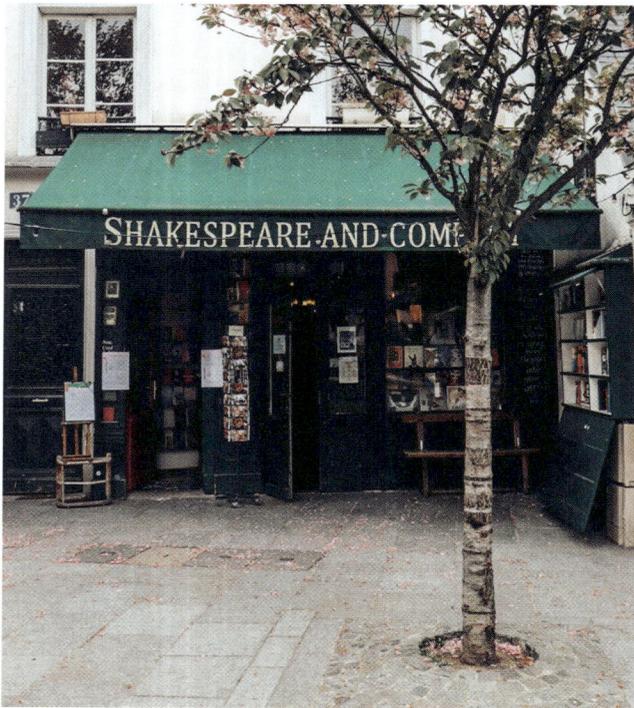

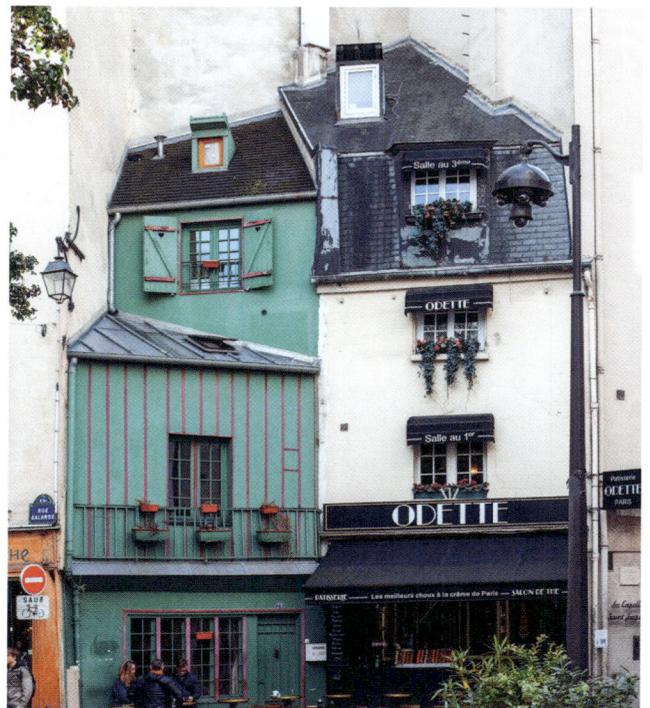

Above and at right:
With enchanting cafés, charming vintage bookstores, and buildings turned whimsically at odd angles,
the Latin Quarter checks all the boxes for a bohemian neighborhood.

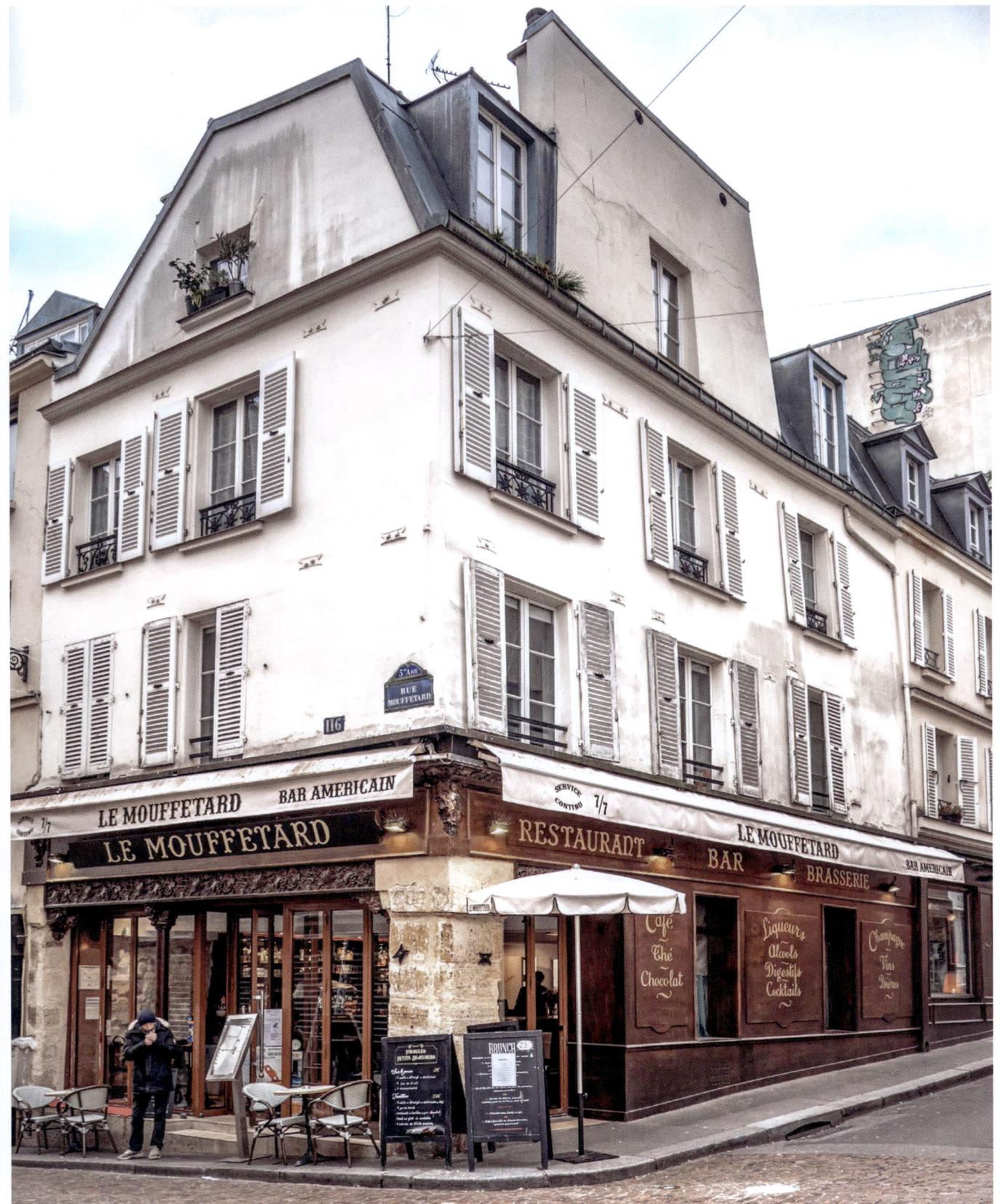

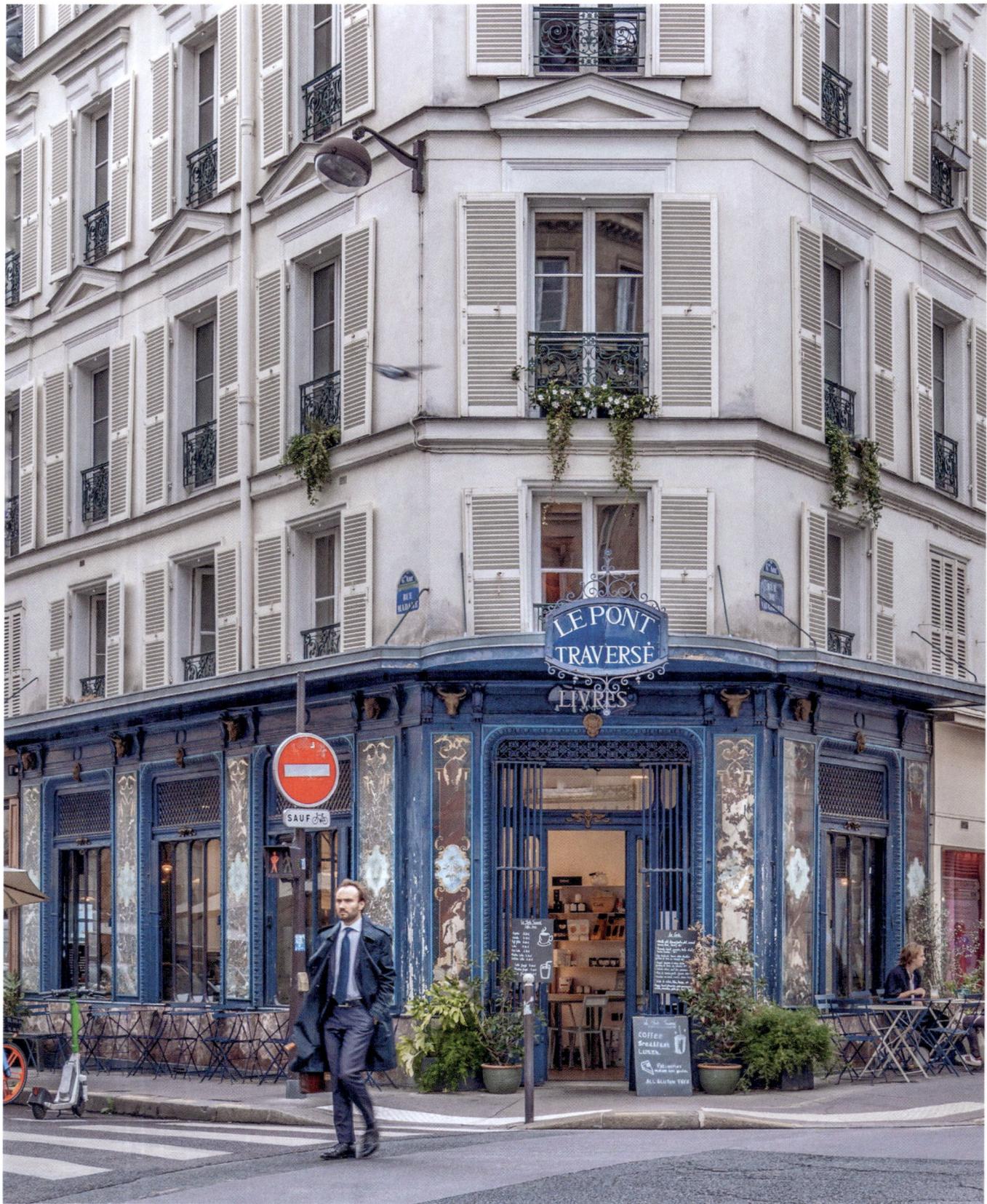

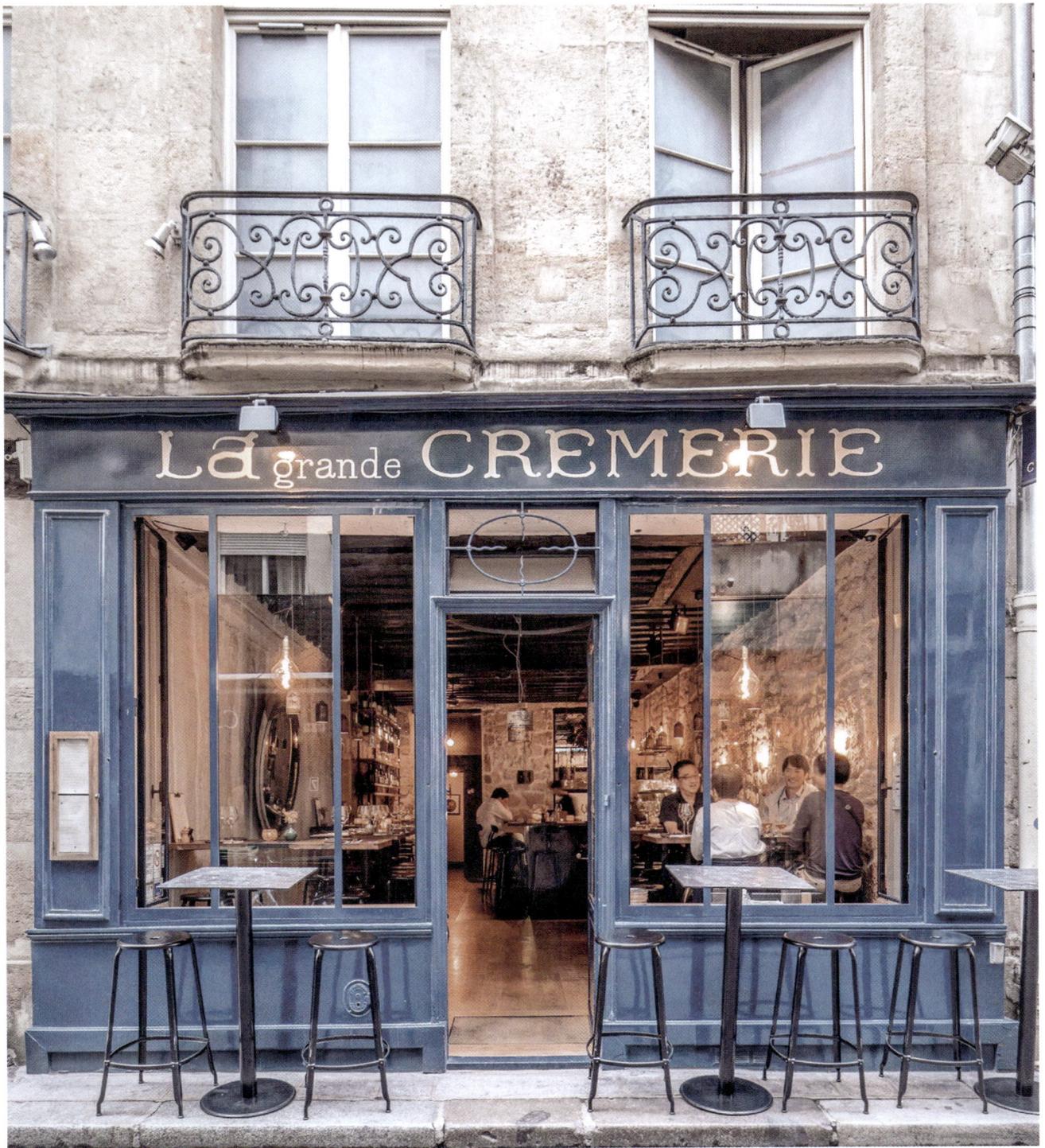

Above:
The nostalgic shopfront makes this old wine bar in the 6th arrondissement a wonderful reminiscence of bygone days.

Left:
The old bookstore Le Pont Traversé in the artist's quarter of Saint-Germain-des-Prés has since been transformed into a café.
Its distinctive façade details—the tiles and the wooden bucrania—are reminders of the butcher's shop that once stood here.

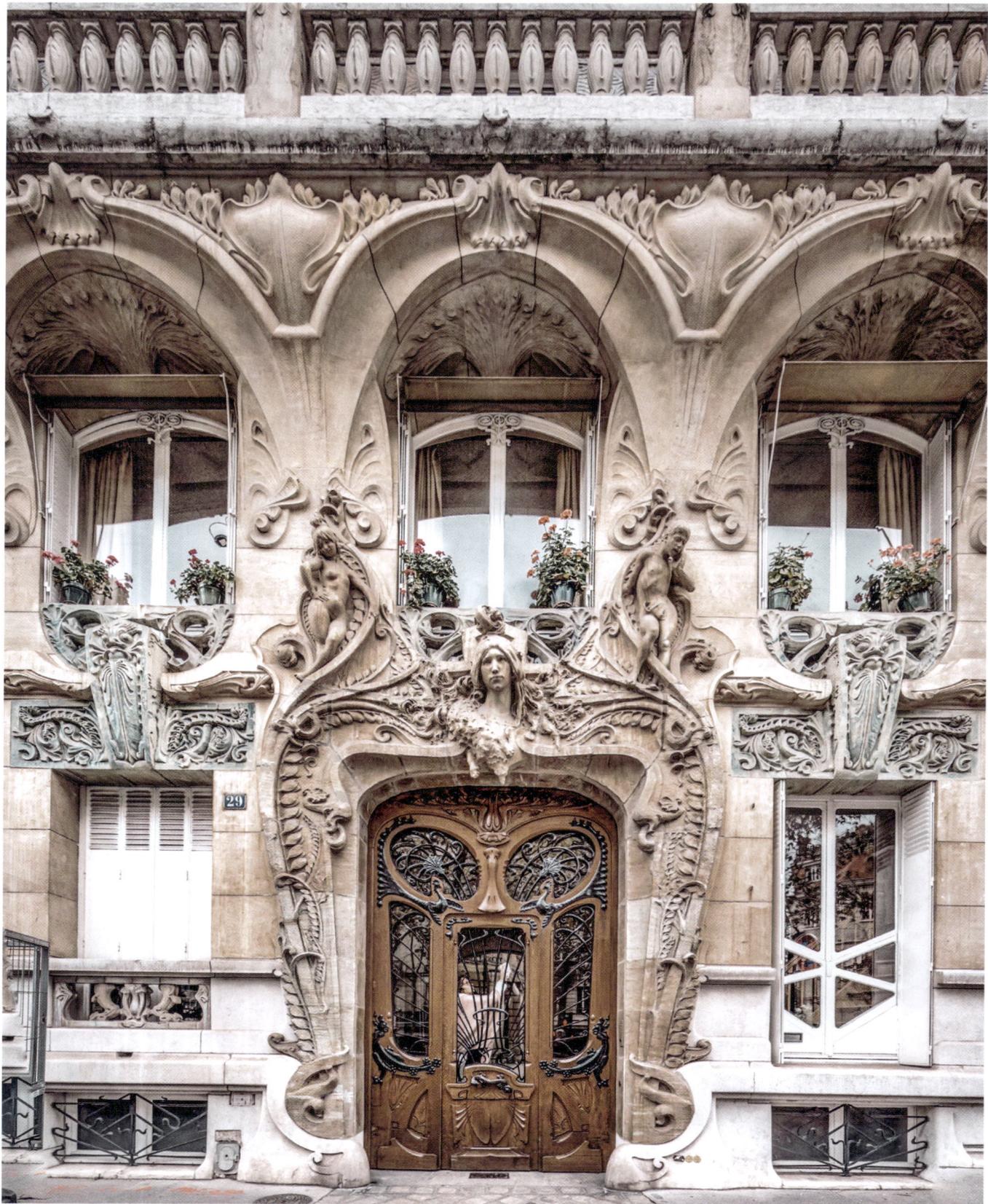

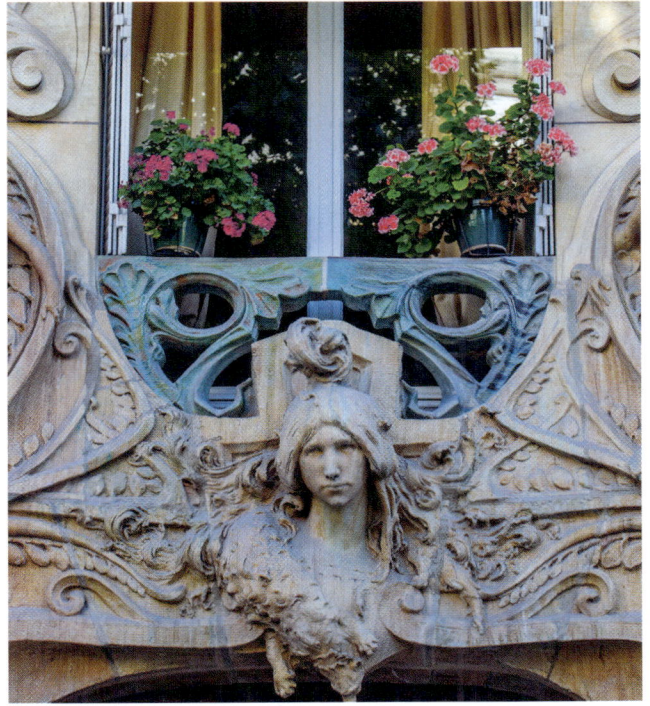
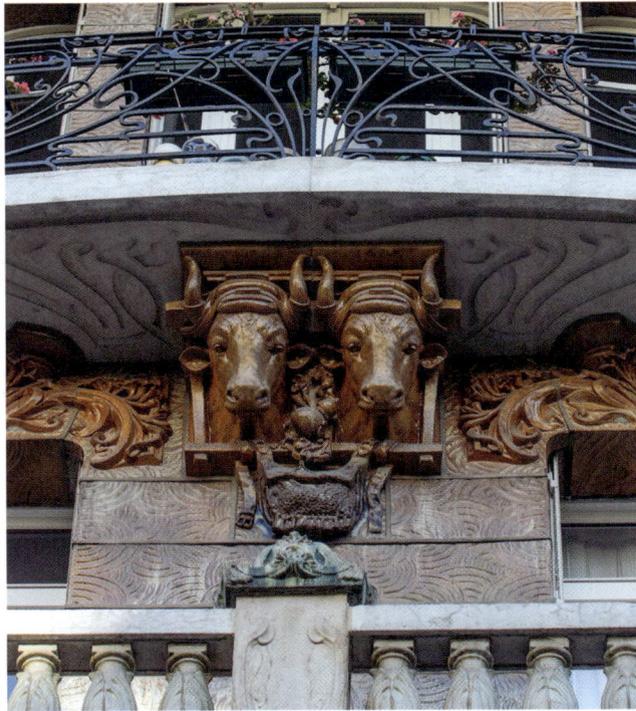
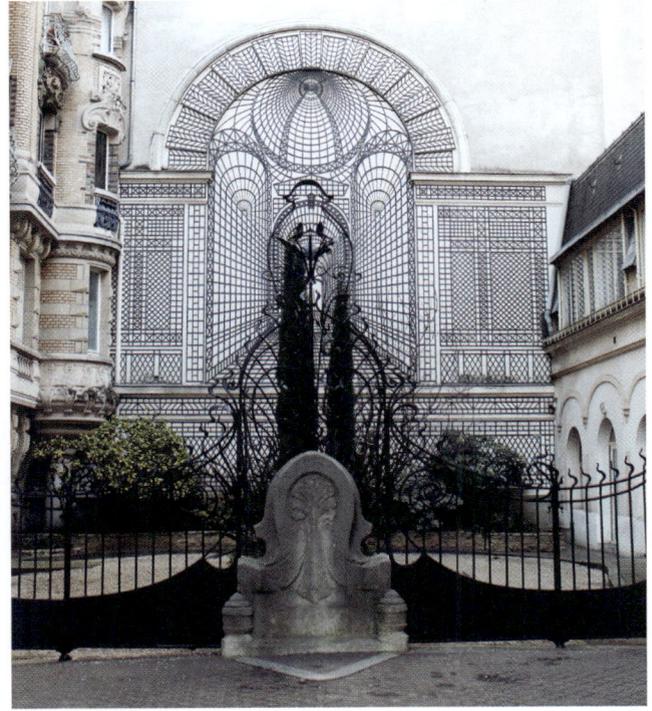

Above and at left:

Extravagant and undeniably provocative: The phallic symbolism on the entrance to the Lavirotte Building sparked a minor scandal upon its completion in 1901. Café de Flore (above, top left) was a favorite haunt of Parisian icons like Jean-Paul Sartre and Simone de Beauvoir. And, of course, a romantic encounter from Emily in Paris is set there.

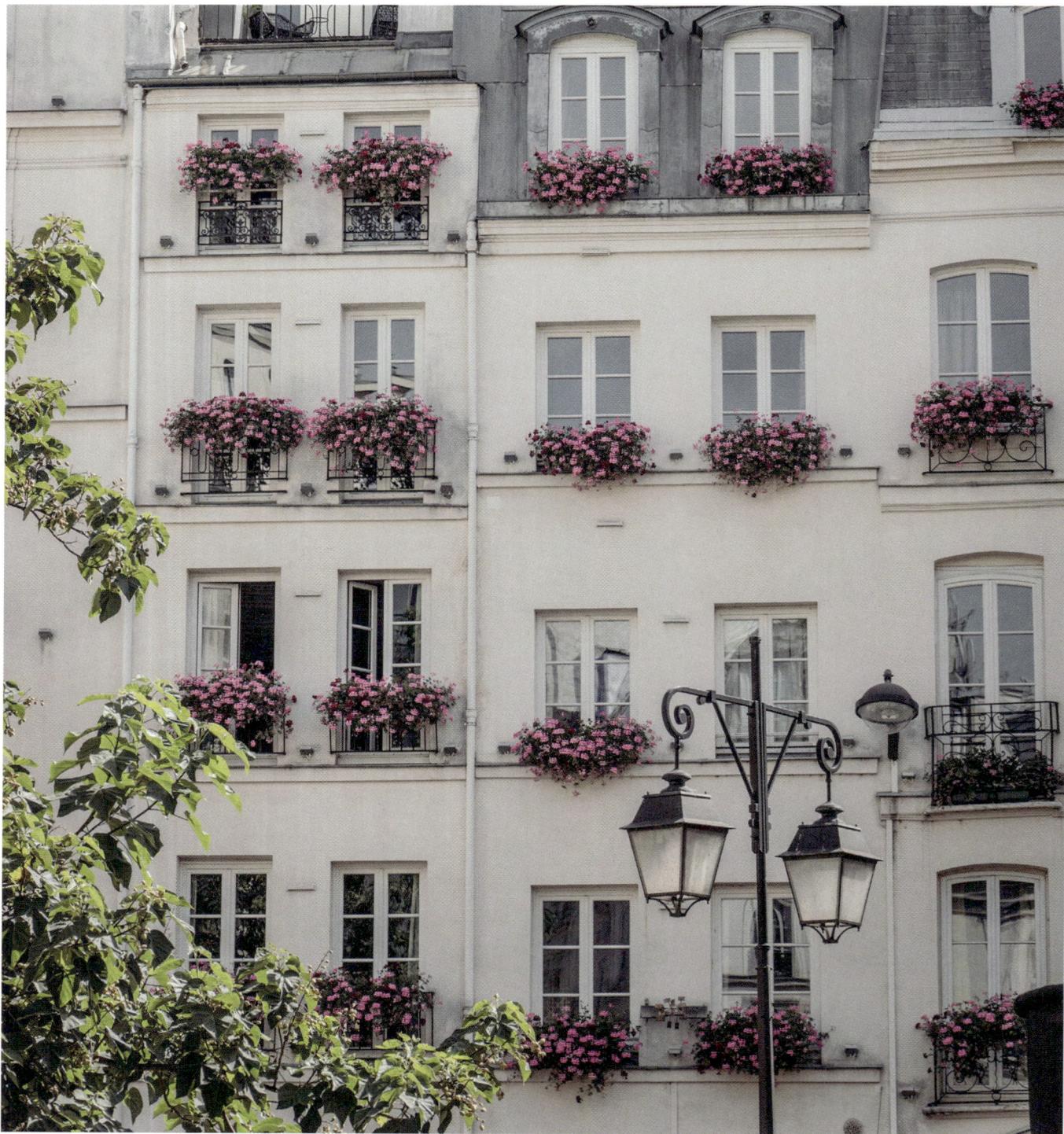

Above:
Even the simplest façade becomes an eye-catcher with floral decorations.
Right:
One of the most beautiful cheese shops in Paris is on Rue de Grenelle. Enter at your own risk:
Few leave with only the modest trifle they first intended.

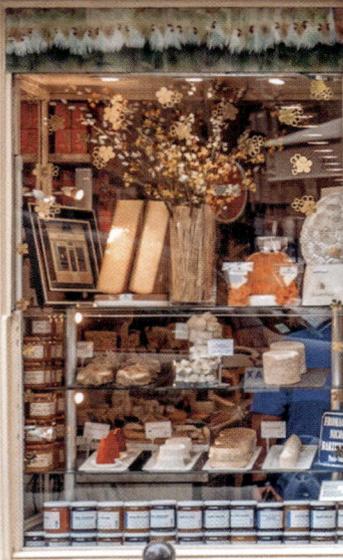

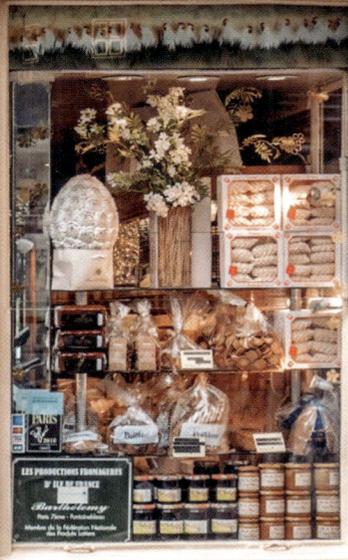

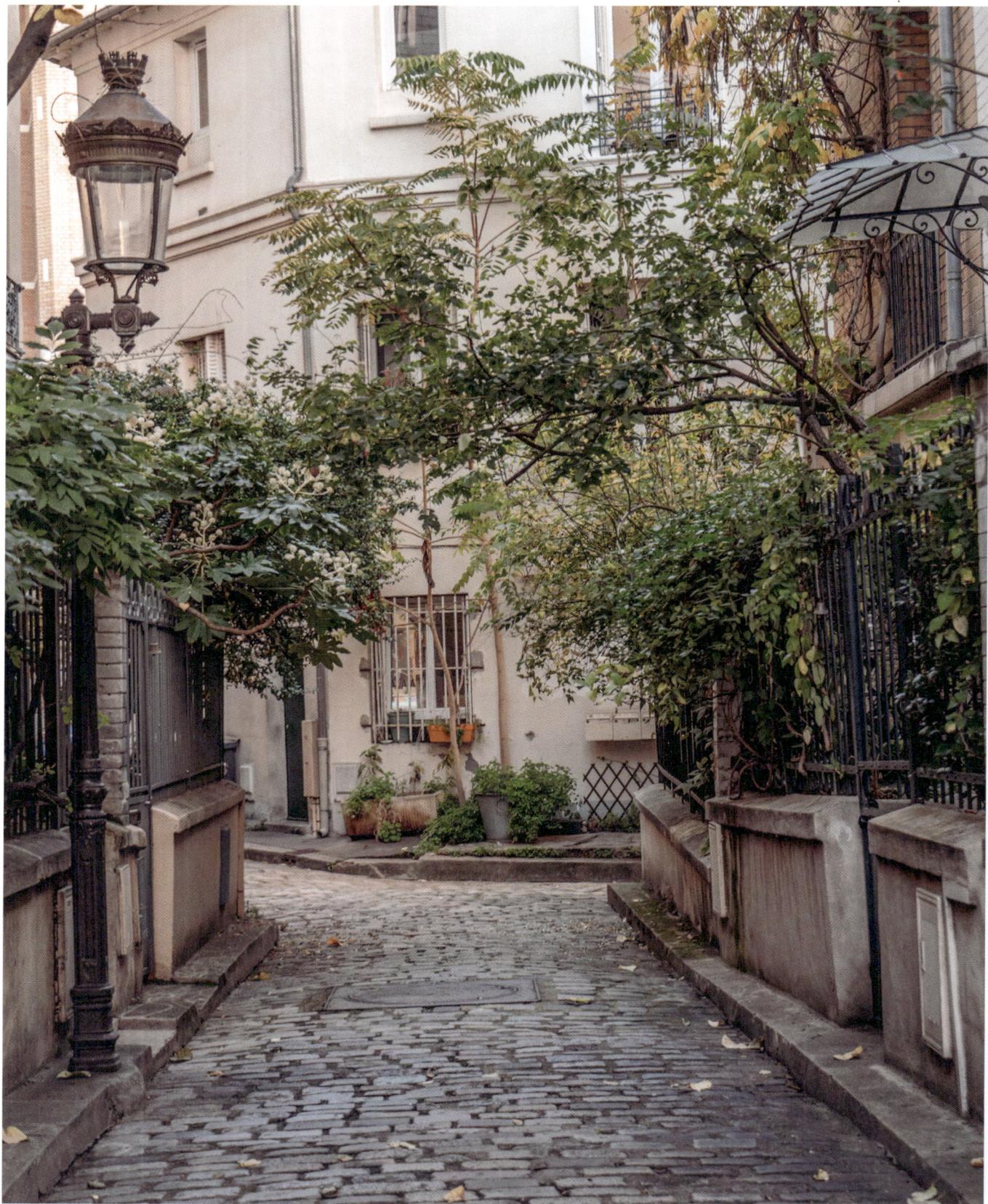

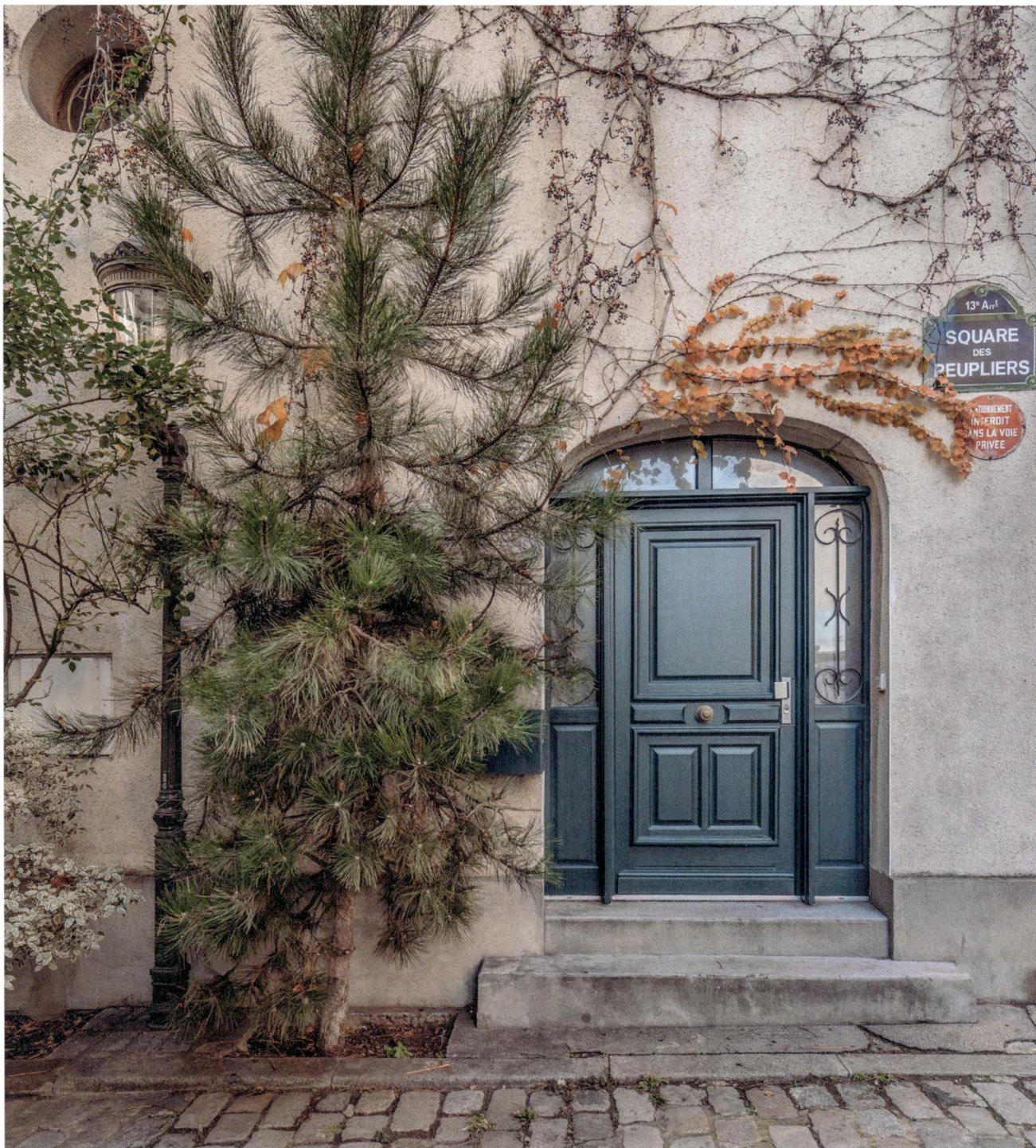

Above and at left:
Square des Peupliers—a hidden pocket of village charm in the heart of the 13th arrondissement. Once constrained in its growth by a former branch of the Seine, the area's low-set houses define its unique character. In summer, climbing vines drape the façades, and a spectacular show of wisteria bursts into bloom behind the wrought-iron fences. It's stunning.

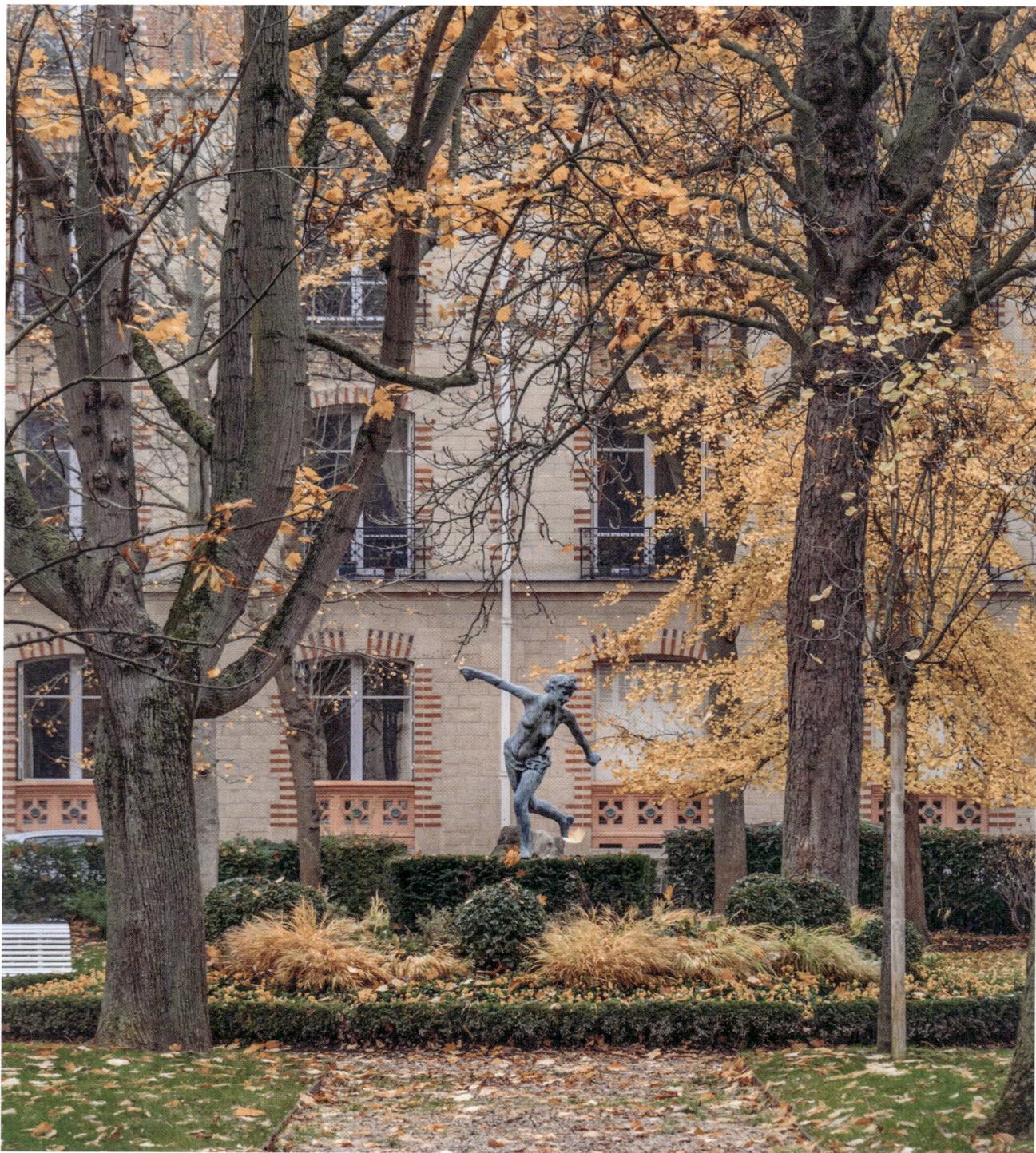

Above and at right:
In the 14th arrondissement, just south of Montparnasse Cemetery, Villa Adrienne is an unexpected oasis of greenery and calm. Here house numbers give way to names of renowned scientists, artists, and writers—Molière, Racine, and more.

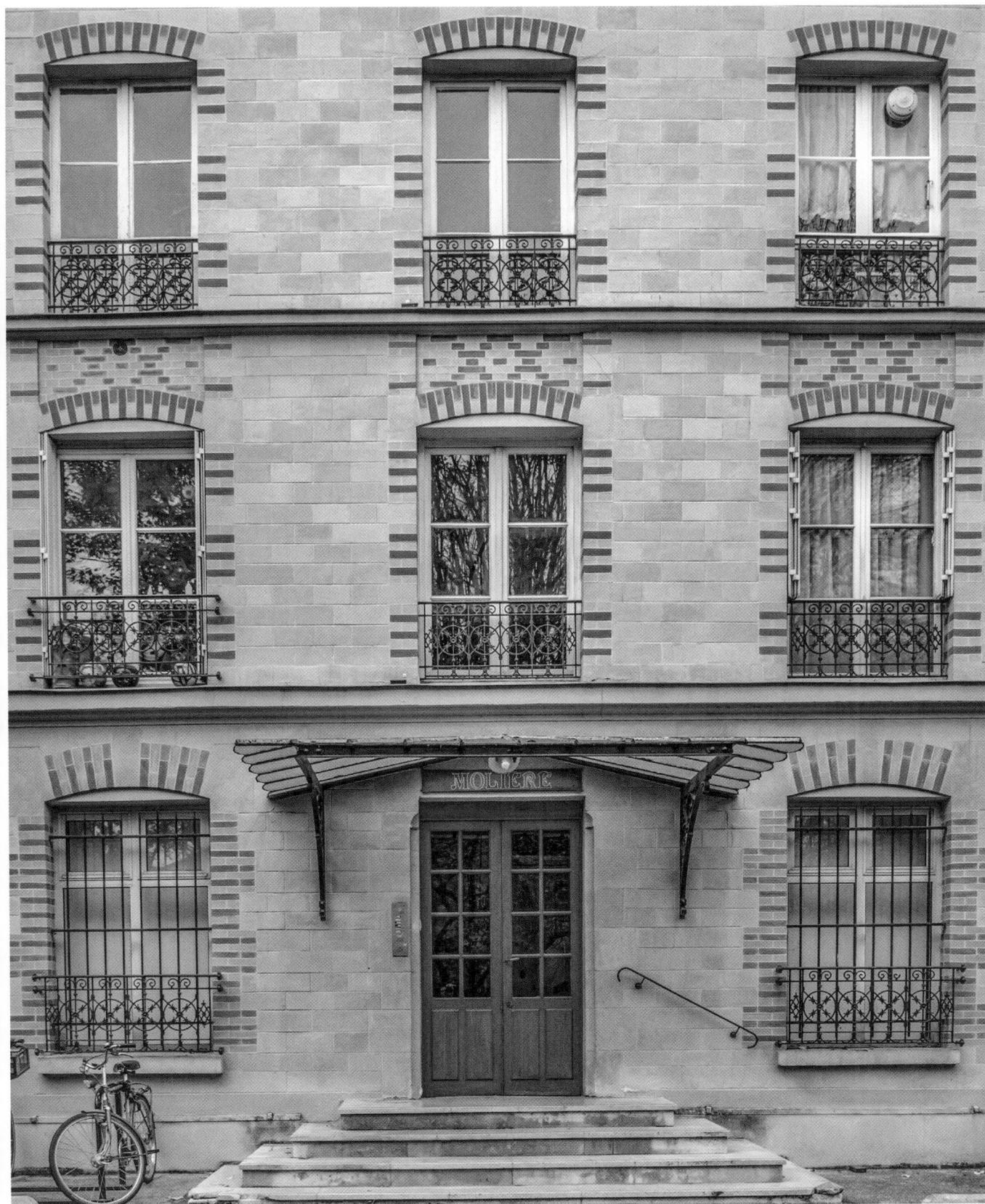

MOLIERE

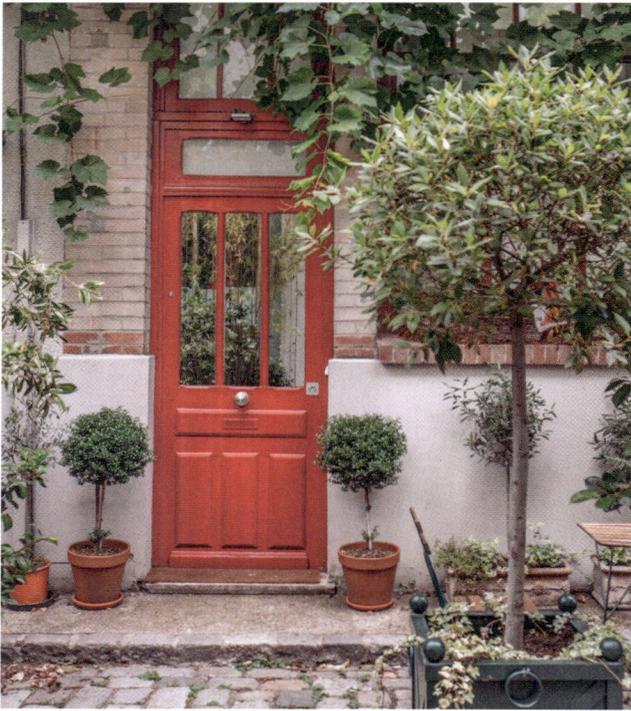

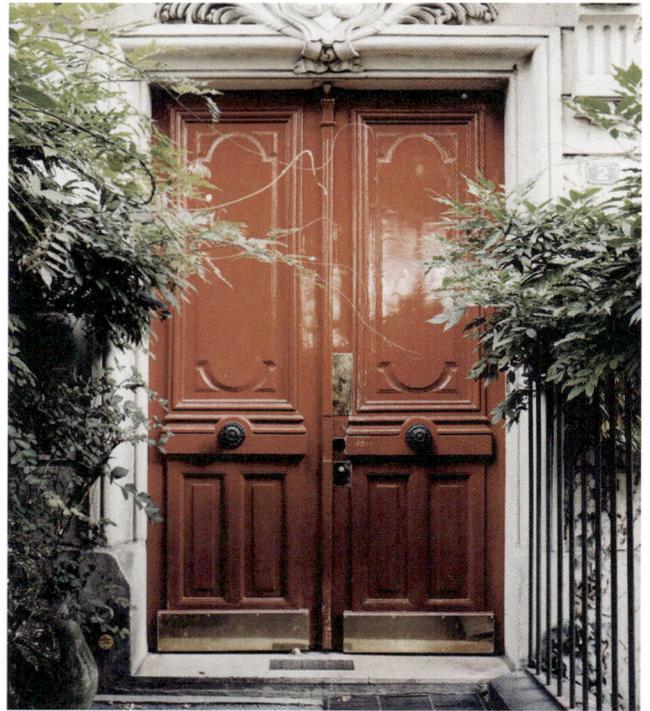

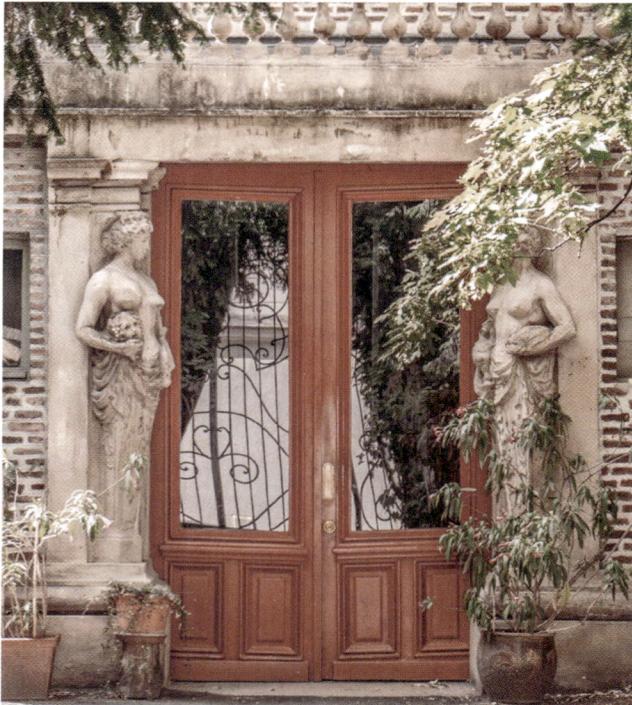

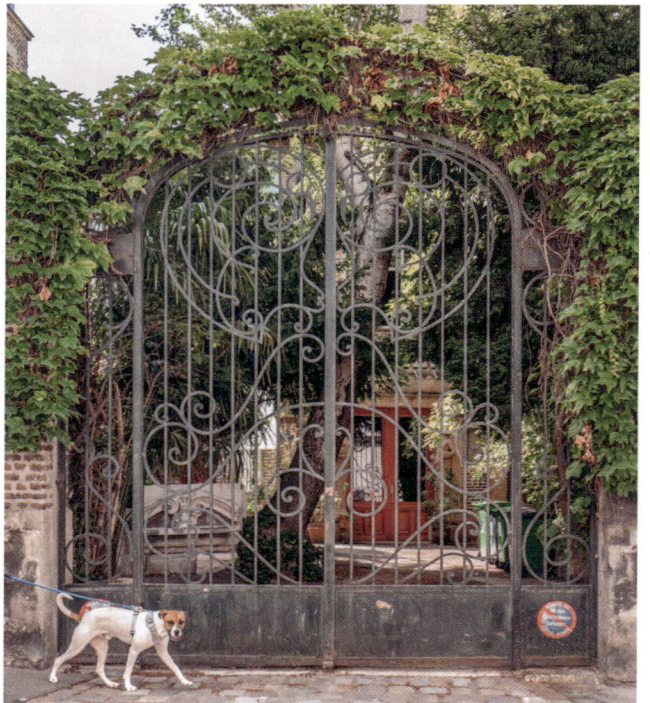

Above:
Does every gate conceal a secret? Elegant statues stand guard at the entrance to the La Ruche artists' colony.

Facing page and following page:
Nature carved in stone—stylized sunflowers, irises and curling lily roots turn the Art Nouveau building on Place Étienne-Pernet into a masterpiece of sculpted nature.

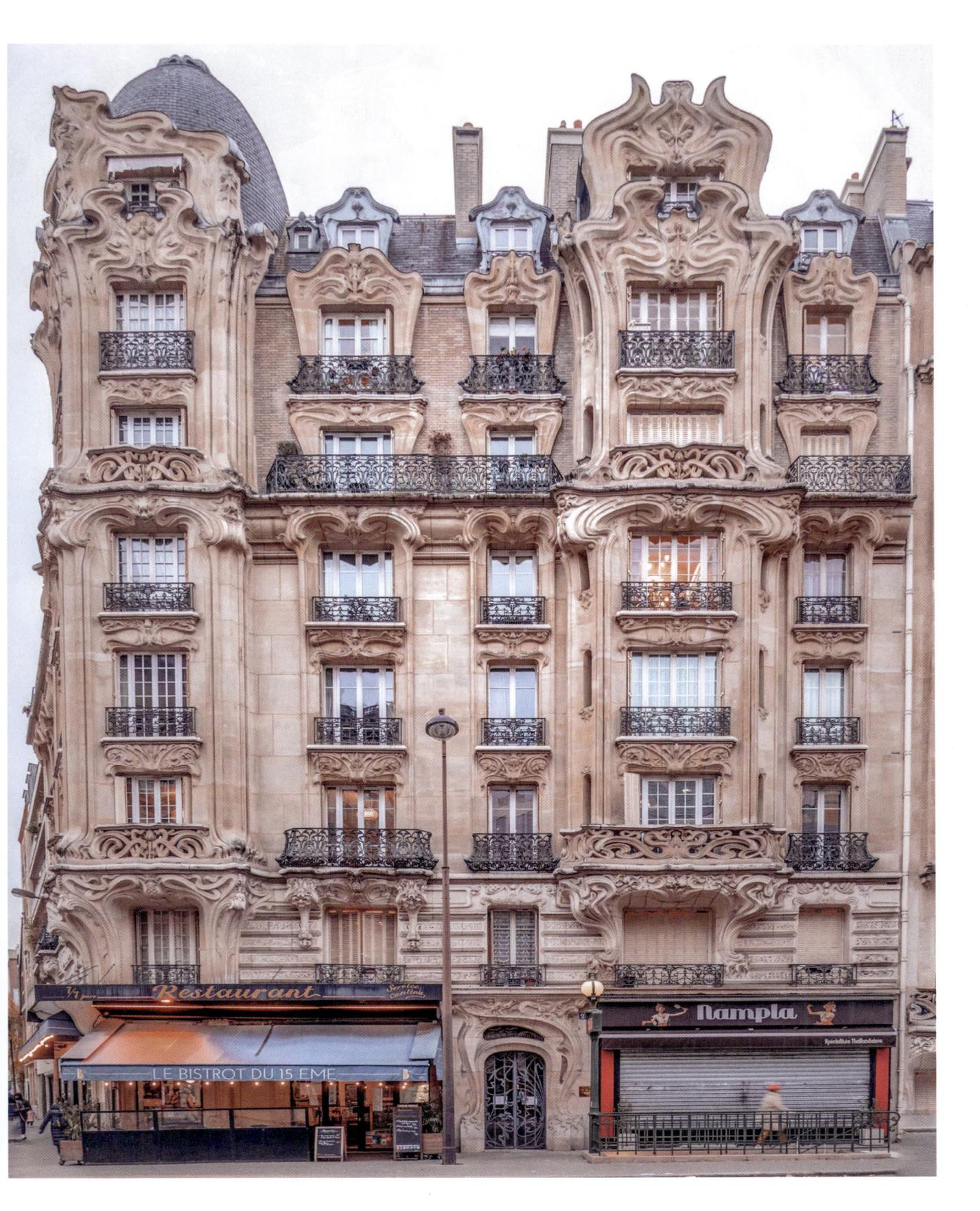

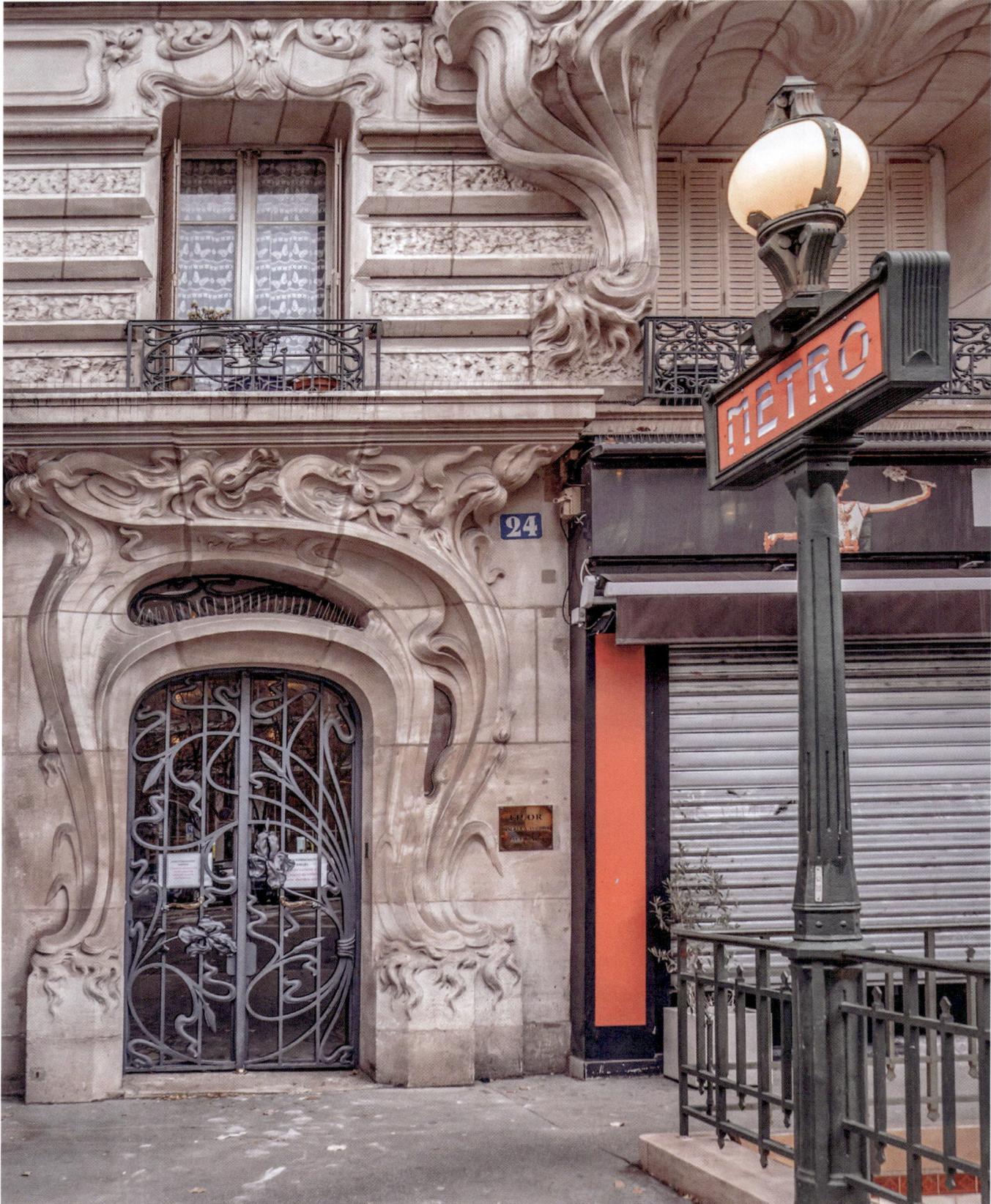

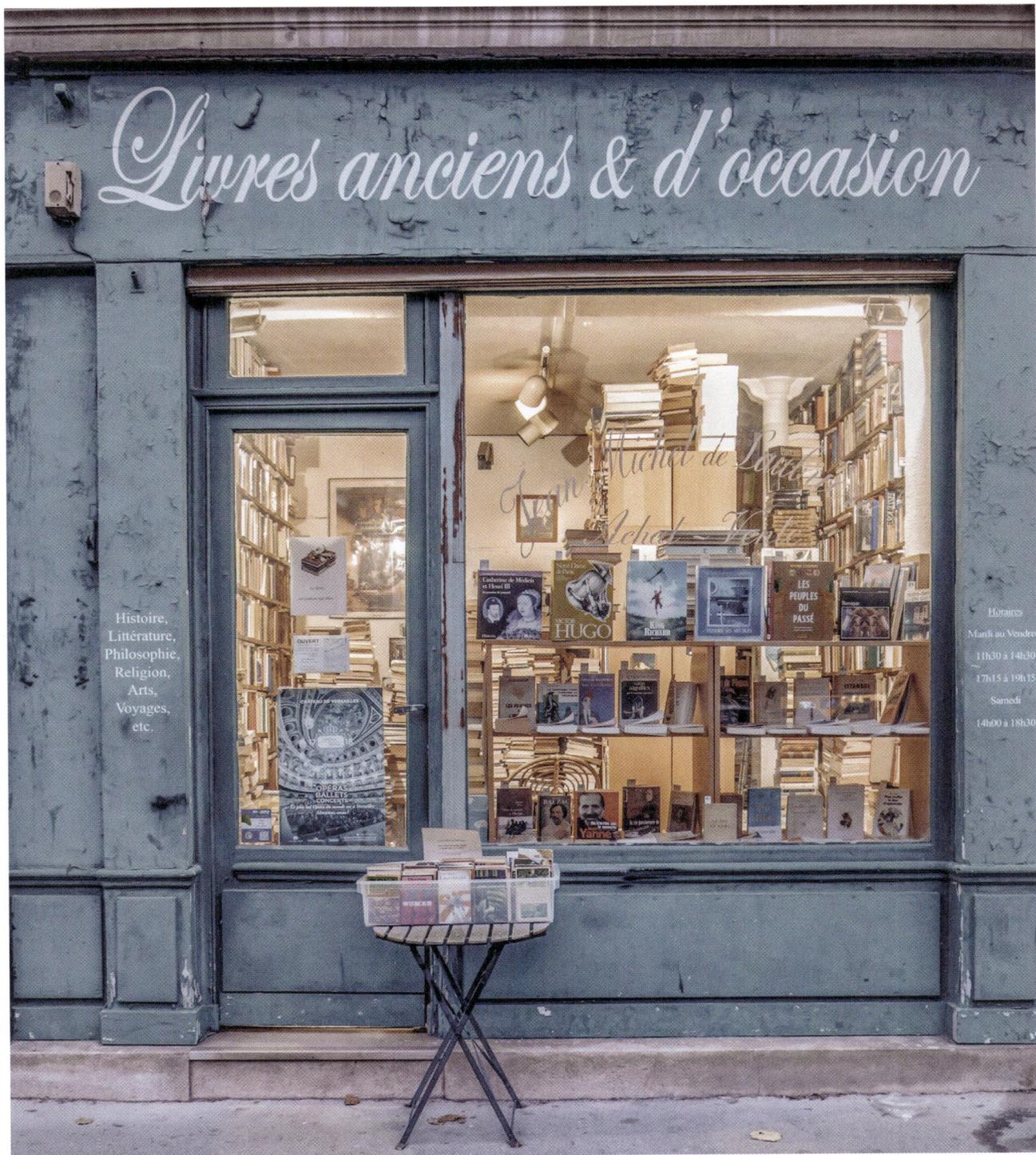

Above:

Monsieur de Laubrière's charming antiquarian bookshop on Boulevard Grenelle is a go-to for rare literary gems and sought-after out-of-print editions.

NOËL À PARIS

WINTER MAGIC IN THE CITY OF LOVE

At the first note of Charles Aznavour's melancholy, dreamy voice, crooning *"C'est Noël, chéri, et nous sommes à Paris"*, you're instantly transported to the City of Love. In Advent, another side of Paris appears. The gray streets are brightened by dazzling Christmas decorations, as fir trees and twinkling garlands vie for attention. Winter somehow softens the city's bustle, inviting a slower rhythm. Wrapped in a warm coat, you can meander through Montmartre's quaint old shops and feel snowflakes dance around your nose on the steps of Sacré-Cœur. Winter casts a magical glow over the city's antiquarian bookstores, their warm light spilling through old windows at dusk. A glimpse inside feels like peering into a world nearly vanished, yet vibrantly alive. For lovers, Christmas in Paris is pure indulgence—it's nearly impossible to resist the temptation of Ladurée's delicate macarons or the chocolate masterpieces at À la Mère de Famille. As dusk falls and the city lights begin to glow, it's hard not to be swept up in the Christmas spirit. Holiday shopping feels most glamorous beneath the elegant roof of La Samaritaine or amid the golden splendor of Galeries Lafayette. Every year, Parisians insist that Christmas truly begins with the department store's elaborate window displays and the ever-grander Christmas trees towering under the dome. The December chill transforms one of Paris's Art Nouveau gems in the glass halls of the Grand Palais, which are turned into the largest skating rink in France. Who could resist gliding across the ice, spinning a pirouette, and twirling into the Christmas season in the heart of Paris?

Right:
The many small restaurants and bistros in Paris look even more inviting during the holiday season.

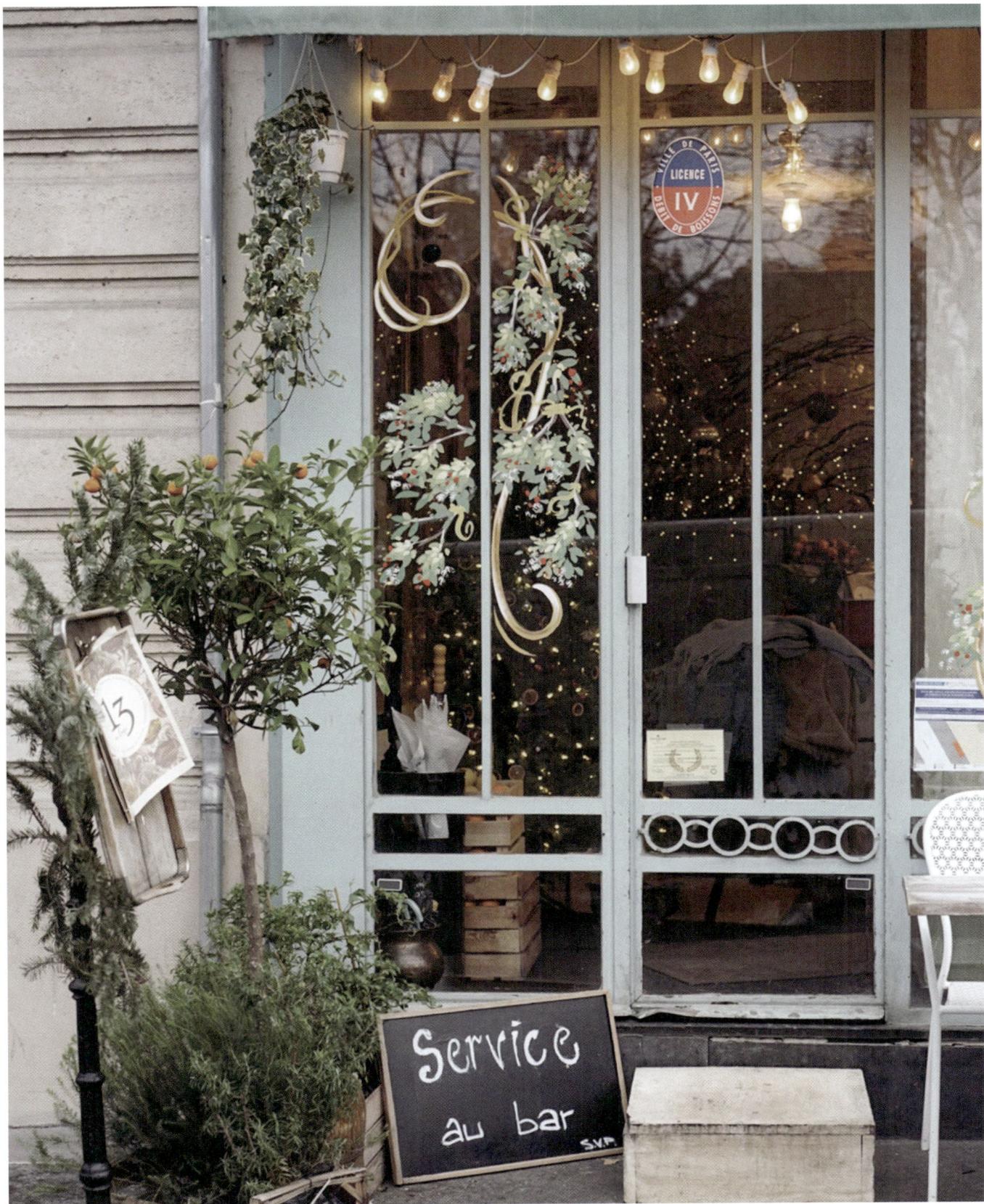

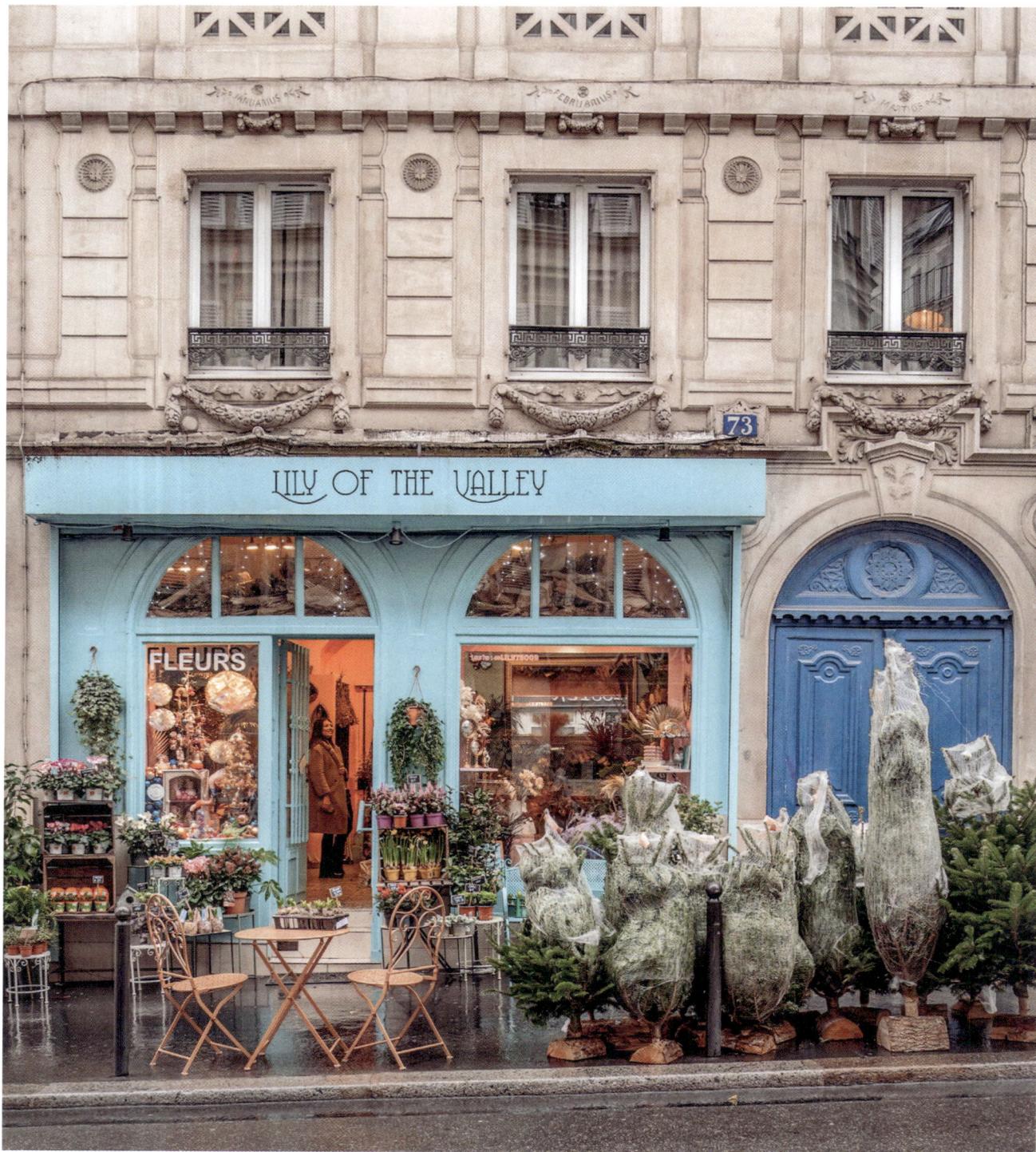

Above:
When a flower shop blends into a romantic still life under a Neoclassical facade: Lily of the Valley on Rue Blanche during the holiday season.

Right:
The ambiance of this small café on Rue Maubeuge, south of Montmartre, is both festive and cozy.

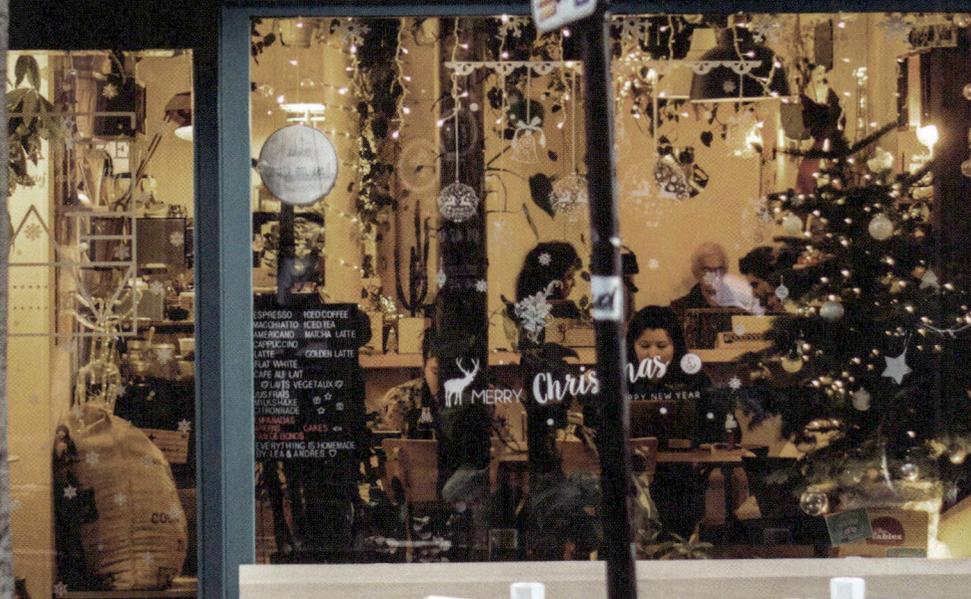

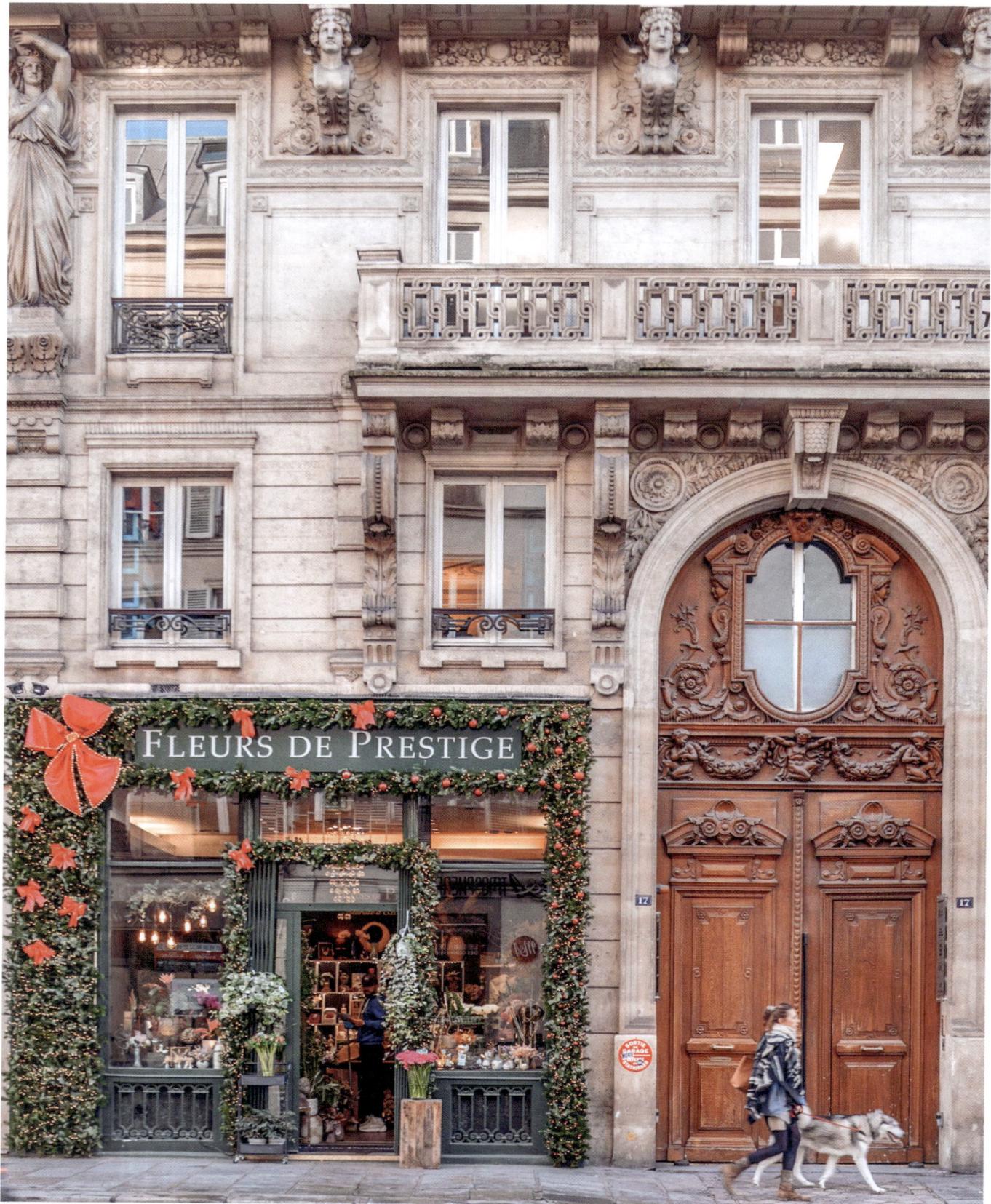

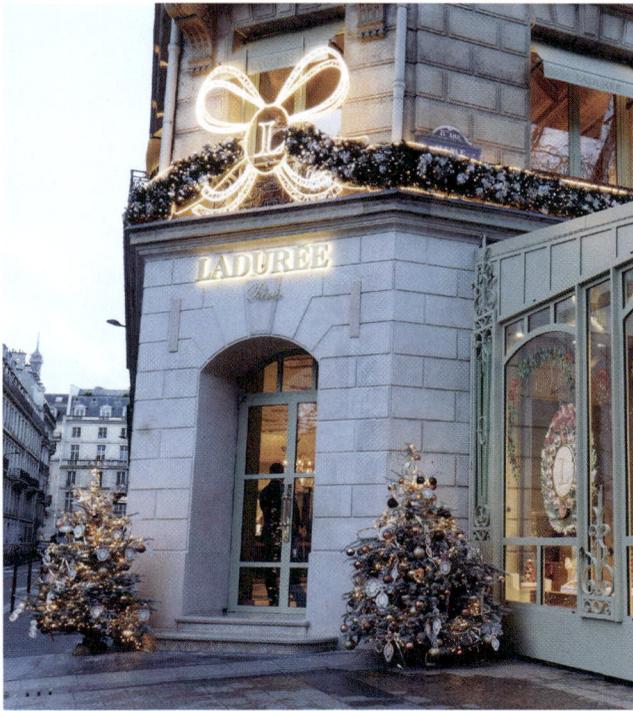
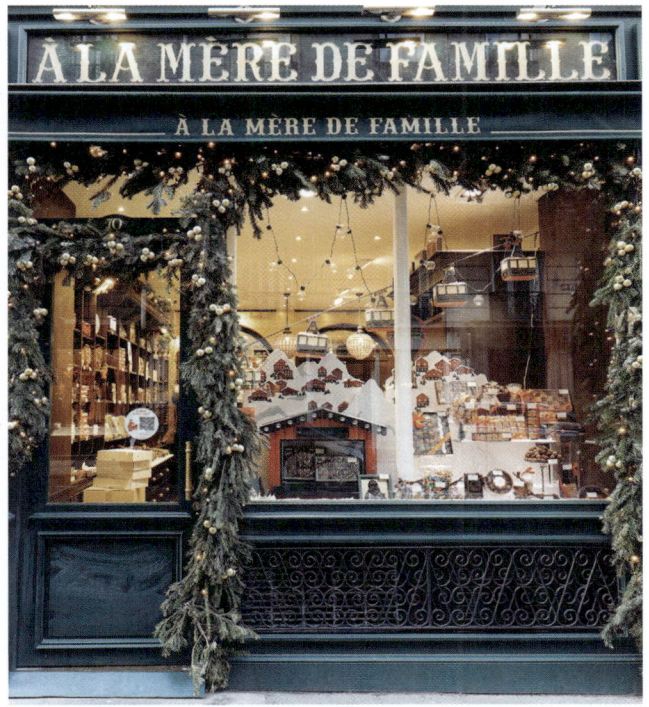

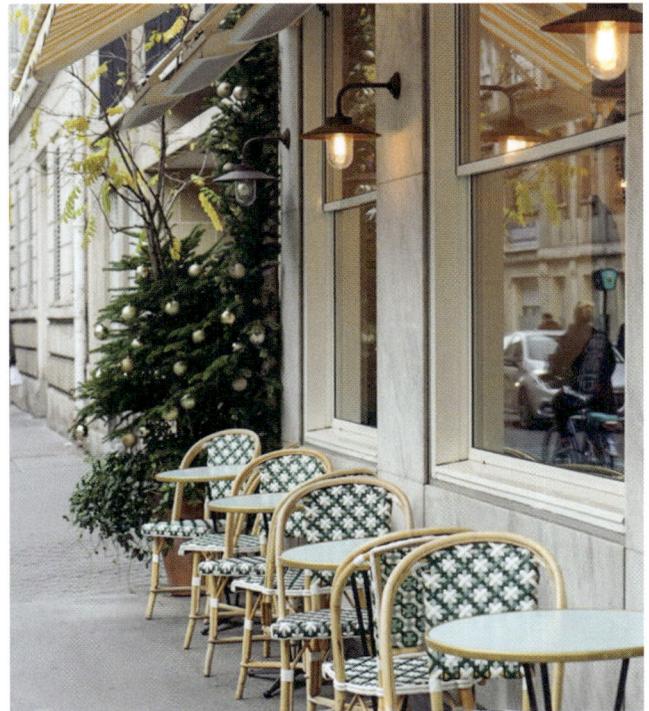

Above and at left:
Magnificent stone façades: Christmas always finds boutiques, bars, and cafés vying for attention in a festive spectacle.

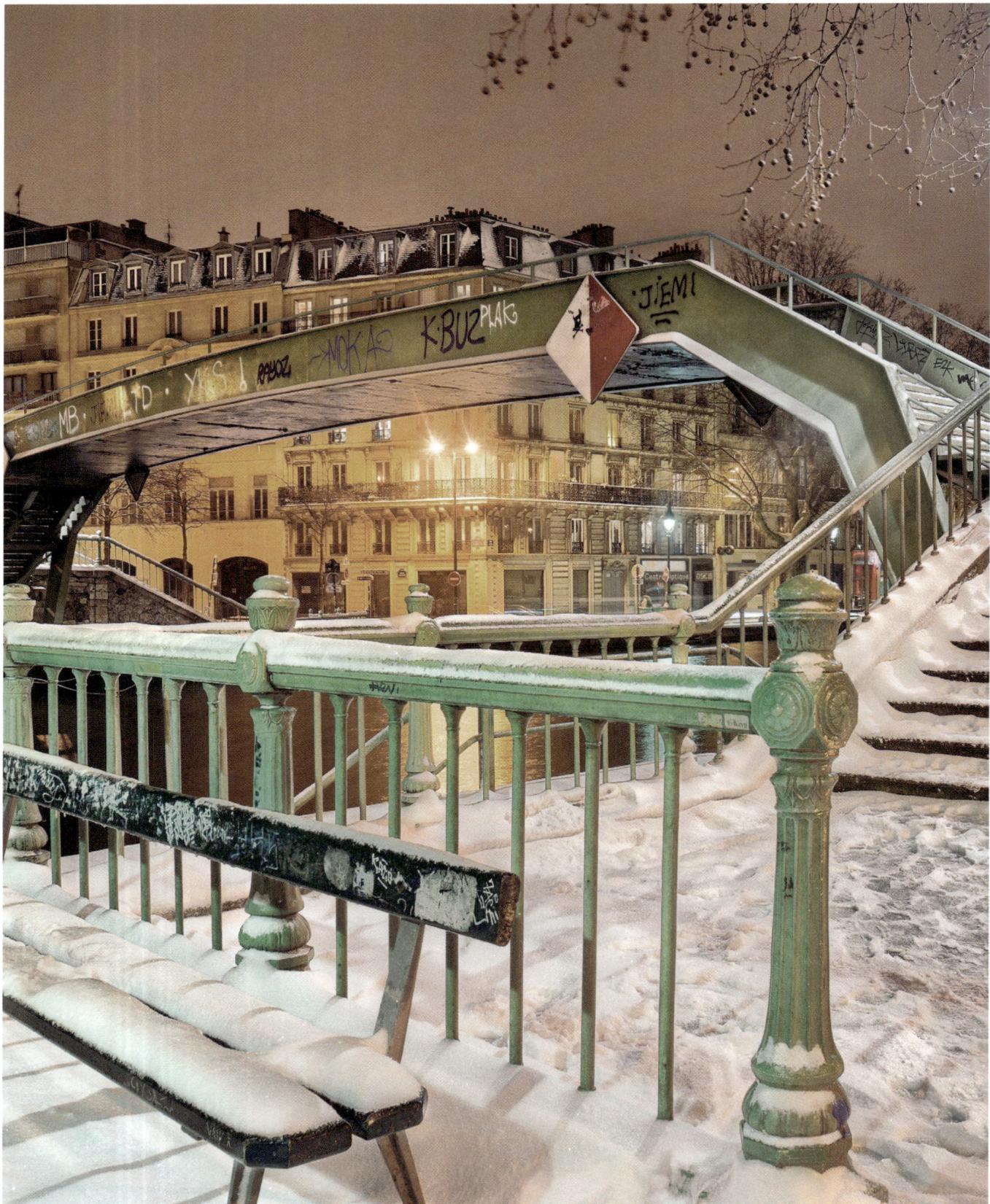

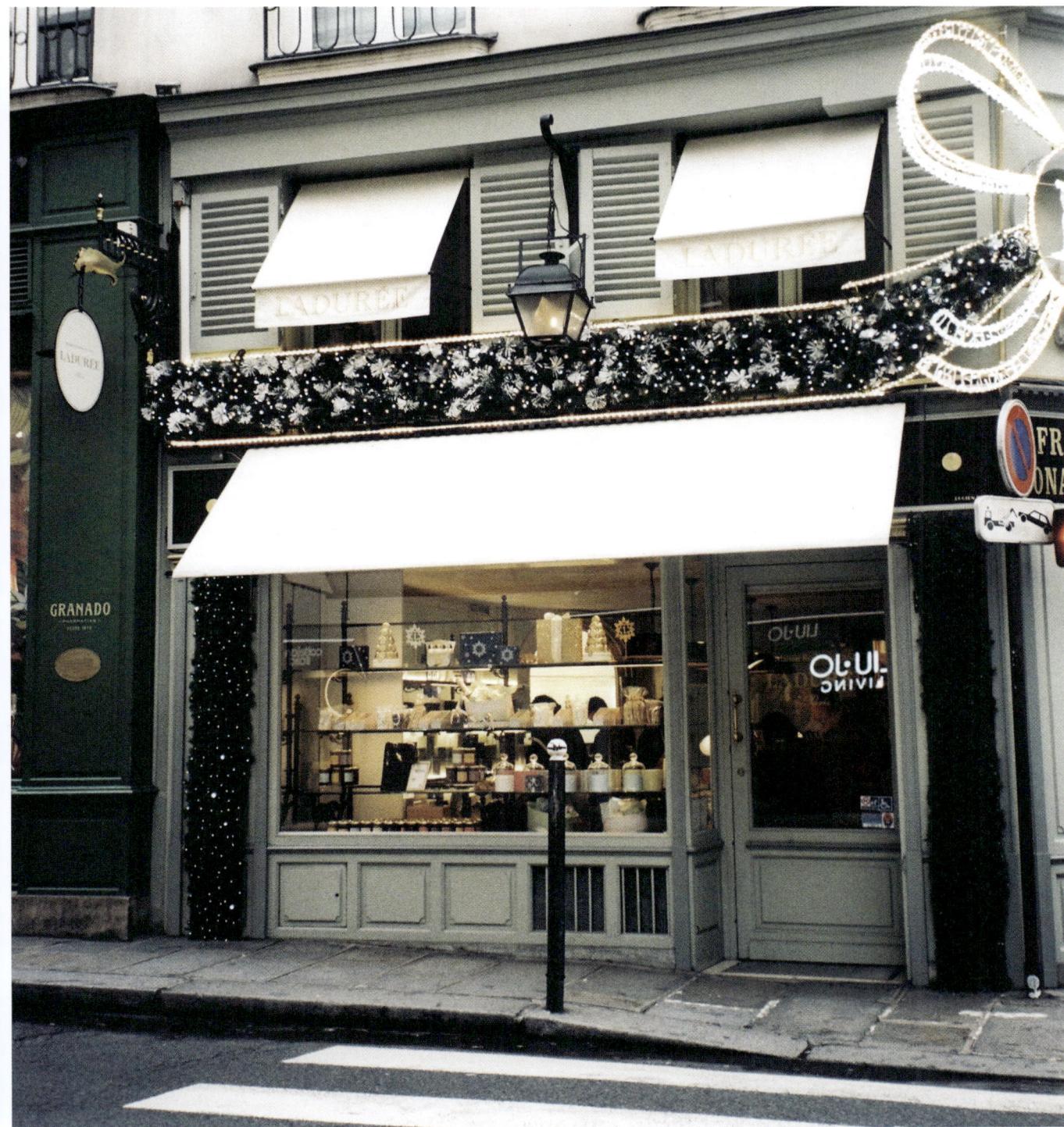

Above:
*Christmas magic and culinary delights – at the patisserie of Ladurée on Rue Bonaparte, you can indulge
in tempting sweet treats.*
Left:
*Snow has blanketed the City of Love. Few things feel more romantic than a stroll along Quai de Valmy
on Canal Saint-Martin at night.*

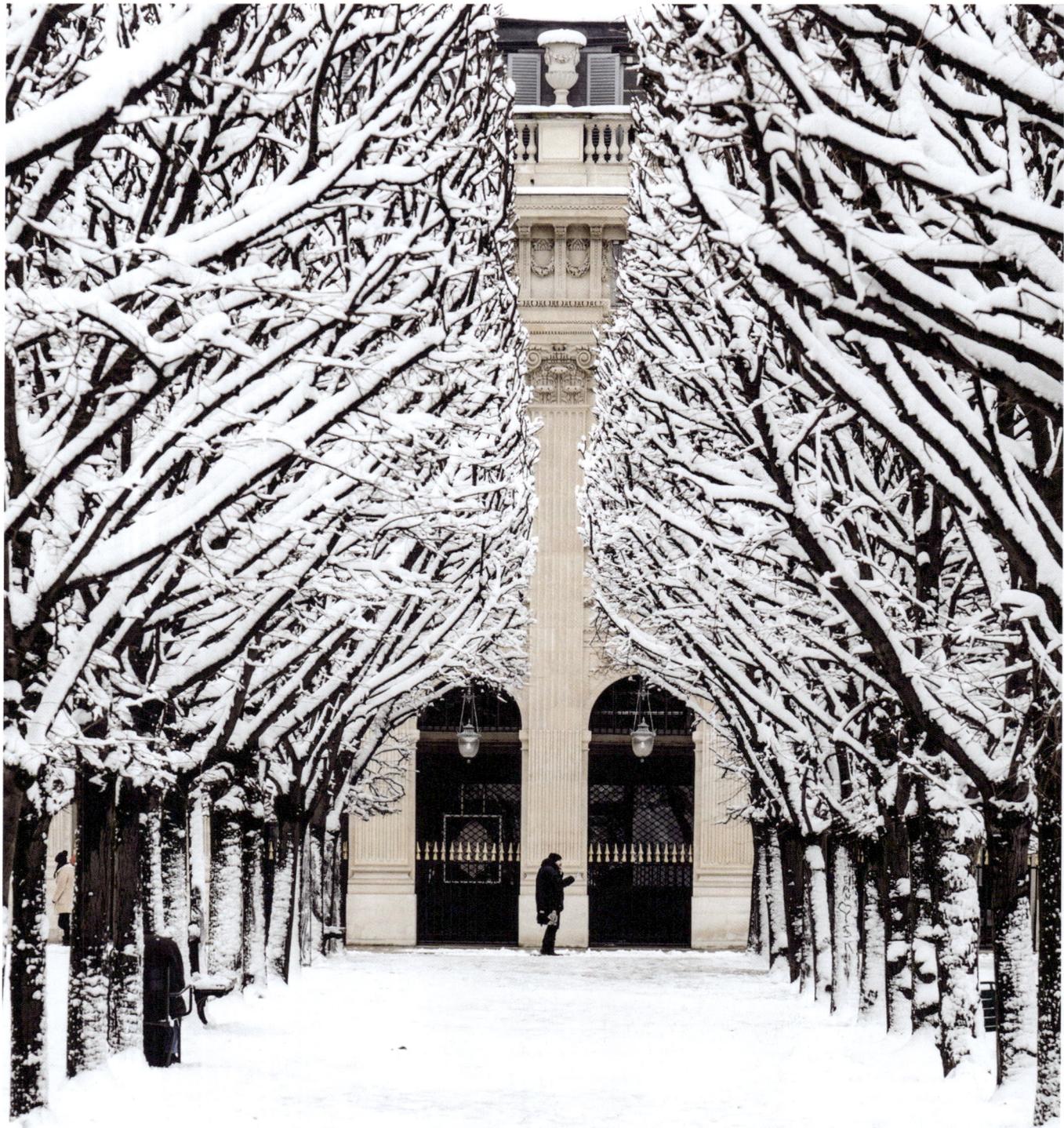

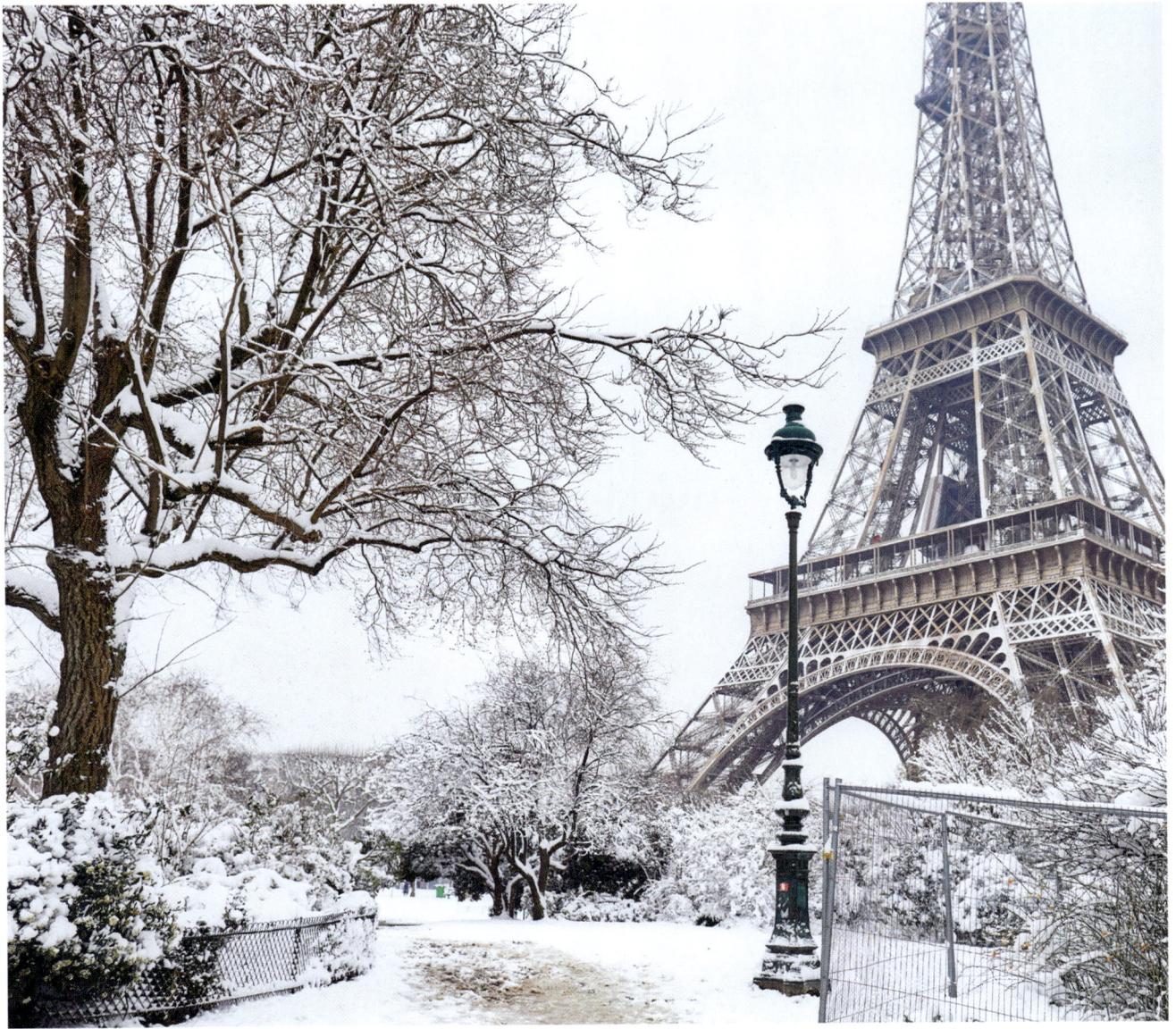

Above and at left:
When the rows of trees at the Eiffel Tower and the Jardin du Palais Royal are draped in snow, the city's bustle gives way to a fleeting, yet magical, tranquility.

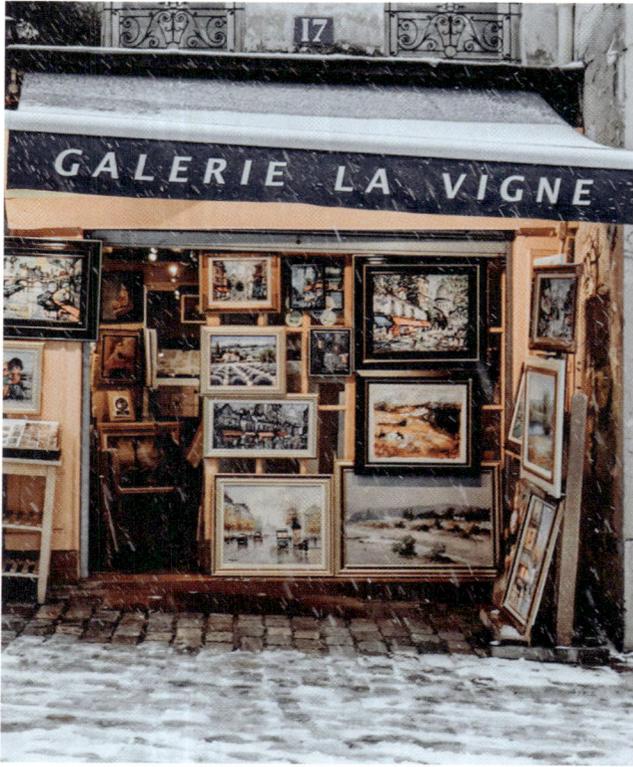
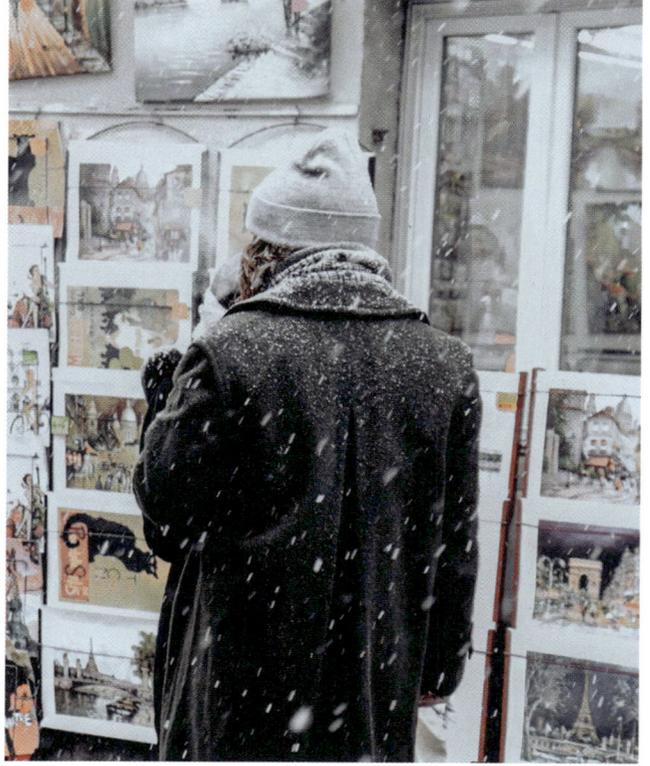

Above and at right:
A vivid dream: Wander through Montmartre's antique book stores and galleries in the weeks before Christmas and perhaps discover an extraordinary gift for that special someone.
Following pages:
What could be more delightful than wandering through Paris in the Advent season, seeking inspiration for Christmas gifts, whether in charming little shops or the opulent luxury department store La Samaritaine?

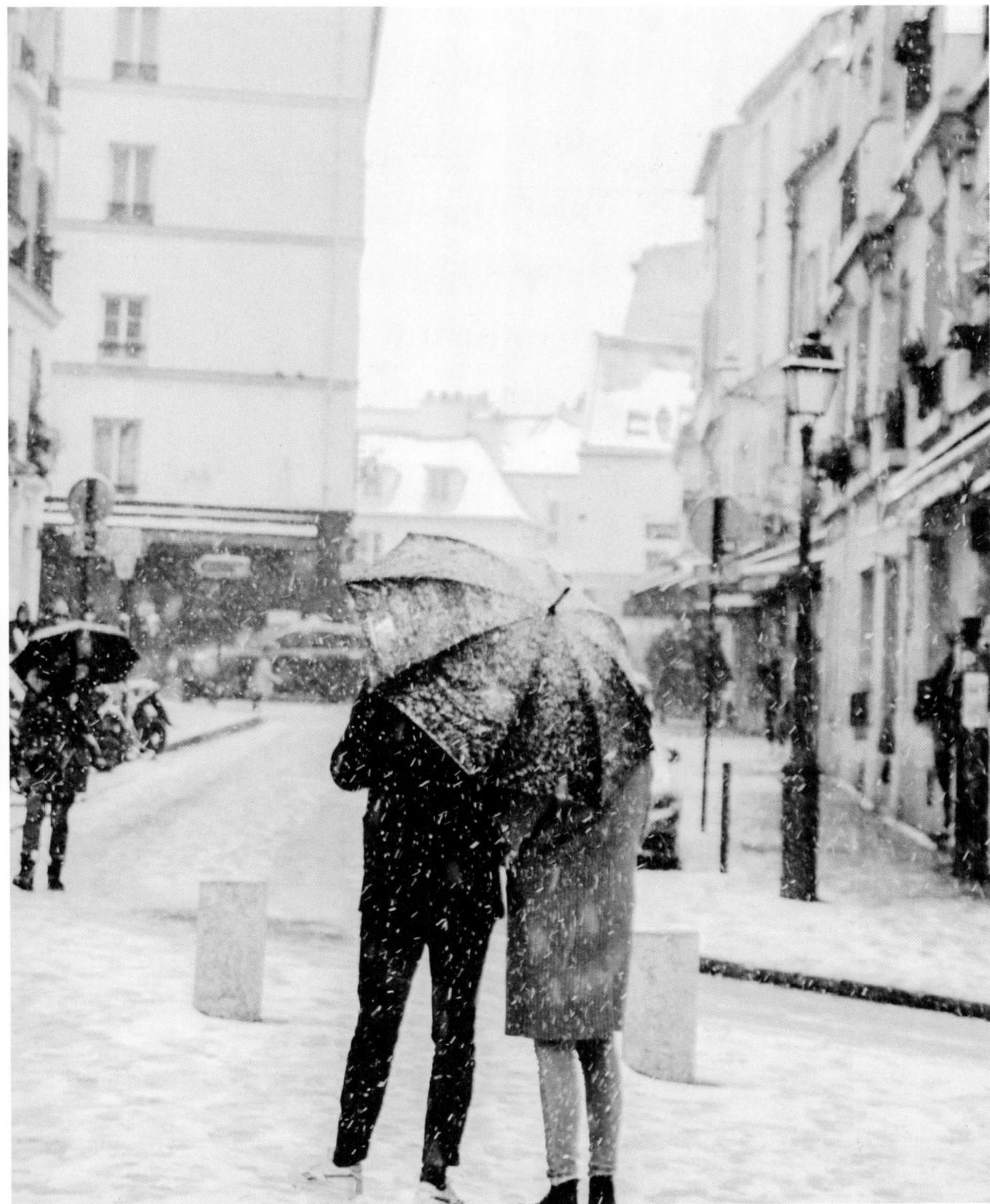

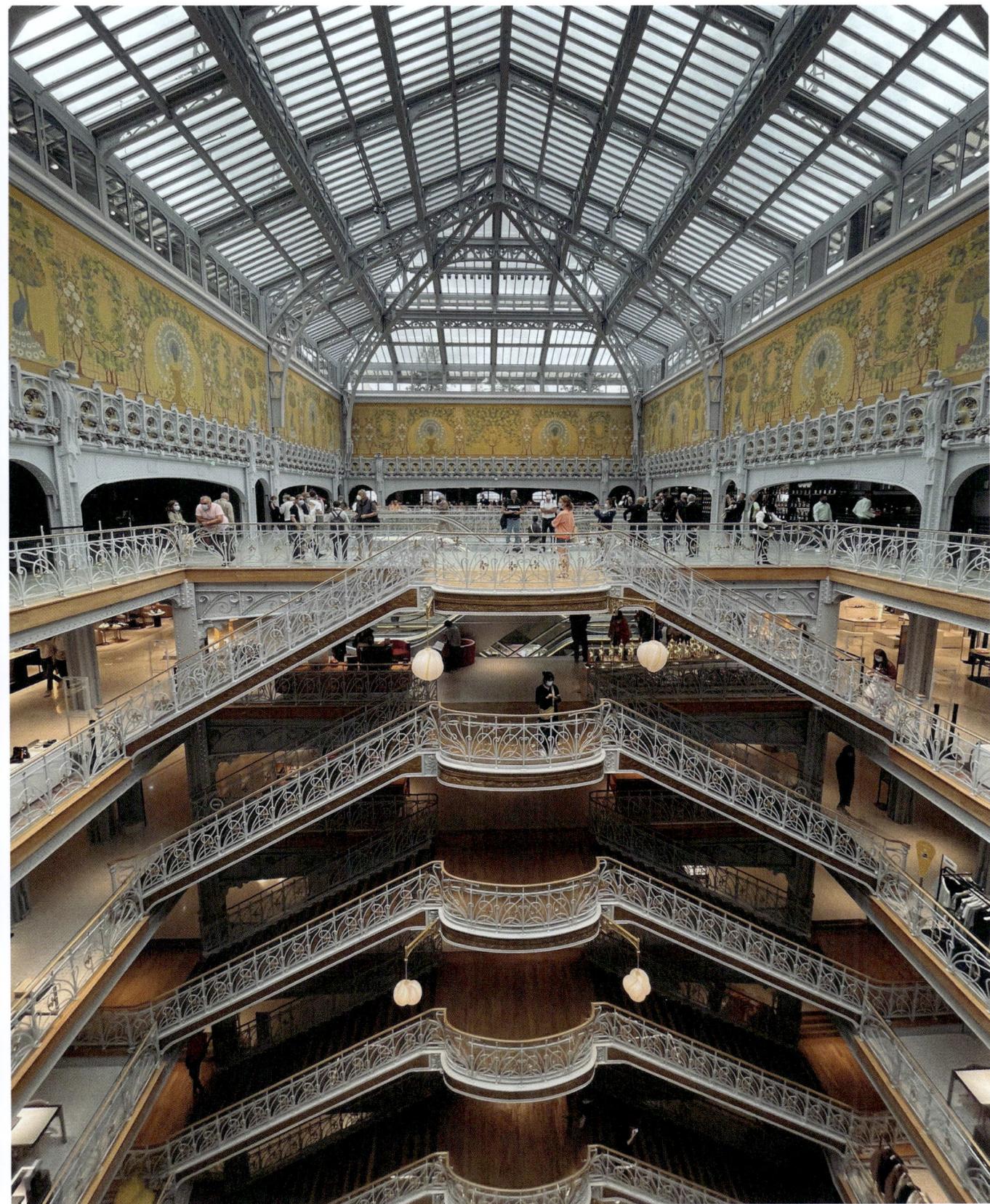

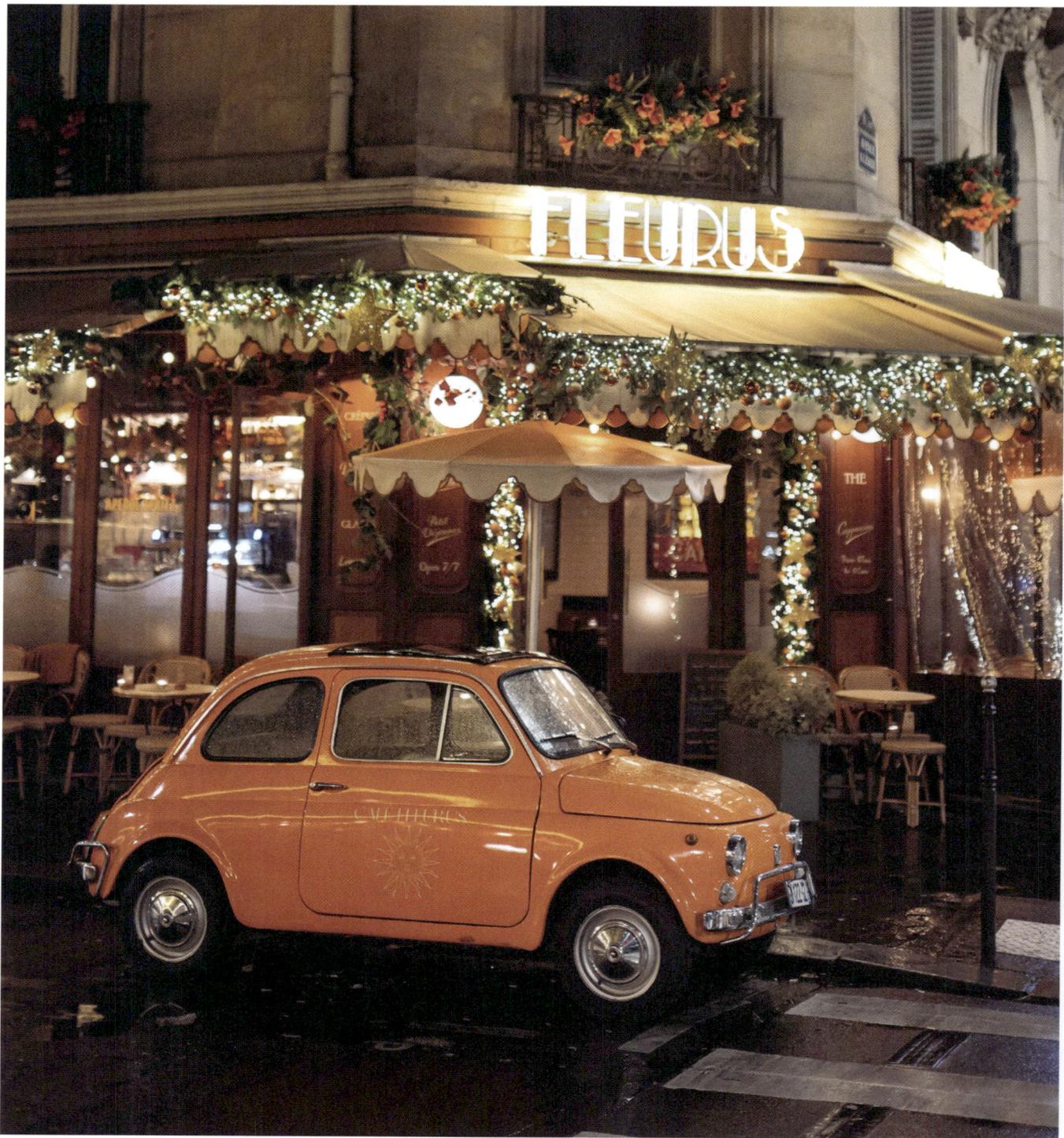

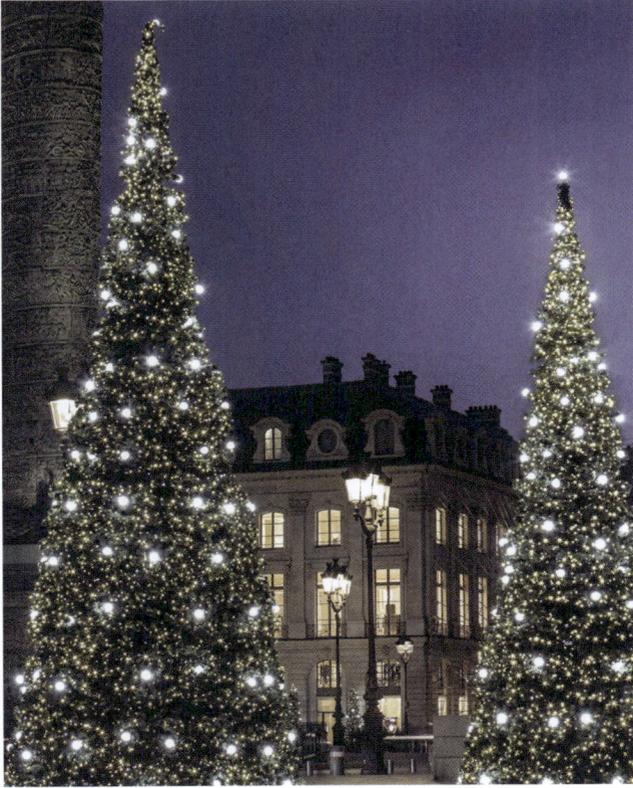
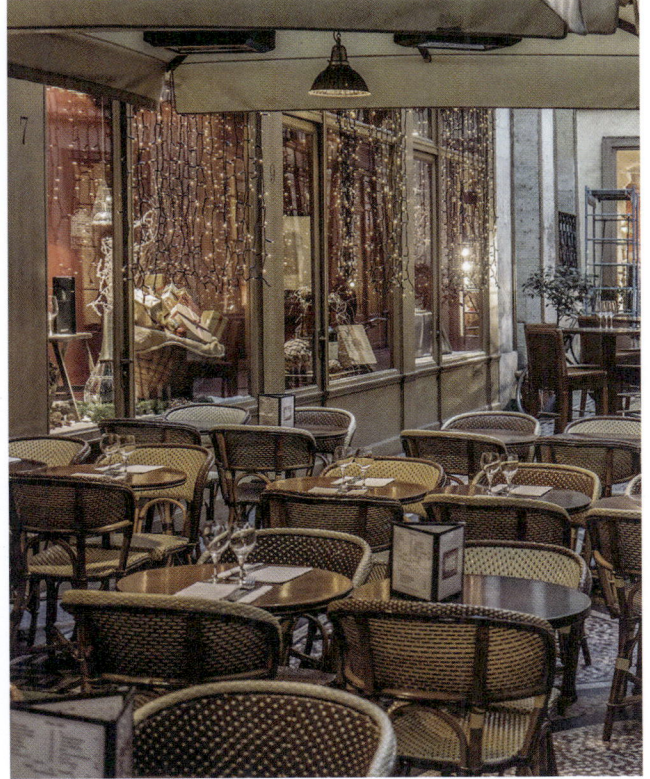

Above and at left:

On December evenings, all across Paris, garlands of lights and twinkling Christmas trees sparkle. Kudos to those who snag a table at one of Paris's incredible little restaurants to enjoy one last gathering with friends and loved ones before the holidays.

La Côte d'Azure

WHERE THE WATER IS BLUER THAN THE SKY

A Brit is credited with first popularizing the Côte d'Azur. In the eighteenth century, when travel writer Tobias Smollett lauded this sun-drenched coastline for its brighter skies and unmatched climate, he ignited a travel craze among Europe's nobility. Overnight, the idyllic "French Riviera" became the destination of the elite. A century later, the French politician Liégeard achieved an unexpected marketing triumph. He authored a book on France's Mediterranean coast, convincing the world that the sea between Marseille and Menton was unrivalled in blueness. His book, *La Côte d'Azur*, not only named the region but forged a lasting myth and brand. For many, the Riviera means luxury yachts, movie stars, and the glamorous jet-set lifestyle of Cannes and Saint-Tropez. Yet beyond the glitzy glamour, where steep cliffs meet sandy beaches, hidden corners dazzle with raw beauty. Explore defiant hilltop villages like Èze or medieval towns like Antibes, where the labyrinthine lanes behind Château Grimaldi are barely wide enough to fit a carriage and irresistibly charming. In Menton's old town, a pastel symphony unfolds: façades glow in sun-bleached ochre, orange, and rose, accented by sea-toned shutters and doors. Under the Mediterranean sun, you'll be shaded on the old town's stairs, always on the hunt for the swooniest photo angle. In Nice, the kilometer-long Promenade des Anglais beckons, flanked by the azure sea and magnificent Belle Époque buildings. Yet the city's winding old town boasts a character all its own. And Marseille? In its oldest neighborhood, Le Panier, the vibrant spirit of a bustling port and cultural melting pot comes alive. Unique shops, cozy cafés, and graffiti-adorned walls make it perfect for experiencing the city's raw, dynamic energy.

Right:
Breathtaking views of the azure sea beneath the arches of the Promenade des Anglais in Nice.

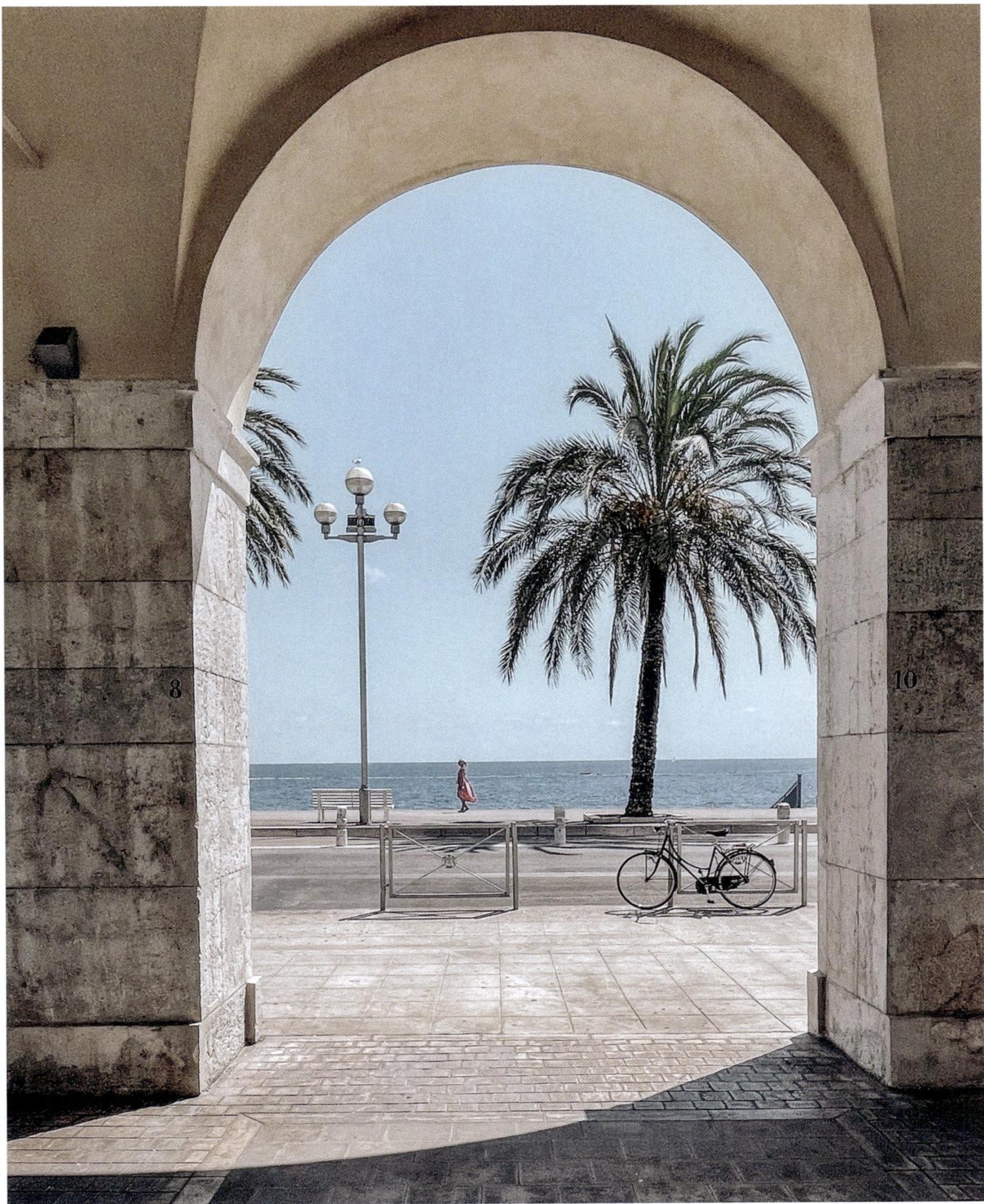

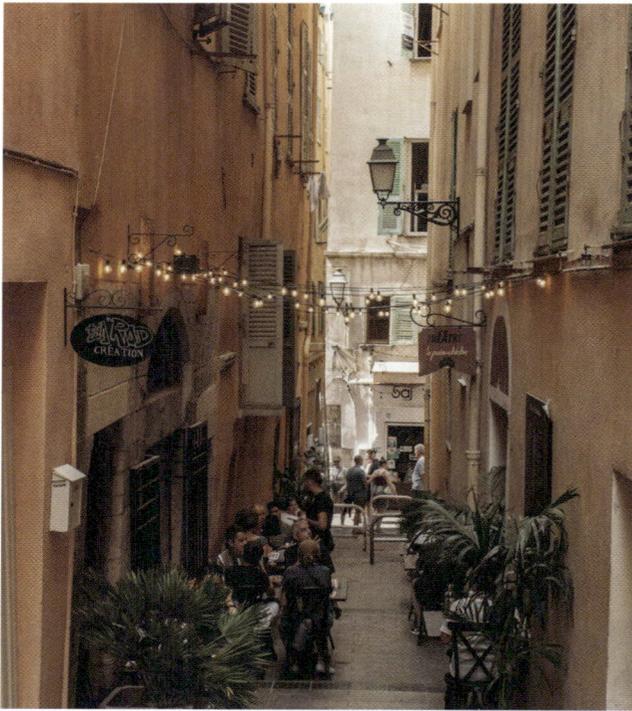
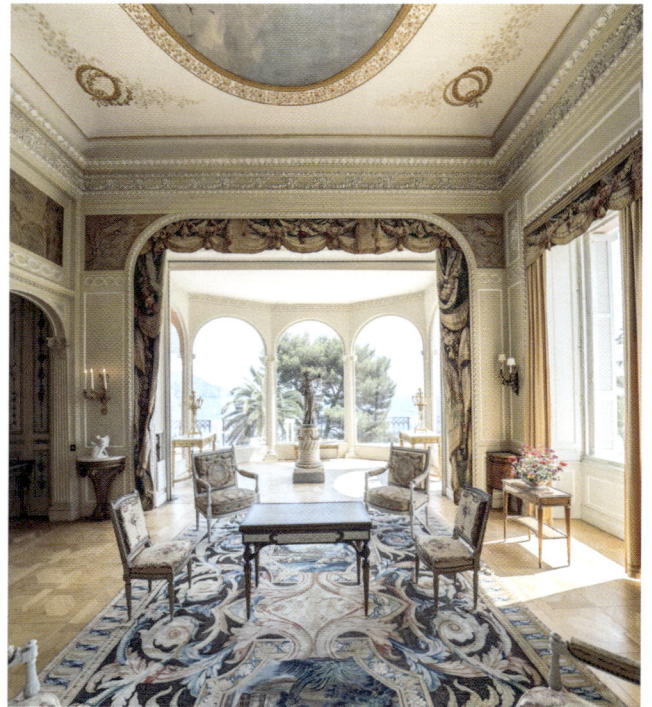

Above and at right:
Southern European flair: Strolling through Nice's old town, a culinary interlude at the historic Gare du Sud, followed by a trip to Saint-Jean-Cap-Ferrat to wander the new gardens at Villa Ephrussi de Rothschild.

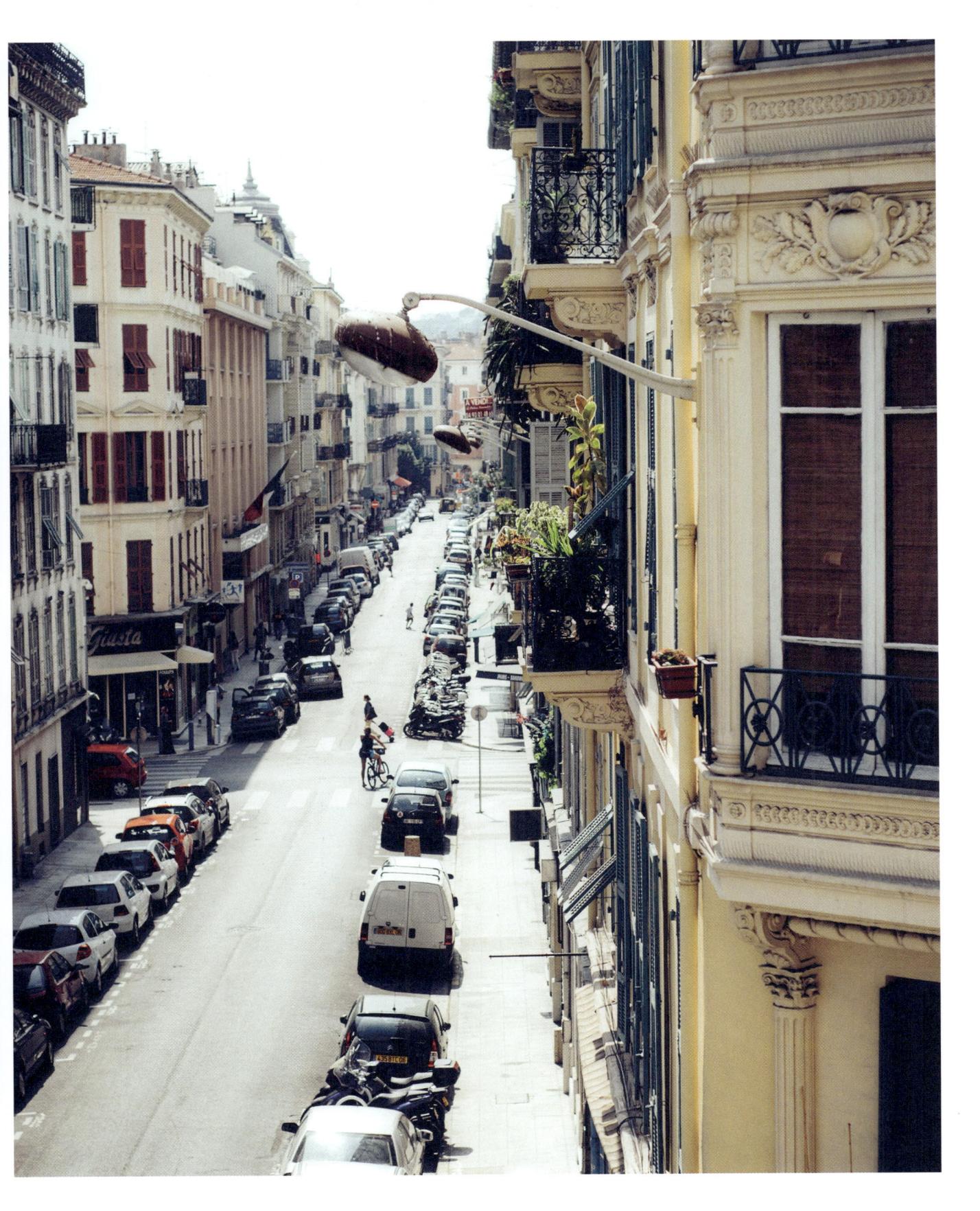

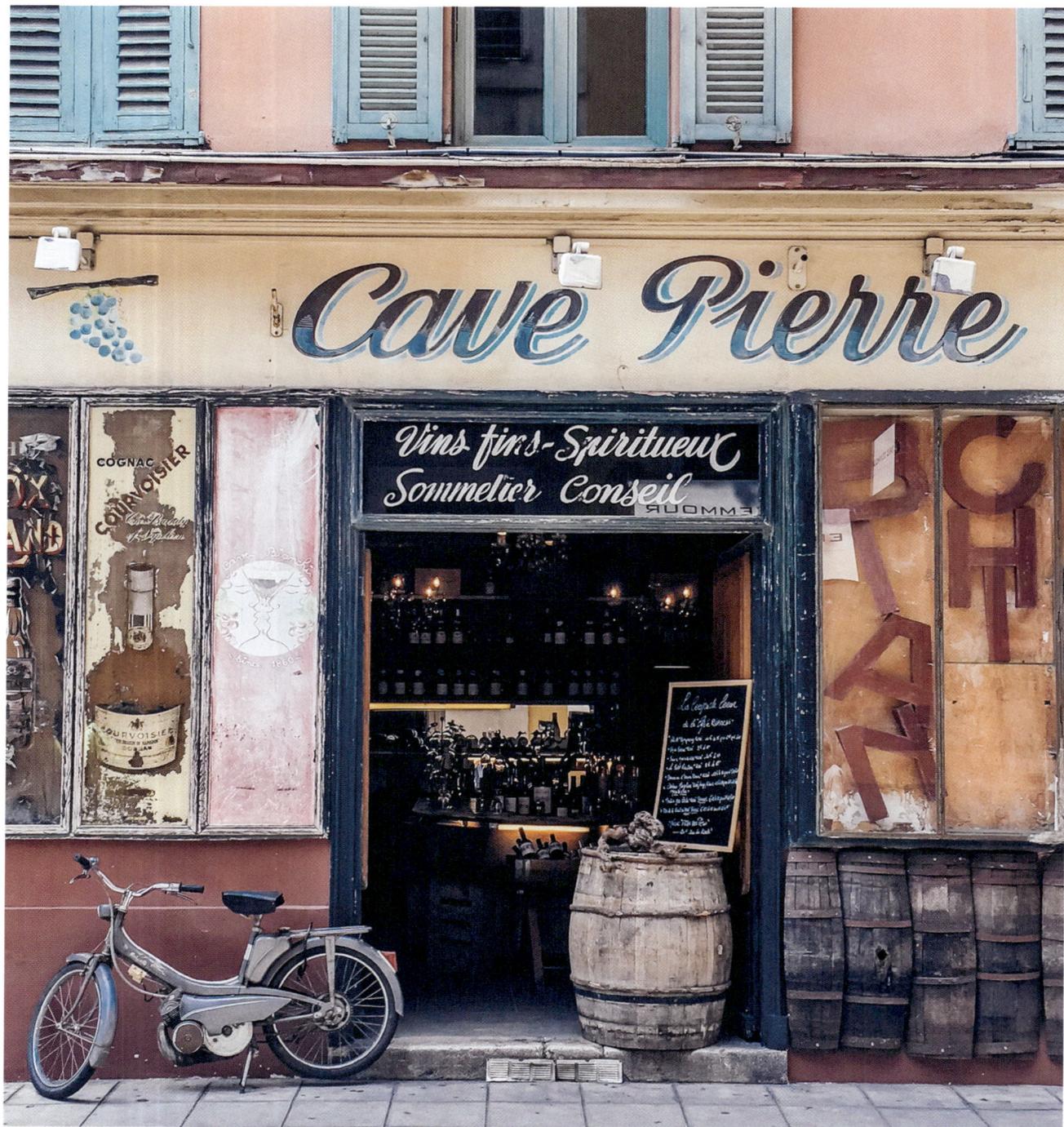

Above:
Nice is home to quite a few historic wine cellars that invite wine tasters to savor exquisite vintages in the cool environs beneath arched ceilings.

Right:
See and be seen: Niçois gather for a relaxed apéro in the cozy eateries around Place Masséna.

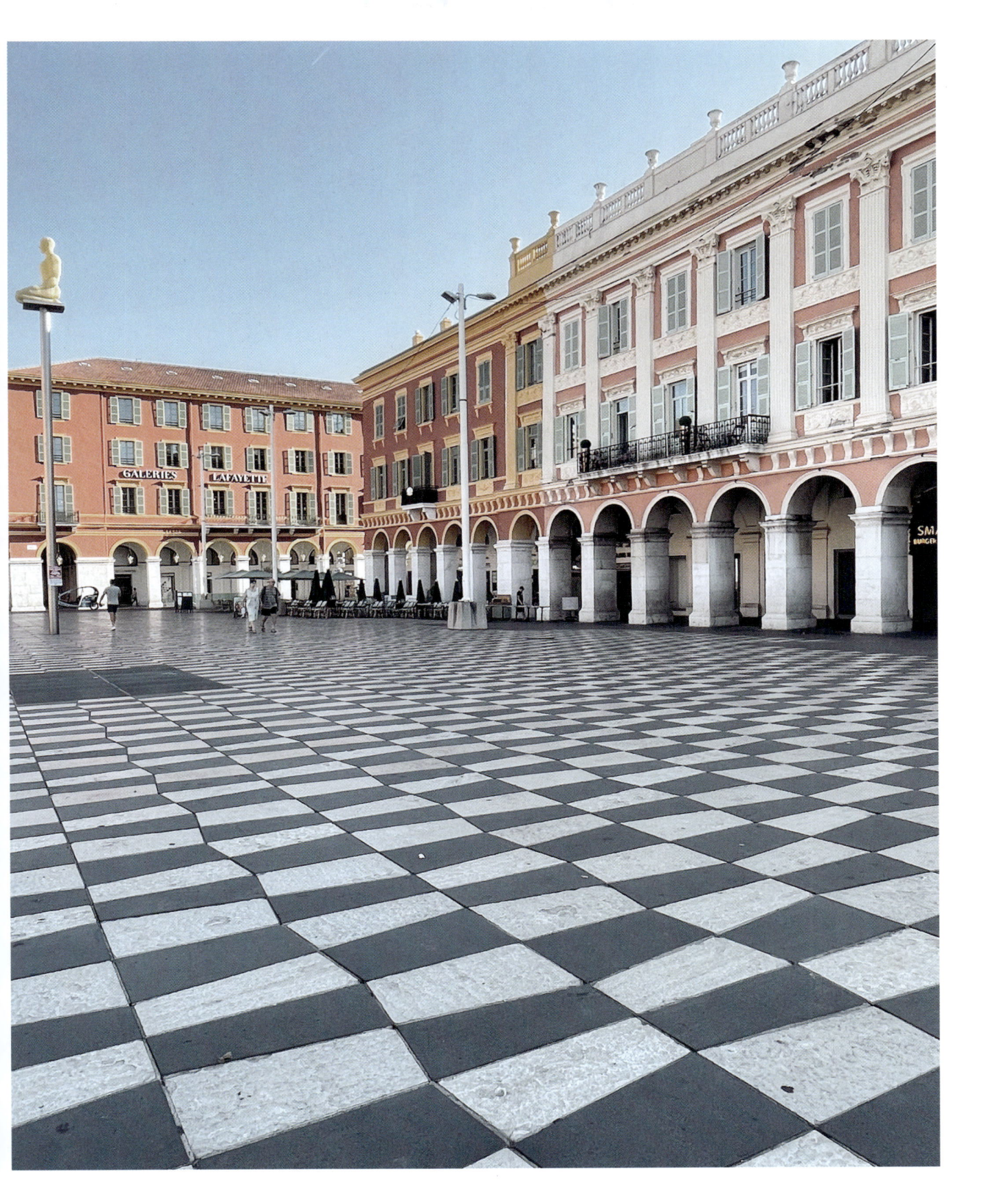

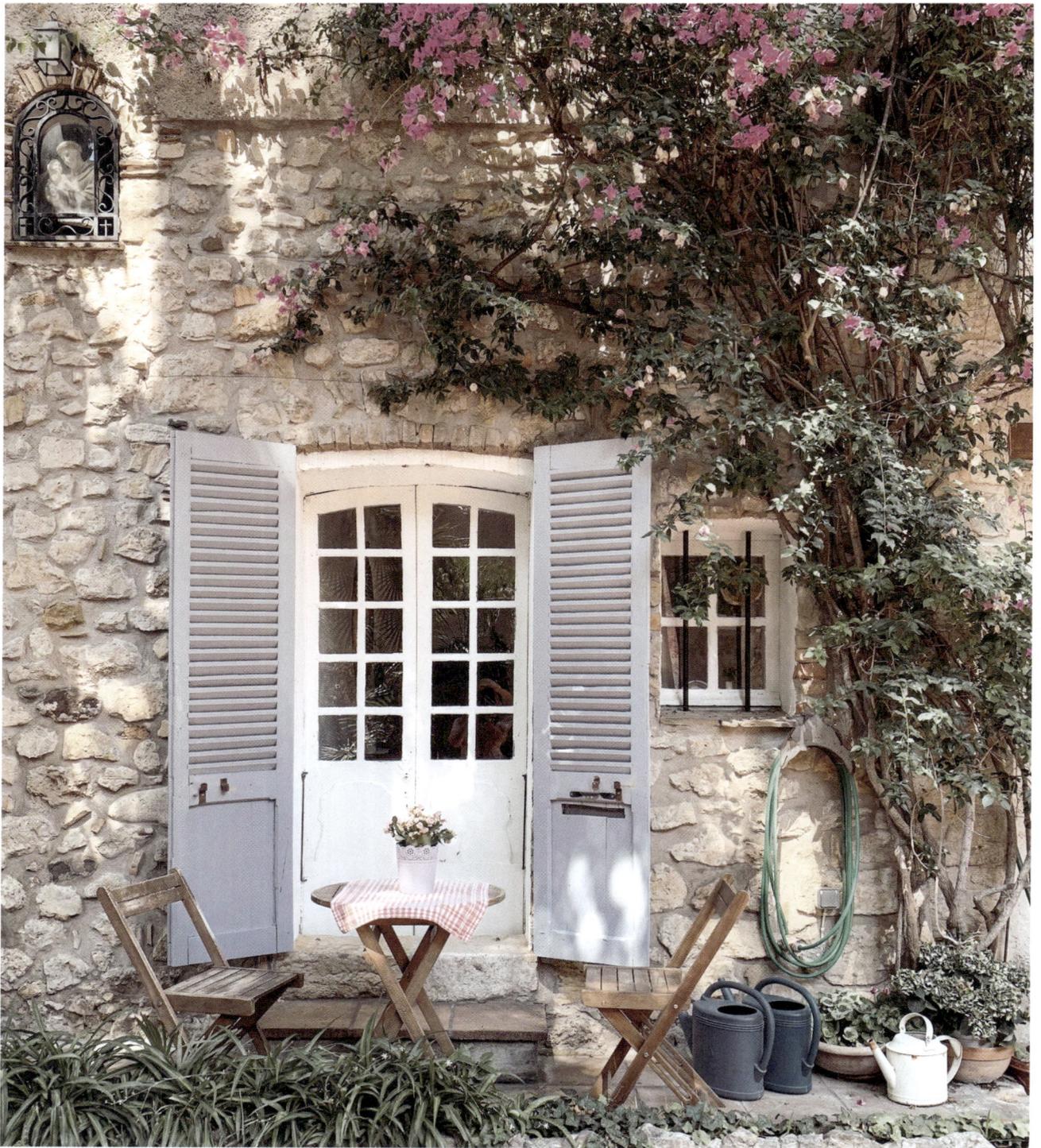

Above and at right:
Antibes captivates with its Provençal charm, stunning beaches and the picture-perfect streets of its old town—which may be why this medieval port town today draws luxury yacht owners just as it once enchanted renowned artists like Monet and Picasso.

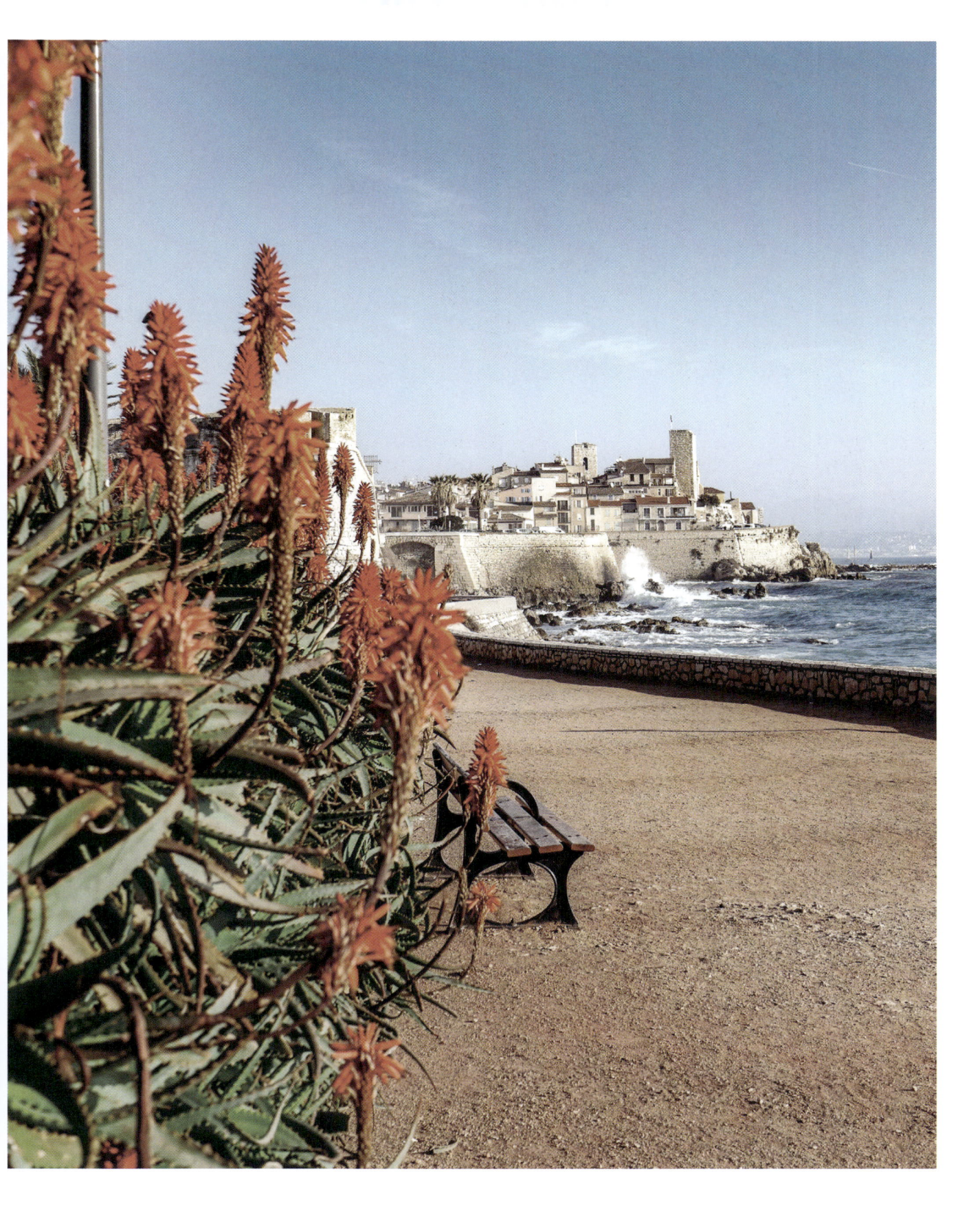

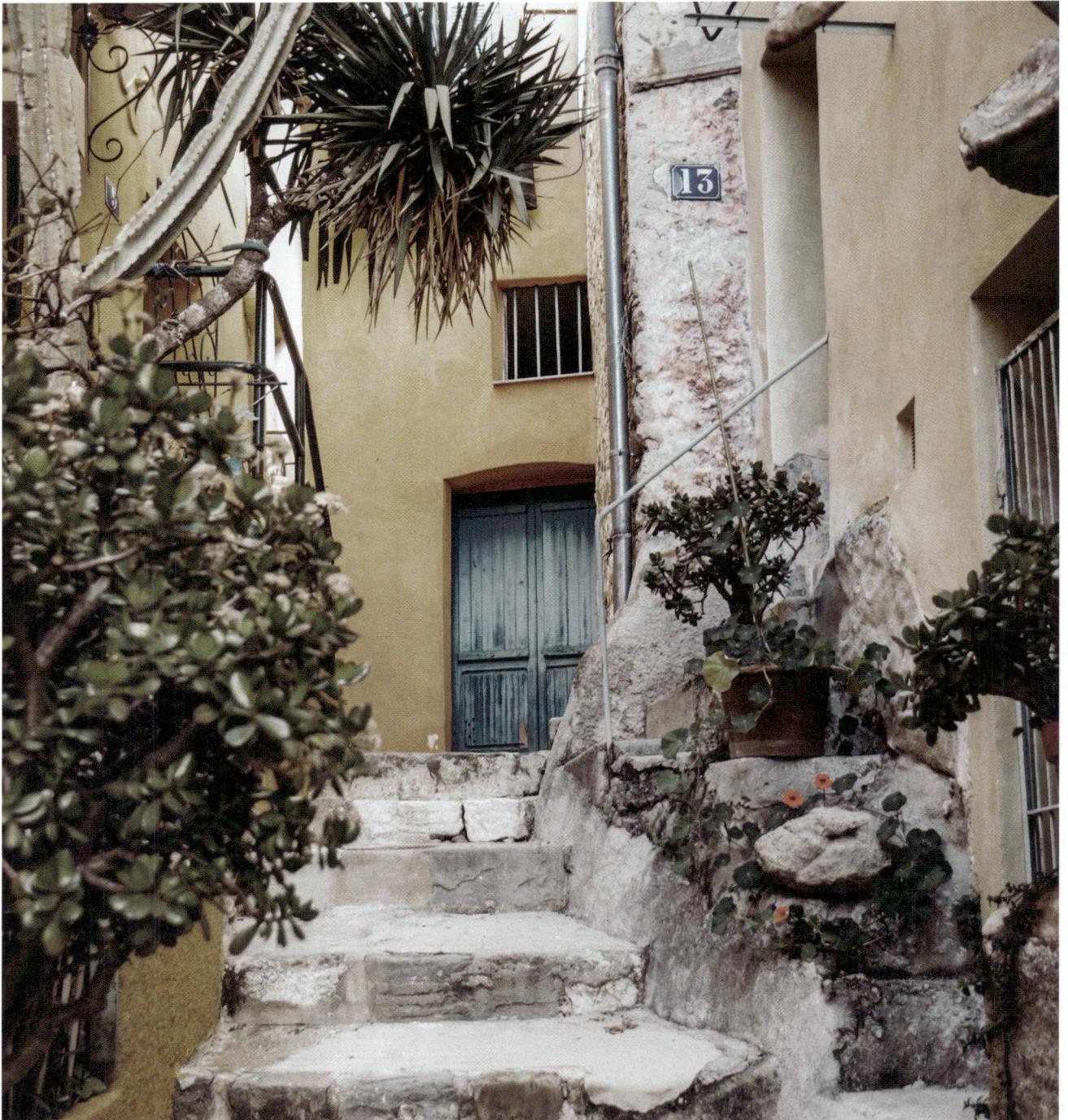

Above and at right:
Steep stairs and narrow buildings in warm rose and ochre set off lively contrasts against faded shutters painted in blues and greens to match the sea. Every corner of Meton feels like living art.

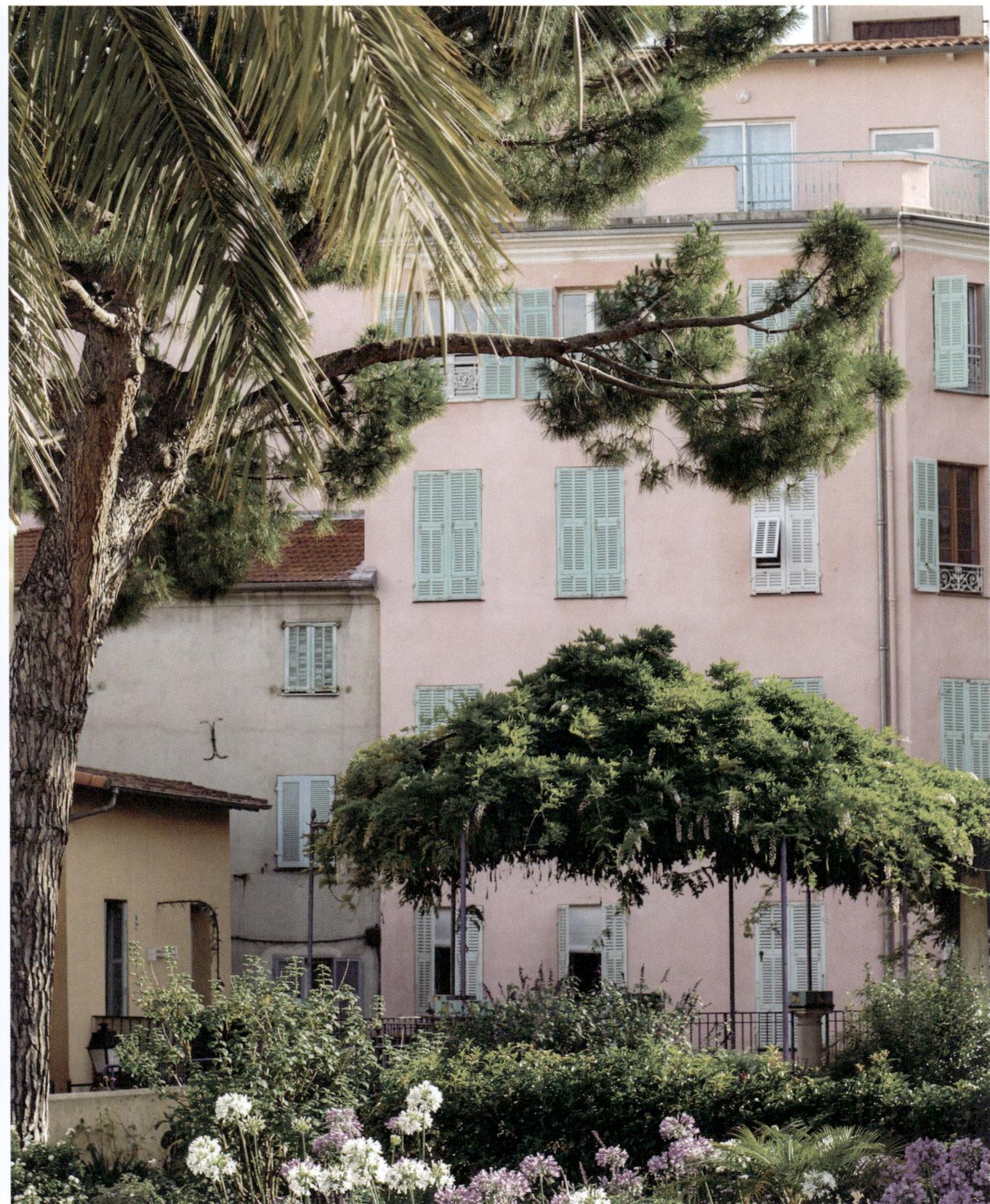

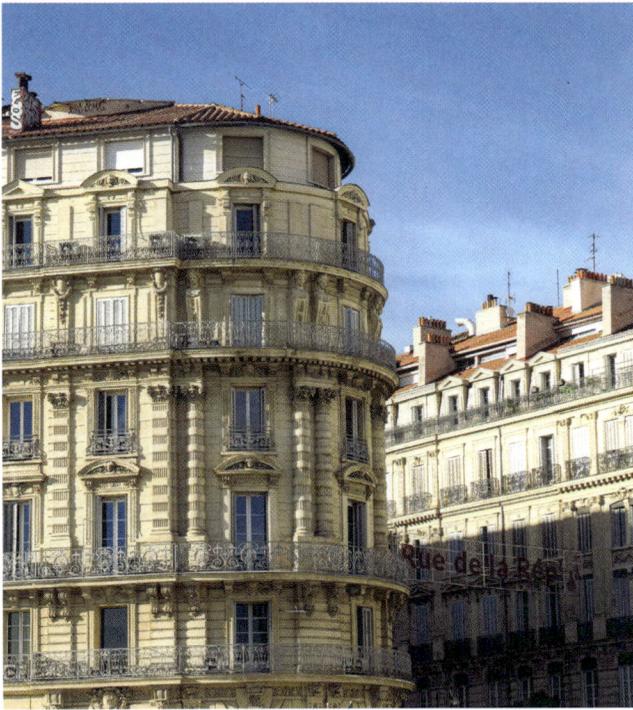
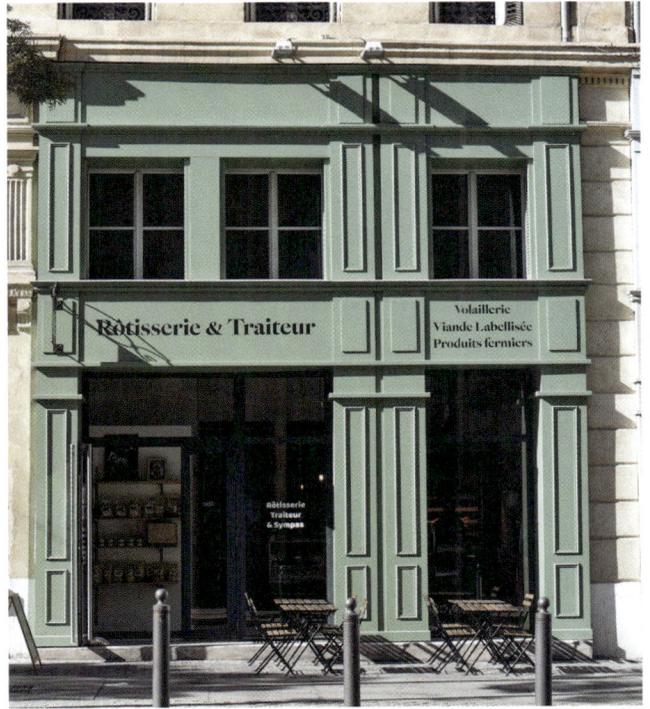
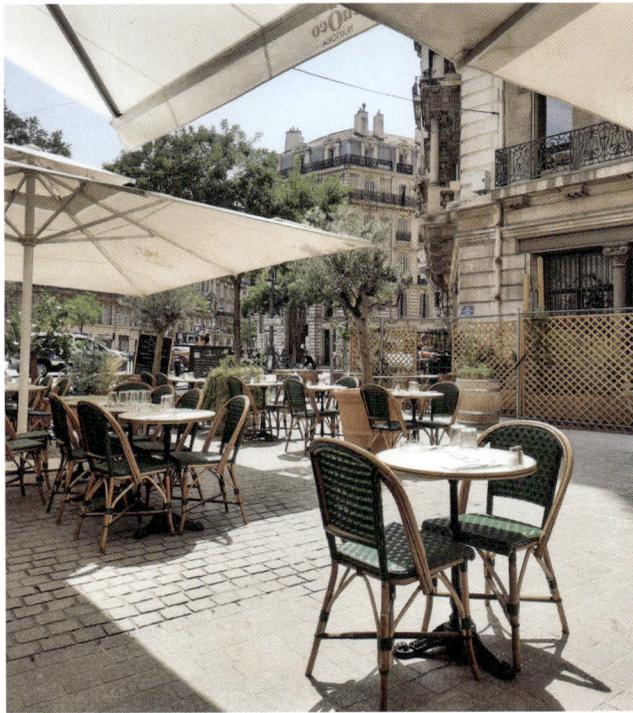
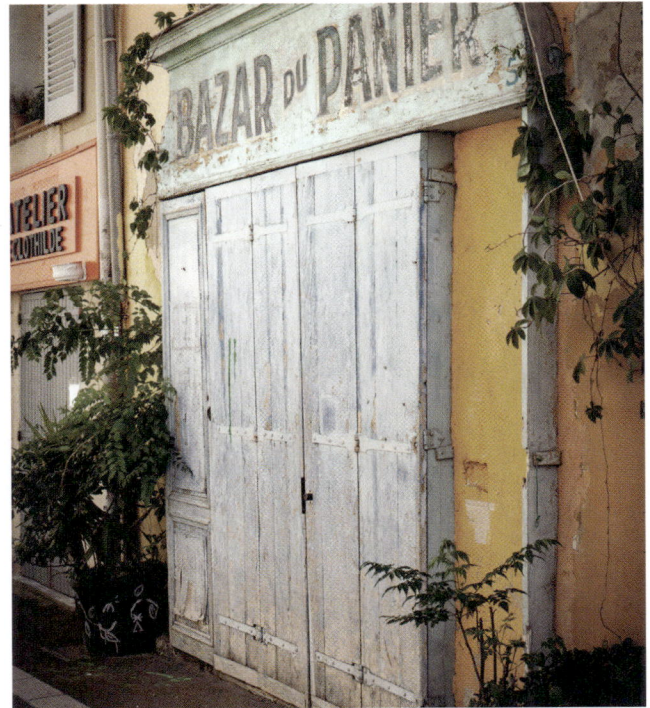

Above and at left:
Experience authentic Marseille in the colorful old town of Le Panier, a lively mix of small shops, bars, street art, and artfully sun-bleached façades.

LA BRETAGNE

STORM-TOSSED COASTS AND MEDIEVAL VILLAGES

Brittany enchants with rugged coastal landscapes and dramatic contrasts, from the expansive beaches of the southern Côte d'Amour to the jagged, wind-sculpted rocks of the Côte de Granit Rose, and on to the Côte d'Émeraude around Saint-Malo, where the sea shimmers in a vibrant green like emeralds hidden beneath the waves. While it's easy to lose yourself in the sea's wild spectacle, the region's old towns and villages offer a charm all their own. Perched along the banks of the Rance just south of Saint-Malo lies enchanting Saint-Suliac, with its well-preserved stone houses and the maritime charm of an old fishing port. A bit farther south, Dinan feels like a step back into the Middle Ages. Upon arrival, the town's imposing twelfth-century wall dominates the view, stretching nearly three kilometers—the longest surviving city wall in France. By day, strolling along the wall reveals stunning views of the city center. Inside, narrow streets are lined with characterful houses built from Brittany's signature materials—weathered timber and coarse granite blocks. Climbing the steep Rue du Jerzual from the city gate, you can almost hear the echoes of horses' hooves and wooden carts from a bygone era. Rennes, the capital of Brittany, preserves its late medieval heritage in the old town. Colorful, narrow half-timbered houses dot the historic center, weaving between the cathedral and two Gothic basilicas. How better to savor Rennes than pausing at a café for a traditional Breton buckwheat galette?

Right:
The Nantouar lighthouse on the bay near Perros-Guirec resembles a chapel.

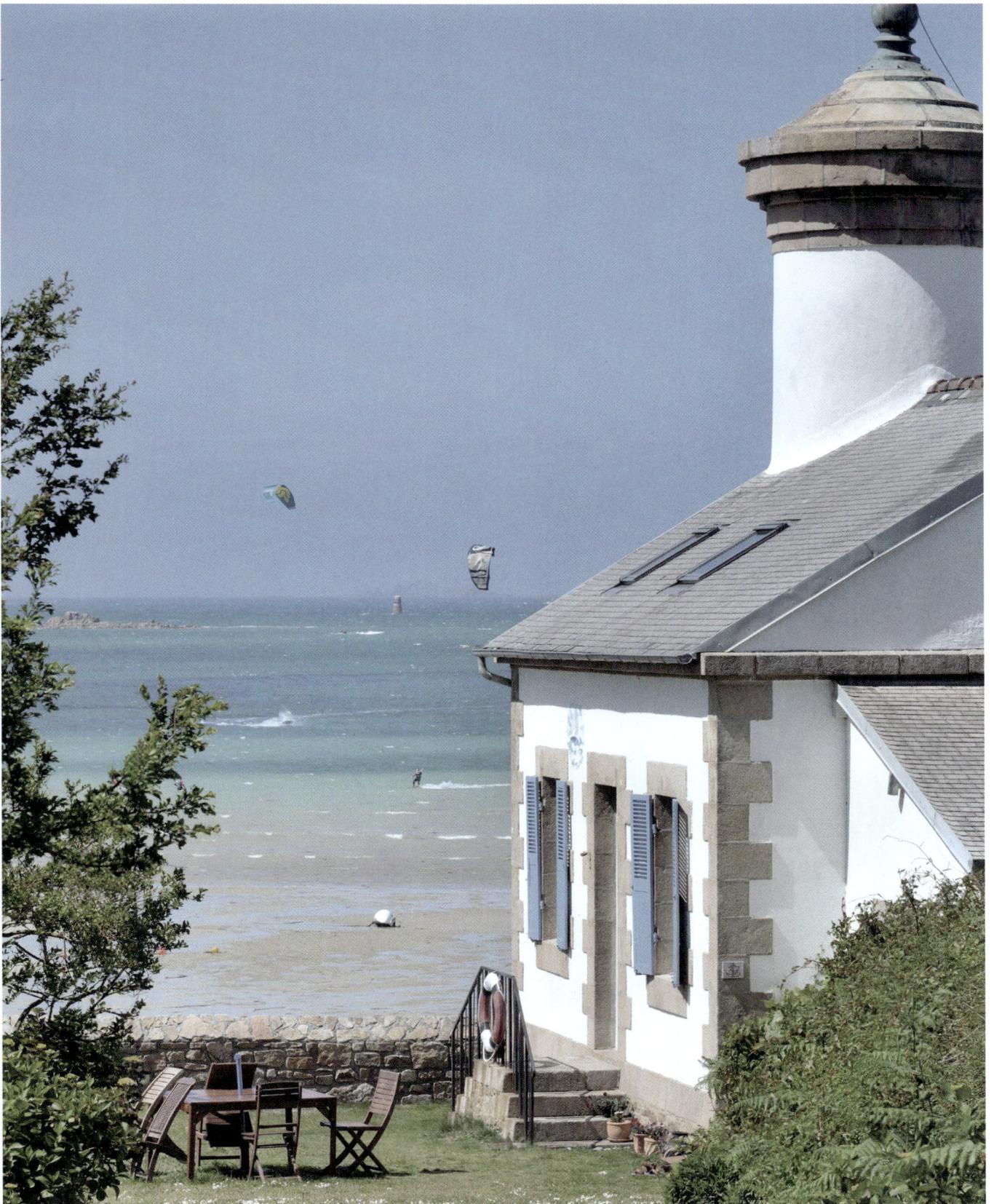

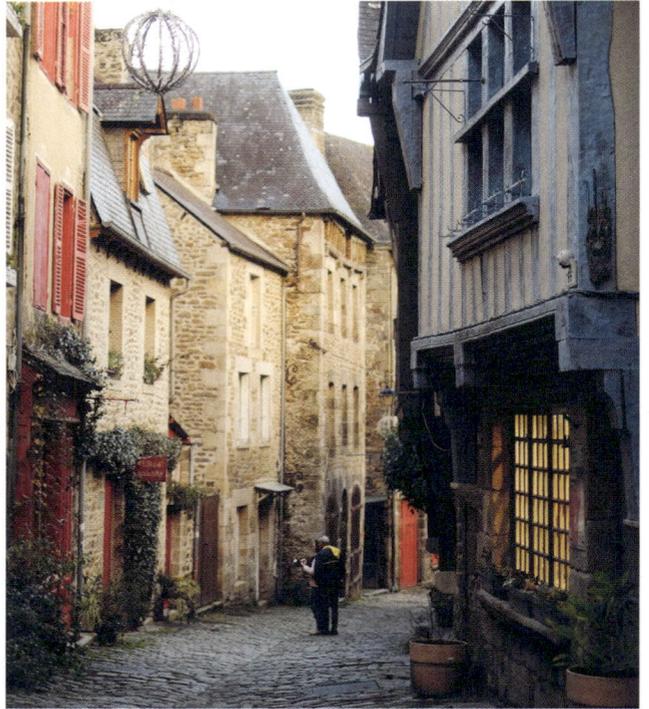

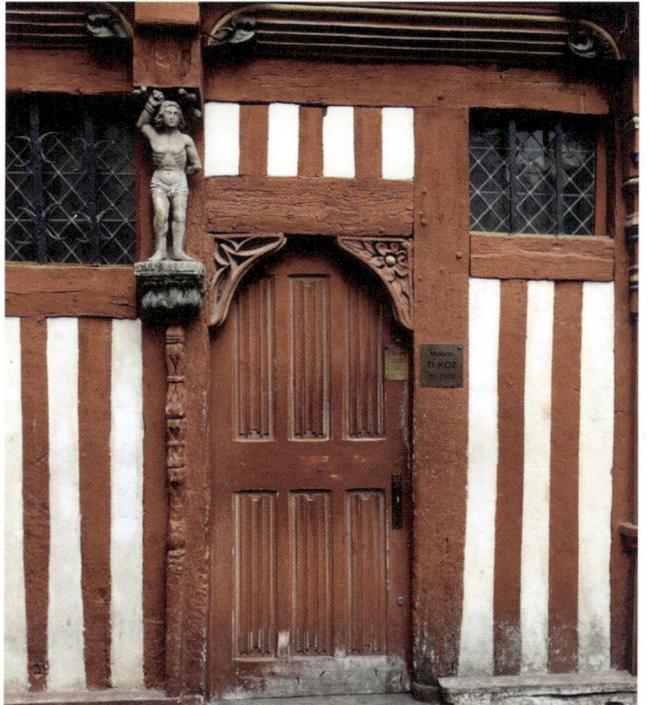

Above:
Dinan and Rennes captivate with the timeless allure of their medieval half-timbered and stone architecture.
Right:
The antiquarian bookstore Librairie Septentrion in Saint-Malo is a treasure trove for book lovers.

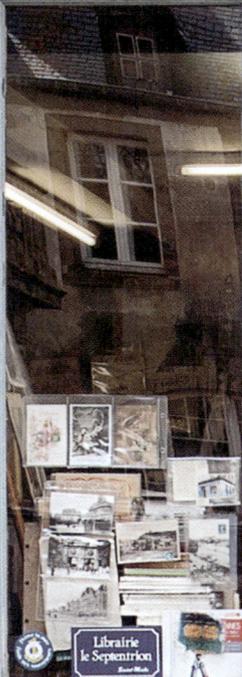

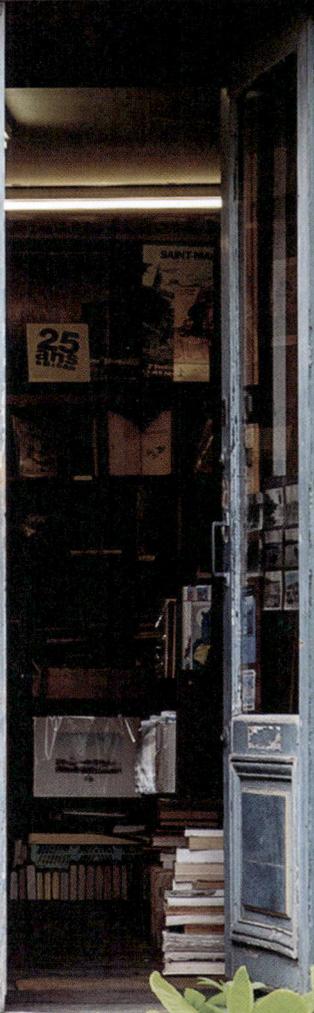

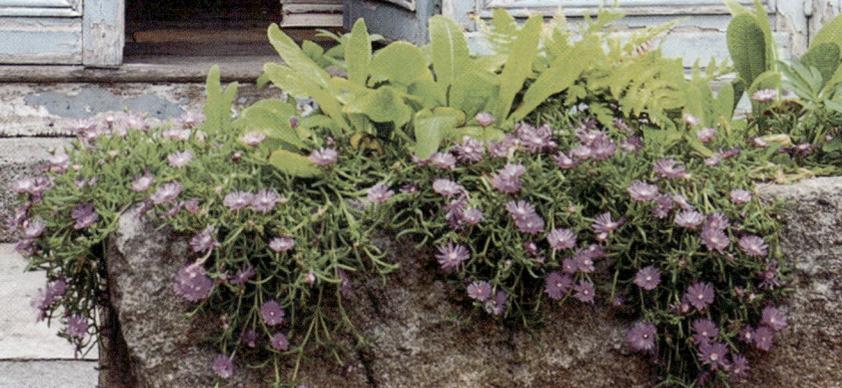

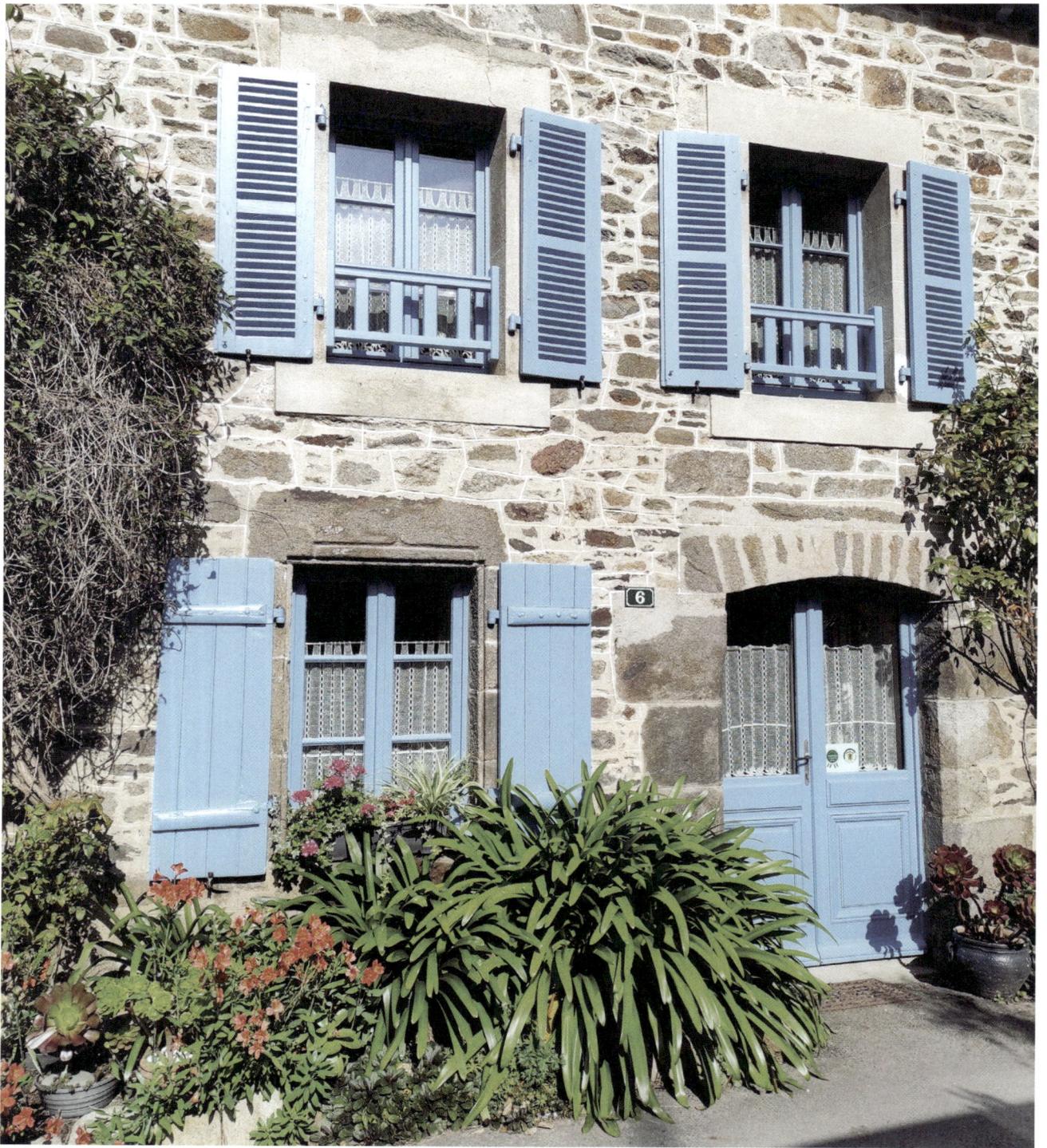

Above and at right:
*In the charming fishing village of Saint-Suliac, vibrant doors and window shutters lend a maritime charm
that softens the stark granite houses.*

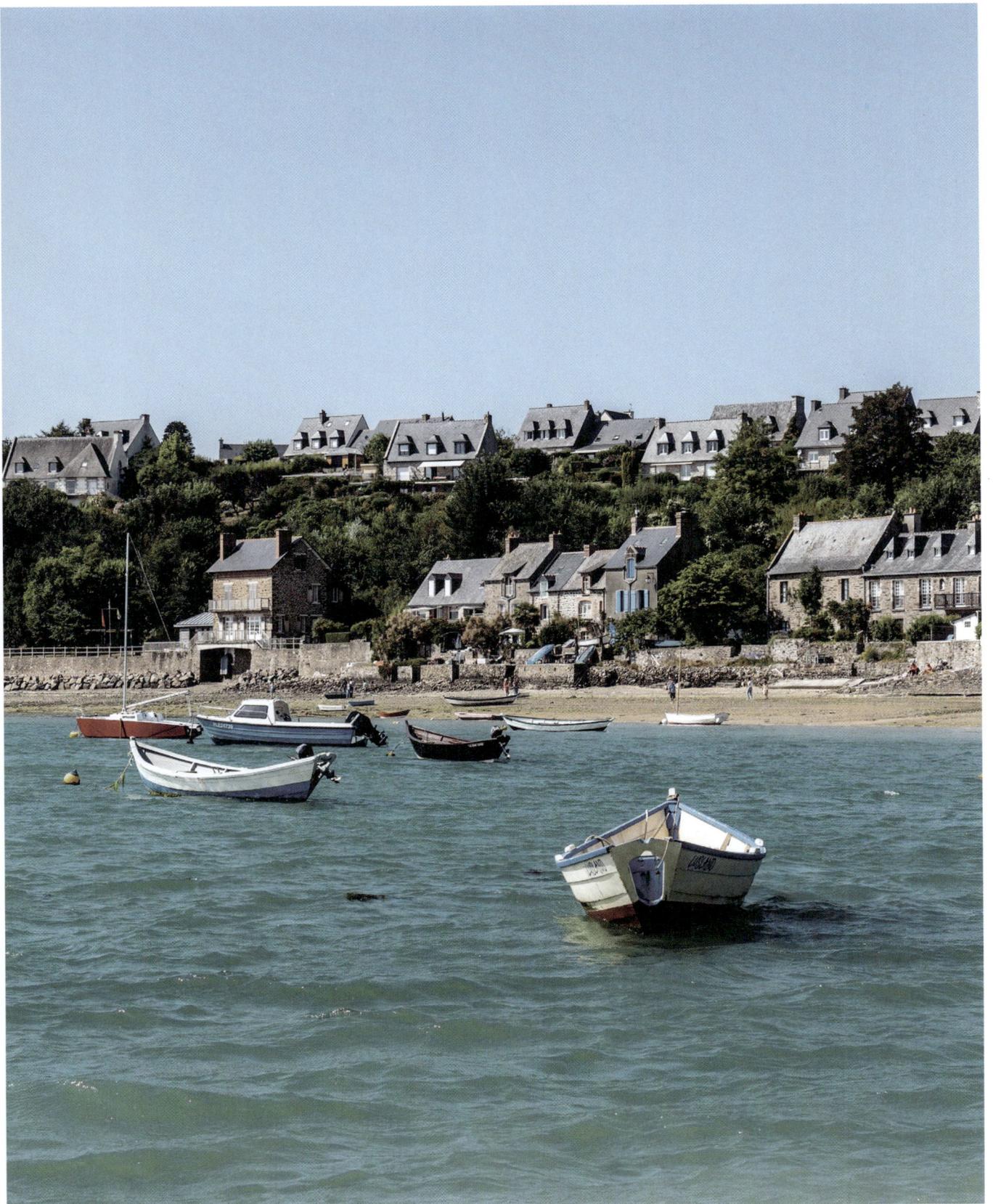

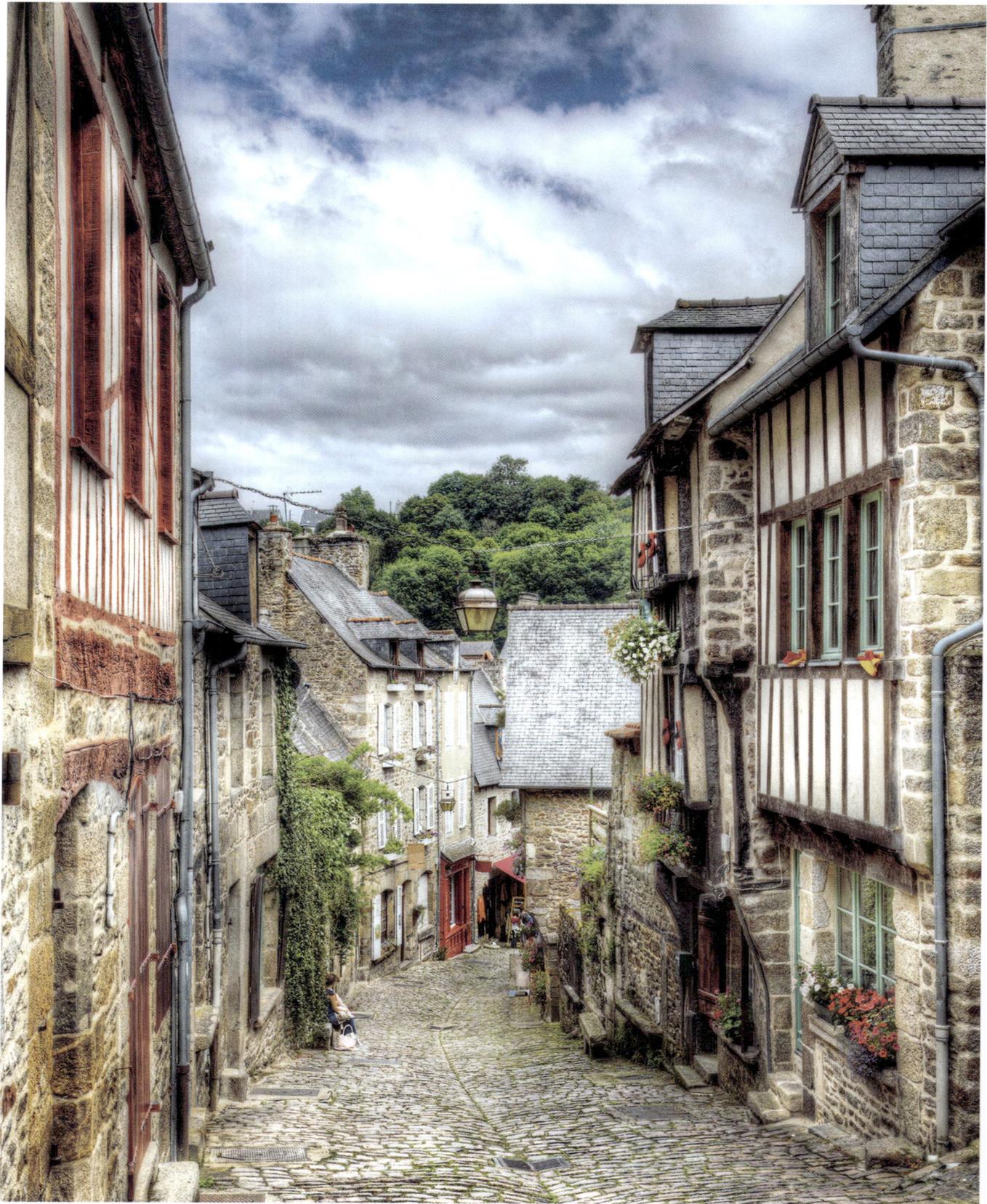

Above and at left:
Equally charming as in Saint-Suliac (both pictures above), Dinan showcases its beauty, where navigating the steep, rough pavement of Rue du Jerzual is no easy feat, but the picture-perfect idyll of the old houses rewards every step.

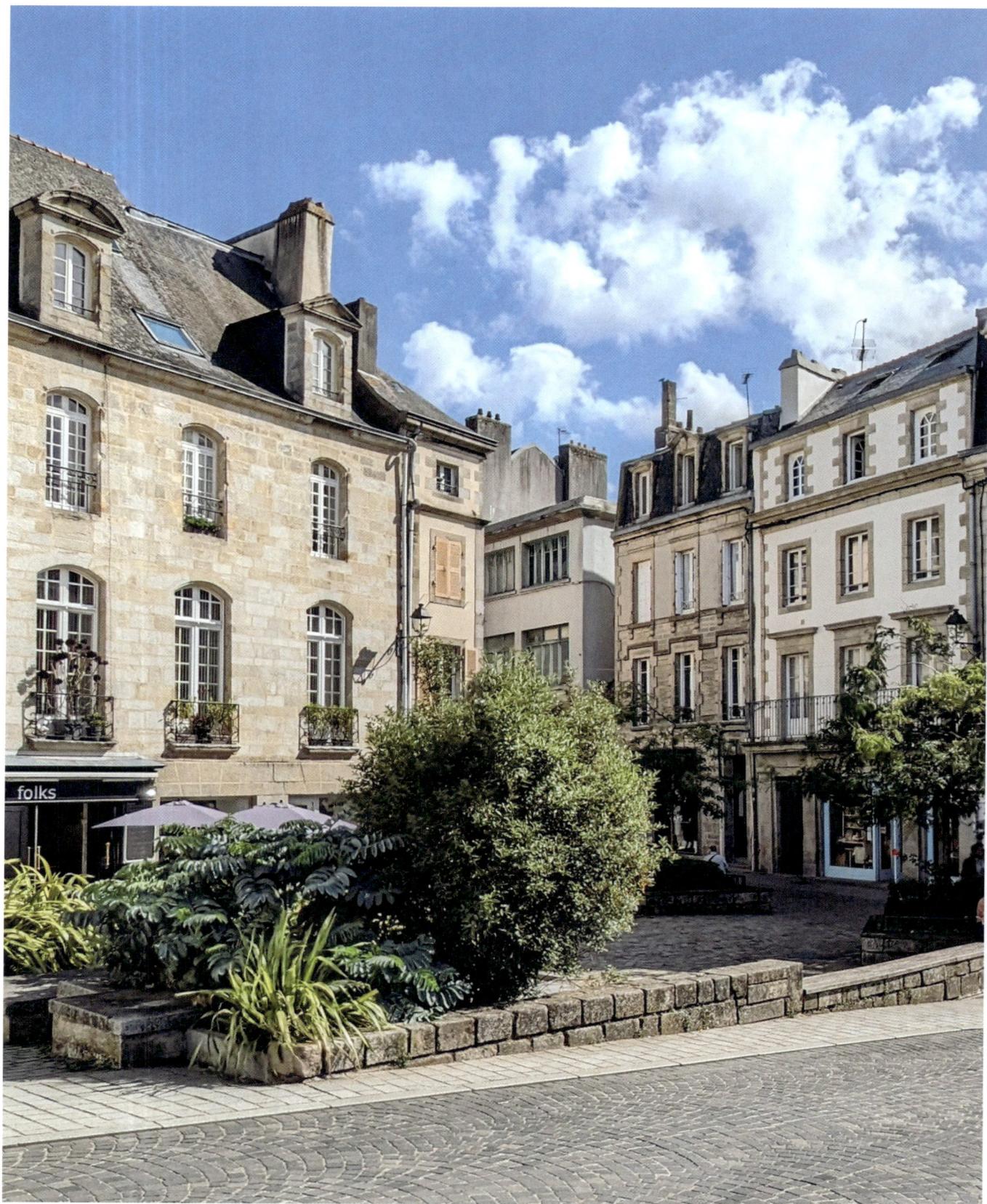

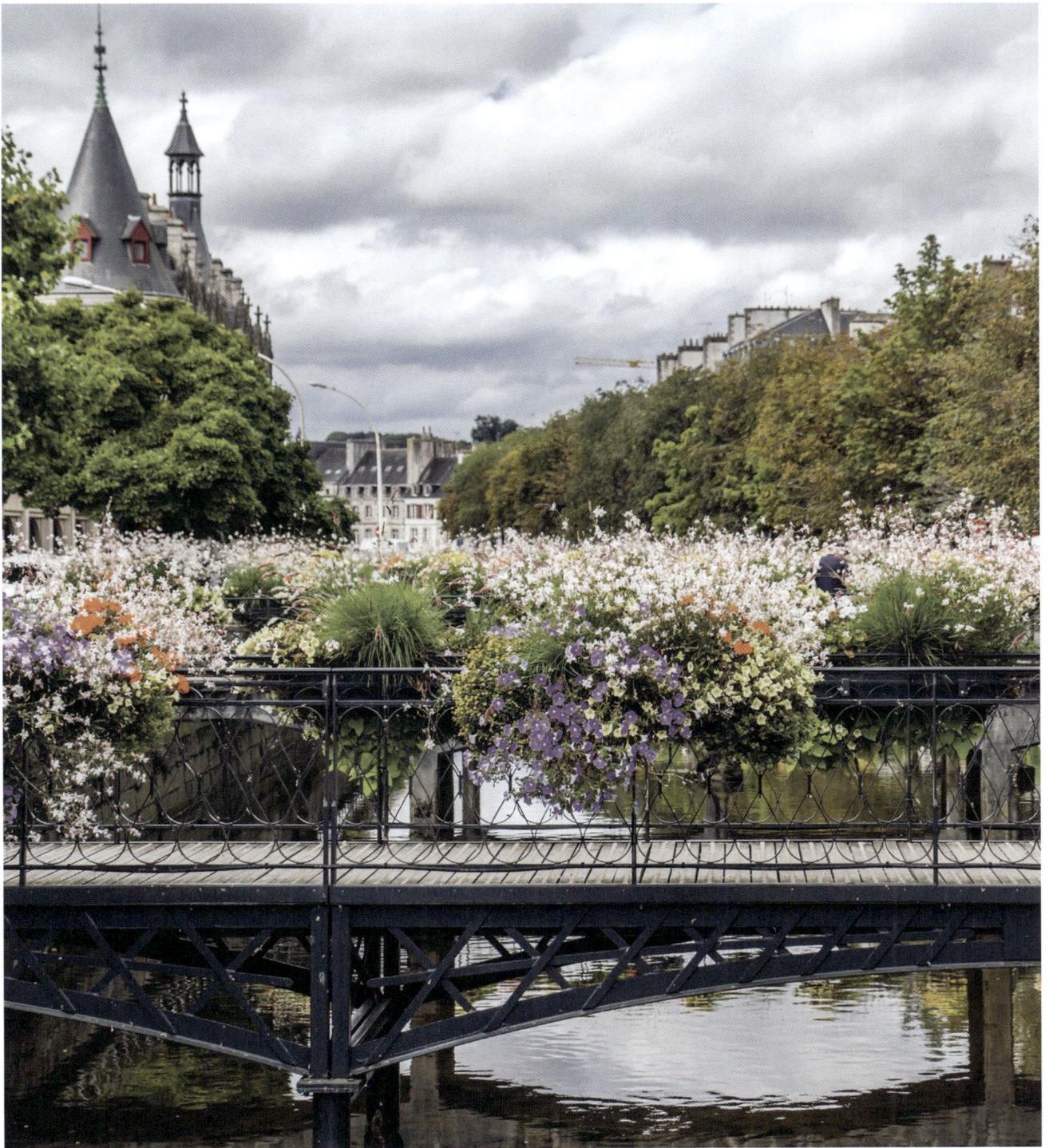

Above and at left:
When exploring Quimper's old town, pause at a café on Place Médard by the riverbank before wandering the cobblestone streets to Saint Corentin Cathedral.

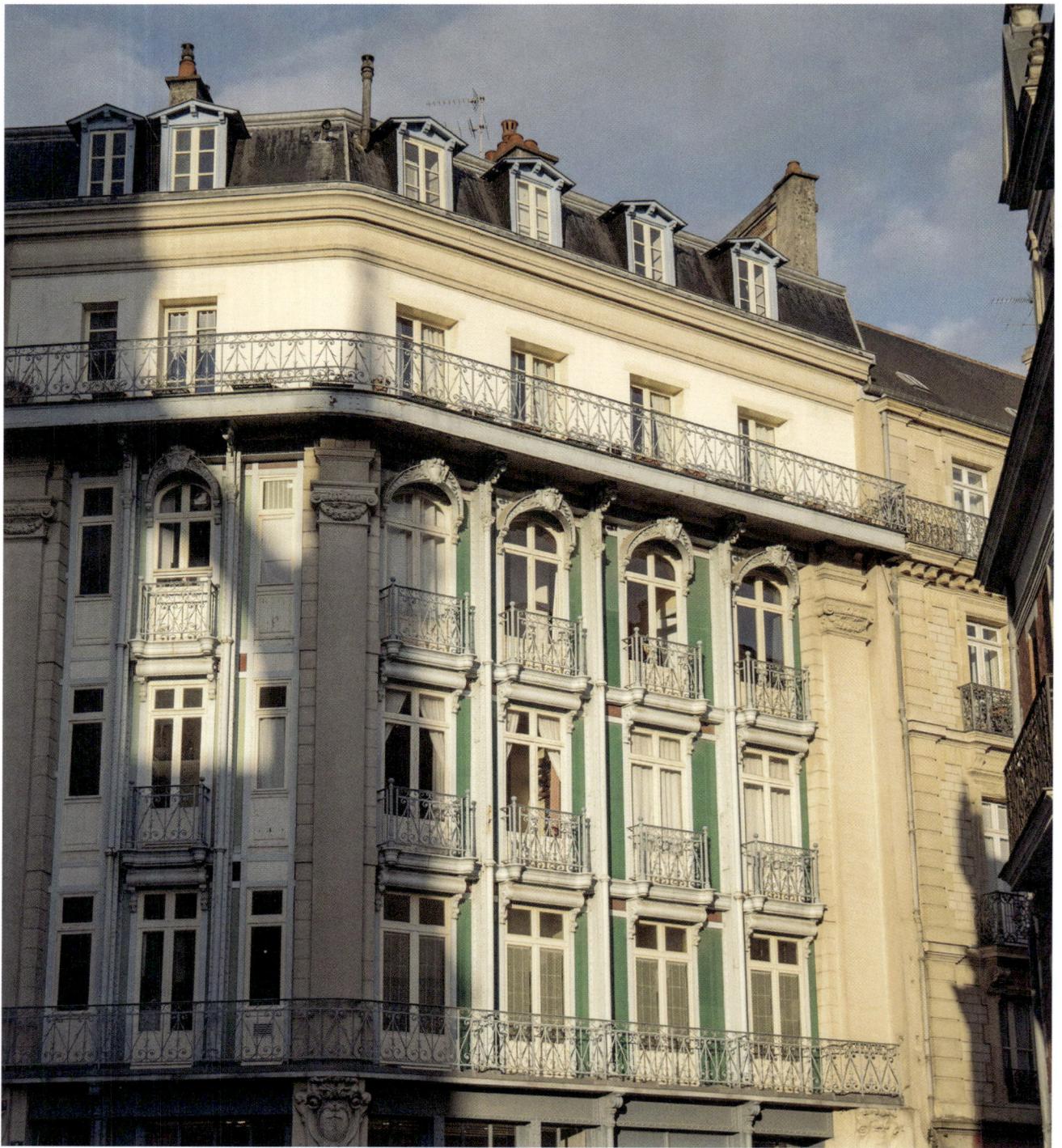

Above and at right:

The Art Deco façade of this vintage department store in central Rennes draws the eye with its delicate filigree. From quaint old shops to the Basilica of Notre-Dame de Bonne Nouvelle, it is always rewarding to look up at Rennes' façades.

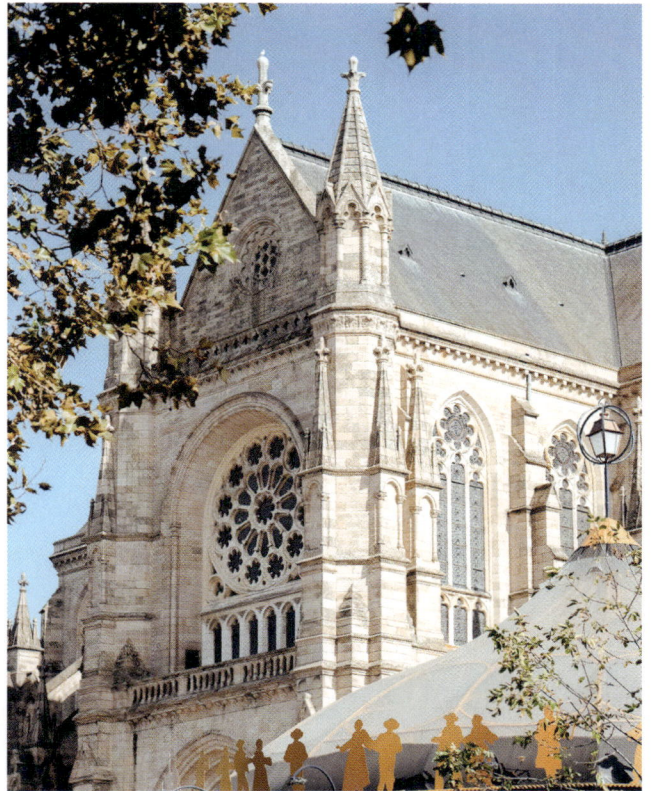

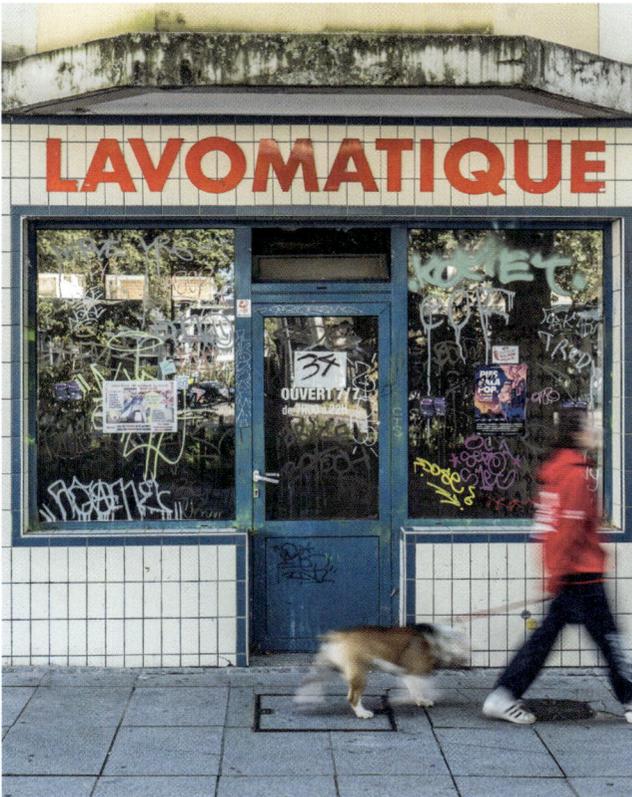

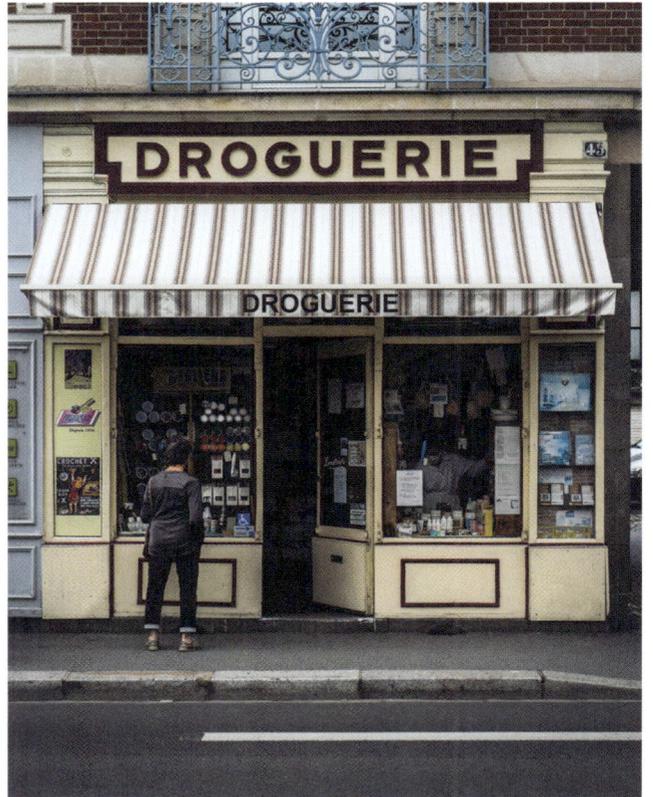

La Normandie et le Nord

RUGGED NORTHERN CHARM

Like Brittany, the very name of Normandy evokes a striking coastline. Among the most picturesque stretches is La Côte d'Albâtre, the "Alabaster Coast", between Le Havre and Dieppe, famed for its pale chalk cliffs. Near Étretat, the cliffs mesmerize with shifting hues of the sea and dramatic formations around the Porte d'Aval. No wonder Impressionists like Monet and Degas were drawn to this breathtaking landscape. In far-western Normandy lies the legendary tidal island of Mont-Saint-Michel with its many layers of history. Founded over a thousand years ago as a monastery dedicated to the archangel Michael, the fortress-like rocky hill later became a grim prison colony. Climbing the steep steps to the majestic abbey on a stormy day immerses you in the haunting beauty of its ancient walls. By contrast, Veules-les-Roses, one of Normandy's oldest villages, feels like something out of a storybook. Life has flourished here at the mouth of France's tiniest river since the fourth century. Thatched half-timbered houses stand beside sturdy flint and red-brick buildings. It's no surprise Victor Hugo and other artists were enthralled by the village's picturesque character, which earned it a place among the "most beautiful villages in France". Farther northeast, Lille buzzes with energy. Lille boasts the birthplace of Charles de Gaulle in its historic center of Vieux Lille. Here seventeenth-century Flemish townhouses with brightly colored, ornate façades line the streets near the imposing star-shaped citadel. As the polyphonic chimes of the carillon ring out from the tower at the town hall, the *carillonneur* commands your attention, preserving the region's cultural heritage and keeping alive a cherished tradition among Lille's proud residents.

Right:
The play of light and shadow along the chalk cliffs of Étretat once captivated Claude Monet. The rocky giants with their cleaved forms shift appearances as swiftly as the coastal weather.

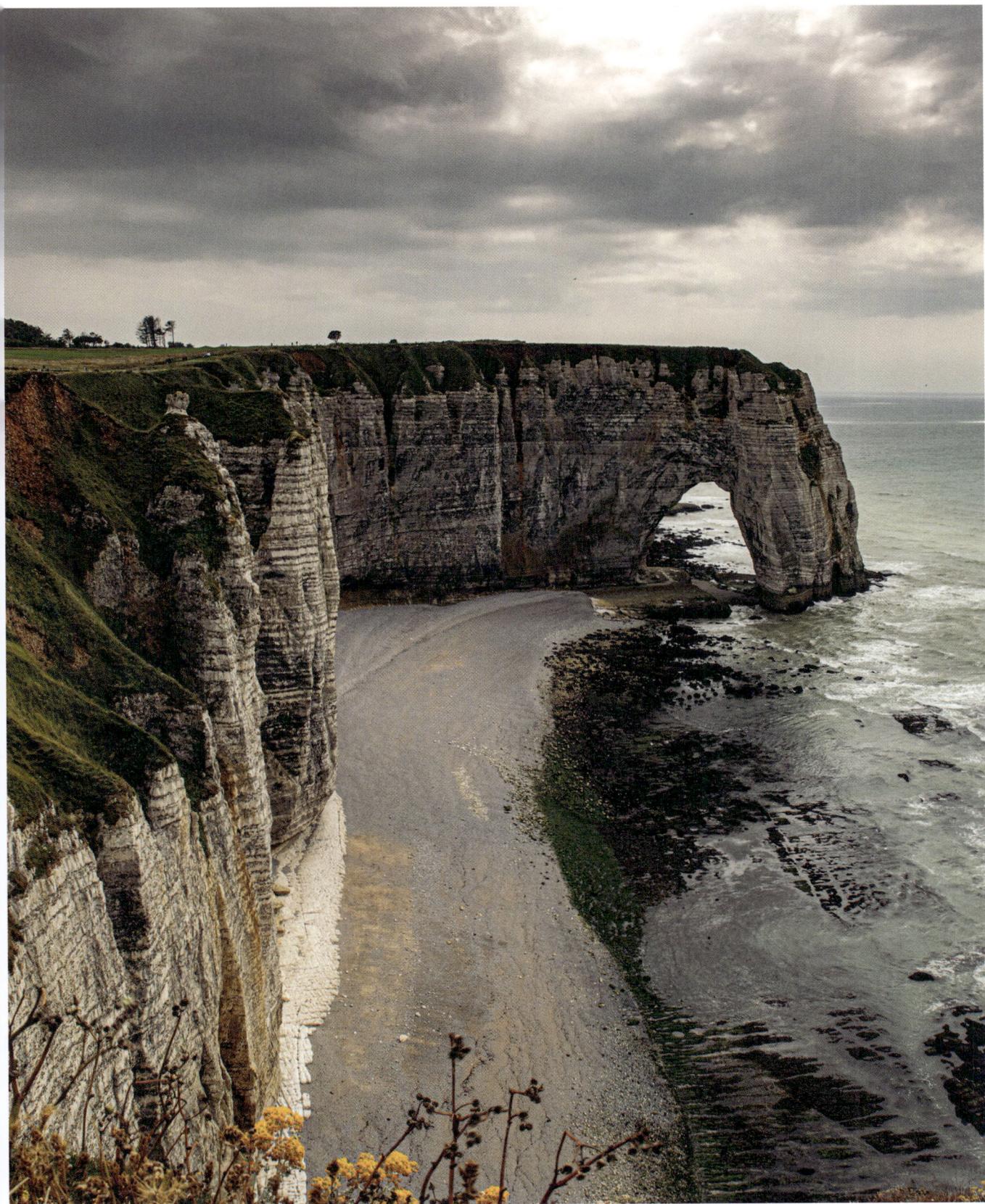

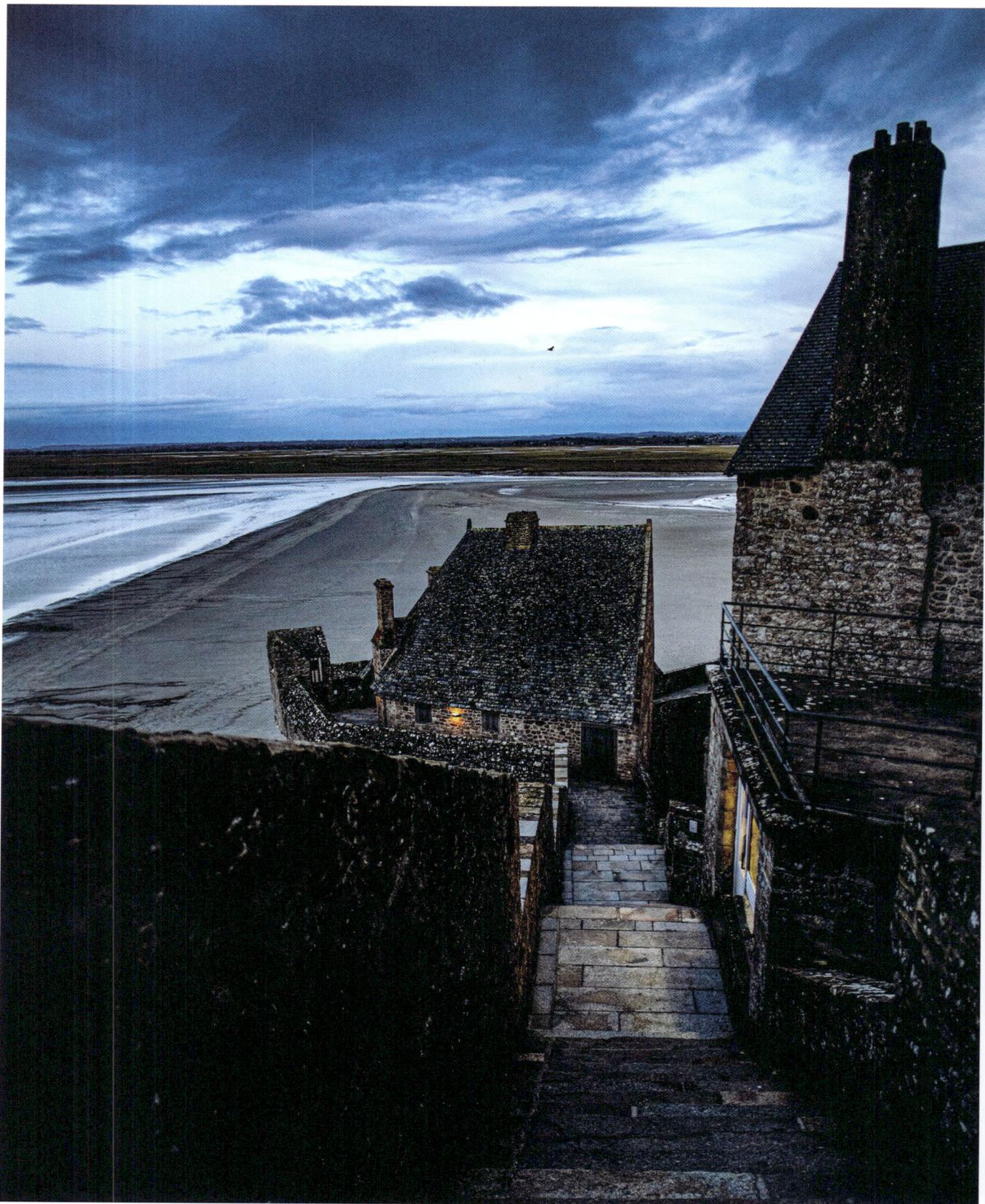

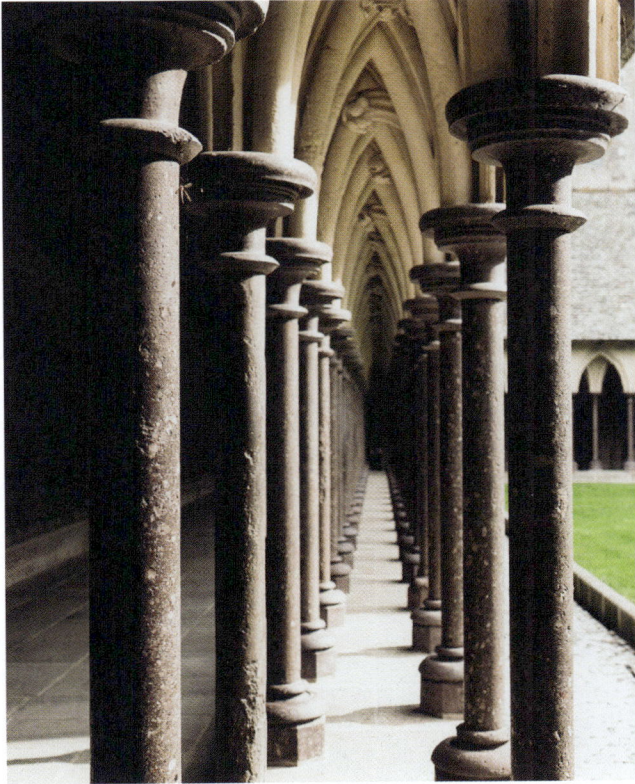

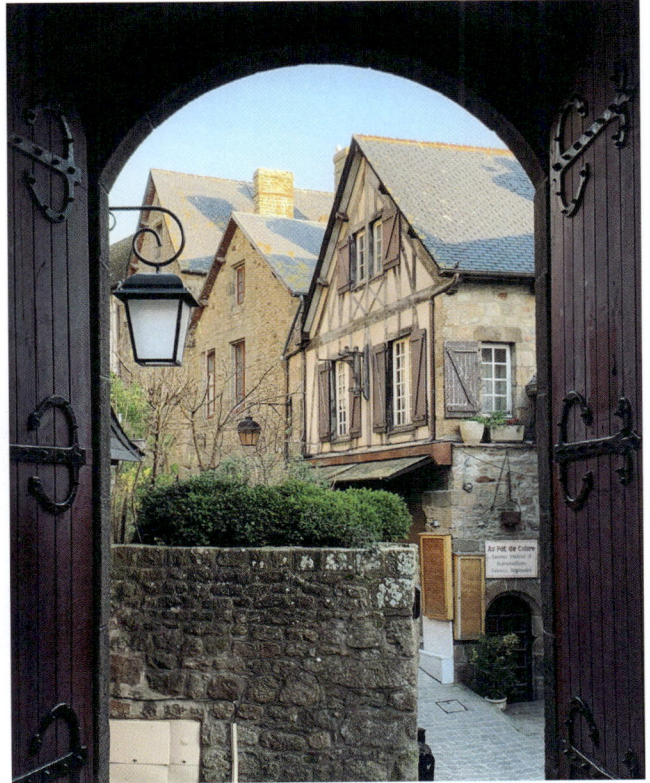

Above and at left:
A storm is approaching, and the majestic tidal island of Mont-Saint-Michel reveals its most dramatic face.
It's a chance to explore this beloved World Heritage site with a smaller crowd.

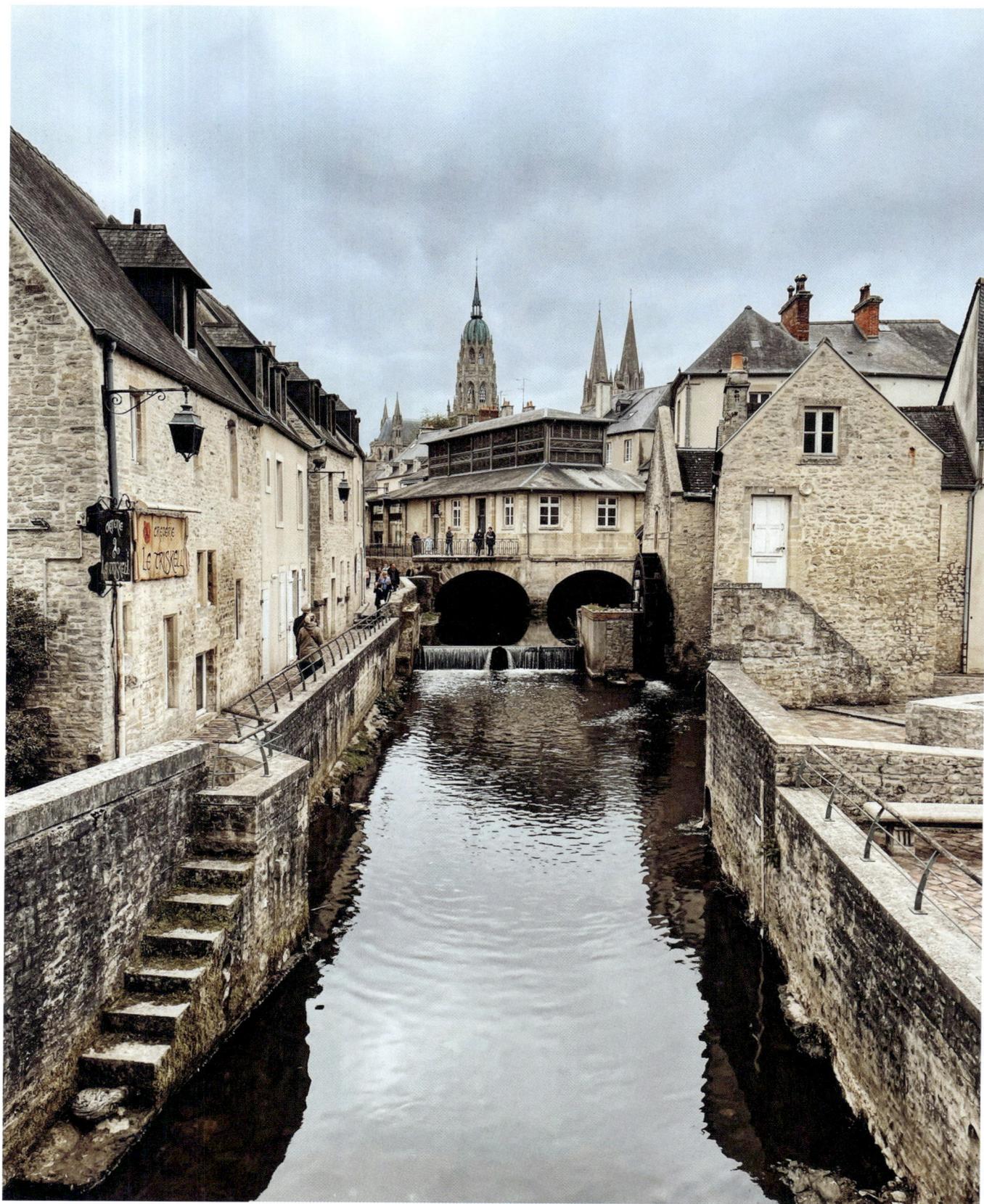

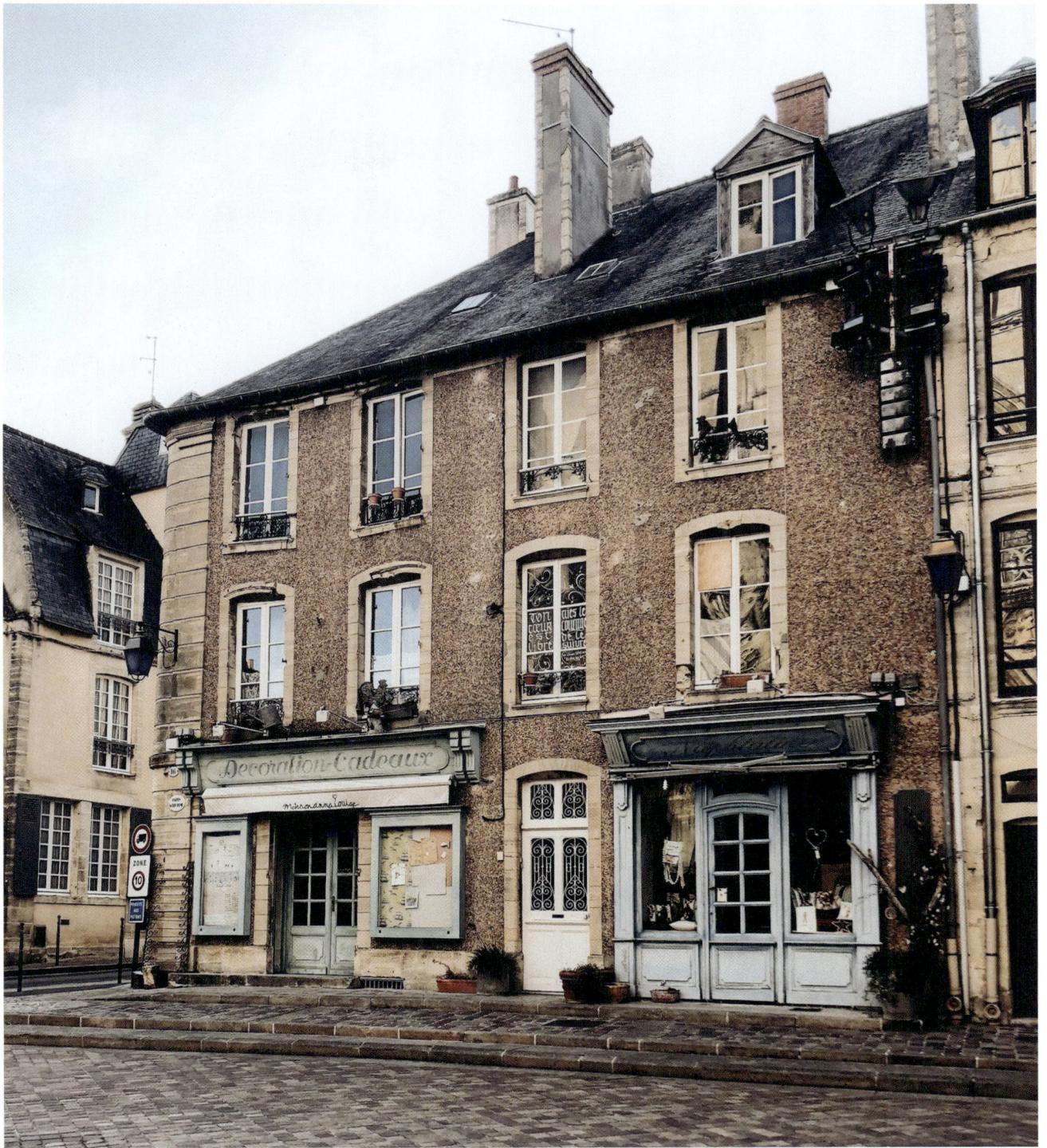

Above and at left:
Bayeux is best known for its 68-meter-long tapestry, legendarily attributed to Queen Matilda, wife of William the Conqueror—a remarkable historical narrative spun in fabric and yarn. The old town surrounding Cathédrale Notre-Dame de Bayeux exudes a similarly fascinating charm.

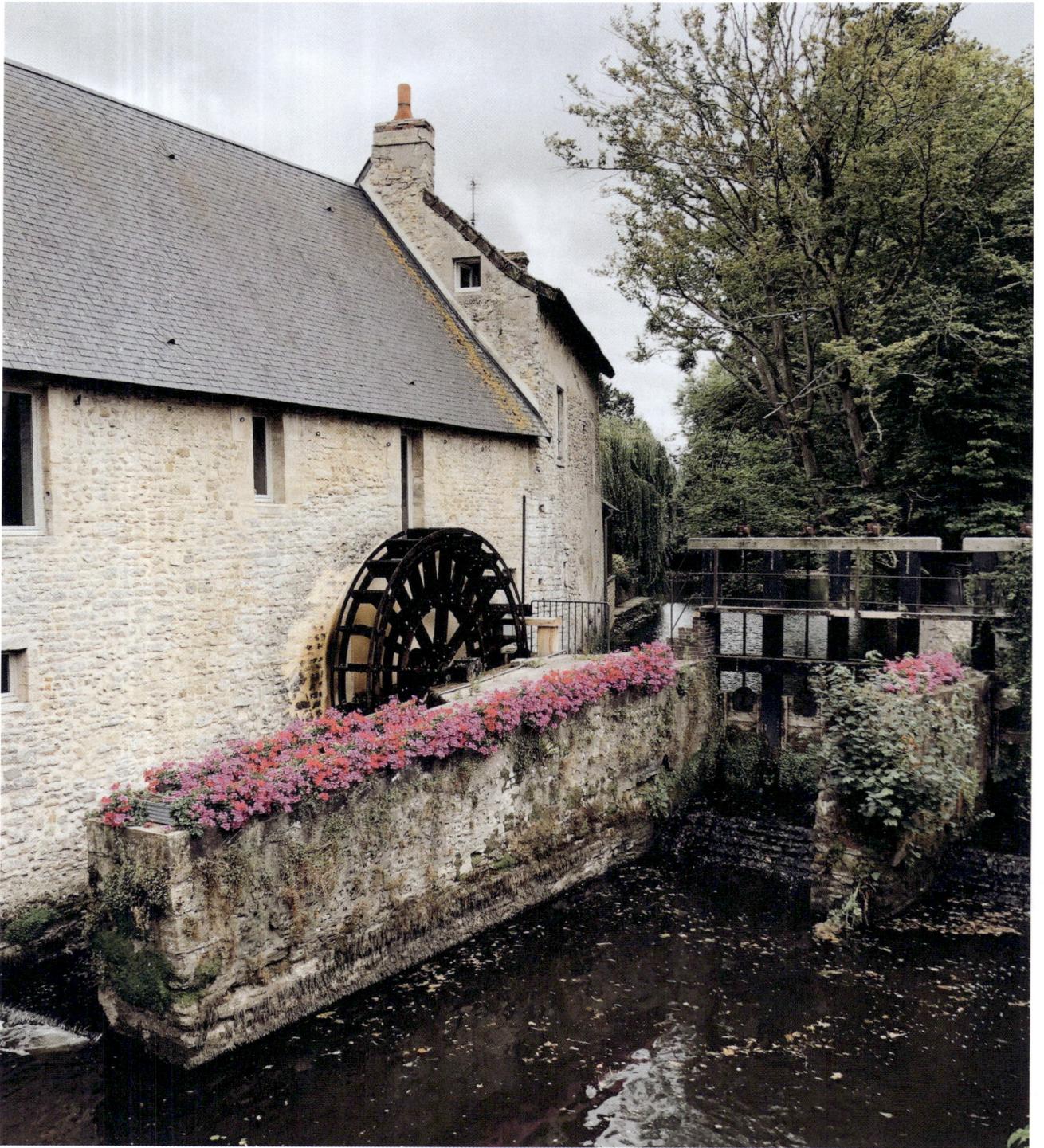

Above and at right:
Views along the river Aure, winding through Bayeux, offer charming impressions of the medieval mill.

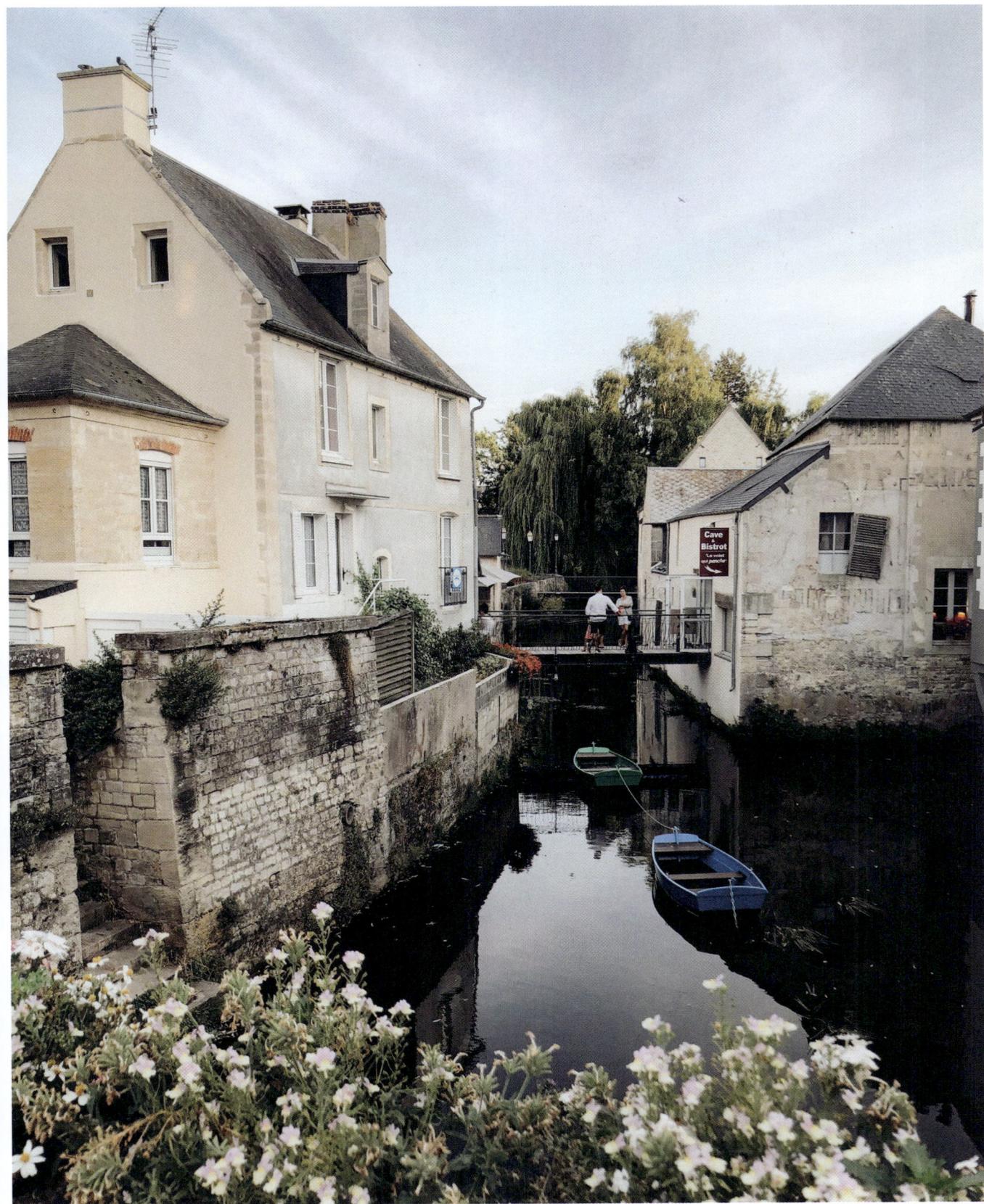

CHOCOLATERIE ~ EP

Spécialité
PATES
À TARTINER
de Mathilde

LE COMPTOIR DE MA

LE COMPTOIR DE MATHILDE

LE CO

COMESTIBLES

VENTE
EN
GROS
ET
DÉTAIL

terrines

TAPENA

LE COMPTOIR DE
MATHILDE

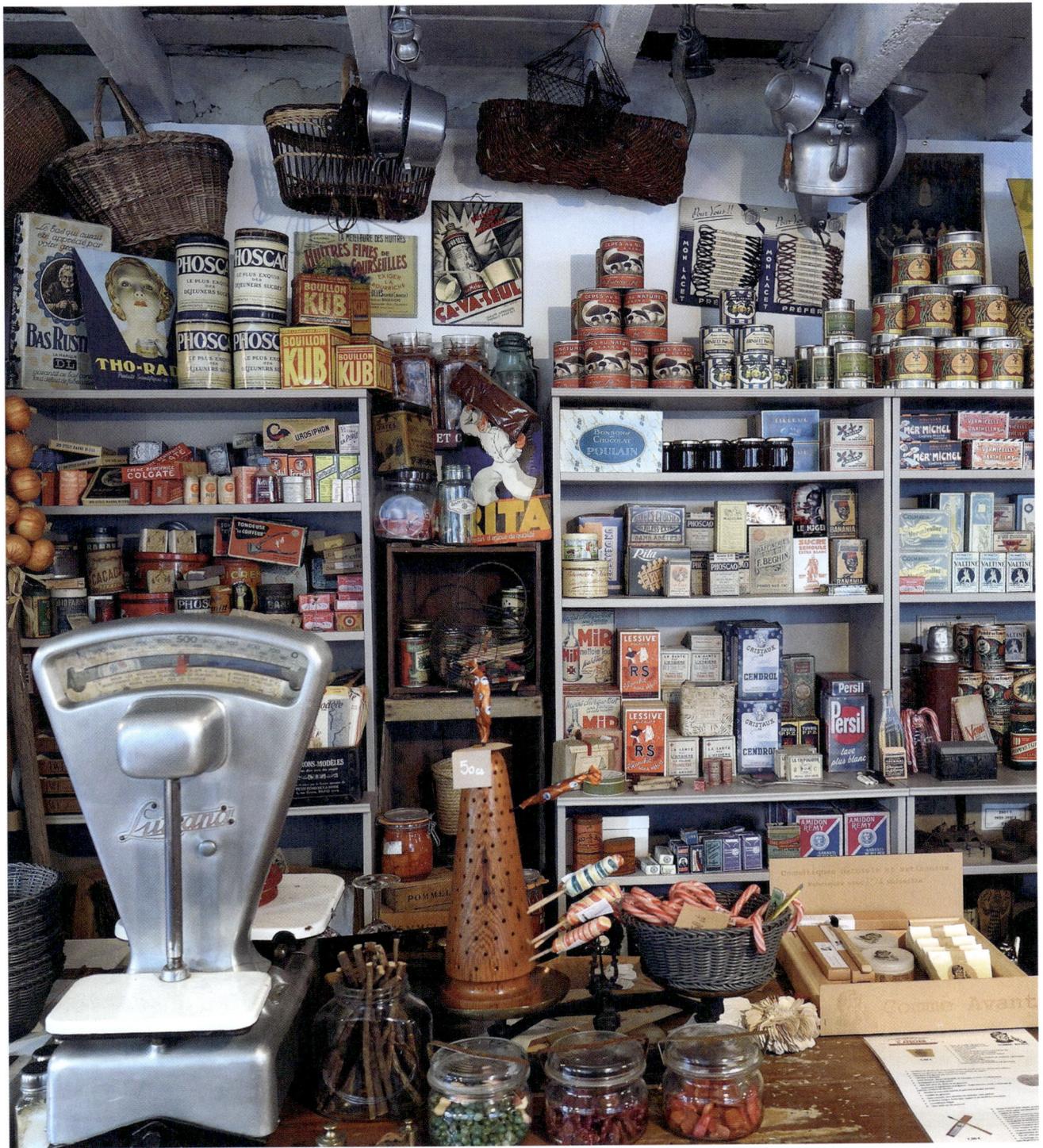

Above and at left:
The old storefronts evoke nostalgia for the old days; some have even been preserved as museums.

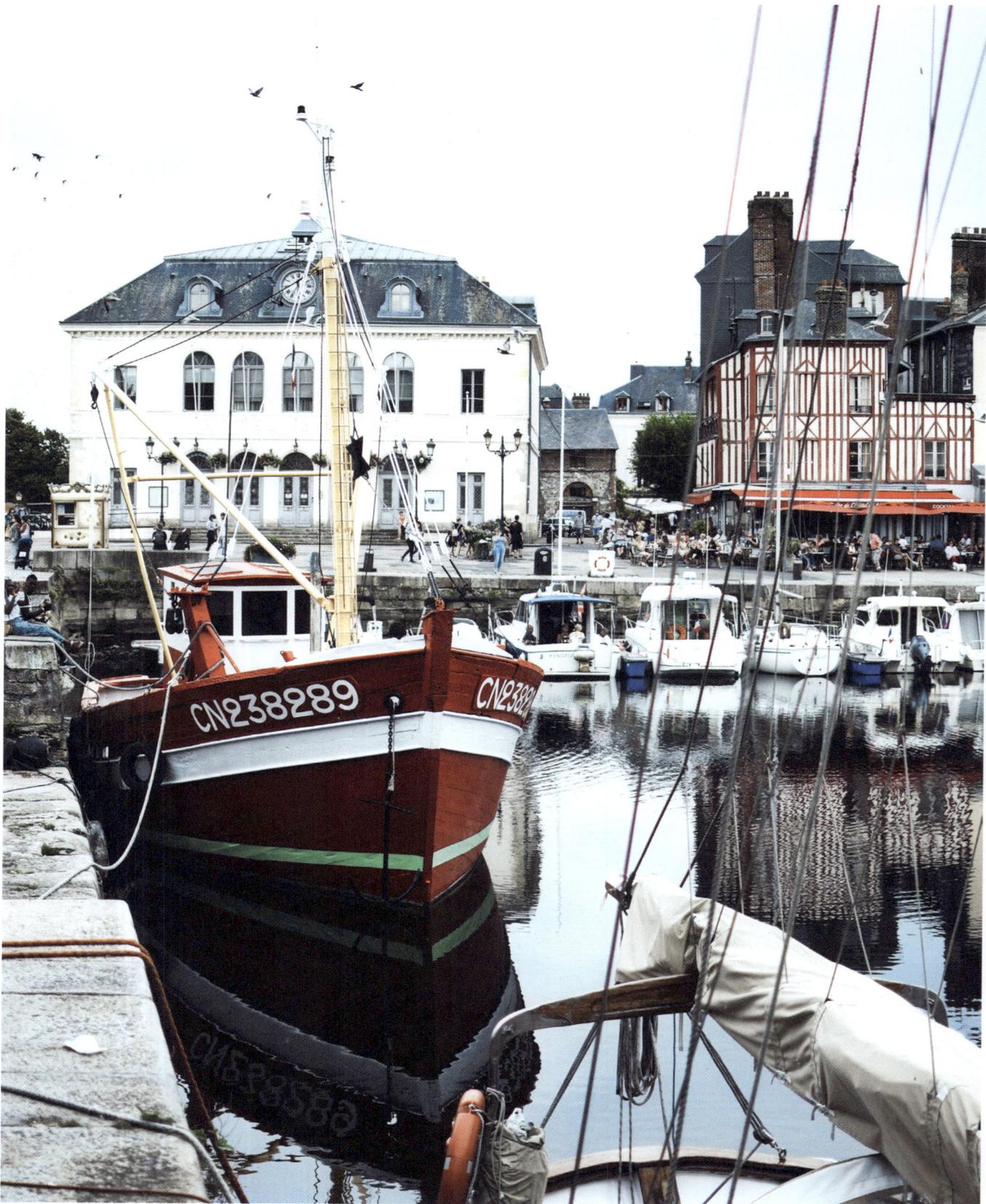

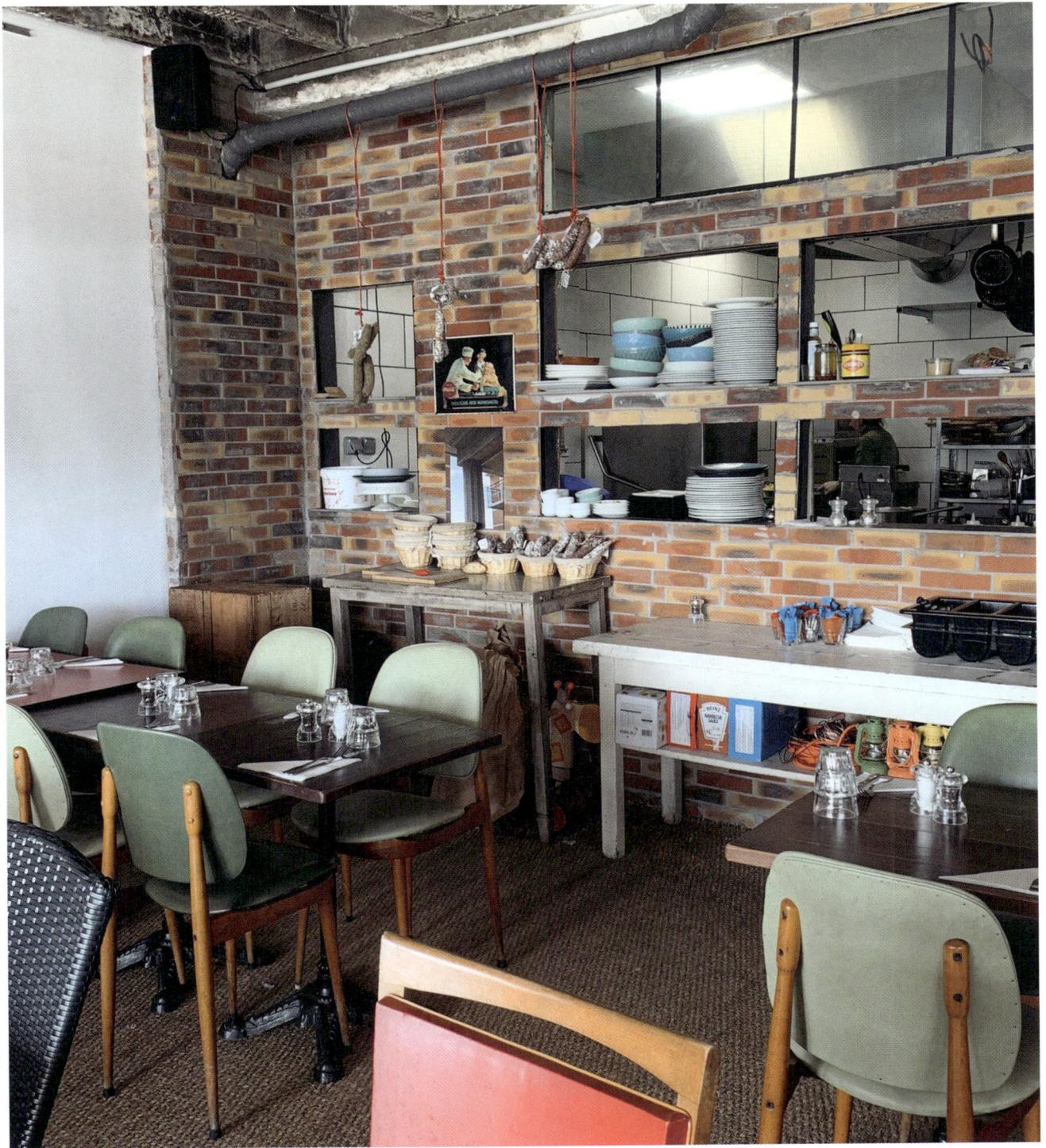

Above and at left:
Follow in Monet's footsteps to the old harbor of Honfleur, where fishing vessels bob in the water, or check out the restaurants in Le Havre: Two captivating port towns on the Seine estuary.

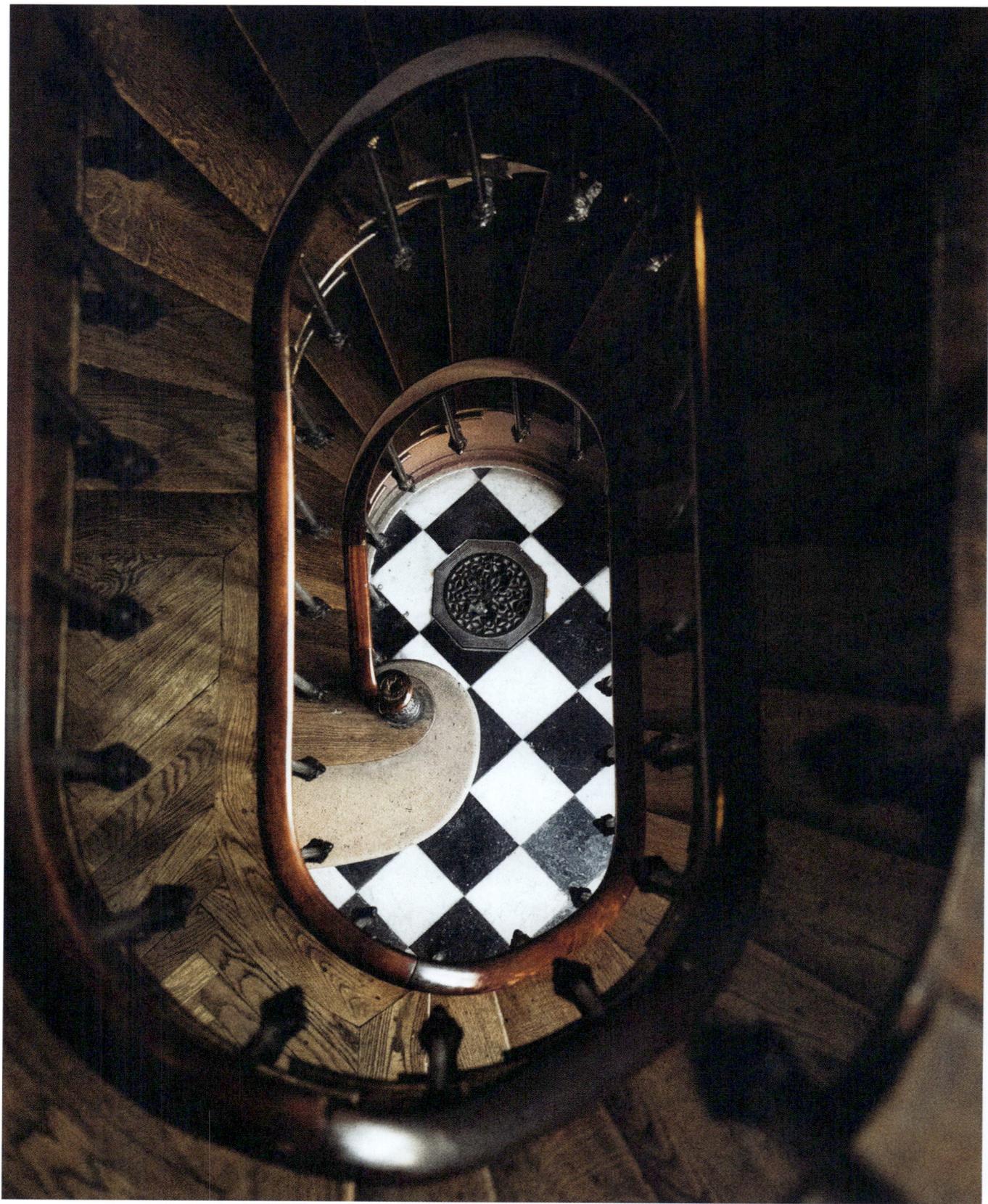

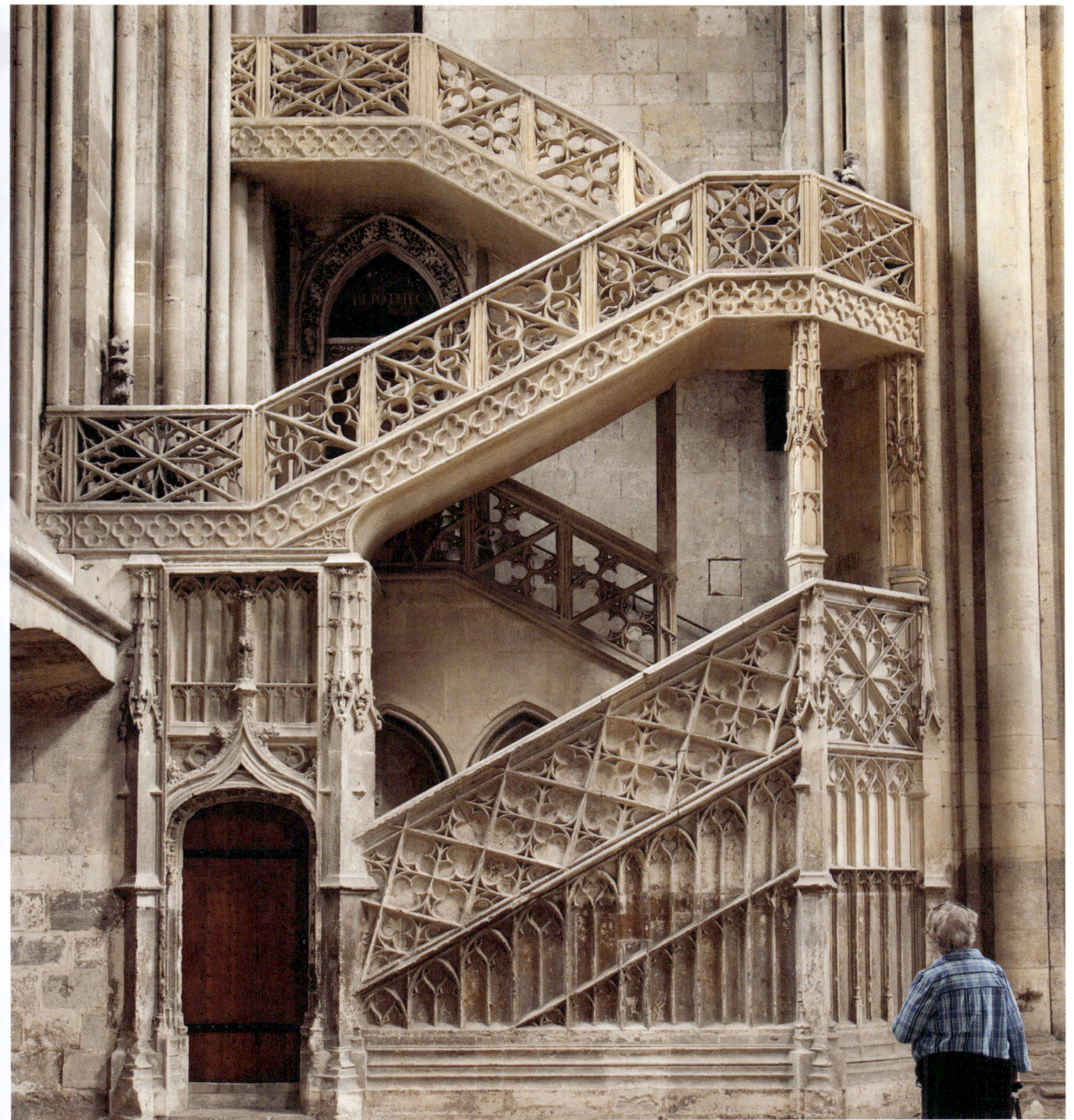

Above and at left:
*Old spiral staircases possess a mysterious allure—yet few can rival the delicate splendor of the filigree staircase
in Rouen Cathedral.*

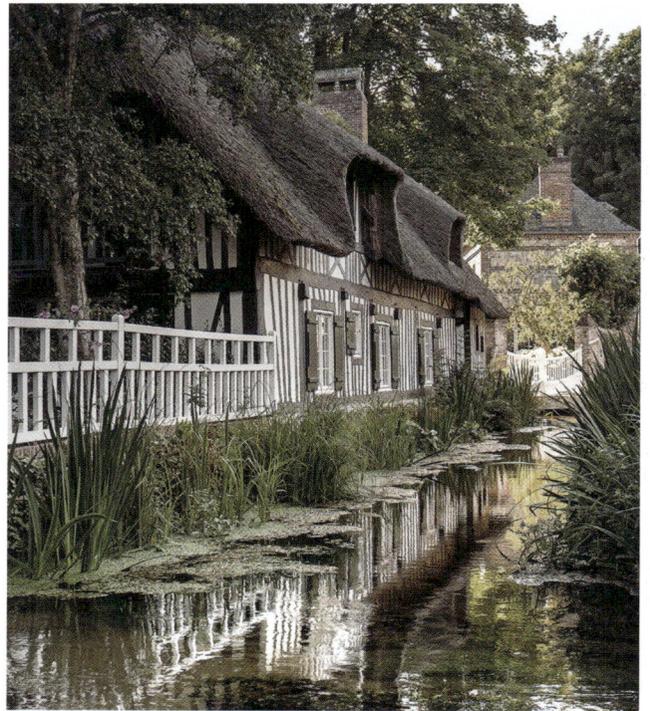

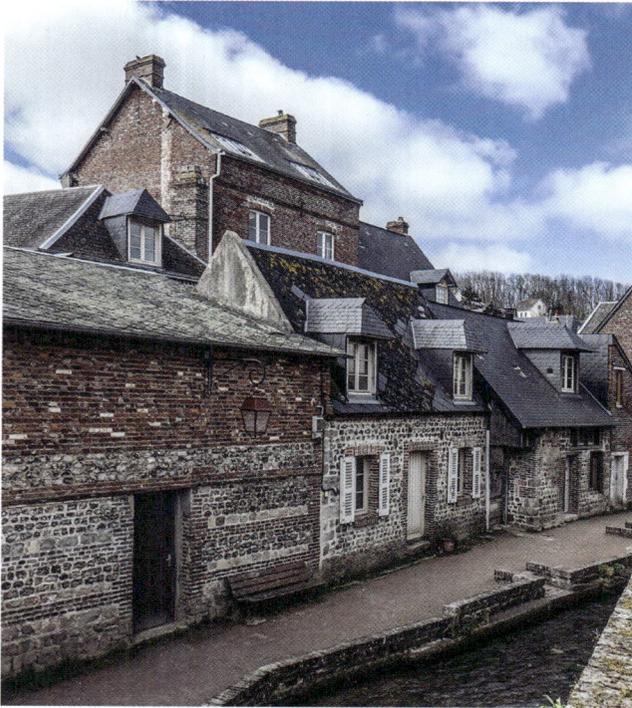

Above and at right:
The idyllic village of Veules-les-Roses on the English Channel is a gem: half-timbered houses with thatched roofs and old water wheels line the banks of France's most diminutive river.

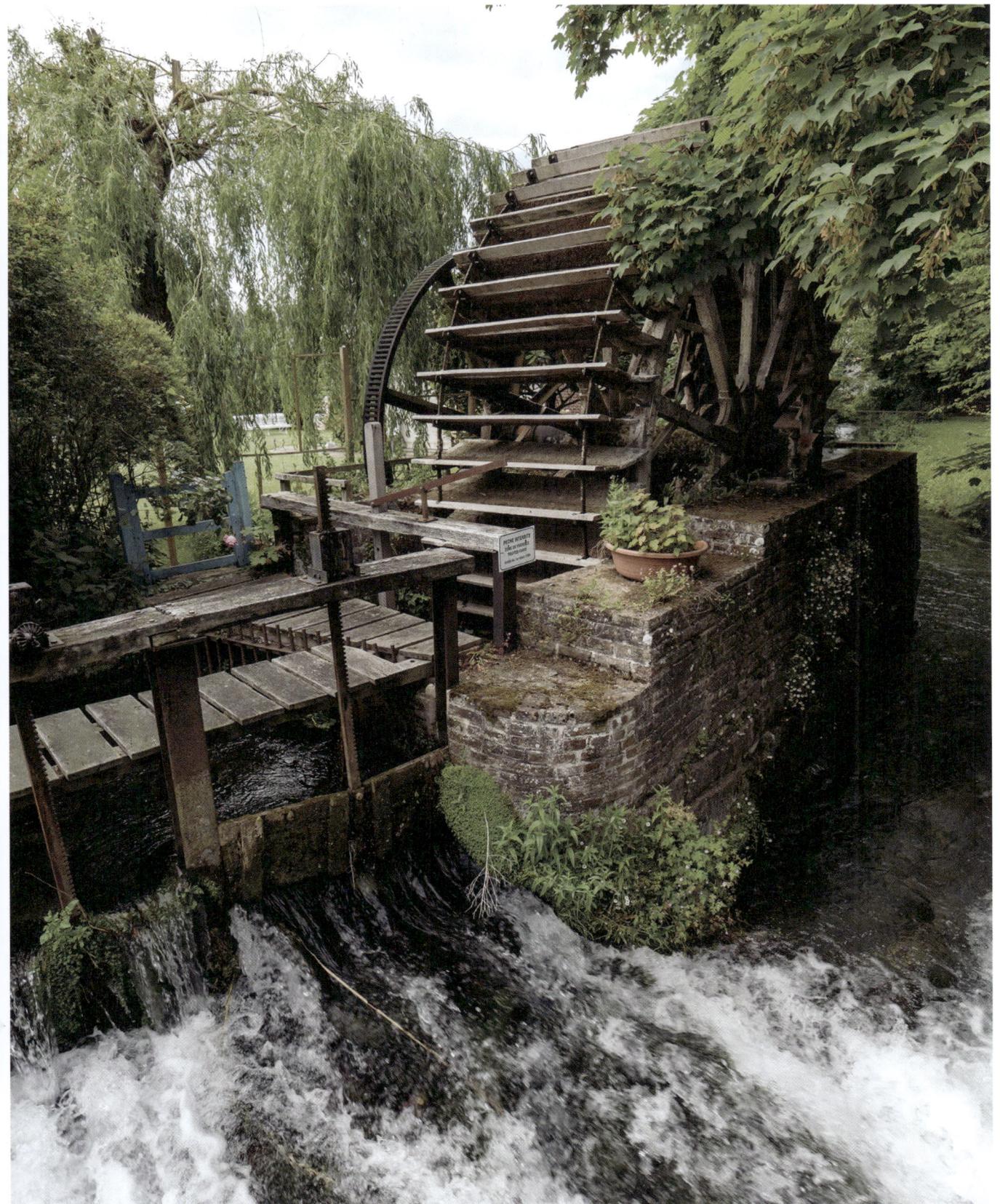

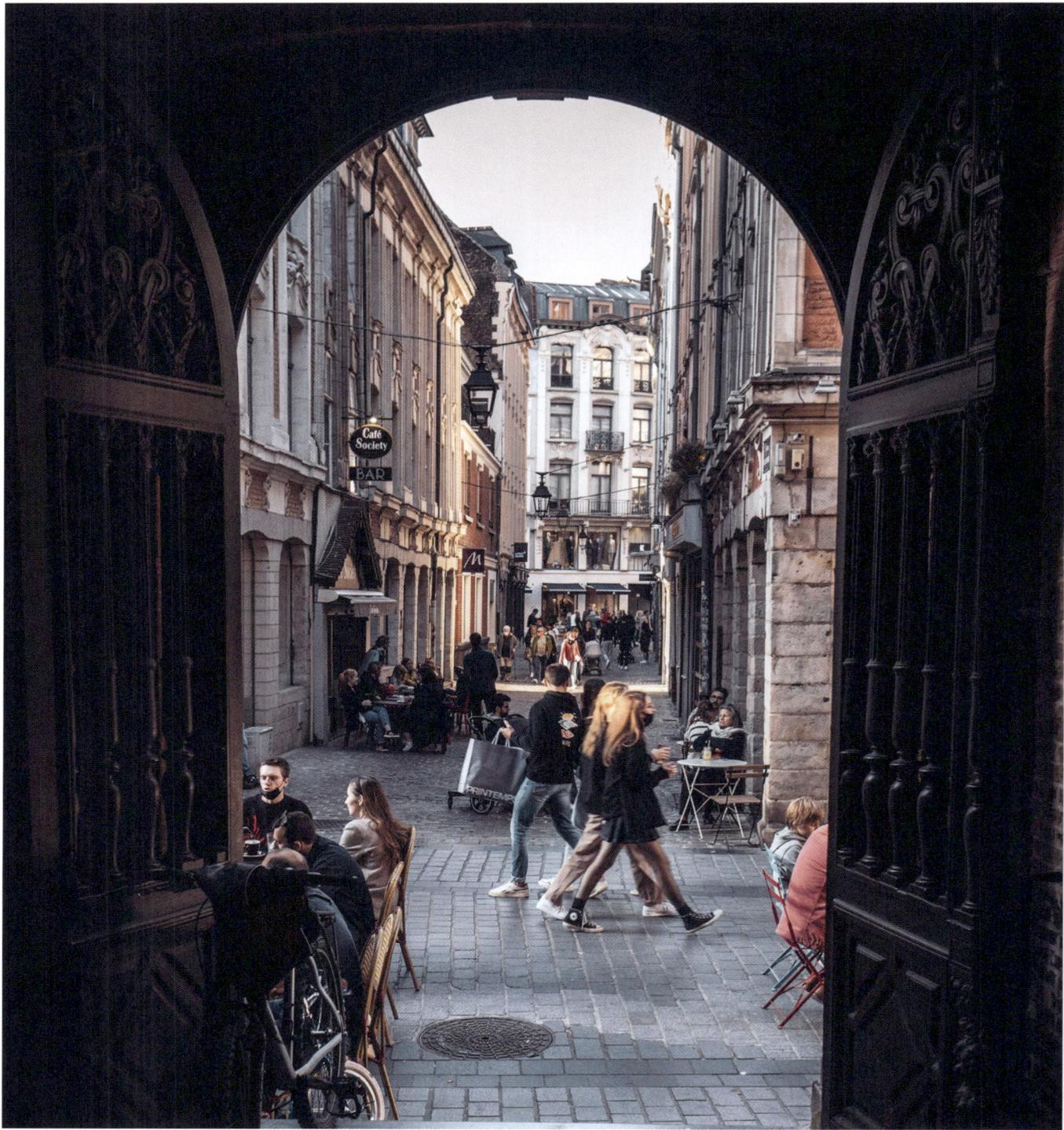

Above and at right:
Lille's old town, tucked beside the historic citadel, teems with charming cafés and independent shops.

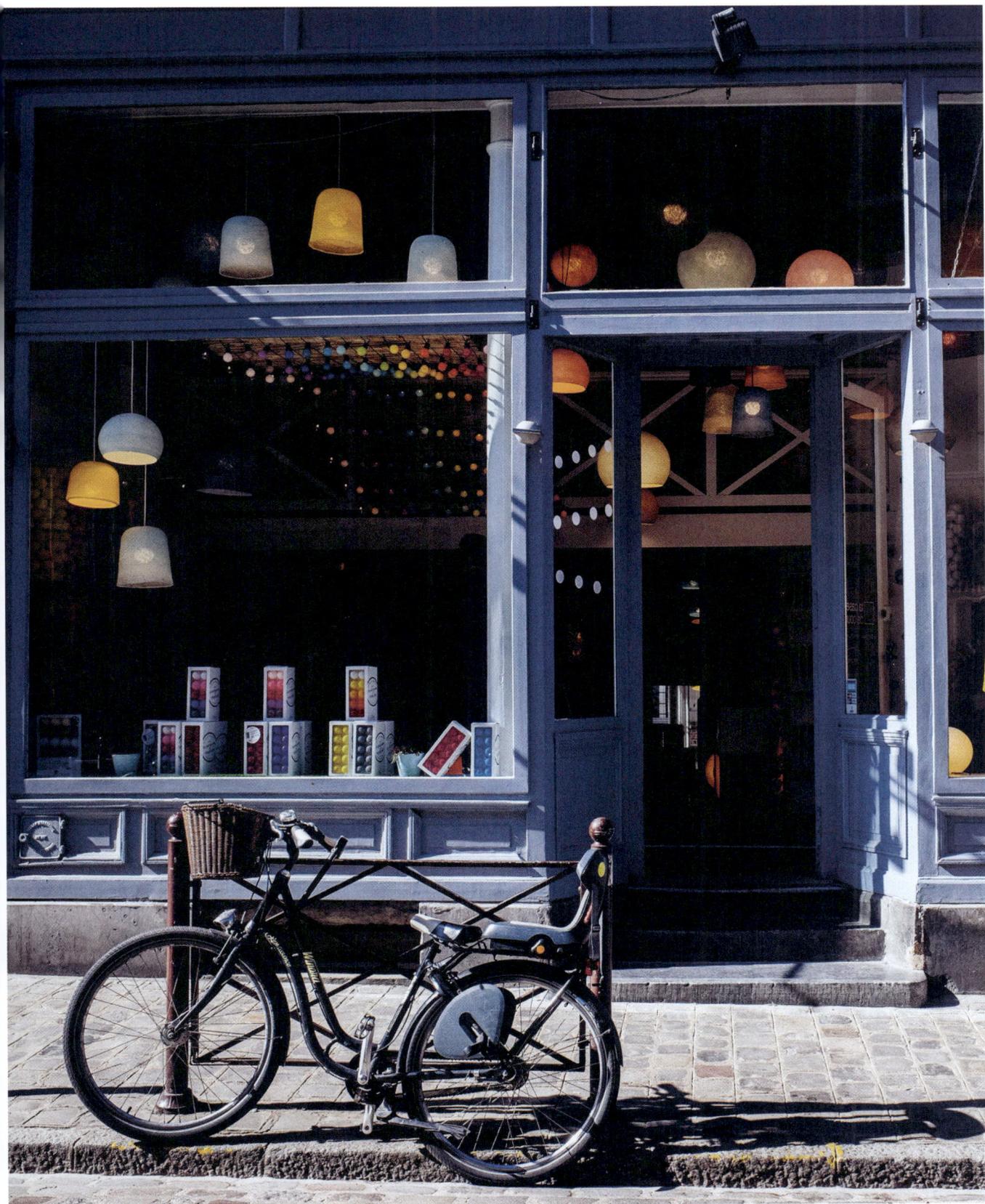

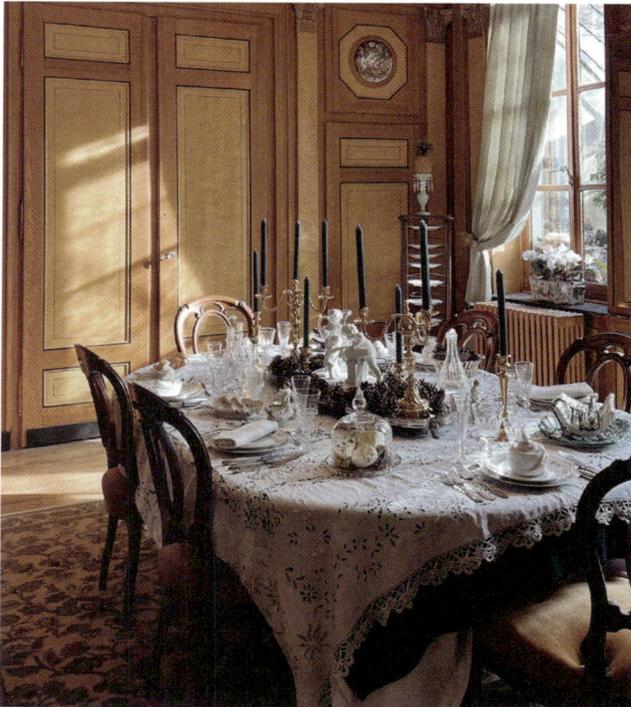

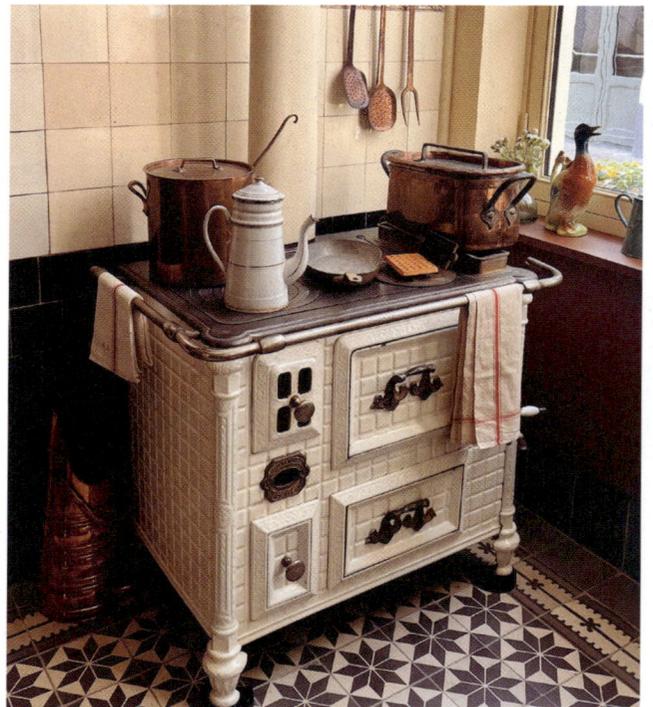

Above and at right:
Charles de Gaulle's birthplace in Vieux Lille is a fascinating museum where time seems to stand still, immersing visitors in the past.

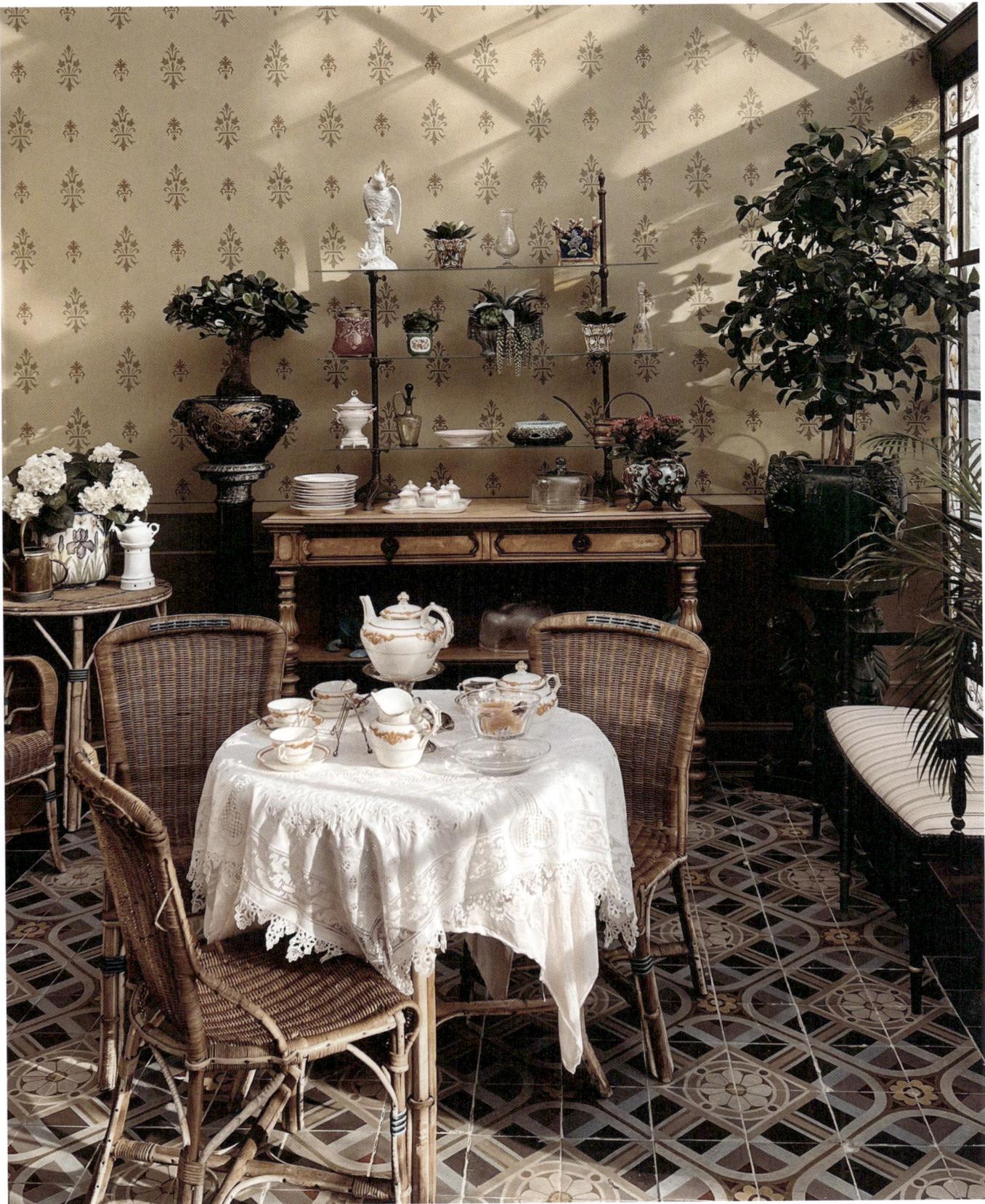

ℭUNE JOURNÉE À LA MER

AMONG FISHING BOATS AND BEACH CABINS

The days when France's coastal villages were secluded fishing hamlets are long gone. That changed in the nineteenth century, when the nobility—and later the wealthy bourgeoisie—discovered the joys of summer vacations. Eager to escape the sweltering city streets, they sought out the fresh, invigorating salt air of the coast. Beach promenades became fashionable places to stroll, where people paraded with purpose—a stage for seeing and being seen, and reveling in the spectacle. Before long, casinos sprang up, offering the rich and glamorous a way to while away their time by the sea. Even today, Art Deco cabins and cheerful, candy-colored huts still line the shoreline promenades in tidy rows, their pastel hues evoking the Belle Époque, when a day at the beach revolved around a refreshing swim in the sea. Deauville, one of the most elegant spots on the Côte Fleurie, quickly became a favorite, along with neighboring Trouville and Yport—though visitors were likely to run into the same Parisian high society they had left behind. The seaside became more accessible—and far more democratic—when France enacted mandatory paid vacation in the 1930s. Deauville earned the nickname "the bathtub of Paris" as city dwellers flocked there to escape the heat and enjoy a day at the beach. For over 150 years, the Atlantic coast has also been a magnet for summer travelers from across France. Biarritz, with its mild maritime climate, was once an exclusive retreat of the *haute volée*. Today, its endless sandy beaches, stretching north to the Dune de Pilat, attract devoted beachgoers and surfers eager for coastal charms. And the Mediterranean coast? Always the classic choice for a seaside escape: chic Nice; the candy-colored houses of Saint-Tropez, straight out of a *bonbonnière*; the glamour of the Cannes Film Festival. Once reserved for genteel summer retreats, the Riviera now hosts throngs of vacationers—even the smallest fishing villages.

Right:
Yport in Normandy evolved from a quiet fishing village into a favorite (sun-)bathing spot.
The blue-and-white cabins on the beach evoke nostalgic charm.

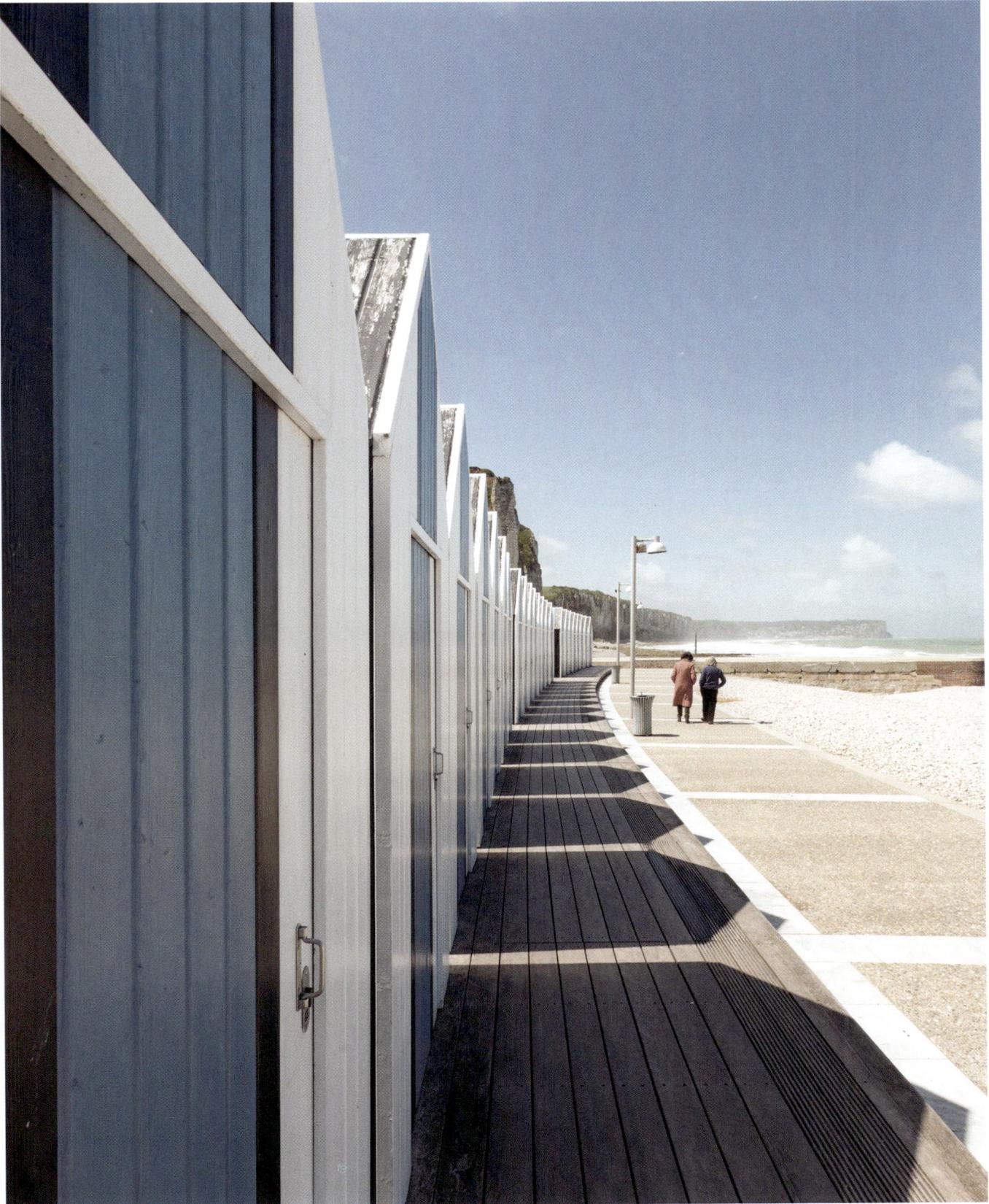

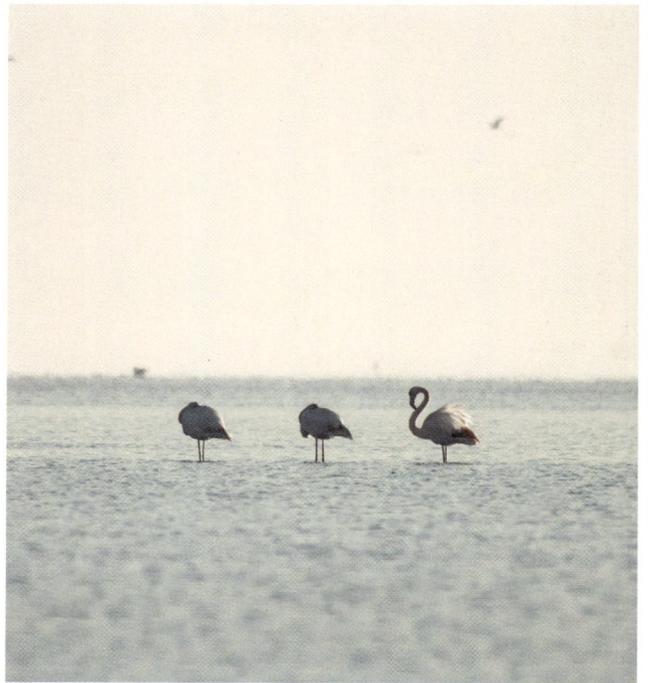

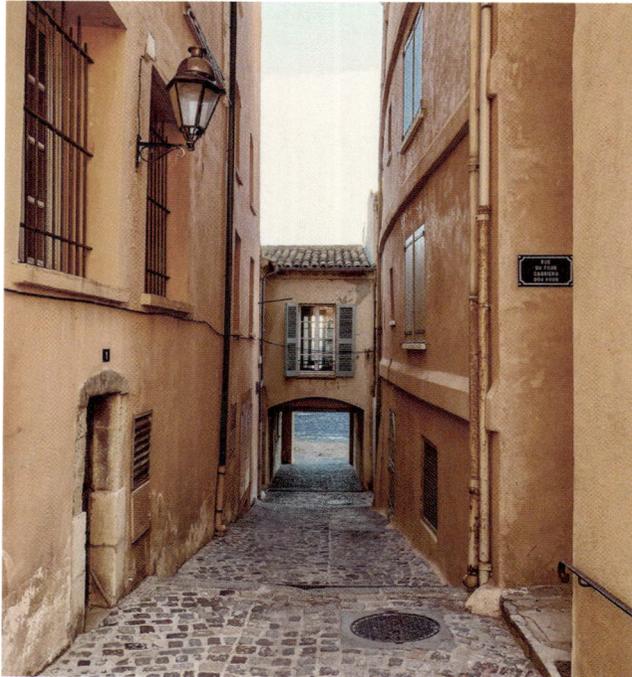

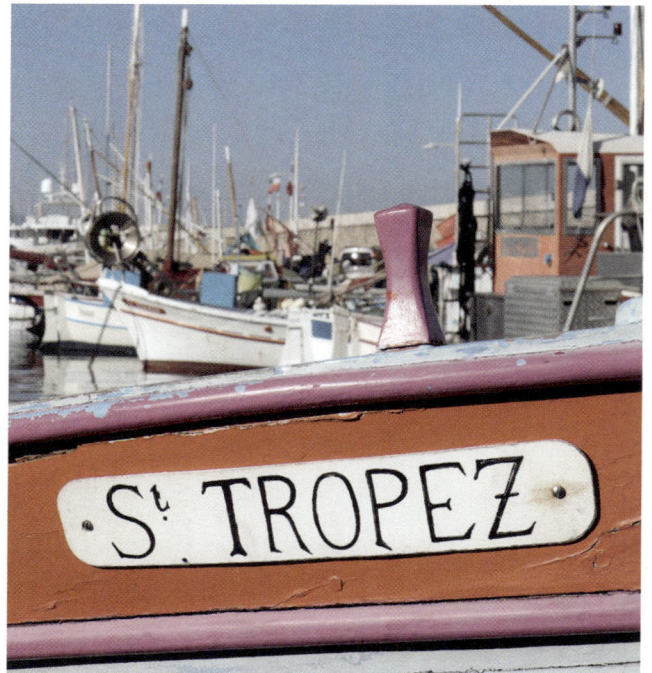

Above:
Just before the salt is harvested, the water in the evaporation ponds of the Camargue turns as pink as the flamingoes in the étangs.

Right:
The pastel fishermen's houses made Saint-Tropez a magnet for artists. In the 1950s, this seaside resort became a symbol of glamour as the jet set followed Brigitte Bardot there.

Following Pages:
Dreamy beaches, medieval towns, and vibrant port cities—the Côte d'Azur beckons with everything one could wish for from a seaside getaway, stretching from Marseille to Menton.

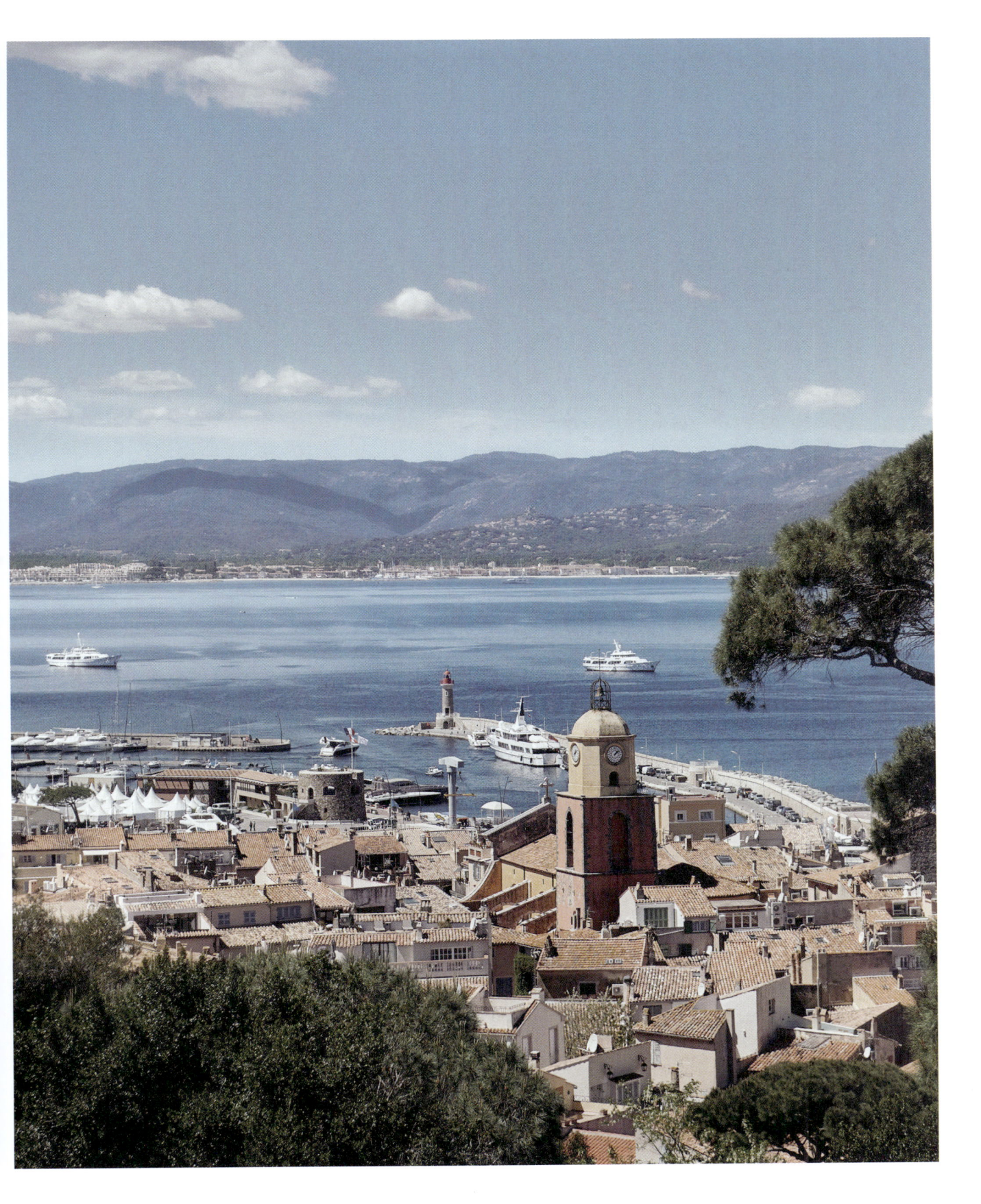

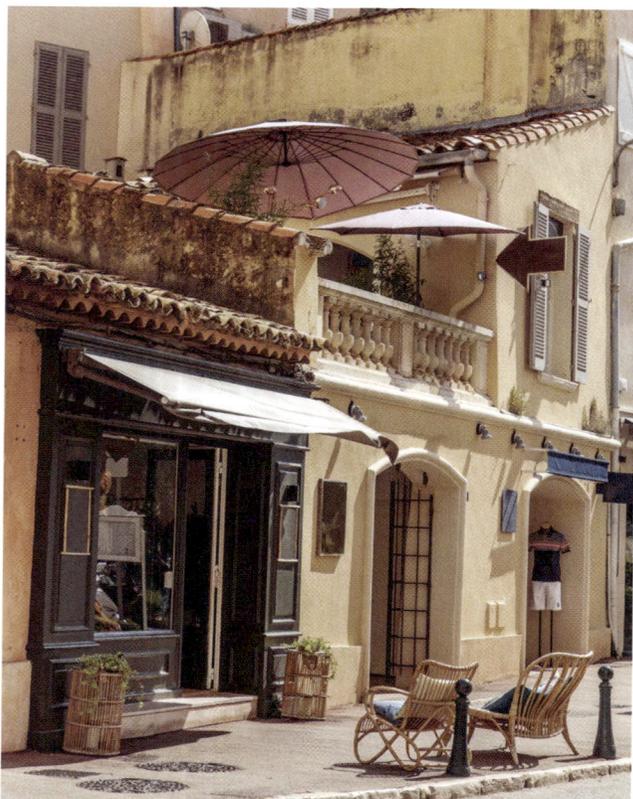

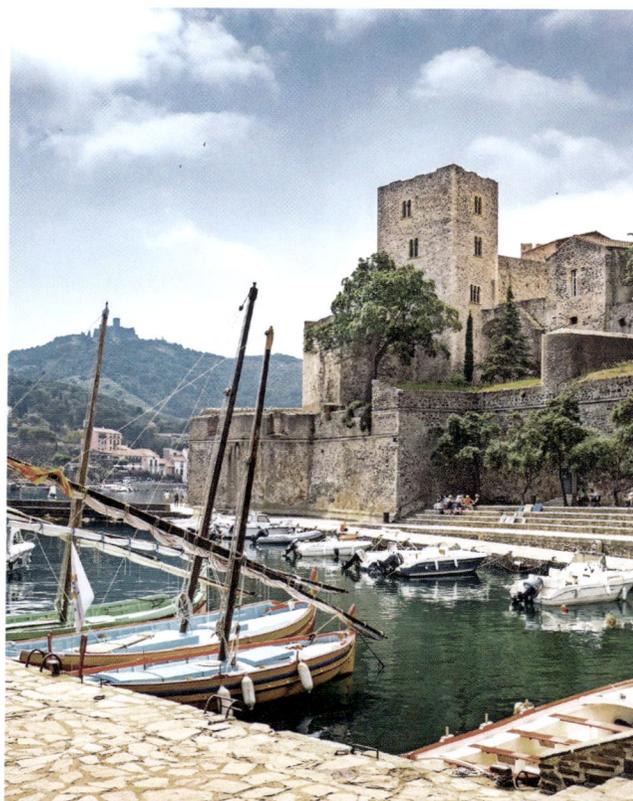

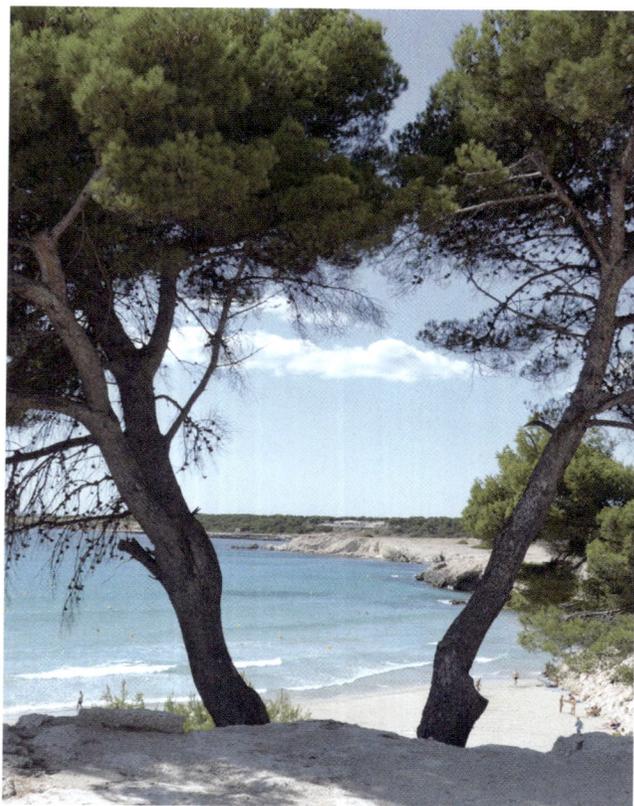

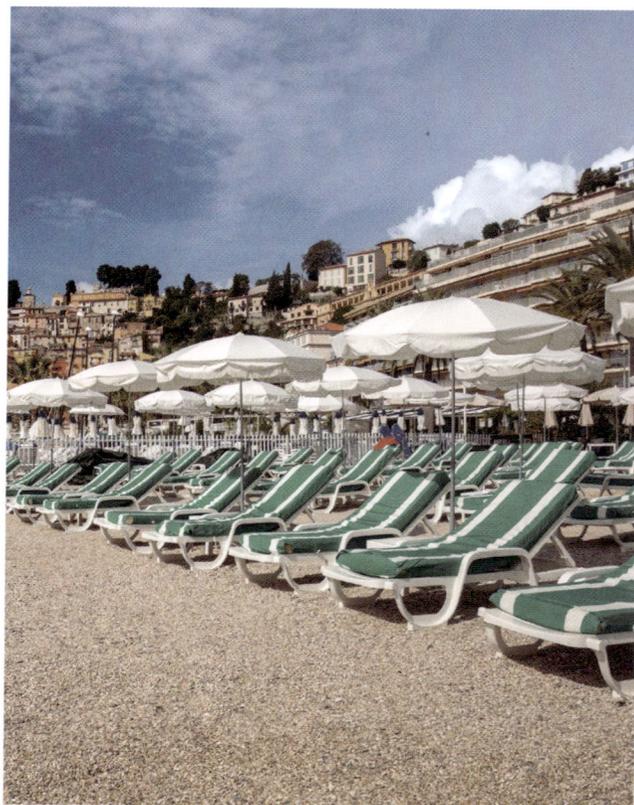

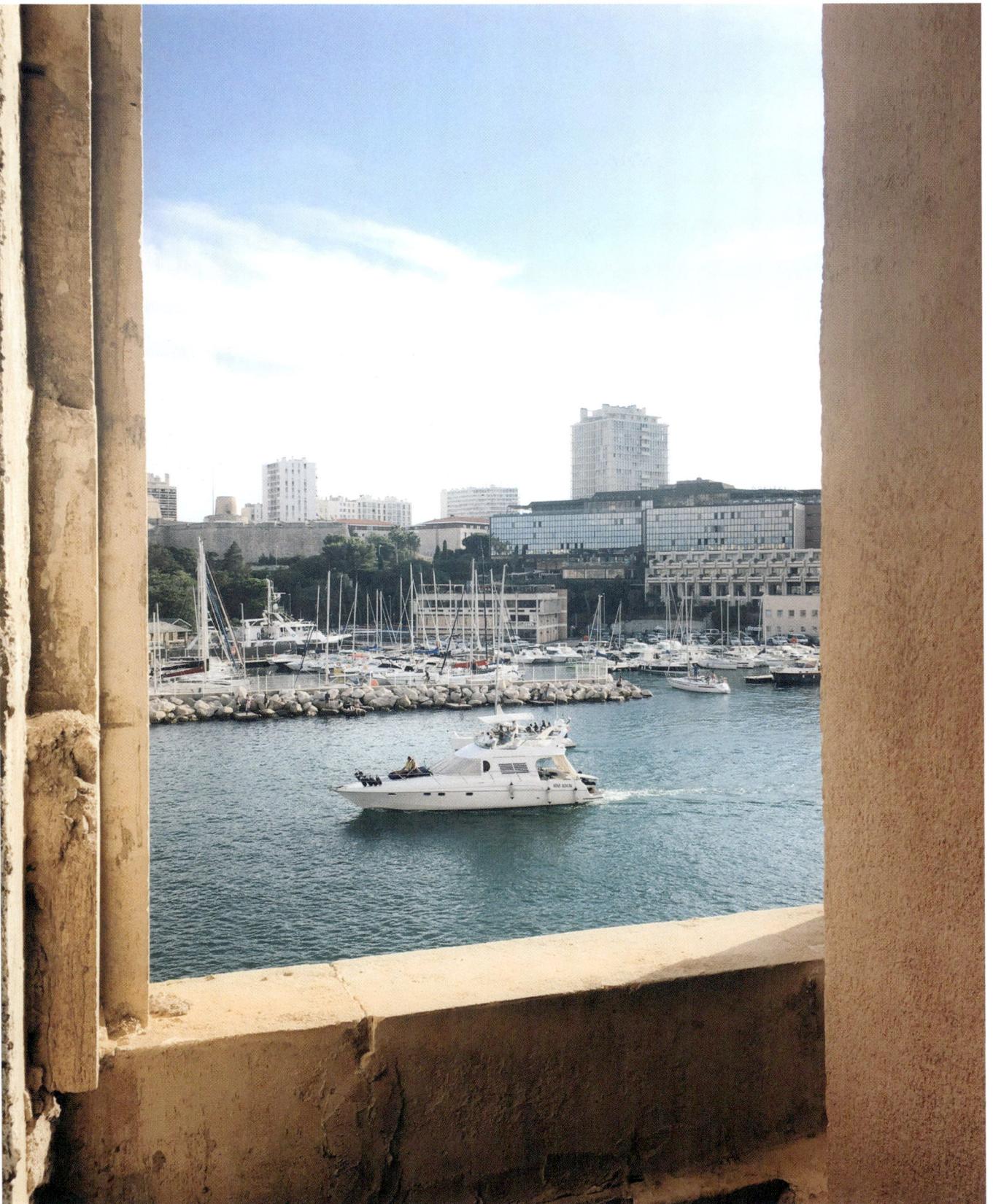

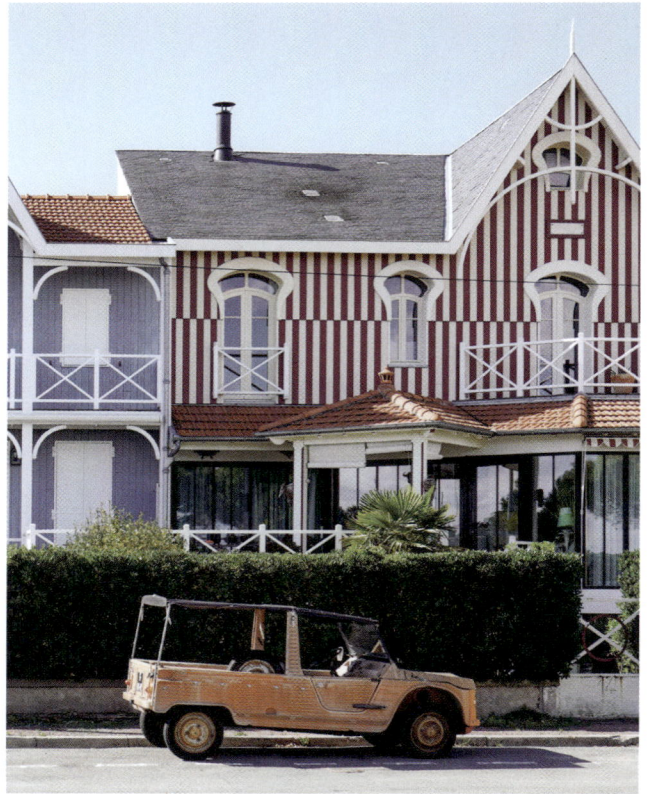
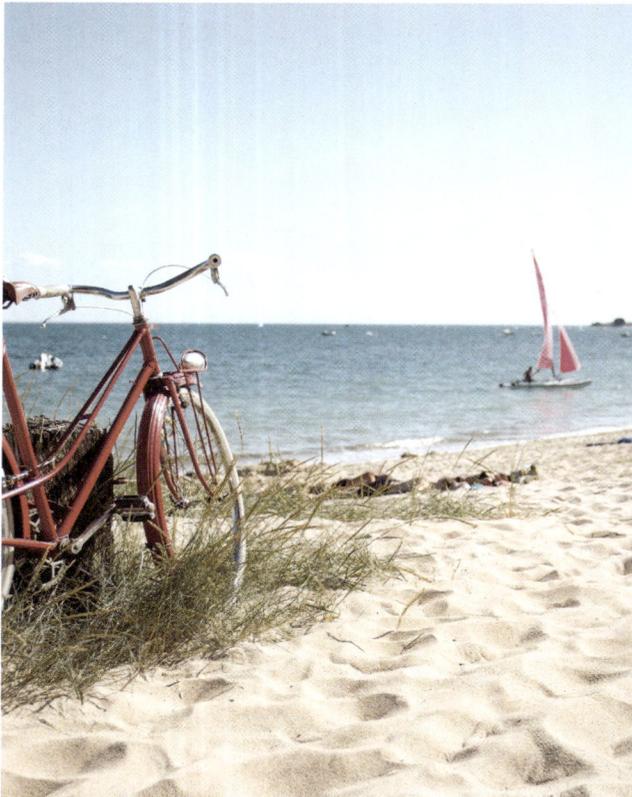
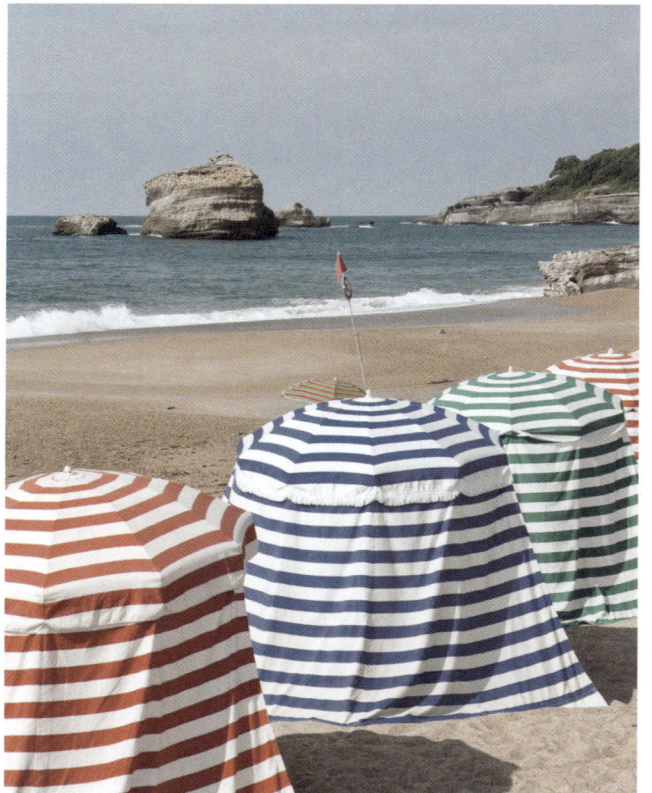

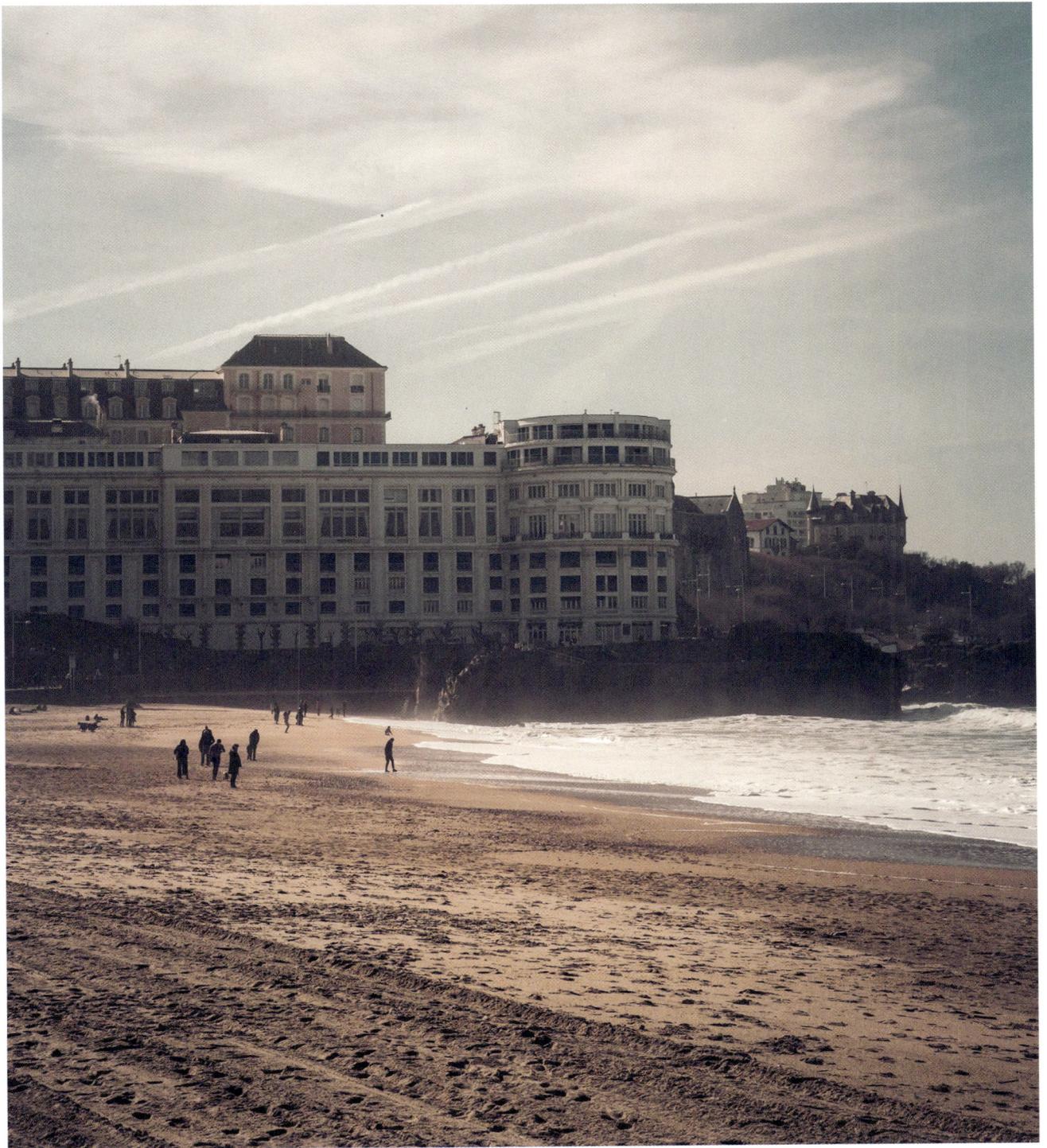

Above and at left:
The Casino Bellevue at La Grande Plage in Biarritz is an architectural jewel of the Belle Époque. Empress Eugénie de Montijo fell in love with what was then a small fishing town with its vast beaches and mild climate. Soon the French aristocracy followed her to this up-and-coming resort.

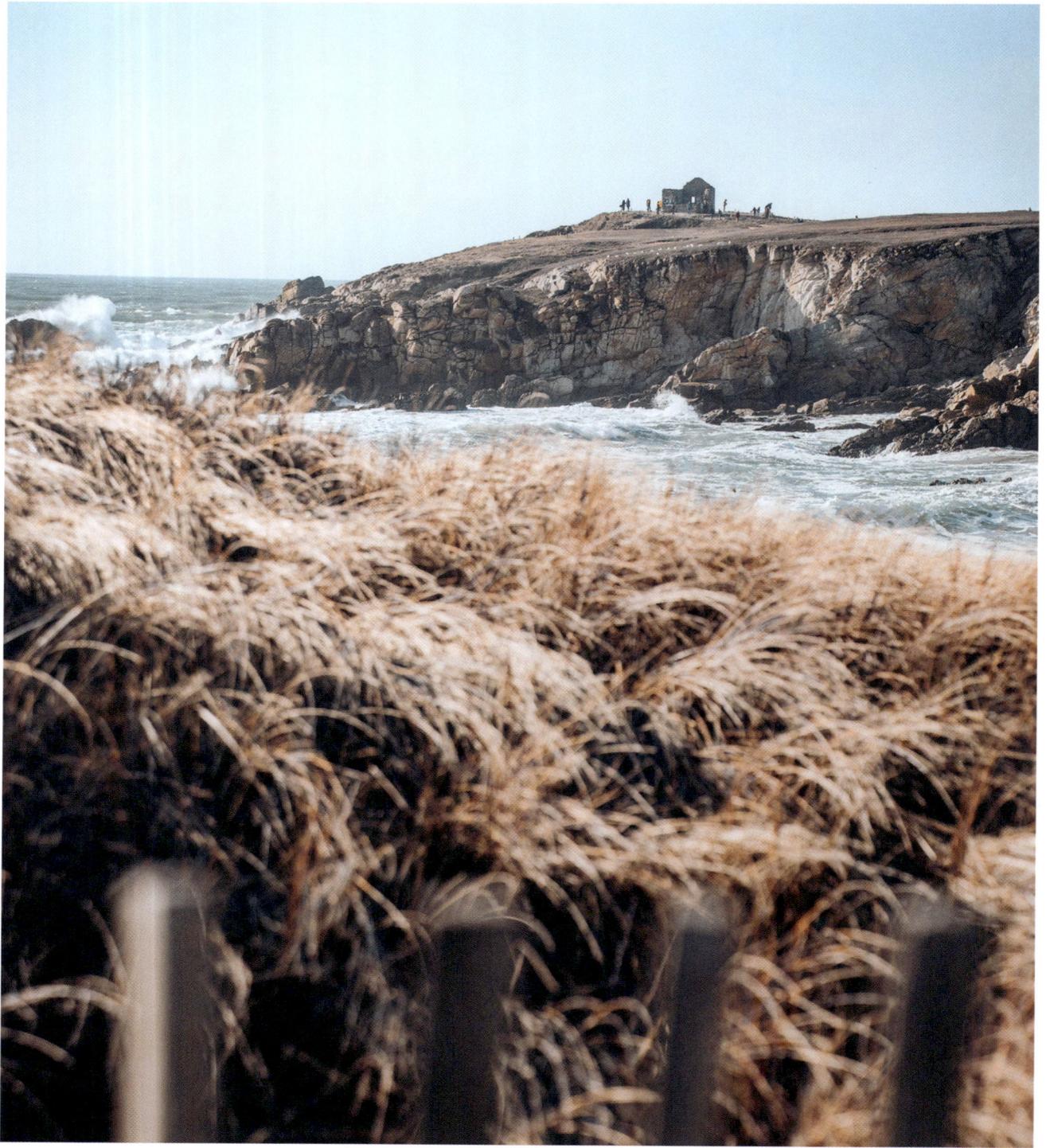

The Atlantic crashes full force against the granite cliffs of the Quiberon peninsula.

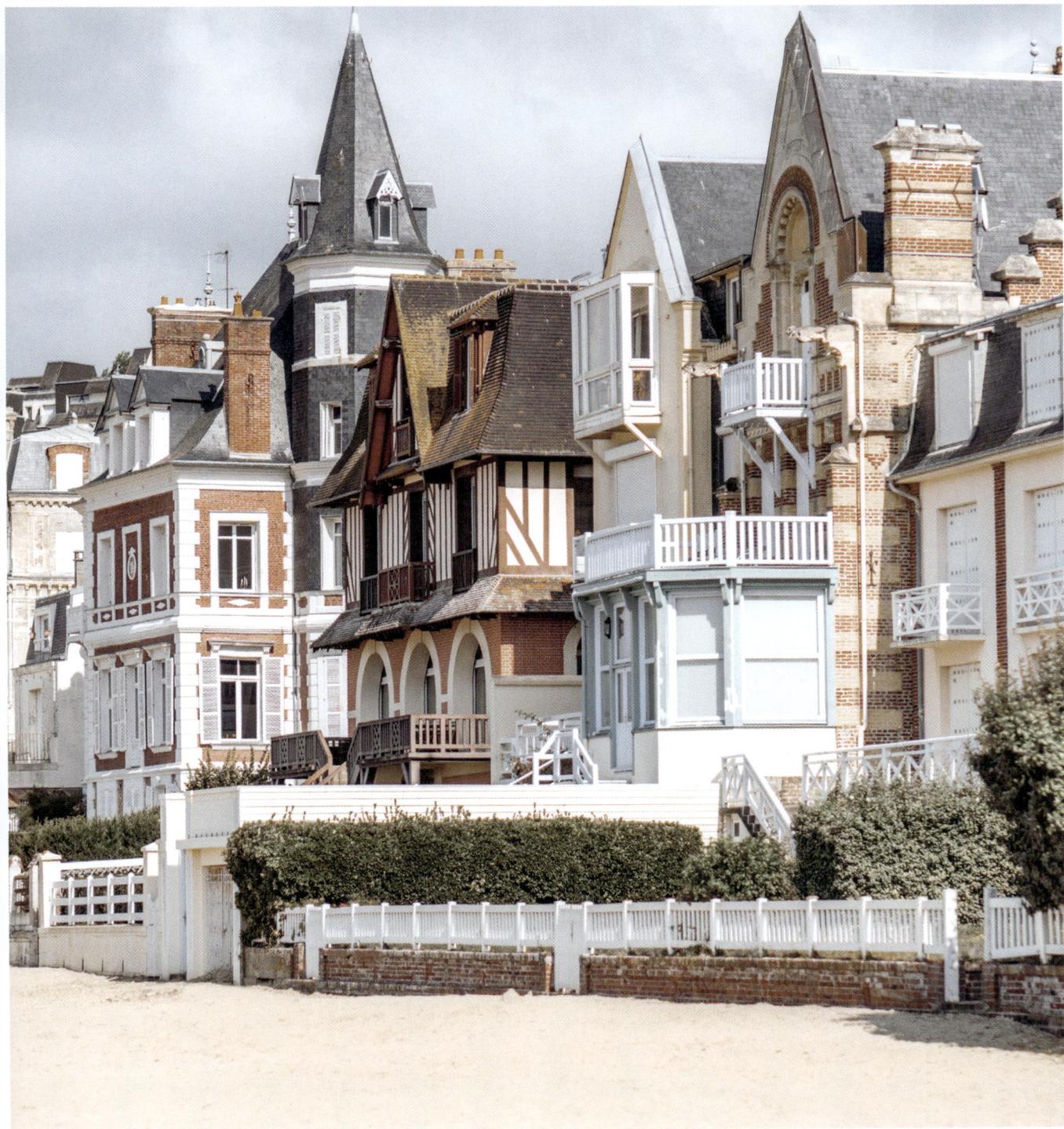

The best way to admire the charming waterfront villas of Trouville is to stroll along what is likely Normandy's oldest seaside promenade.

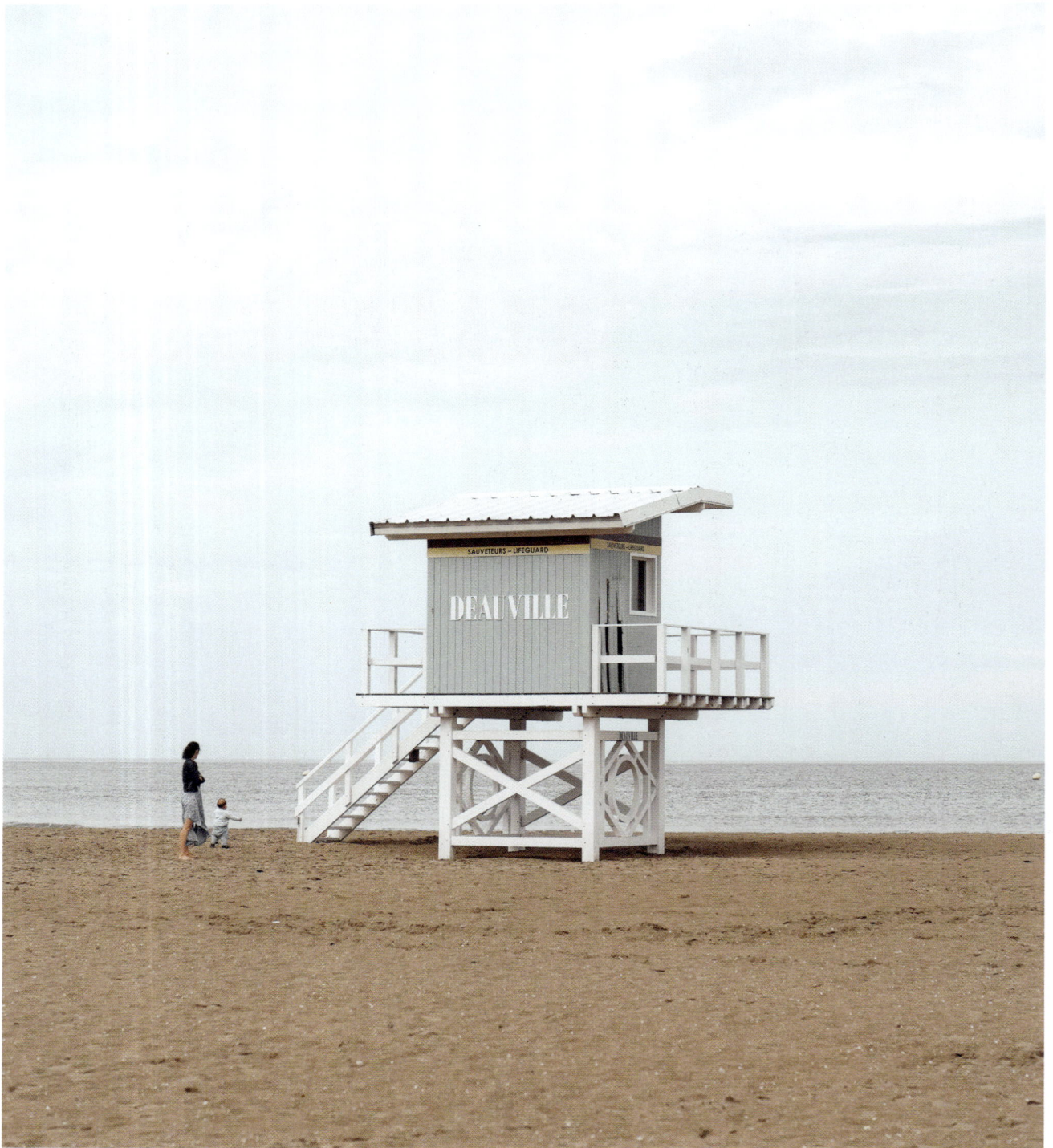

Above and at right:
Belle Époque bathing: Deauville will forever be associated with these pastel-colored Art Deco lifeguard stands.

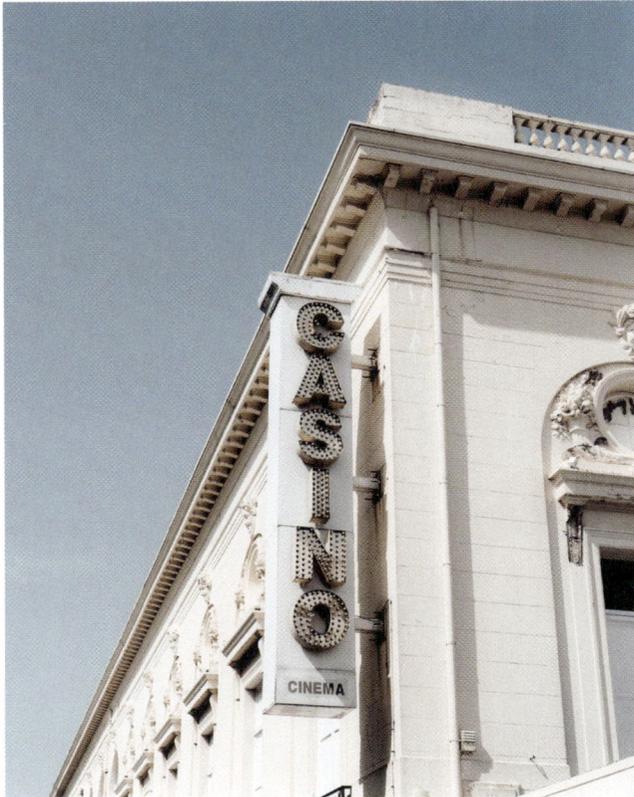

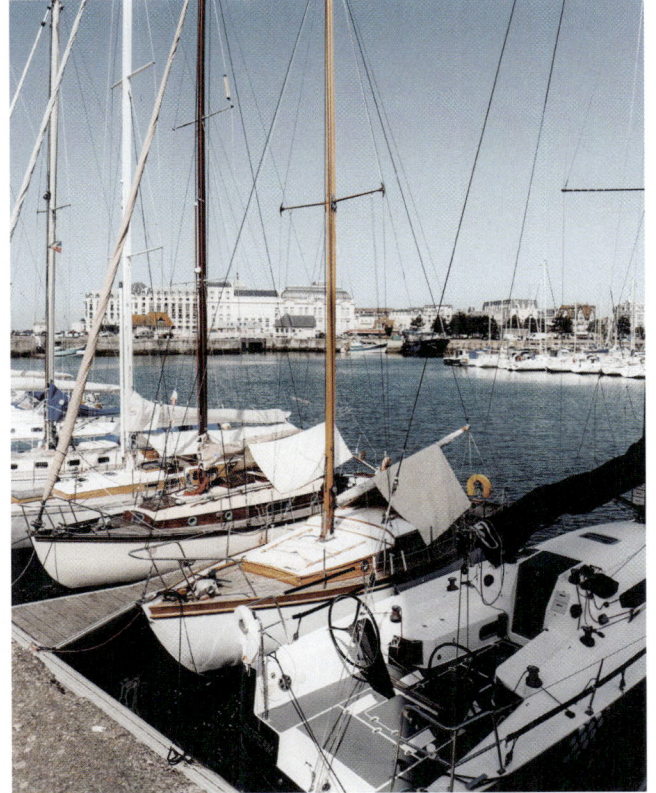

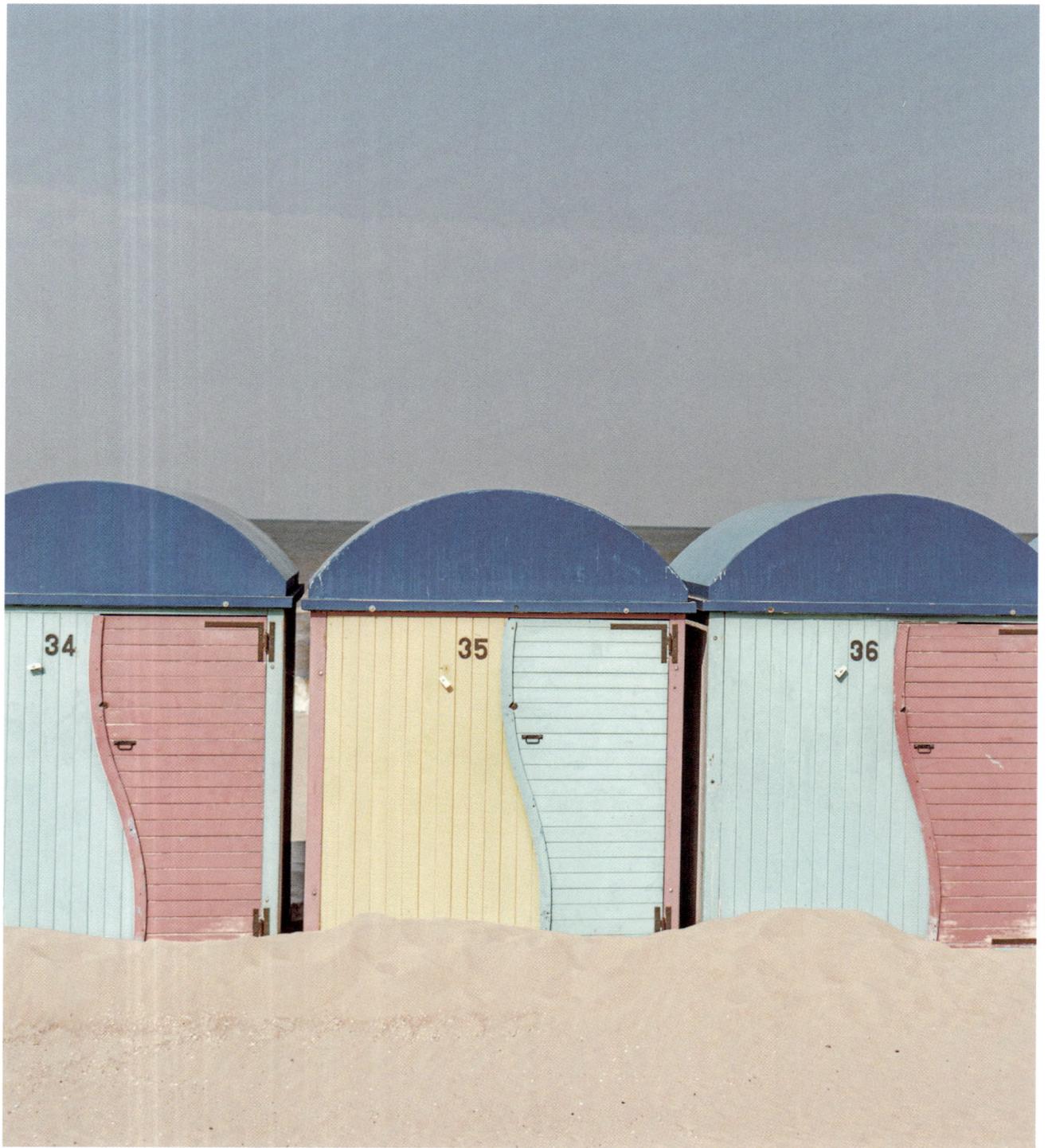

Above and at right:
Brilliant splashes of color on the beaches of the English Channel: vibrant beach cabins line the long sandy beach at Malo-les-Bains in Dunkirk; colorful boats brighten Étretat.

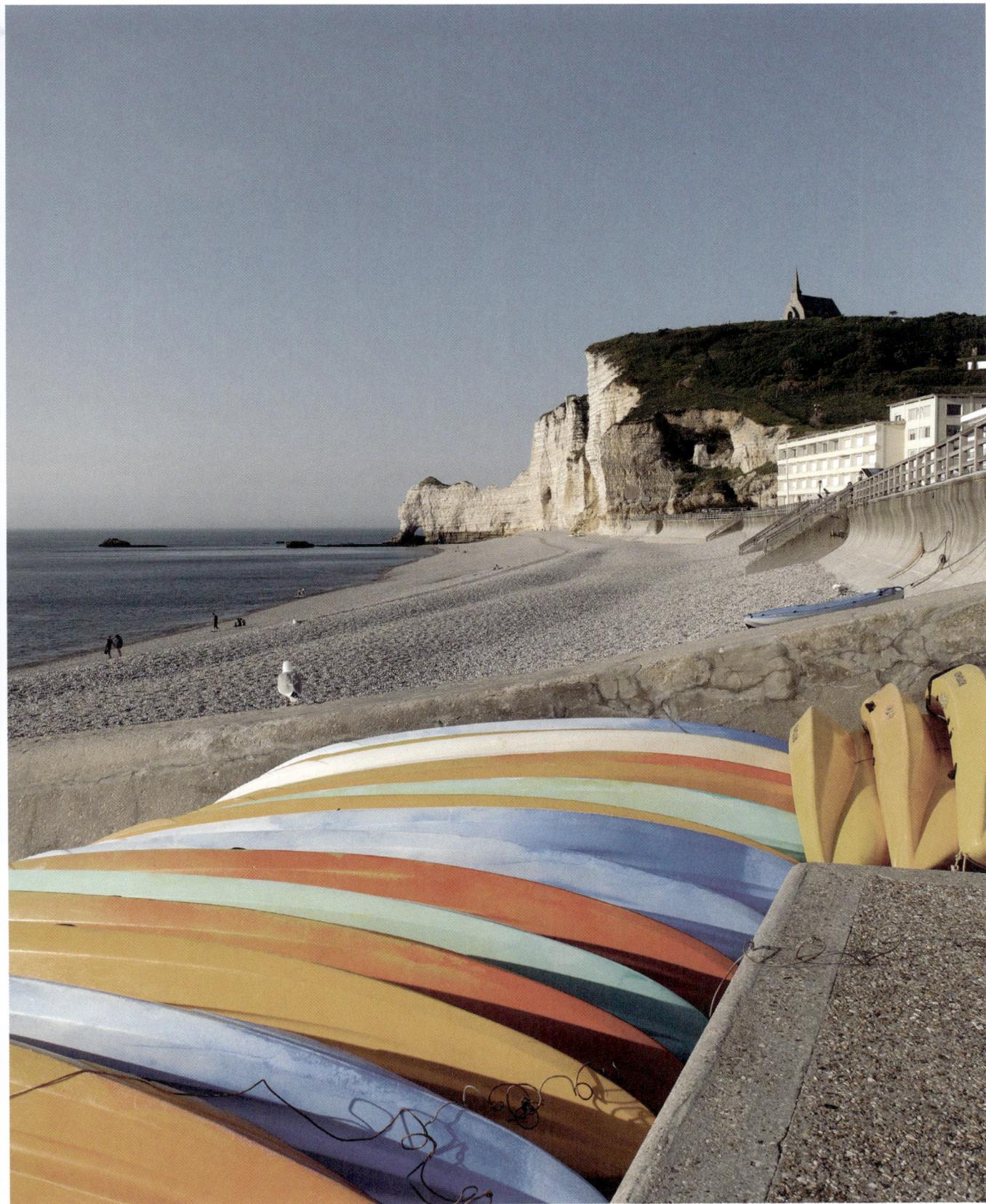

LA RHÔNE ET SES ALENTOURS

IN THE SOUTH OF FRANCE, TRACES OF ANCIENT ROME

Along the Rhône and Saône valleys, many towns still bear traces of the Roman Empire more than two thousand years after the Romans first poured into Gaul. Here, history and natural beauty blend in unmistakable harmony. Take Autun, for example: now a charming town in Burgundy, it was once an important trading post on the ancient Via Agrippa during the reign of Caesar Augustus. Its Roman amphitheater and imposing Romanesque cathedral still testify to a glorious past. Lyon, France's third-largest city, lies at the confluence of the Rhône and the Saône. Ancient thermal baths and amphitheater ruins hint at Roman origins, while the old town—Vieux Lyon—boasts beautifully preserved Renaissance buildings, their narrow streets and alleys winding through the district. Perched high above the last bend of the Saône before it meets the Rhône, the Basilica of Notre-Dame de Fourvière offers sweeping panoramic views. East of Lyon, in a small hollow at Les Charmettes near Chambéry, stands the former home of France's most renowned social philosopher, Jean-Jacques Rousseau, who lived there during the mid-eighteenth century in an idyllic house, gathering his thoughts on the Enlightenment, a legacy now commemorated by a museum housed in the same building. Then there's Annecy, set on a lake of the same name at the foot of the French Alps. It immediately charms visitors with its distinct Mediterranean ambience. The river Thiou and its branching canals crisscross the medieval old town, which is why Annecy is often called the "Venice of the Alps". Even the small medieval prison on an island in the Thiou exudes an idyllic charm, making it a much-coveted subject for photographers meandering through streets lined with plenty of cafés and bars, soaking it all in.

Right:
Cheerful façades draped in blooms and streets lined with alfresco cafés. A leisurely wander through the peaceful town of Annecy reveals delightful views at every turn.

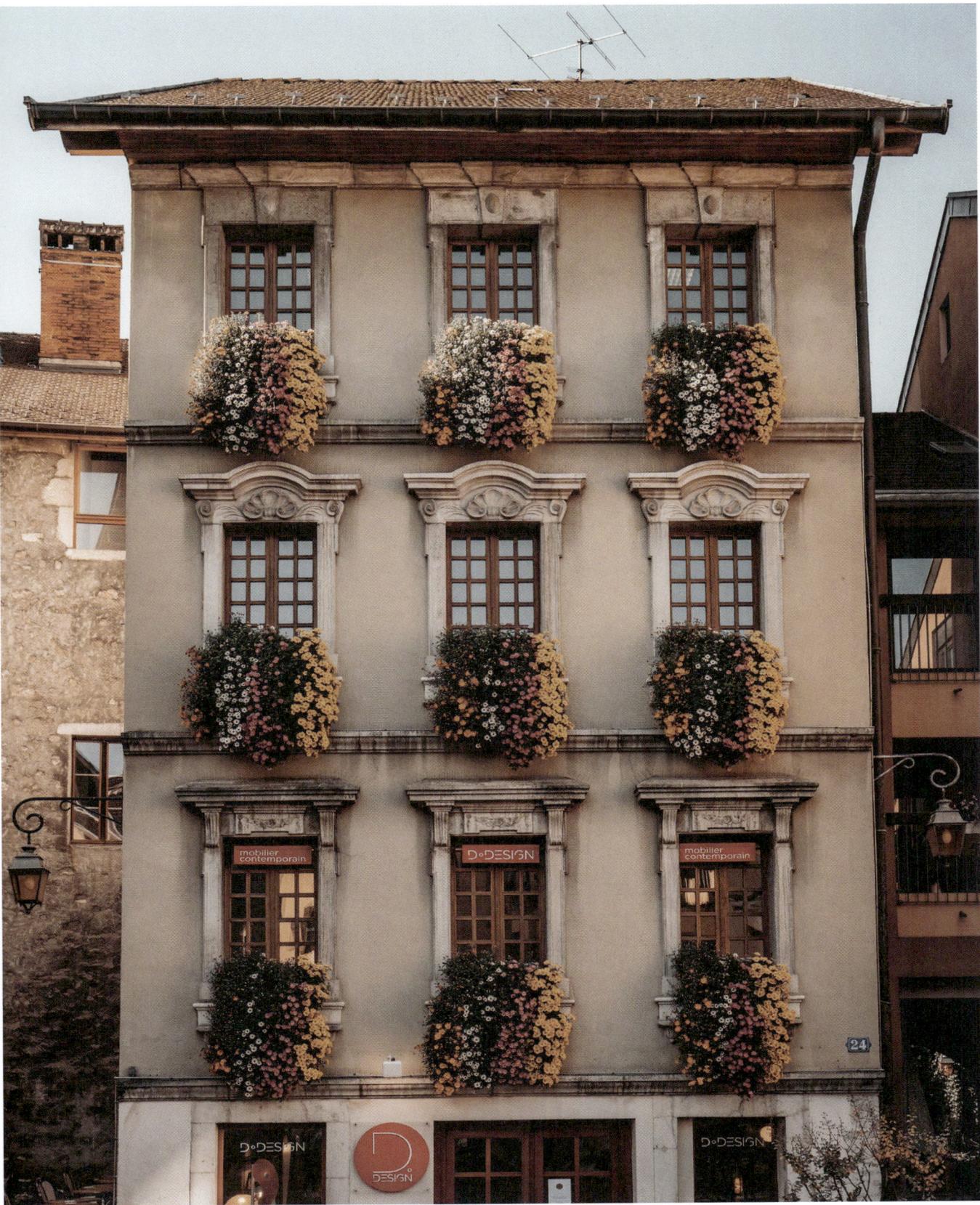

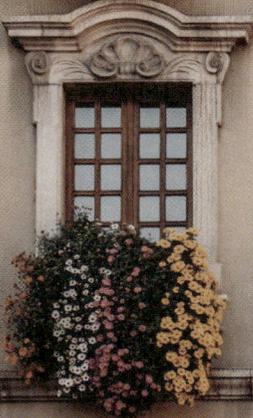

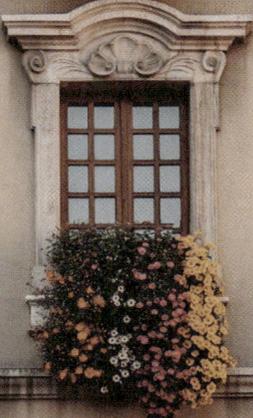

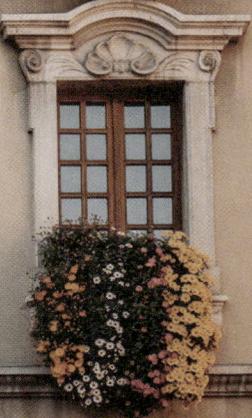

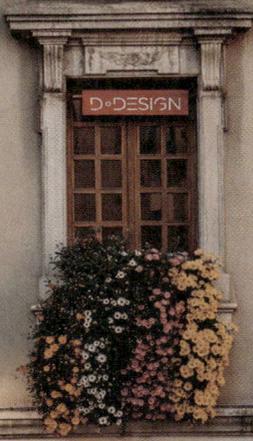

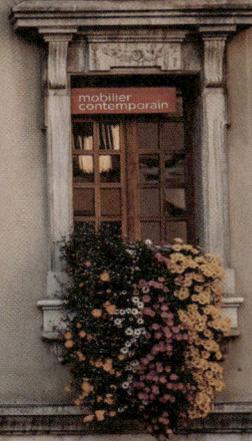

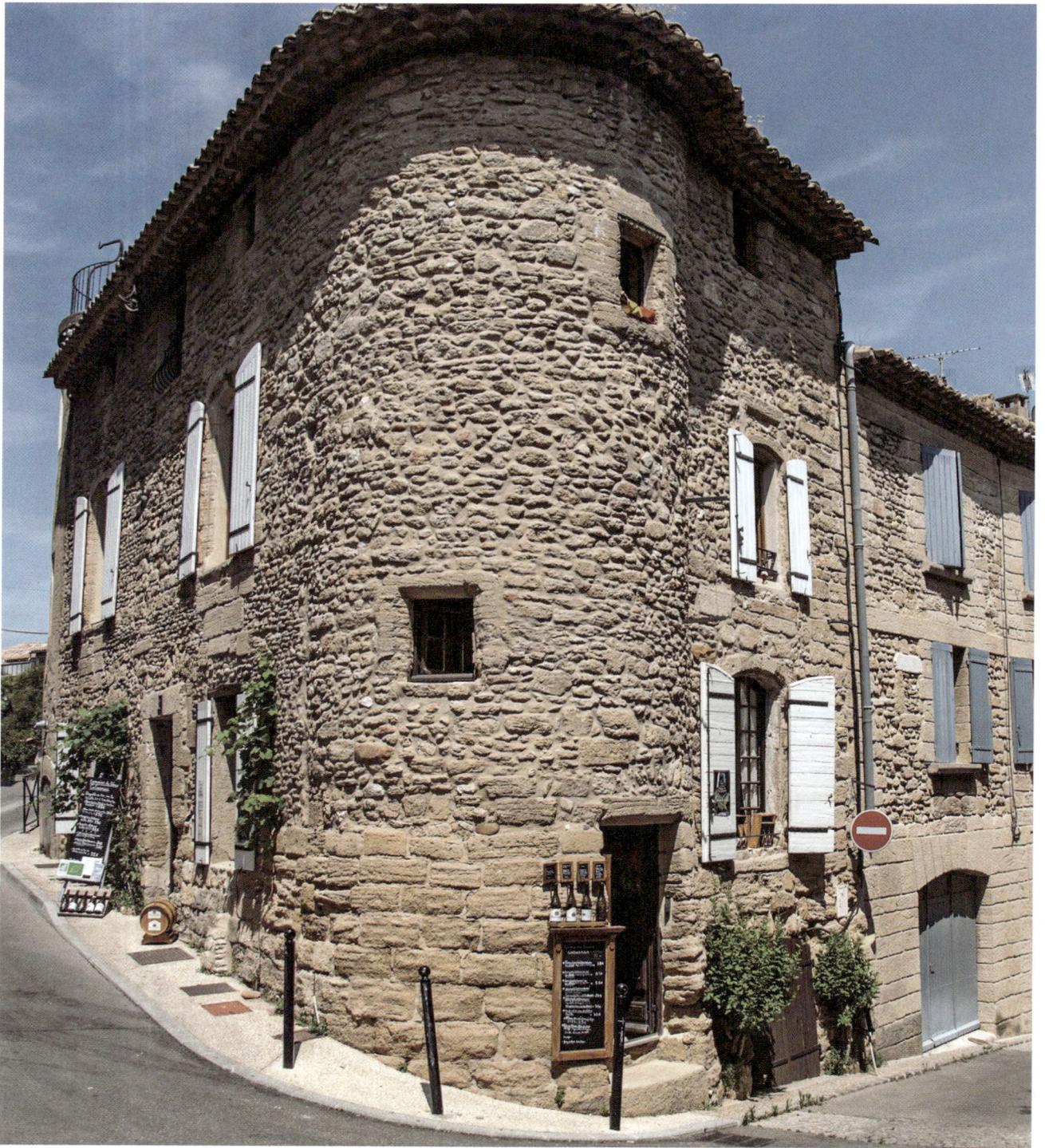

Above and at right:
Not far from Avignon, Châteauneuf-du-Pape in Vaucluse is a must for wine enthusiasts, who can savor the region's superb vintages in its cellars.

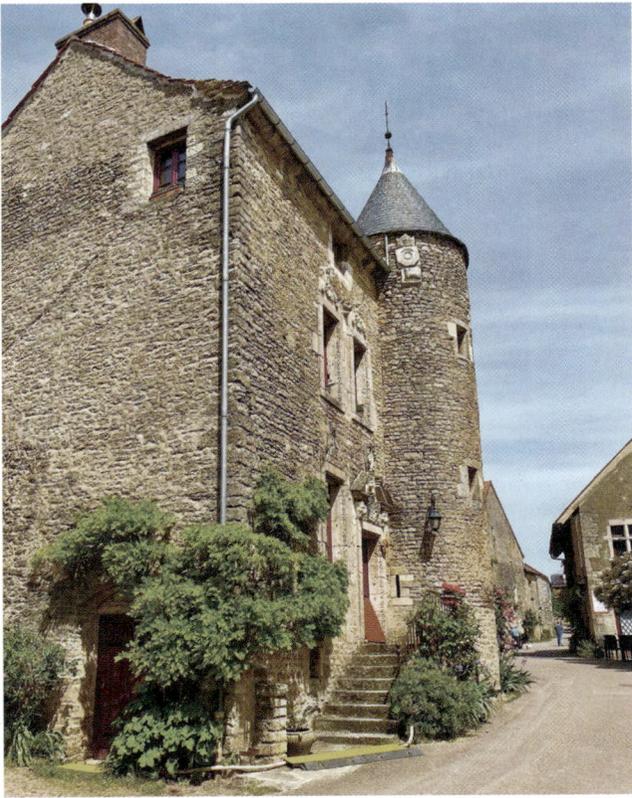

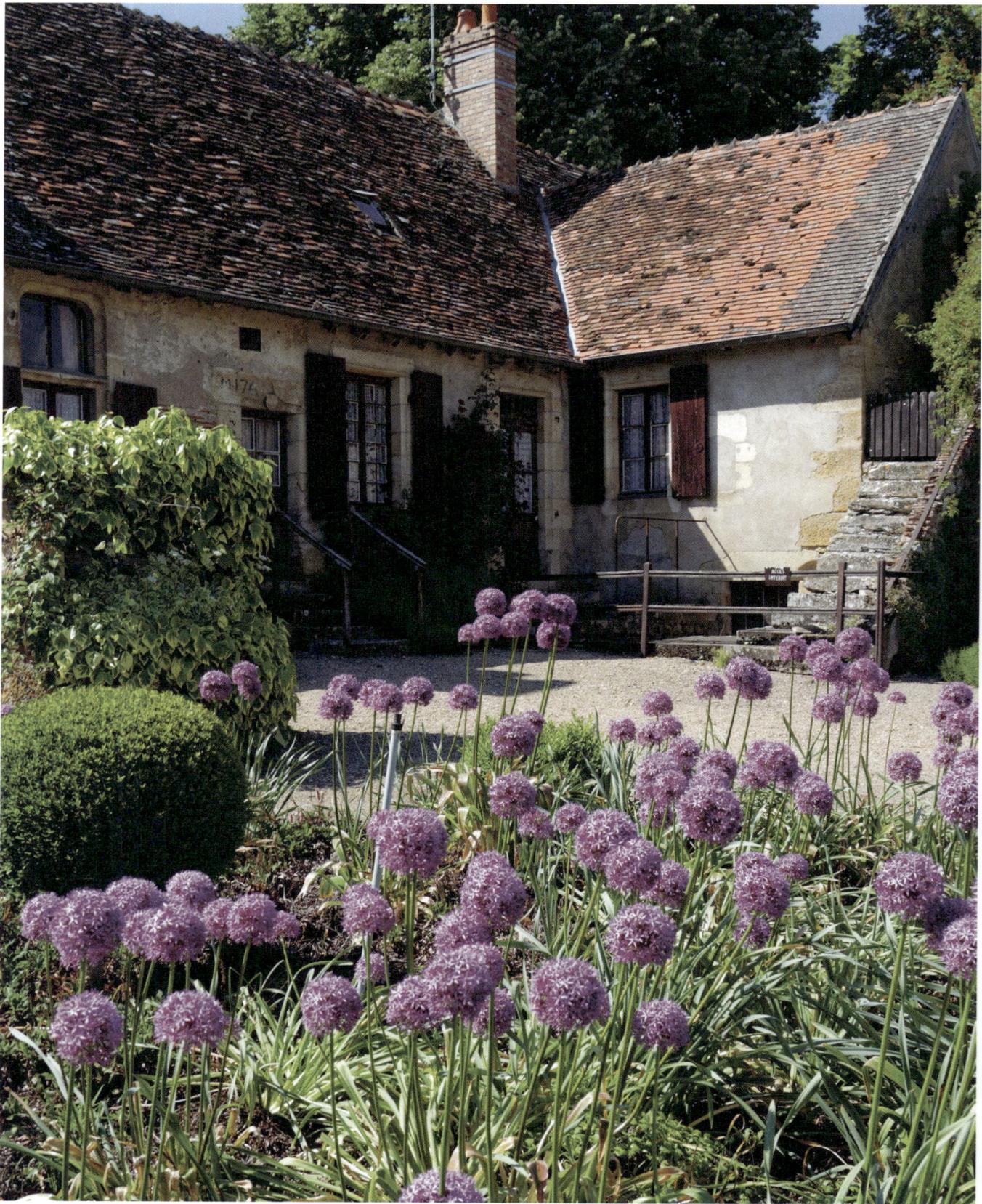

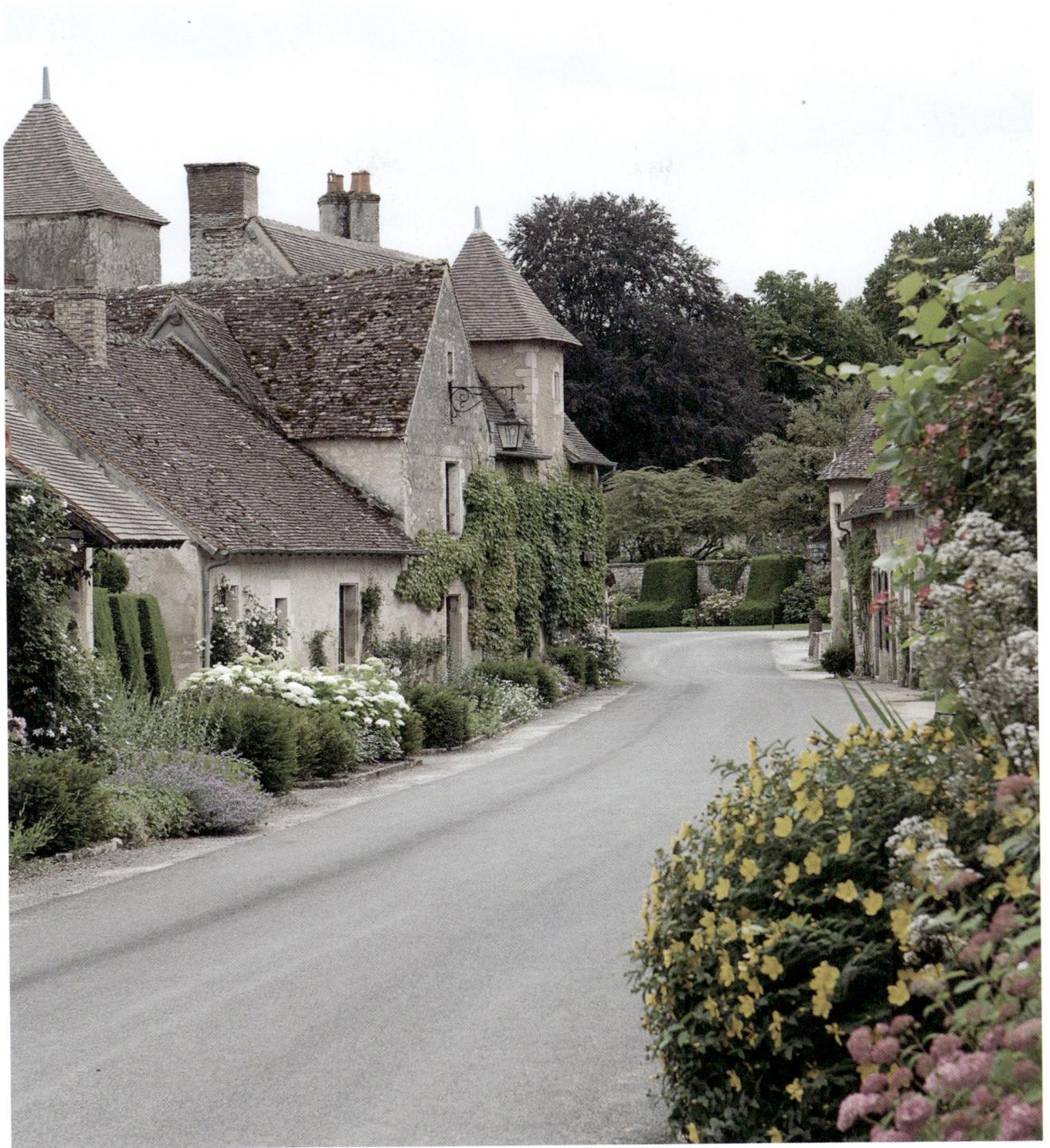

Above and at left:
*The golden-stone houses of peaceful Apremont-sur-Allier wouldn't look out of place in the English Cotswolds—
this enchanting Loire village is just as idyllic as its famed English counterparts.*

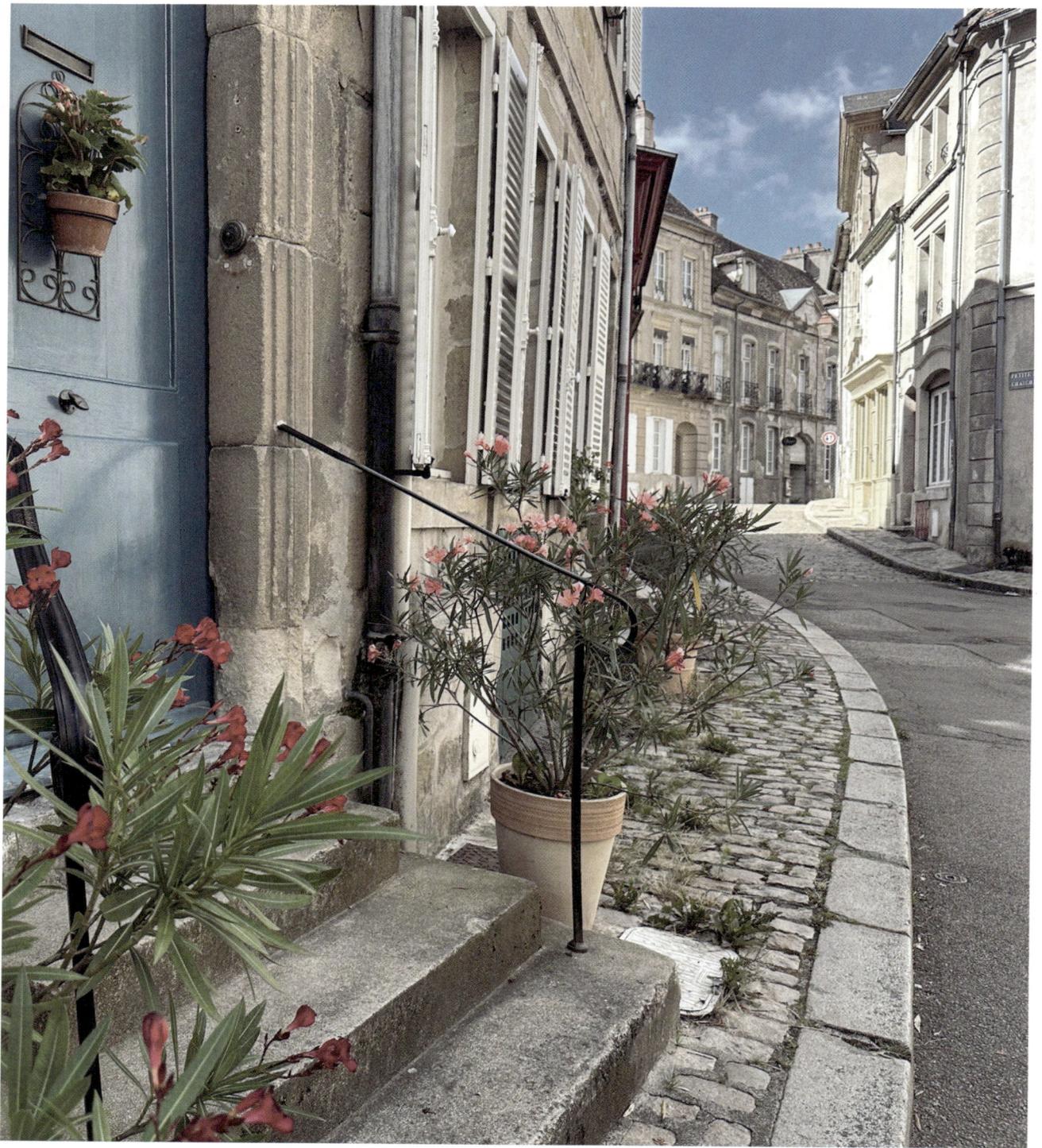

Above and at right:
Autun's roots stretch back to Roman times—Emperor Augustus even lent his name to this charming town.
Wander the quaint lanes of the old town and immerse yourself in over 2,000 years of Burgundian history.

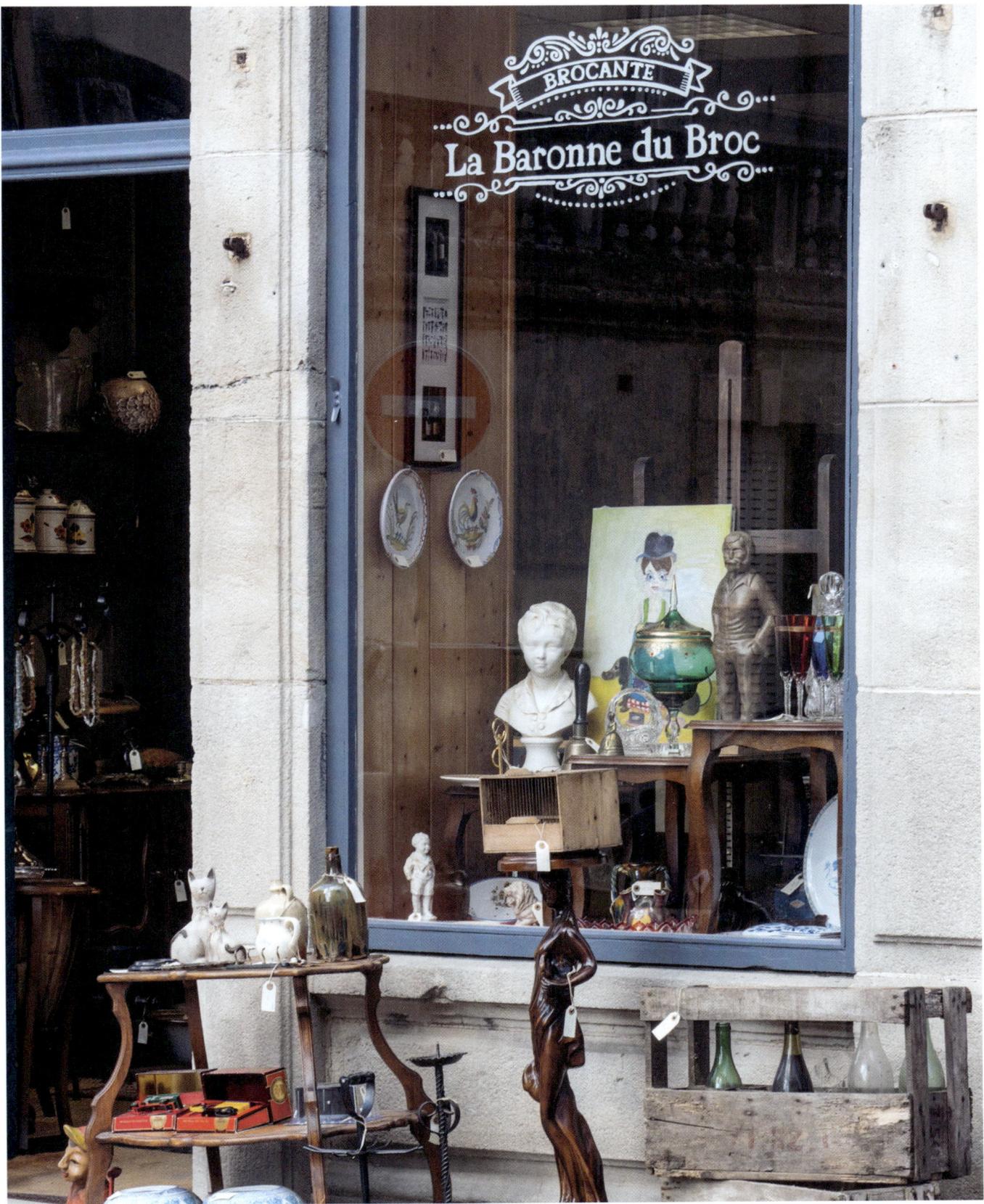

BROCANTE

La Baronne du Broc

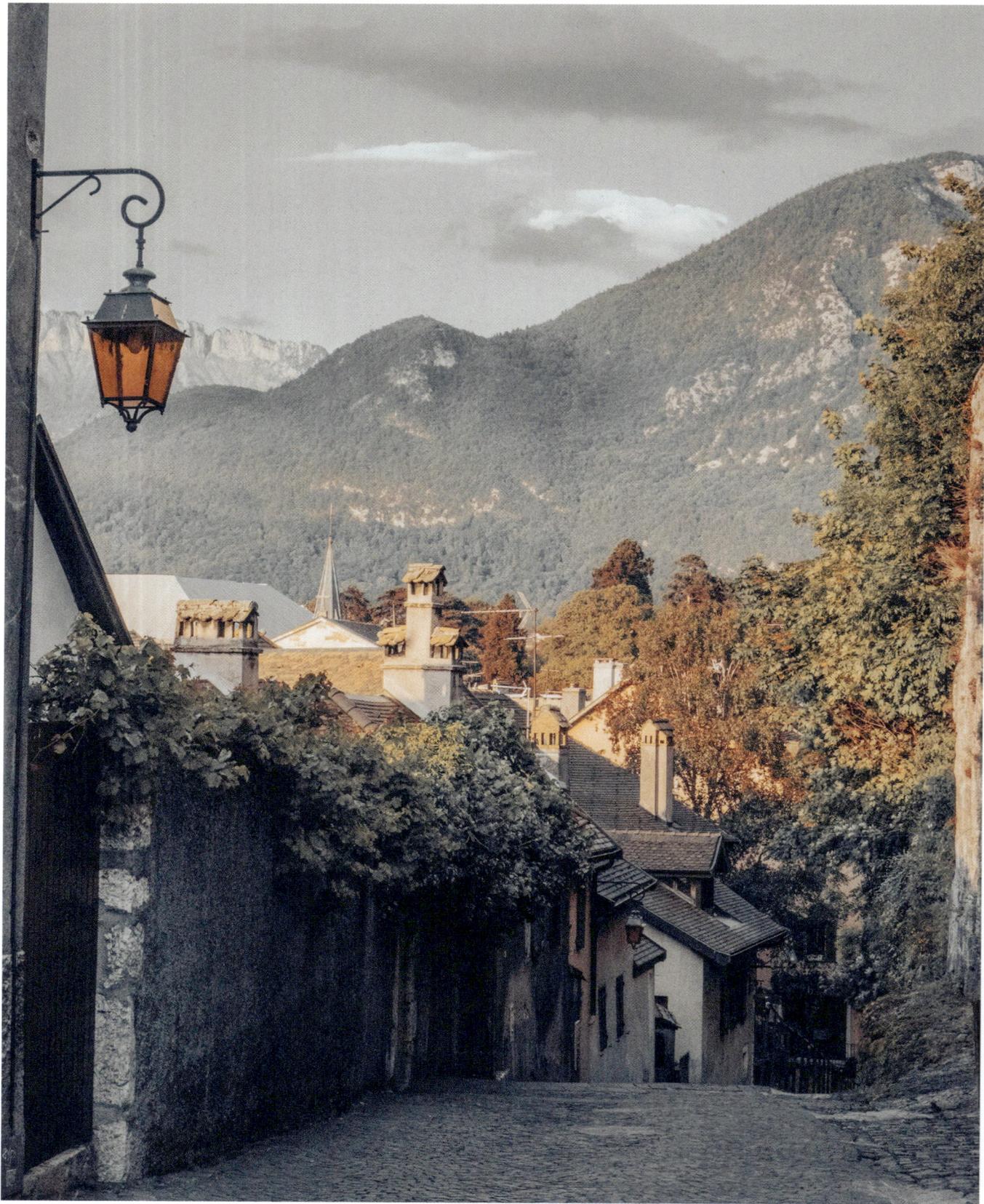

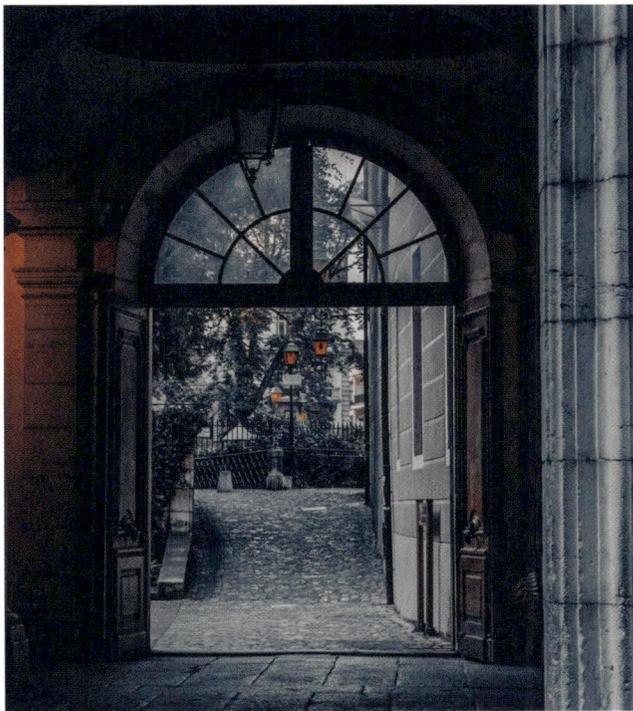

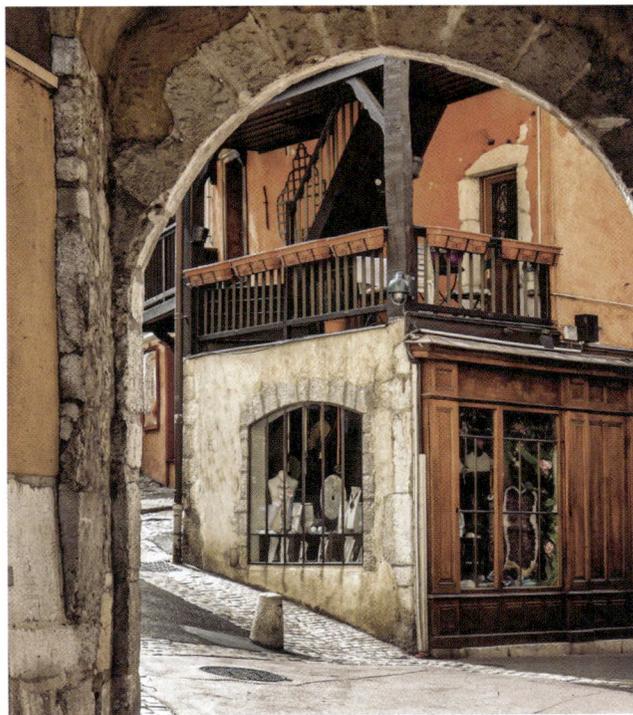
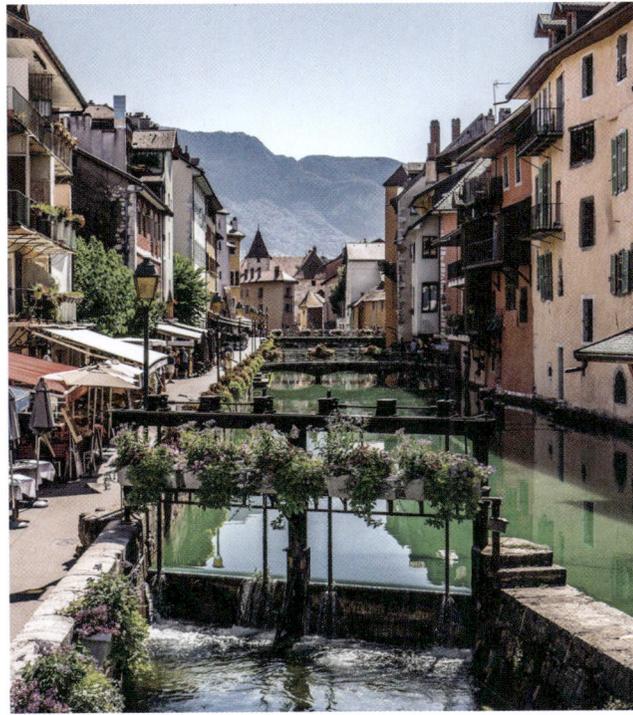

Above and at left:
A hint of Venice in the French Alps: while rambling through Annecy's delightful old town, with its maze of little canals, you could feel as if you were on the Adriatic.

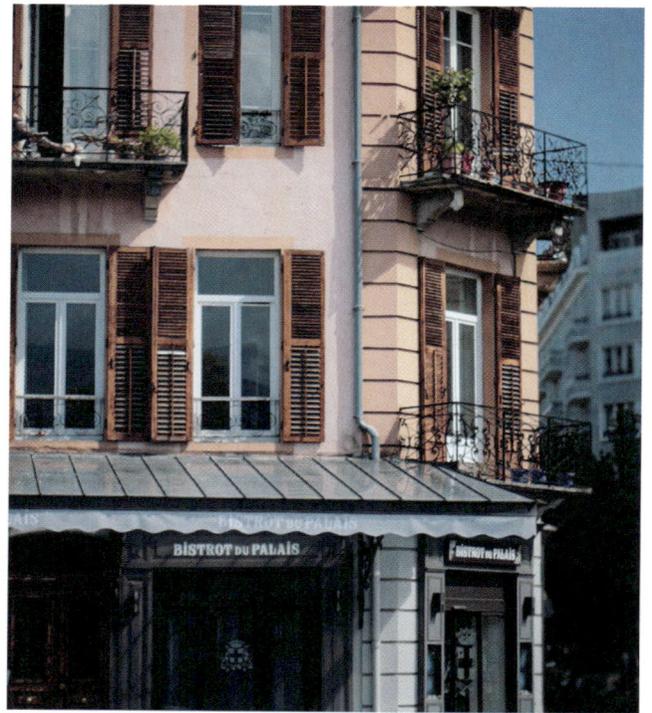

This page:
Les Charmettes near Chambéry—once home to philosopher Jean-Jacques Rousseau—now serves as a museum.
Facing page:
Some things stay: Behind this delightfully nostalgic storefront on Place Saint-Jean, the oldest herb shop in Lyon still offers an array of teas and tinctures.

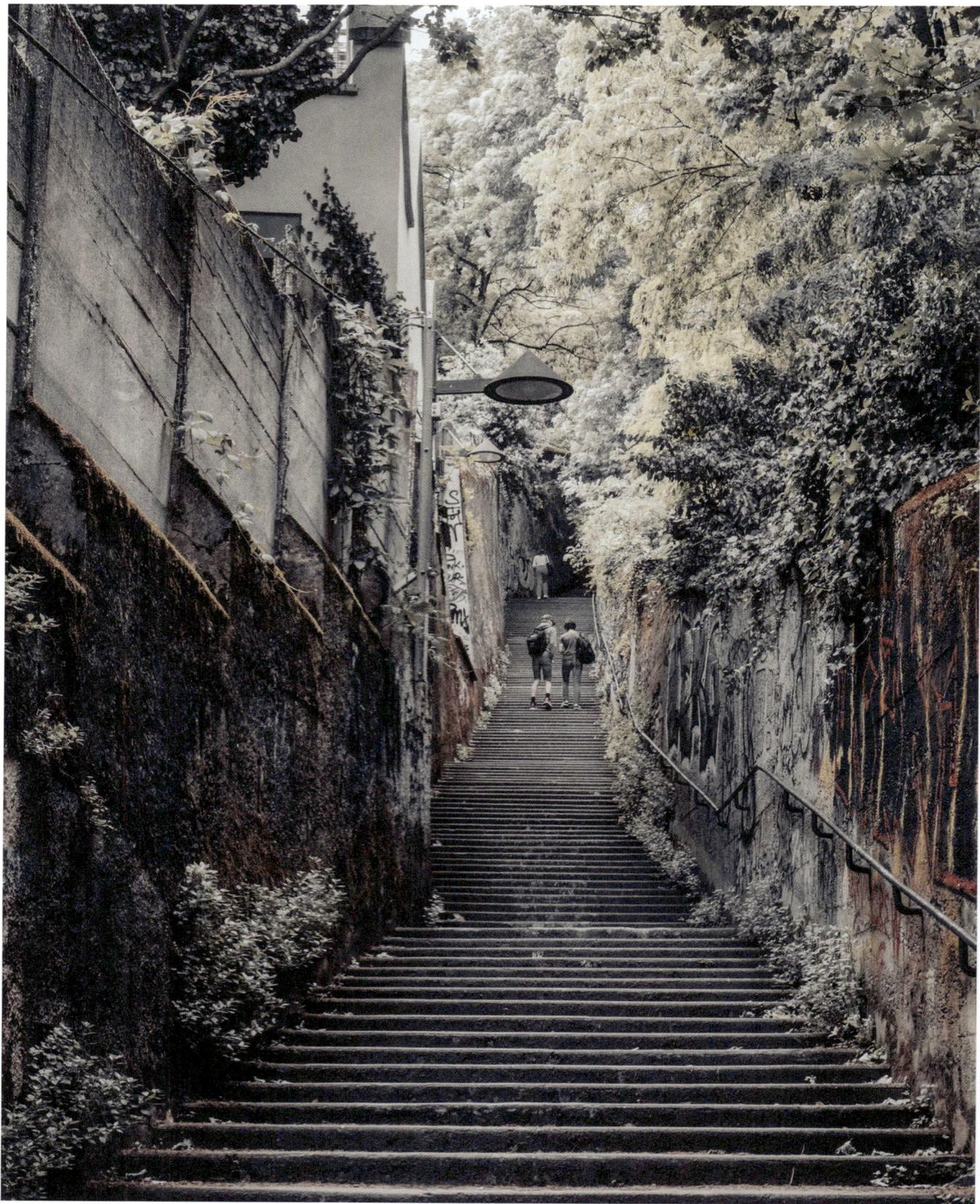

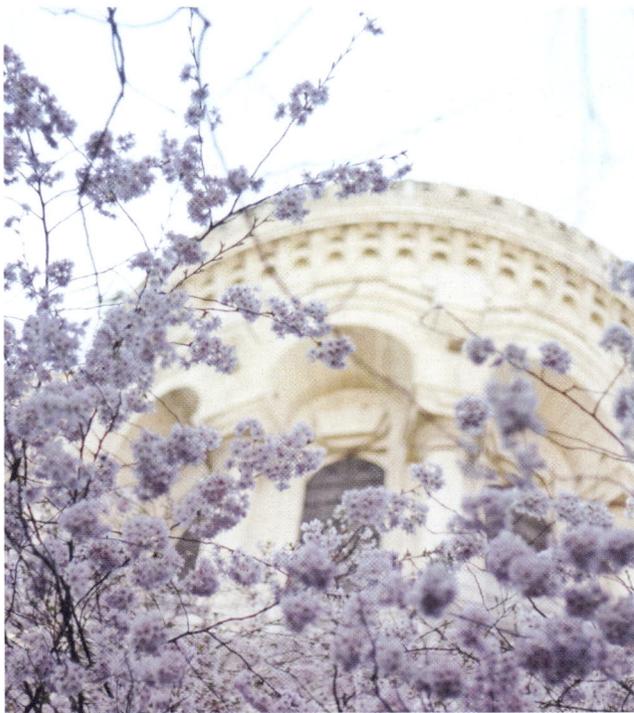
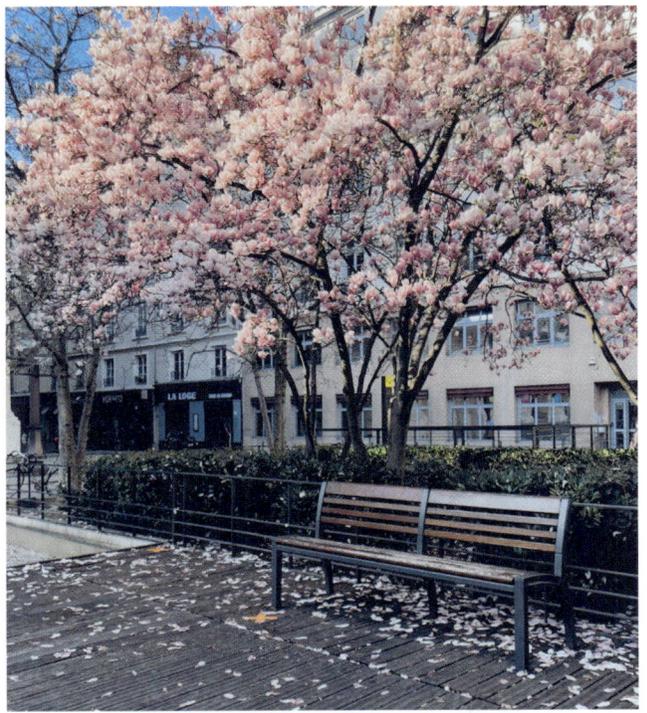
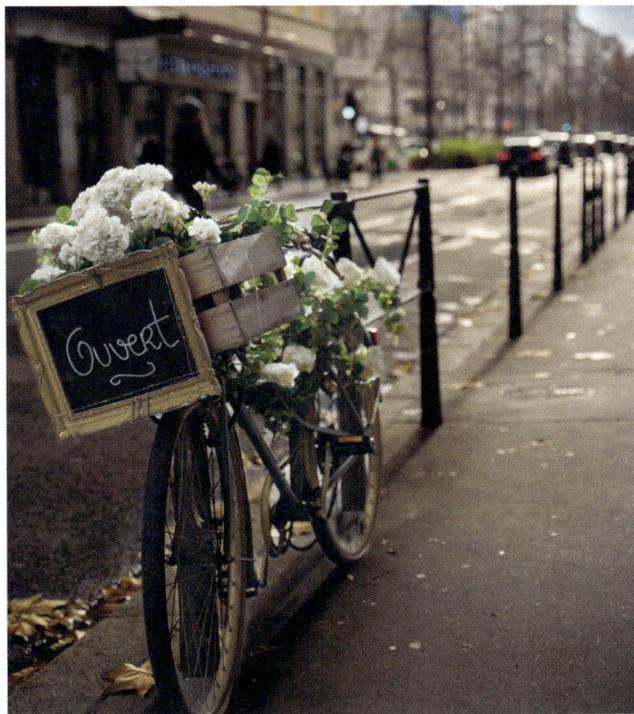

Above and at left:
Lyon in full bloom—in early summer, it's well worth climbing the steep steps from the old town, beneath blossoming trees, to the top of Fourvière Hill on a bend of the Saône. Here a romantic rose garden and sweeping views await amid the woods surrounding the Basilica of Notre-Dame.

Above and at left:
Crossing one of the numerous Saône bridges brings you to the heart of Lyon's oldest district: Lined with elegant restaurants, quaint artisan shops, and studios, the streets of the Presqu'île de Lyon invite leisurely strolls.

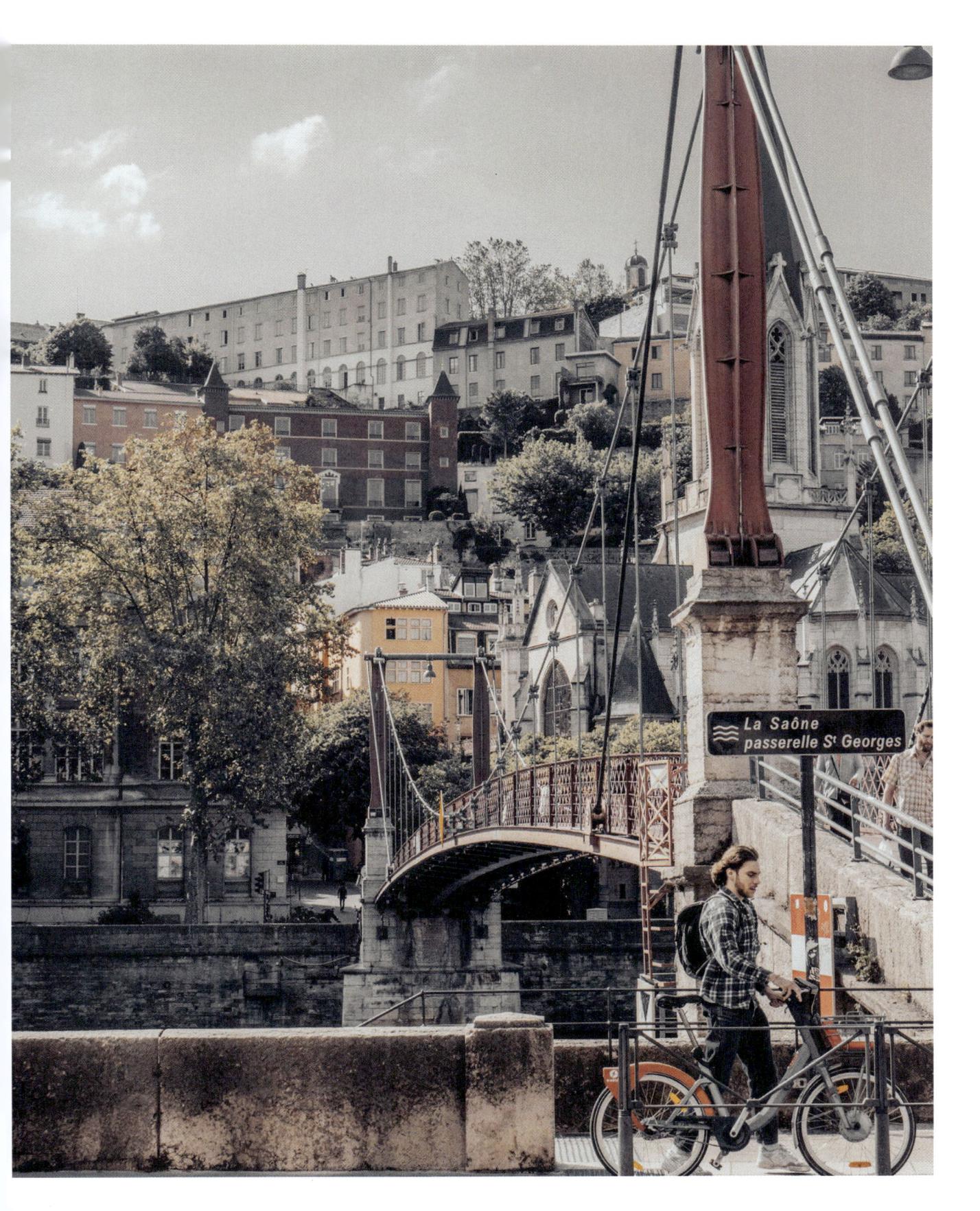

La Saône
passerelle St Georges

AU PAYS DU SOLEIL

WHAT COUNTS AS THE SUNNY SOUTH OF FRANCE?

Sticklers for definitions will say that everything south of the 45th parallel is *le Midi*. That just barely encompasses Bordeaux (France's secret second capital). But spend a long, hot summer in this city, and you know: in the lively university town on the Garonne, the sun works full-time and only gets two weeks' annual leave. That means Bordeaux is definitely *au pays du soleil*—in the land of the sun. The very mention of the name "Bordeaux" will quicken the wine-lover's pulse. And the city itself, surrounded by outstanding wine country, beckons to the epicurean spirit. The sunny summer charm of *le Midi* is perhaps felt most intensely in the picturesque villages along the Garonne, specks on the map that have largely kept their rural character and, with their narrow paved streets and masonry buildings, have a knack for keeping alive the distinct feel of an earlier time. In towns like Monflanquin or Auvillar, the mornings and long evenings are for enjoying the warm climate, and the midday heat is best endured beneath trellised walkways, pergolas, and arcades that usually ring the old market squares. We take a far leap to the southeast, to Languedoc, and find ourselves in a fairy-tale world or a picture-book in which we see the imposing *Cité* of Carcassonne, Europe's largest still-inhabited fortified town, dominating its surroundings. A three-kilometer-long double wall encircles the town, and atop it are 52 proud stone bastions and turrets. As a photographic subject, there's nothing else quite like it. The narrow streets inside the mighty walls combine a medieval atmosphere with southern-European charm. But now it's time to turn westward and visit the broad beaches of Biarritz, with its long history as one of France's oldest seaside resort towns, drawing an upper-class clientele to the Atlantic Ocean since the nineteenth century. Of the many architectural treasures there, one stands out in particular: Villa Belza, constructed during the Belle Époque, perched dramatically on a steep rocky promontory above the Atlantic.

Right:
In central Bordeaux, it's all about seeing and being seen—locals and visitors alike gather at the many restaurants for a leisurely apéritif.

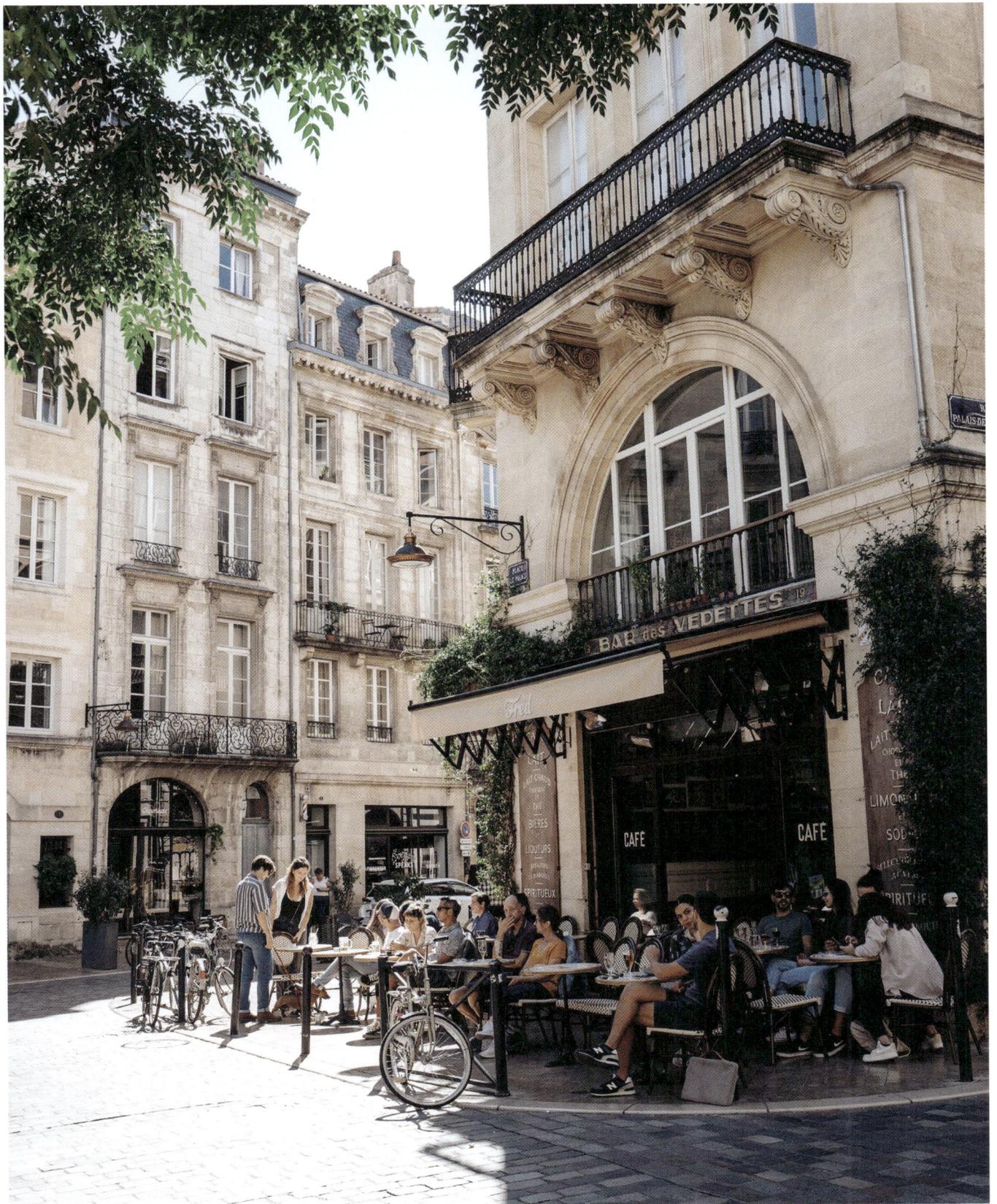

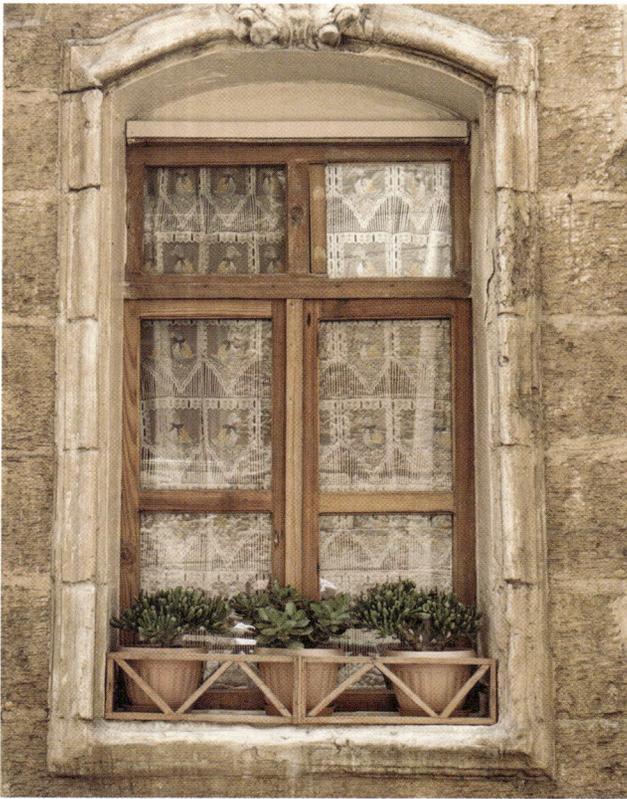

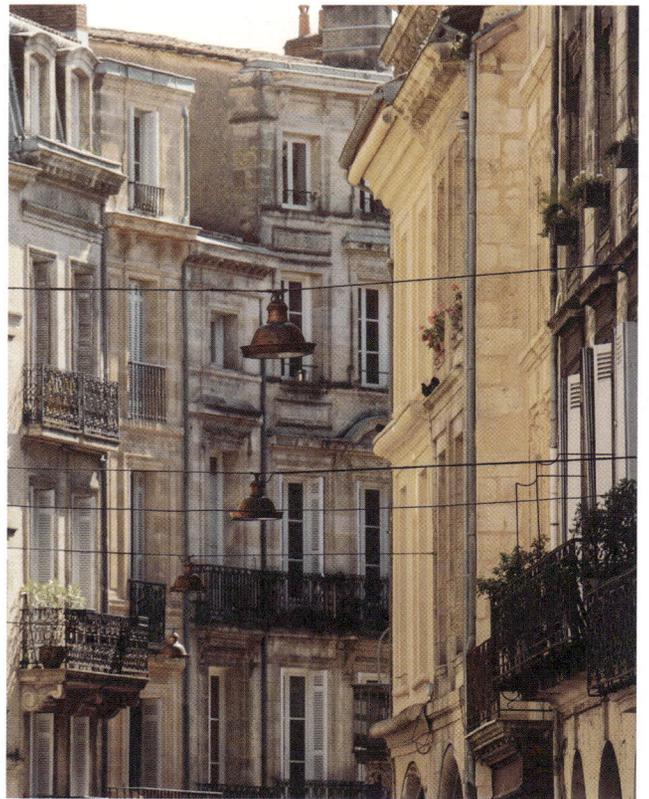

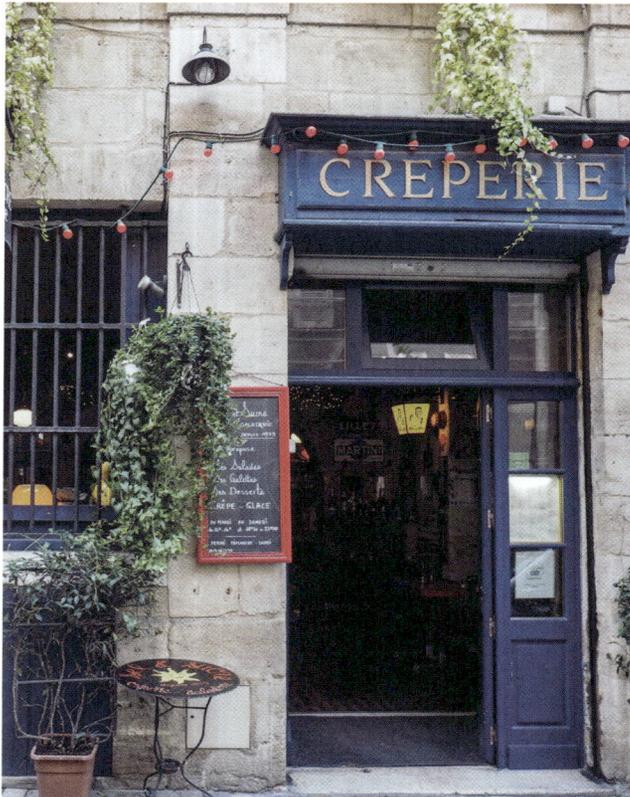

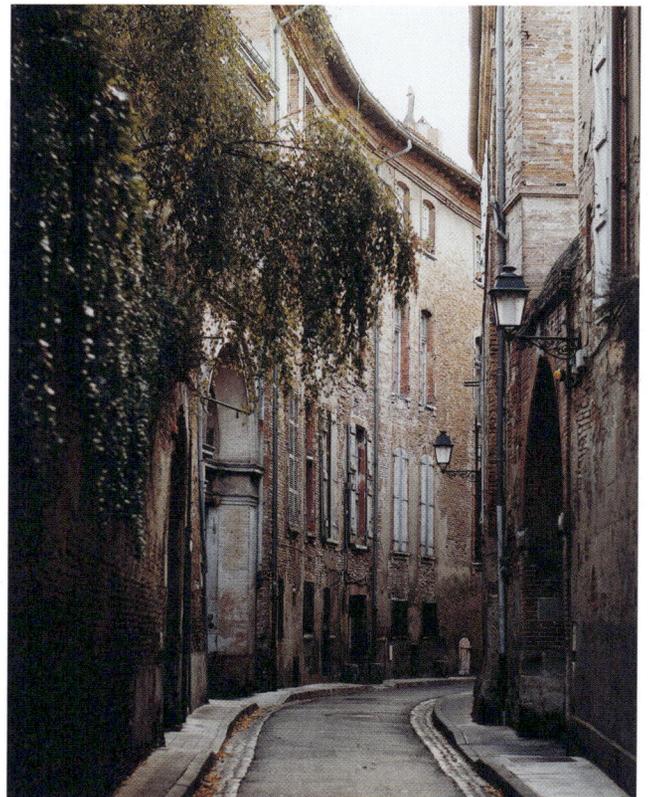

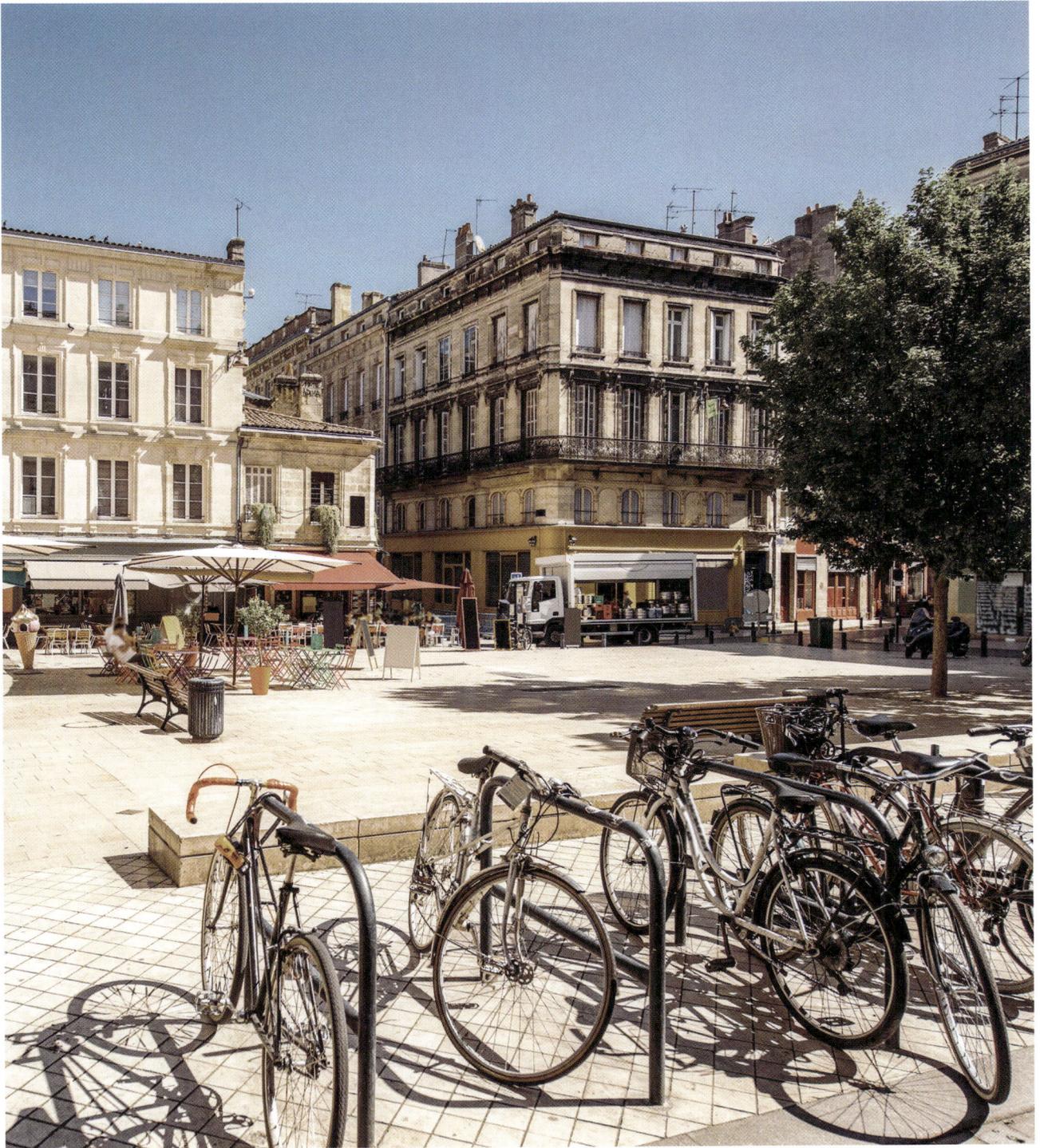

Above and at left:
Bordeaux is a visual treat for history buffs—nearly half the old town is preserved as a historic landmark, ensuring that the elegant charm of its classicist architecture endures.

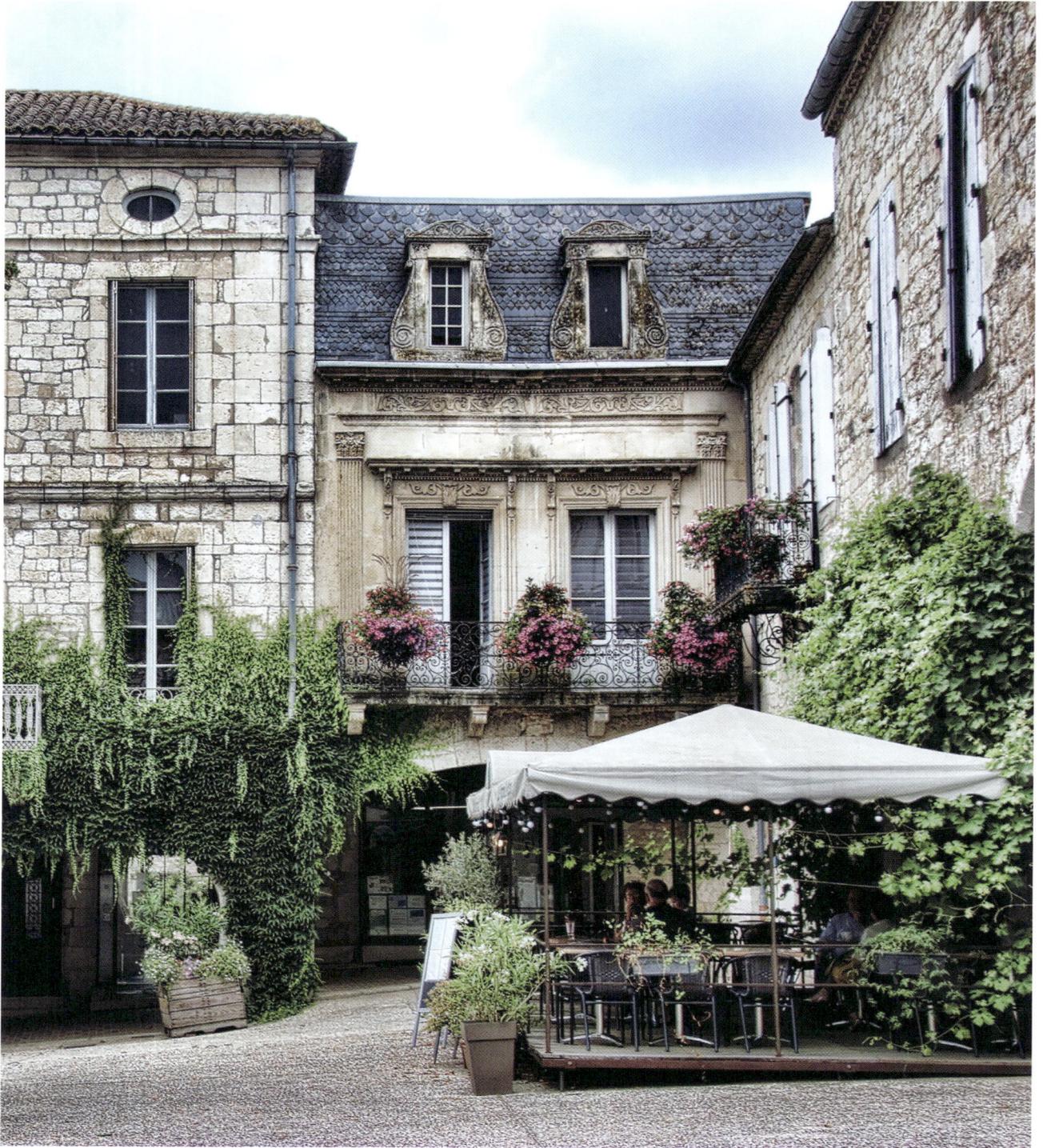

Above:
The Bastide of Monflanquin is one of the best-preserved fortified villages from the Middle Ages.

Right:
The serene Gascon village of Auvillar on the Garonne ranks among Occitania's most beautiful gems. As they wander through its ancient streets, pilgrims on the Camino de Santiago find respite in the verdant accents adorning its buildings.

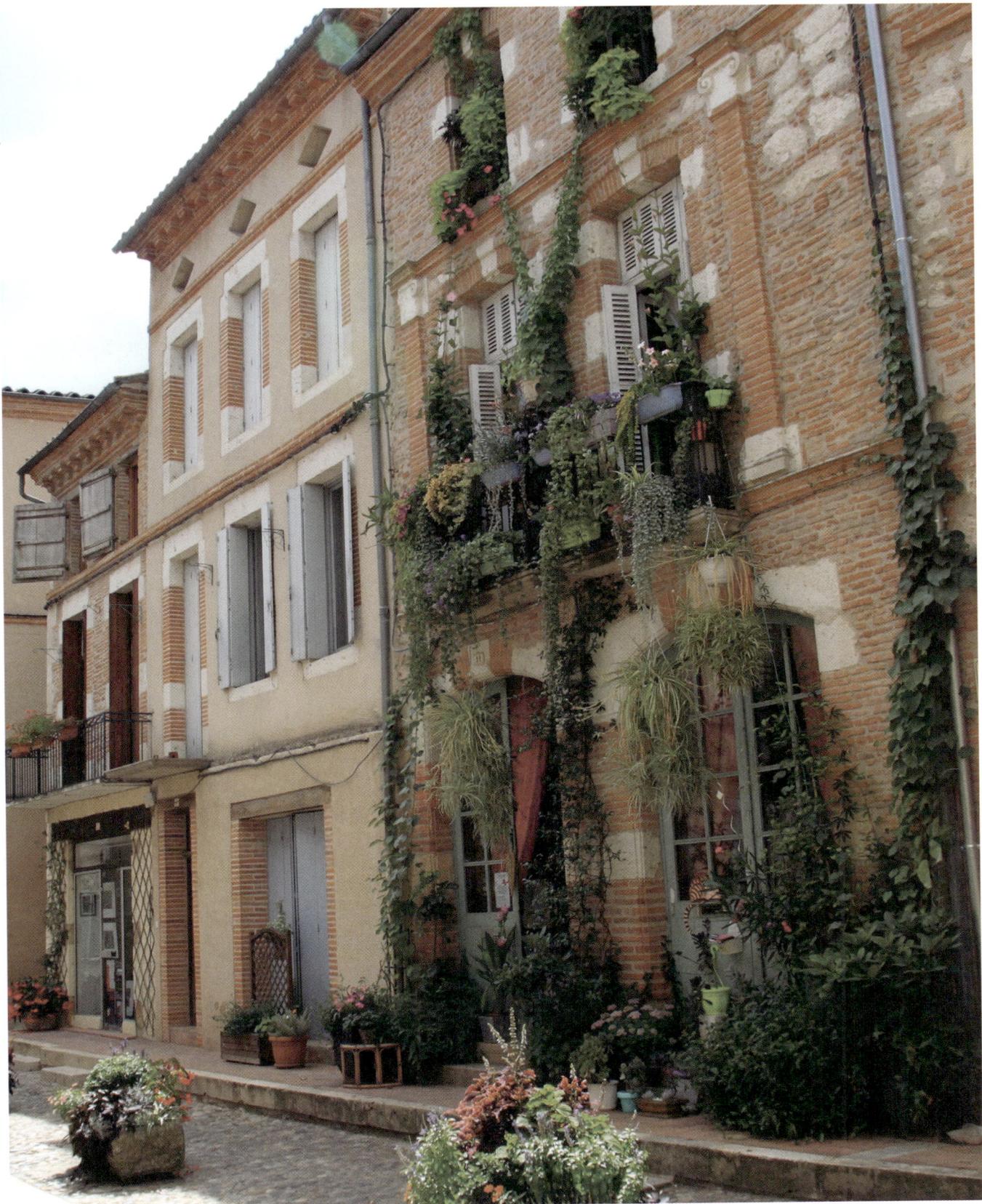

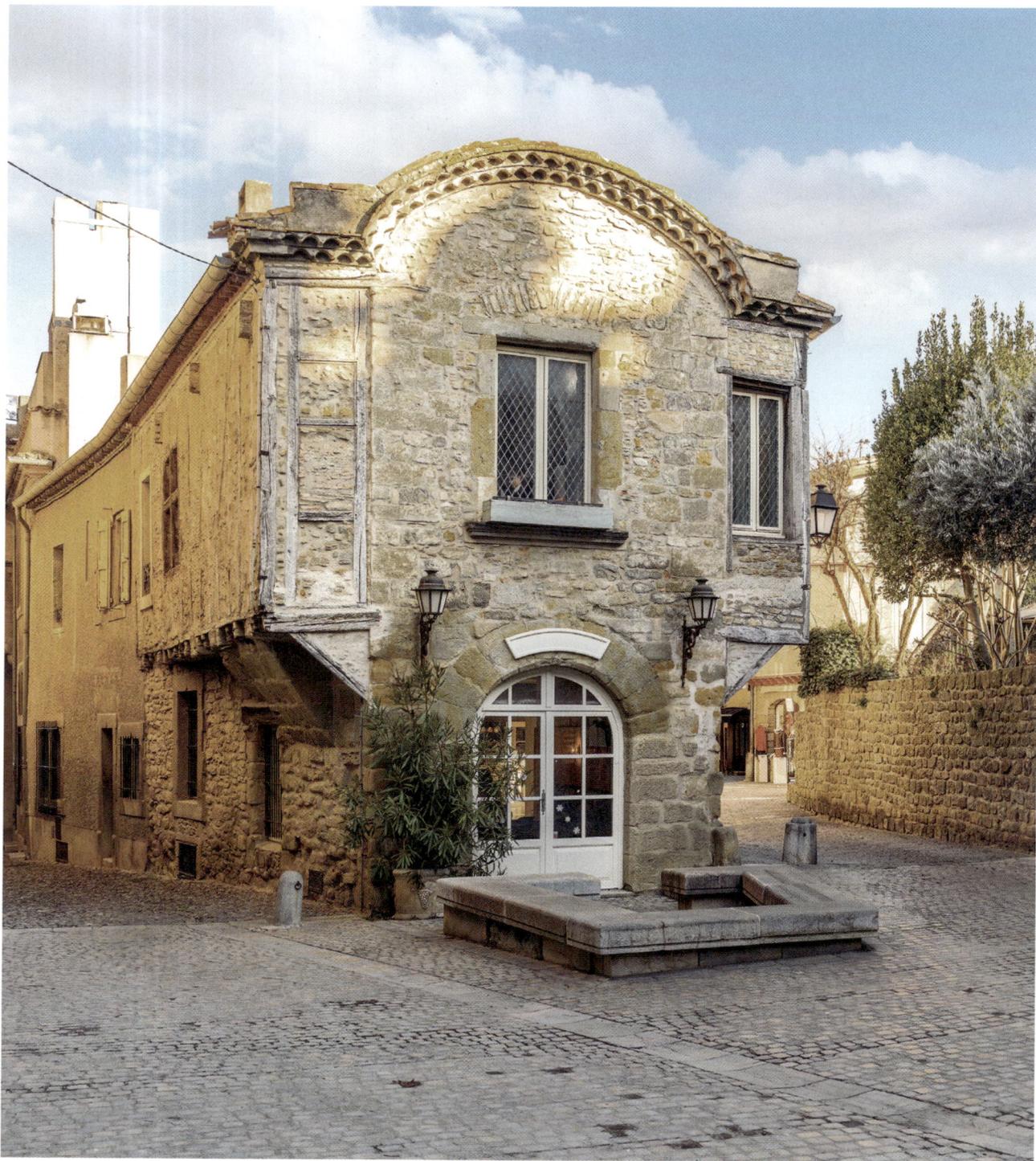

Above and at right:
Even within the medieval stronghold of Carcassonne, known as La Cité, *charming independent shops still sport vintage doors and façades.*

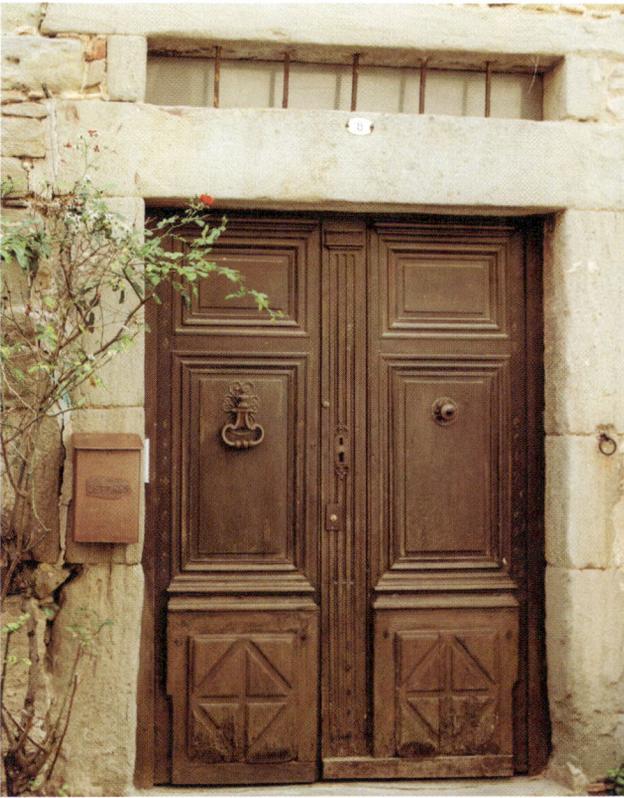
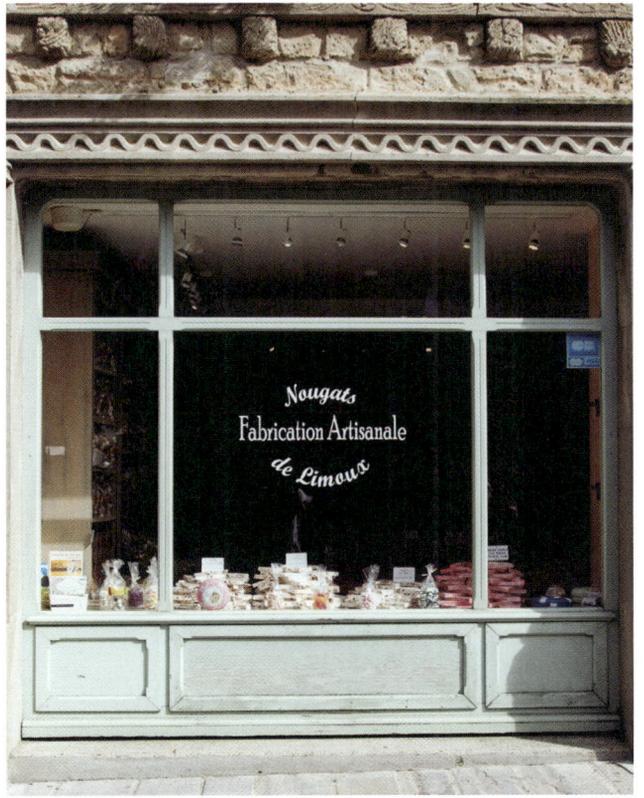
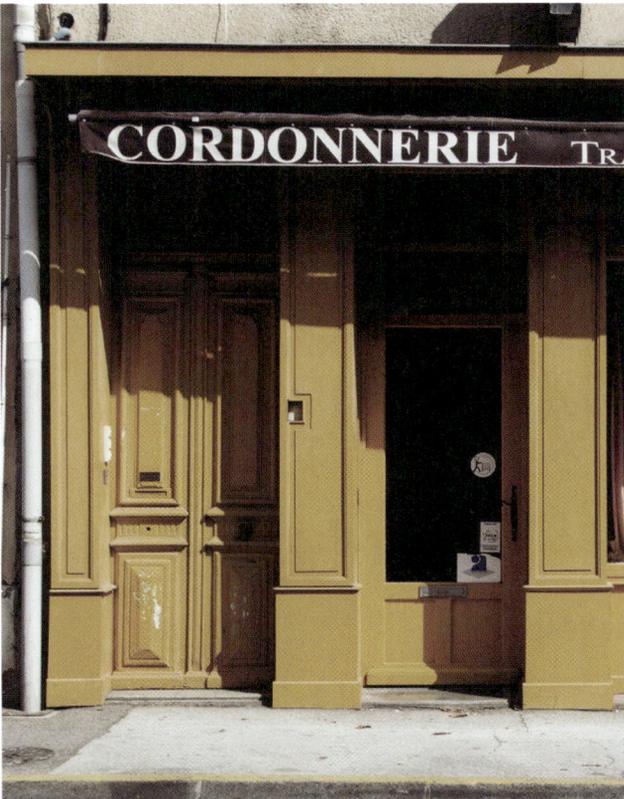
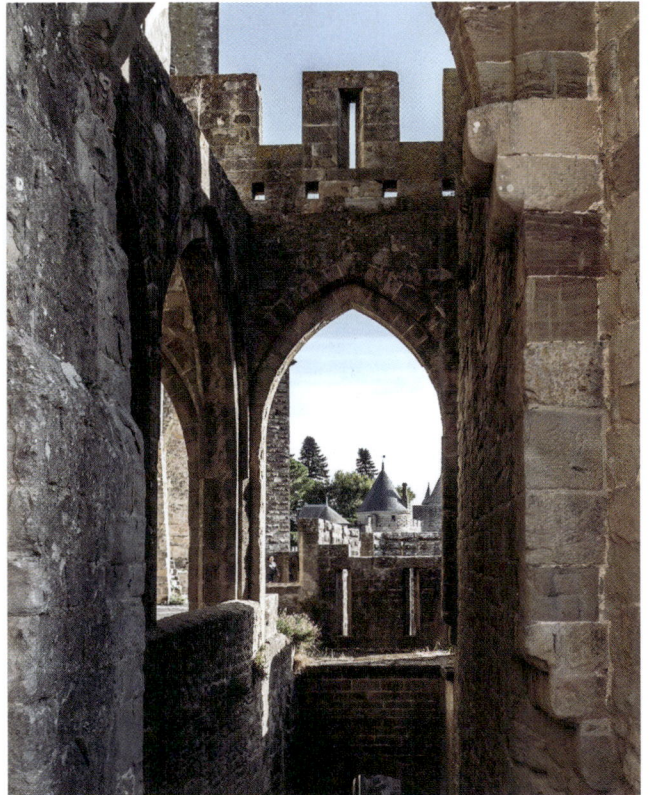

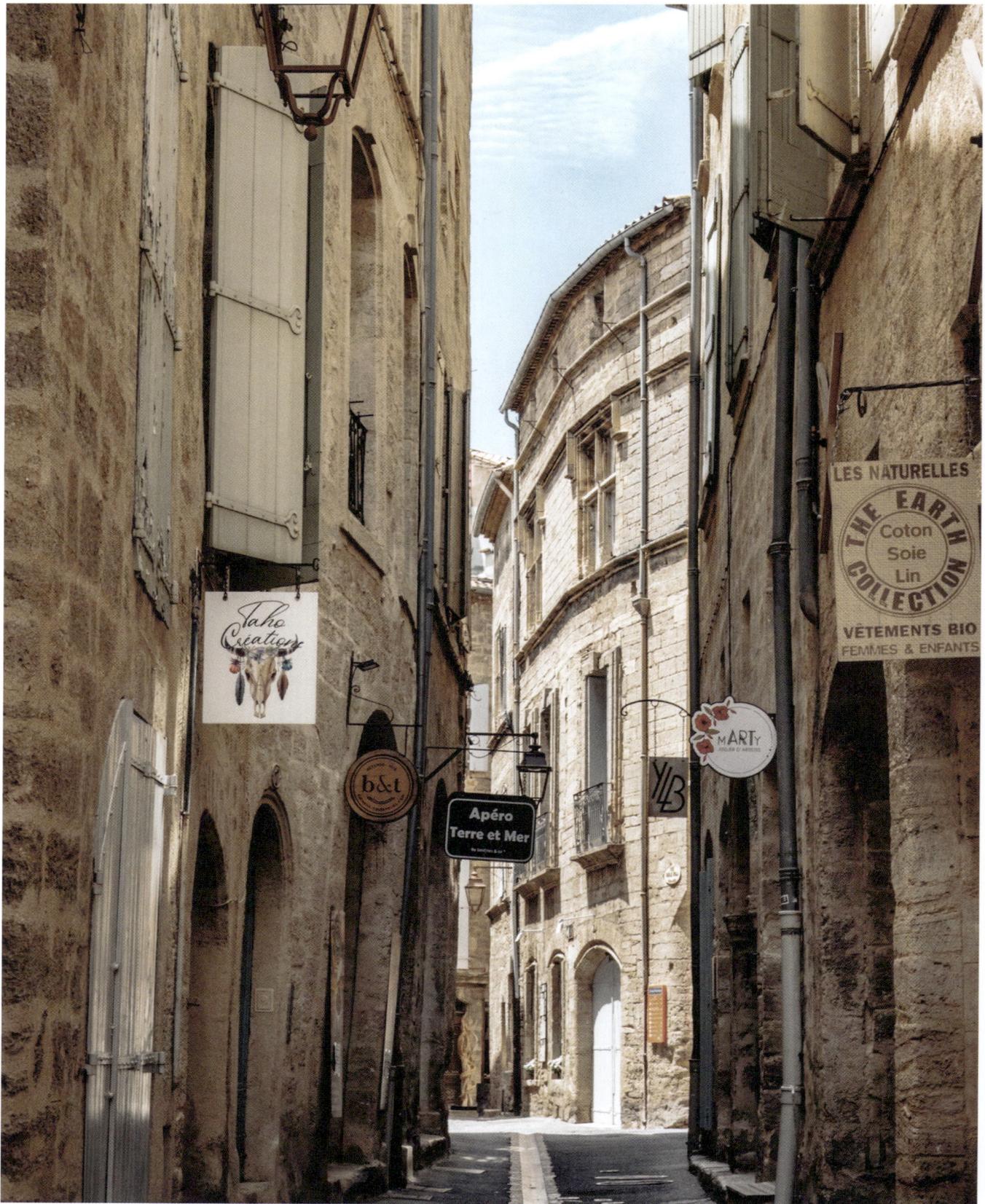

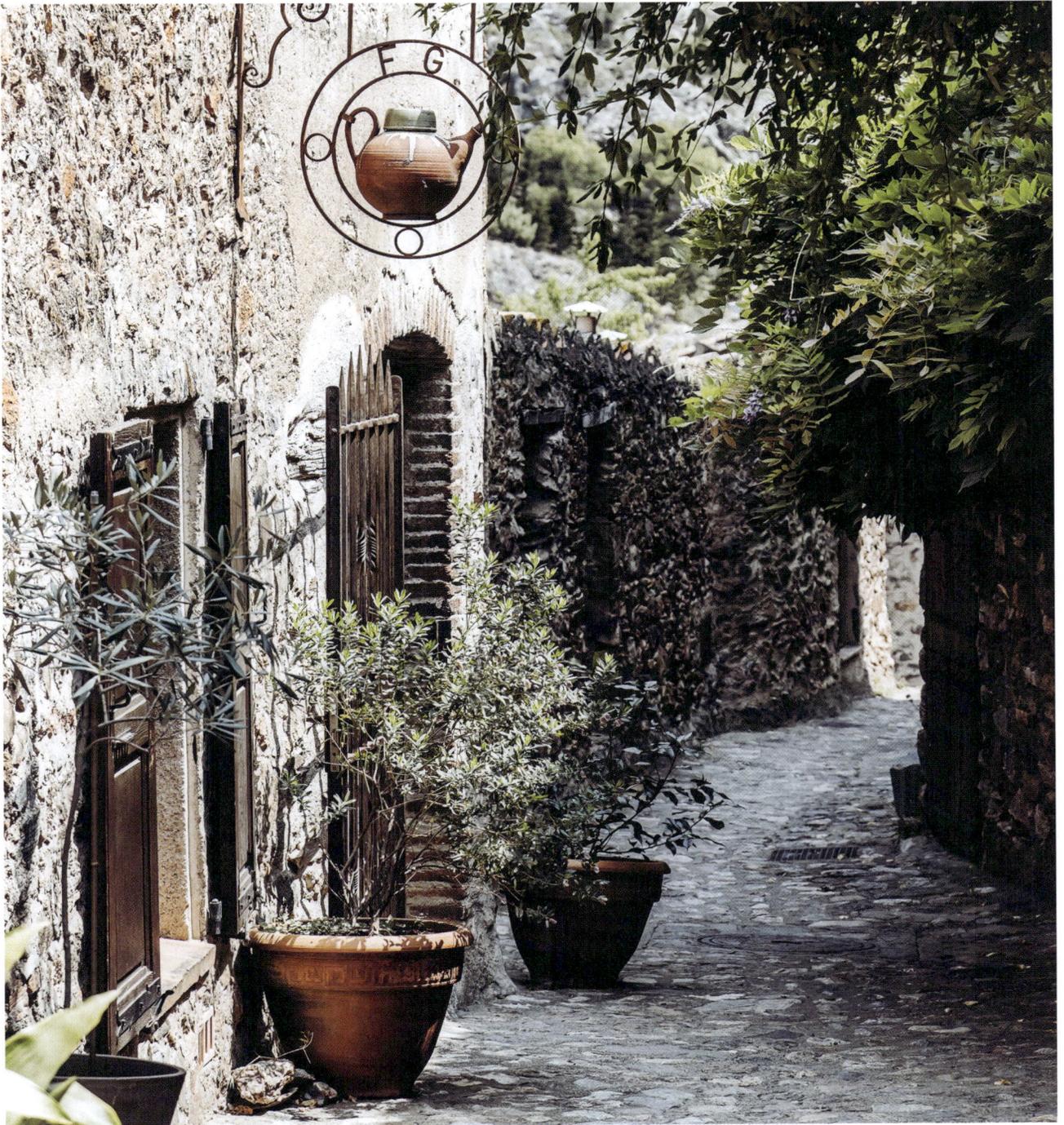

This page:
The small town of Castelnou is dominated by austere stone façades, with olive trees and lush greenery offering welcome shade.
Left:
Medieval stone façades define the historic heart of Pézenas.
Following pages:
From the Phare de Biarritz, one of the most beautiful lighthouses on the Basque coast, to the neo-medieval Villa Belza, dramatically perched on the cliffs, Biarritz boasts a diverse range of architecture.

Cover: Giulia Cremonese
Backcover: see p. 7, 126, 127.

p. 2 Vlad Hilitanu/unsplash, p. 3 Ekaterina Belova/Adobe Stock, p. 4 Marianne Furnes, p. 5 Patrick Boucher/unsplash, p.7 Giulia Cremonese, p. 9 Mathilda/Adobe Stock, p. 13-15 Marianne Furnes, p. 16 Shorty25/Adobe Stock, p. 17 Claude Dallaire/Adobe Stock, p. 18 Augustin Lazaroiu/Adobe Stock, p. 19 garrykillian/Adobe Stock, p. 20, 21 Marianne Furnes, p. 22 Luca Bravo/unsplash (a.l.), dpe123/Adobe Stock (a.r.), Acker/Adobe Stock (b.l.), Acker/Adobe Stock (b.r.), p. 23 SerFF79/Adobe Stock, p. 24 Sina Ettmer/Adobe Stock, p. 25 Anna/Adobe Stock (a.l.), Markobe/Adobe Stock (a.r.), Graham/Adobe Stock (b.l.), John N/Adobe Stock (b.r.), p. 27 Anton Ivanov Photo/Adobe Stock, p. 28, 29 Marianne Furnes, p. 30 Katerina Arkhypova/Adobe Stock, p. 31 Mehdi33300/Adobe Stock (a.l.), Martin Dube/unsplash (a.r.), La Coccinelle/unsplash (b.l.), David Vives/unsplash (b.r.), p. 32 Gérard Labriet/Photononstop/Mauritius Images, p. 33 Klaus Neuer/Mauritius Images, p. 34 Olga Demchishina/Adobe Stock, p. 35 Marianne Furnes, p. 36 Philippe Prudhomme/Adobe Stock, p. 37 M.Vinuesa/Shutterstock, p. 38 Franck/Adobe Stock, p. 39 Franck/Adobe Stock, p. 40 Chole Martin/unsplash, p. 41 Caroline Hernandez/unsplash (a.l.), Courtesy of Chuca Cimas (a.r.), Noel Bennett/Alamy Stock Photos/Mauritius Images (b.l.), Dimitry B/unsplash (b.r.), p. 42, 43 Marianne Furnes, p. 45 Fran the now time/unsplash, p. 46 Mathieu Gauzy/unsplash, p. 47 Sarah Sheedy/unsplash, p. 48 Camille/Adobe Stock, p. 49 Anastasia Mitiushova/unsplash (a.l.), Mathias Reding/unsplash (a.r.), Yves Destours/unsplash (b.l.), Michele Bergami/unsplash (b.r.), p. 50 Inguunal/Adobe Stock, p. 51 kovalenkovpetr/Adobe Stock, p. 52 Louis le Pessot/unsplash, p. 53 kovalenkovpetr/Adobe Stock, p. 54 Nicola Ripepi/unsplash, p. 55-60 Giulia Cremonese, p. 61 Celine Ylmz/unsplash, p. 62-72 Giulia Cremonese, p. 73 Dat Vo/unsplash, p. 74 Giulia Cremonese, p. 75 Stories/unsplash, p. 76 Giulia Cremonese, p. 77 Maria Lupan/unsplash, p. 78 Alex Harmuth/unsplash (a.l.), Giulia Cremonese (3), p. 79 David Giral/Alamy Stock Photos/Mauritius Images, p. 80 Catarina Belove/Shutterstock, p. 81 Pascale Gueret/Adobe Stock (a. 2), Giulia Cremonese (b. 2), p. 82-87 Giulia Cremonese, p. 88 Celine Ylmz/unsplash (a.l.) kovalenkovpetr/Adobe Stock (a.r.), Giulia Cremonese (b.l.), OK Camera/Shutterstock (b.r.), p. 89-92 Giulia Cremonese, p. 93 Valentin Kremer/unsplash (a.l.), enzogialo/Adobe Stock (a.r.), enzogialo/Adobe Stock (b.l.), Studio Laure/Adobe Stock (b.r.), p. 94 Louis Paulin/unsplash, p. 95-99 Giulia Cremonese, p. 100 Oscar Nord/unsplash (a.r.), p. 101-103 Giulia Cremonese, p.105 mohamed-jamil-latrach/unsplash, p. 106 Giulia Cremonese, p. 107 Augustin Lazaroiu/Adobe Stock, p. 108 Giulia Cremonese, p. 109 kovalenkovpetr/Adobe Stock (a.l.), kovalenkovpetr/Adobe Stock (a.r.), Slowmotiongli/Adobe Stock (b.l.), Megan Bucknall/unsplash (b.r.), p. 110 David Henry/Almay Stock Photos/Mauritius Images, p. 111 Ellie/Adobe Stock, p. 112 Cedric/Adobe Stock, p. 113 Ekaterina Pokrovsky/Adobe Stock, p. 114-115 Celine Ylmz/unsplash, p.116 Megan Bucknall/unsplash, p. 117 Vincent Giersch/unsplash, p.118 The Now Time/unsplash, p. 119 Jerome Labouyrie/Adobe Stock (l.), Dbrnjhrj/Adobe Stock (r), p.121 Marianne Furnes, p. 122 Florian K/unsplash (a.l.), Robert Dering/Adobe Stock (a.r.), Anika Labreigne/unsplash (b.l.), Ludovic Charlet/unsplash (b.r.), p. 123 Oscar Nord/unsplash, p. 124-126 Marianne Furnes, p.127 V2F/unsplash, p. 128 Natalia Schuchardt/Adobe Stock, p. 129 андрей горбунов/Adobe Stock, p. 130 Coline Hasle/unsplash, p. 131 Jawz/unsplash (a.l.), Claudia Salini/unsplash (a.r.), Lien van Win/unsplash (b.l.), Andrei Koscina/unsplash (b.r.), p. 133 Aquaphoto/Adobe Stock, p. 134 Erwan Hesry/unsplash (a.l.), Eric Barbeau/unsplash (a.r.), Packshot/Shutterstock (b.l.), Ian Kirkland/unsplash (b.r.), p. 135 Massimo Santi/Adobe Stock, p. 136 Lescarexpat/Adobe Stock, p. 137 JJFarg/Shutterstock, p. 138 Rolf/Adobe Stock, p. 139 analuciasilva/Adobe Stock (l.), Jesse/Adobe Stock (r.), p. 140 M Poiss/unsplash, p. 141 Bernard Girardin/Adobe Stock, p. 142 Isaline Basle/unsplash, p. 143 Mathis Rialland/unsplash (a.l.), Feodor Chistyakov/unsplash (a.r.), Sebastien L/unsplash (b.l.), Big Dodzy/unsplash (b.r.), p. 145 Alessandra Bechis/unsplash, p. 146 Clement Souchet/unsplash, p. 147 Kevin et Laurianne Langlais/unsplash (l.), Marissa Price/unsplash (r.), p. 148 Nella N/unsplash, p. 149 Nusa Urbancek/unsplash, p. 150 Nusa Urbancek/unsplash, p. 151 Nusa Urbancek/unsplash, p. 152 Kirk Fischer/Adobe Stock, p. 153 Bertrand Rieger/Hemis/Mauritius Images, p. 154 Vlad B/unsplash, p. 155 Judith Girard Marczak/unsplash, p. 156 Justin Chrn/unsplash, p. 157 Robert Harding/Adobe Stock, p. 158 Suzanne Plumette/Adobe Stock (a.l.), Didier Laurent/Adobe Stock (a.r.), dbrnjhjr/Adobe Stock (b.l.), Didier Laurent/Adobe Stock (b.r.), p.159 Tommy Larey/Adobe Stock, p. 160 Geoffroy Hauwen/unsplash, p. 161 Artem Gavrysh/unsplash, p. 162, 163 Rhayane Daibert/unsplash, p.165 Eyewave/Adobe Stock, p. Milena Kiefer/unsplash (a.l.), Julian di Majo/unsplash (a.r.), Renan Brun/unsplash (b.l.), Clemens van Lay/unsplash (b.r.), p. 167 Vaceslav Romanov/Adobe Stock, p. 168 Marcin Krzyżak/Adobe Stock (a.l.) 168 Golovianko/Adobe Stock (a.r.), Uga VM/Getty Images (b.l.), Kavalenkava/Adobe Stock (b.r.), p. 169 Erin Doering/unsplash, p. 170 Joackim Weiler/unsplash (a.l.), OceanProd/Adobe Stock (a.r.), Thierry RYO/Adobe Stock (b.l.), Slava/Adobe Stock (b.r.), p. 171 Eric Terrade/unsplash, p. 172 Clement Proust/unsplash, p. 173 Ross Helen/Getty Images, p. 174 Victor Pot/unsplash, p. 175 Mathias Reding/unsplash, p.176 Yannaty Kouyate/unsplash, p. 177 Aterrom/Adobe Stock, p. 179 Kyle Evans/unsplash, p. 180 Celli07/Shutterstock, p. 181 Elena Skalovskaia/Adobe Stock, p. 182 goran/Adobe Stock, p. 183 BWPhoto-Hermann and Andie/Shutterstock, p. 184 Alona/Adobe Stock, p. 185 Chris Warren/Loop Images/Mauritius Images, p. 186 Mathilde C/unsplash, p. 187 Mathilde C/unsplash (a.l.), Anushka Srivastav/unsplash (a.r.), Oliverdelahaye/Shutterstock (b.l.), Keitma/Shutterstock (b.r.), p. 188 Uolir/Adobe Stock (a.l.), Uolir/Adobe Stock (a.r.), Rolf/Adobe Stock (b.l.), Blanche Peulot/unsplash (b.r.), p.189 Paul Shawcross/Alamy Stock/Mauritius Images, p. 190 Hilderose C/unsplash, p. 191 Morgane le Breton/unsplash (a.l.), Titouan Colomb/unsplash (a.r.), Rafael As Martin/unsplash (b.l.), Eduardo Casajus/unsplash (b.r.), p. 192 Nguyen Dank Hoang Nhu La/unsplash, p. 193 Hilderose C/unsplash, p. 195 Alexander Brenner/Shutterstock, p. 196 196 Tatyana Vyc/Shutterstock (a.l.), Nonglak/Adobe Stock (a.r.), Philipbird123/Adobe Stock (b.l.), Maeva Vigier/unsplash (b.r.), p. 197 Rh100/Adobe Stock, p. 198 david debray/Adobe Stock, p. 199 Vouvraysan/Adobe Stock, p. 200 Kirk Fischer/Adobe Stock, p. 201 grafxart/Adobe Stock (b.r.), Maria Lupan/unsplash (3), p. 202 Pernelle Voyage/Adobe Stock, p. 203 PicsArt/Adobe Stock, p. 205 Pauline Bernard/unsplash (a.l.), Clementine Claudel/unsplash (a.r.), Paula de la Pava Nieto/unsplash (b.l.), Dani Fuentes Ortiz/unsplash (b.r.), p.207 Giulia Cremonese

Illustrations Map p. 12-13: babayuka/Shutterstock, ChathrineArt/Shutterstock, Mari Shvetsova/Shutterstock, sarema/Shutterstock

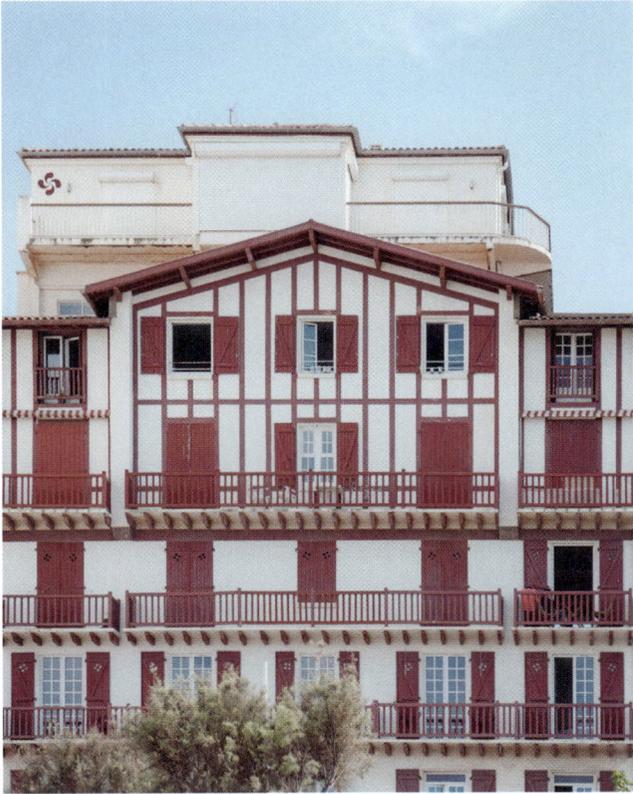
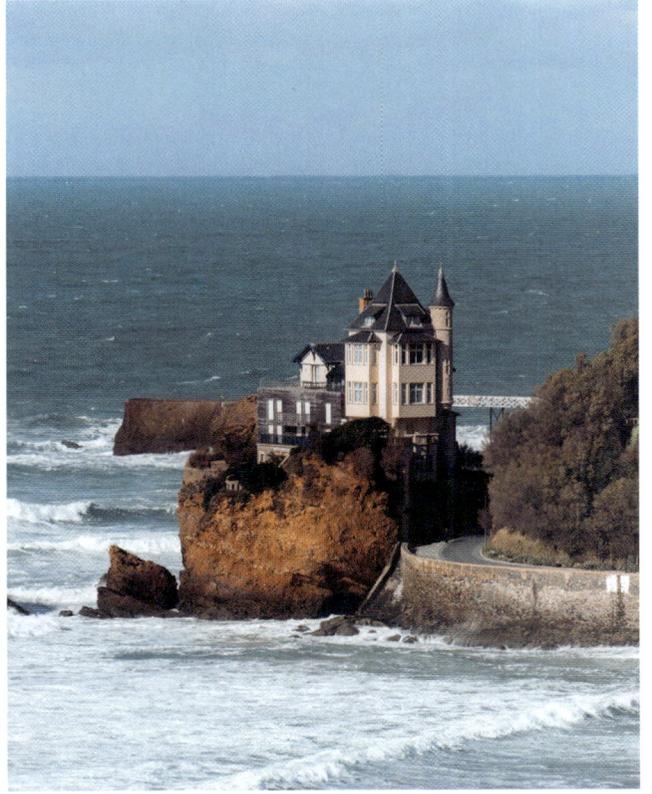
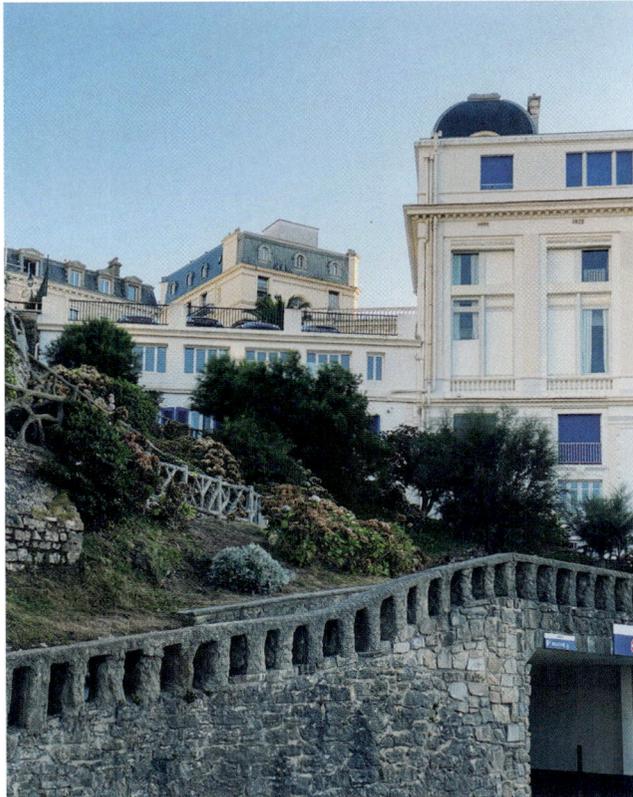
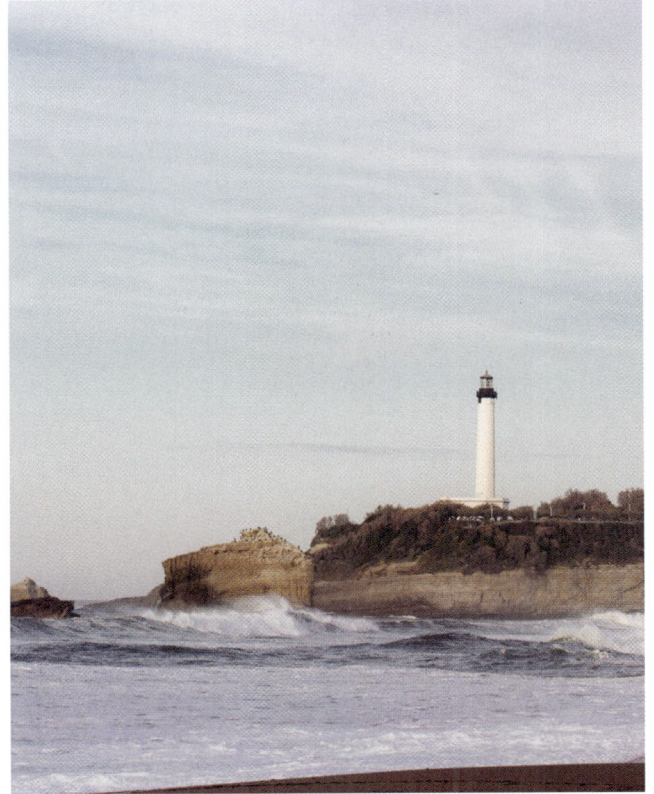

MERCI À TOUS!

A book never comes to life on its own—it always needs one essential element: the right people. I would like to thank Anja Klaffenbach for her inspiring texts, which are the heart of this book. I am also grateful to Eva Stadler for her keen eye for layout and typesetting. I would also like to thank John A. Foulks for his excellent translation, which allowed me to bring my thoughts and ideas to life in a new language.

I would like to express my deep admiration for the photographers whose work adds extraordinary visual depth to this book. They have a remarkable ability to capture unique moments and powerful emotions. This time, a special thank you goes to Giulia Cremonese (@julieaucontraire & @lesfacadesdeparis) and Marianne Furnes (@myfrenchmap).

I would also like to thank all the photographers—see the previous page.

Their support and creativity made this book possible. It's always a pleasure to work with the fantastic team at teNeues.

Merci à tous!

Heide Christiansen started her career as a photo editor at a renowned travel magazine and is now a bestselling author. Born and raised in Canada, with family ties in Canada, Australia, and the United States, she is an avid globetrotter. France became her love at "second sight." Since her youth, she has traveled through France, but it was only in recent years, inspired by influencers, that she began to seek out the lesser-known, authentic spots. In doing so, she has discovered the true charm of France.

Right:
Just around the corner, you'll discover one of the many quiet courtyards that embody the unique charm of Paris.

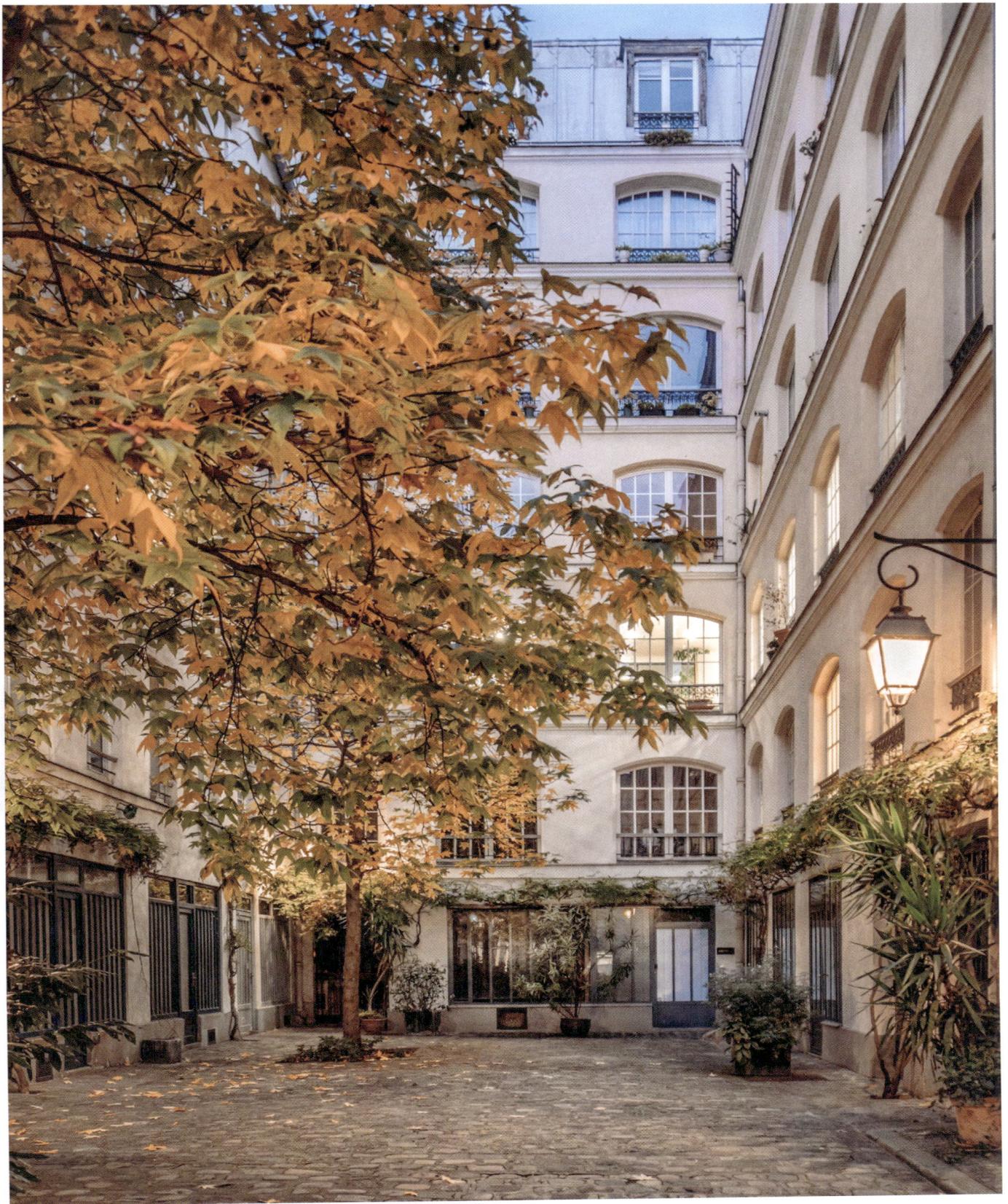

CHARMING FRANCE
HEIDE CHRISTIANSEN

This book was conceived, edited, and designed by teNeues.

Edited by teNeues

Authorship and concept by Heide Christiansen
Text by Anja Klaffenbach
Translation by John Augustus Foulks

Editorial Management by Dr. Johannes Abdullahi
Design by Eva Stadler
Layout by Eva Stadler
Photo Editorial by Heide Christiansen
Edited by Benine Mayer
Proofread by Simona Fois
Cartography by Thomas Vogelmann
Production by Sandra Jansen-Dorn, Alwine Krebber, Robert Kuhlendahl

Printed in Czech Republic by PBtisk

Made in Europe

FSC
MIX
Paper | Supporting responsible forestry
FSC® C004378
www.fsc.org

Published by gestalten, Berlin 2025
ISBN 978-3-96171-640-1
Library of Congress Cataloging-in-Publication data is available from the publisher

1st printing, 2025

The german edition *Charming Frankreich* is available under ISBN 978-3-96171-655-5.

© teNeues, an Imprint of
Die Gestalten Verlag GmbH & Co. KG, Berlin 2025

For more information, and to order books, please visit
www.teneues.com and www.gestalten.com

Die Gestalten Verlag GmbH & Co. KG
Mariannenstrasse 9–10
10999 Berlin, Germany
hello@gestalten.com

Düsseldorf Office
Waldenburger Straße 13
41564 Kaarst, Germany
verlag@teneues.com

teNeues Press Department
presse@teneues.com

Bibliographic information published by the Deutsche Nationalbibliothek. The Deutsche Nationalbibliothek lists this publication in the Deutsche Nationalbibliografie; detailed bibliographic data is available online at www.dnb.de

https://instagram.com/teneuespublishing

www.teneues.com